SWIFTERATURE

SWIFTERATURE

A LOVE STORY: ENGLISH LITERATURE AND TAYLOR SWIFT

Elly McCausland

PEGASUS BOOKS

NEW YORK LONDON

SWIFTERATURE

Pegasus Books, Ltd.
148 West 37th Street, 13th Floor
New York, NY 10018

First Pegasus Books edition November 2025

Interior design by Maria Fernandez

Library of Congress Cataloging-in-Publication Data is available.

ISBN: 978-1-63936-989-8

10 9 8 7 6 5 4 3 2 1

Printed in the United States of America
Distributed by Simon & Schuster
www.pegasusbooks.com

This book is dedicated to all the girls out there who are killing it. But especially those who picked me up from the cold, hard ground when I felt like a crumpled-up piece of paper.

Contents

Foreword: Dear Readers ix

1 The Stories of Us: Writing About Writing 1

2 Who's Taylor Swift Anyway: Controversy and the Canon 20

3 Why We're Still Singing Along: Swift and Style 38

4 Nothing New: Inspiration, Creation, and Anxiety 58

5 No One Knows What to Say: Death, Grief, and Elegy 77

6 Call It What You Want: Reputation, Interpretation,
 and Control 94

7 This Ain't a Fairy Tale: Chivalry and the Dream of Romance 118

8 False Gods and Crimson Clover: Love, War, and Worship 137

9 They'll Tell You I'm Insane: The Madwoman 156

10 Out of the Woods: Writing Nature 177

11 Bad Blood: The Villain, the Victim, Ghosts, and
 the Gothic 199

12 I'm the Problem, It's Me: The Anti-Hero 220

13 A Book Covered in Cobwebs: Adaptation and Afterlives 246

Discussion Questions 267

Books to Put Beside Your Bed: Reading List 269

Playlist of Songs 273

Acknowledgments 275

Index 279

Foreword

Dear Readers

Are you serious?
Are you really serious
You are a ticking idiot and for
Ghent U to pay you for a
Professor
Go back to brexit land!
Moron?

—E. L. Doesburg, via email

In spring 2023, I finally gave shape to something that had been living rent-free in my head for years. Tasked with finalizing my teaching for the fall semester, I put aside my former plan to repeat a tried-and-tested course, opened up a blank document on my laptop, and wrote the heading, "English Literature (Taylor's Version)." Half an hour later, following a brief exchange with two friends who inhabit that sweet spot on the Venn diagram where "literature nerds" and "Swifties" intersect, I'd sketched out ten seminars. They featured many of the topics that you might expect from a master's course in English literature—authorship, intertextuality, literary theory—with one minor difference. Each seminar's title was drawn from a Taylor Swift lyric, and in addition to classics from William

Shakespeare, Charlotte Brontë, and Geoffrey Chaucer, the syllabus featured thirty songs by the twenty-first century's indisputable queen of pop, a woman whose music has soundtracked my life since 2006.

Weeks later, my phone rang: a journalist from one of Belgium's newspapers, *De Standaard*, had heard about the class and wanted to ask me a few questions. My life then took a surreal turn. I found myself setting multiple nighttime alarms to give TV and radio interviews in Sweden, China, Dubai, Germany, Belgium, and the UK. In the space of a couple of days, I'd been asked to chat to CNN, BBC World News, the *New York Times*, and Emily Ratajkowski (whose ethereal radiance made me wish I'd gotten a bit more sleep or at least bothered to put on some lipstick).

It was perhaps a bit like having a newborn baby (I wouldn't know—childless cat lady here), except that the demanding entity constantly clamoring to be fed was the world's media. My inboxes were flooded, not only with journalist requests but with excitable emails from prospective students hoping the course would be taught online so that they could attend. An ex-boyfriend got in touch to say he'd seen me on the news (and I couldn't help but think of Swift's line in "Midnight Rain"). Scholars and teachers already working on Swift in different fields welcomed me into their communities and invited collaborations.

Then came the inevitable responses from the trolls and keyboard warriors. Hate mail calling me a moron, an idiot, a "big bitch," and a stupid woman. Requests that I "go back to Brexit land." A snide article from a Belgian columnist featuring the line, "Het is een aula, geen kleutertuin" ("It's an auditorium, not a kindergarten"). Social media comments accusing me of stealing money off students (university is almost free in Belgium) or bemoaning the depths to which modern universities had apparently sunk.

As Taylor Swift once put it: this is why we can't have nice things. Having worked relentlessly to deliver the kind of "impact" and "outreach" that academics are constantly pressured to achieve, I was disappointed to find myself embroiled in departmental politics at work. Certain colleagues were convinced that comparing historical literature to modern popular culture was somehow blasphemous. Weeks later, a man approached me after a talk I'd given on Swift, asked if I'd "accept some critique," and then proceeded to tell me how I might have done my job better. Another Belgian newspaper wrote an article on my first class, quoting one of my students: "My family aren't pleased. They think this is a sign that the level of Ghent University has plummeted."

"Dear Reader," Swift sings on her 2022 album *Midnights*, "Bend when you can, snap when you have to." And I did. I printed IT'S AN AUDITORIUM, NOT A KINDERGARTEN on a pink T-shirt and wore it to my first class, inspired by a Belgian opera singer who had made Taylor-style bracelets with the same phrase in my honor (thank you, Astrid, for being my first champion). I turned the hate mail into the subject of that first class, projecting some of my favorites onto an enormous screen behind my head. I argued that such skepticism only makes it more important to study popular culture, and to question supposedly established "canons" of literature. In the words of author and educator bell hooks, "popular culture is where the pedagogy is, it's where the learning is." I was spurred on by my students, motivated to try and deliver the course I would want to take were I in their shoes: to be madder, louder, sillier, and more disruptive. "Haters gonna hate," I wrote in an article for the *Guardian*, "but stars like Taylor Swift can help to make literature pop."

One unexpected consequence of all of this is that English Literature (Taylor's Version) is now both a regular course and a metacourse, of sorts. We—my students and I—reflect continually

on its existence and importance in a world that so often condemns popular culture—particularly popular culture enjoyed predominantly by women—as frivolous. This, in many ways, parallels Swift's own career: her self-referentiality and consciousness of the narratives in which she is (willingly or unwillingly) implicated are arguably what set her apart from many comparable artists. This has taken an increasingly feminist slant in recent years, as she lambastes society's tendency to dismiss girls' culture and women's feelings (there are limits to that feminism, though, as I will discuss throughout this book). I was both surprised, and sadly not surprised, by the sexism, snobbery, and xenophobia underlying some of the public reaction to English Literature (Taylor's Version). What amazed me most was that none of these responses ever took into account what we were actually doing in the classroom (I think some envisaged us singing along to "Shake It Off" for three hours while wearing armfuls of friendship bracelets), or what today's university students might want or enjoy.

Even as a literature professor and keen extracurricular bibliophile, I sometimes struggle with certain inclusions in the so-called literary canon, particularly those written in archaic language and far removed in time from our tumultuous present. I can hardly blame my students—whose mother tongue is rarely English—if they aren't able to connect with the tenth-century Old English poem "The Wanderer," about a desolate former warrior isolated from his lord and fellows, reminiscing about the once-great camaraderie of the mead hall and the transience of earthly joy. What if, though, we were to read such a poem alongside Taylor Swift's song "Bigger Than the Whole Sky," which laments everything "turned to ashes" while musing poignantly on what could have been? Might we then start to explore the universality of grief and bereavement, and trace how different cultures at various points

in history have reached for particular metaphors to express those very same feelings?

What about the increasingly urgent issue of how we relate to nature and the environment, an environment we're on the verge of damaging beyond repair? Might we find some answers in the notion of "ecocriticism," which explores how man's relationship to nature is at least partly forged in the fires of language, and played out on the stage of literature? Might we illuminate this conceptual quagmire by looking at Swift's songs "ivy," "willow," and "Out of the Woods," and the way they represent humanity succumbing willingly to nature's power, rather than attempting to conquer and control it? Might we find, concentrated in a single Swift track, the entire fraught history of human–nature relations in microcosm? And if we do, what can we do with those findings in the here and now?

I once read a comment on a Swift fan forum, saying, "it's so crazy how T Swift makes me think, about art, about communication vs perception, about fame, about transparency, about media and feminism and worship and sexism and human nature." To which I can only say: me too. And about much, much more besides.

This book is, in some ways, the result of a massive free association exercise that has been going on in my head since 2006. I sometimes imagine myself like Carrie Mathison in *Homeland*, in one of her manic phases, covering an entire wall in color-coded, interconnected documents, Swift's lyrics at the center of one giant mind map. This book tries to explain the method in my madness (and you'll find more on madness in Chapter Nine). At the heart of it all is the desire to make historical English (by which I mean Anglophone) literature as relevant, accessible, and interesting to as wide an audience as possible, with a little help from my personal

passion for the phenomenon that is Taylor Swift: her lyrics, her chameleonlike public persona, and the fandom she inspires.

By now, you can find countless articles online—and a few printed books, too—listing all the literary allusions in Swift's work, from the explicit ("Romeo, save me") to the more speculative (is "mad woman" a reference to *Jane Eyre*?) Beyond suggesting that Swift is familiar with some of the classics of English literature, these lists don't really tell us much at all. I wanted to go deeper: to see these references as merely the buds on a giant tree, whose roots snake down through the strata of history and culture. Swift doesn't just namecheck *Romeo and Juliet* in "Love Story": she does so in a way that turns a sixteenth-century tragedy into a fantasy, one that actually draws more closely on fairy tale and medieval romance than on Shakespeare. Knowing this helps us to understand better her overall lyrical relationship with romance, but it also tells us a lot about ourselves, too: about the appeal of the medieval in today's popular culture, from Disney to *Game of Thrones*; about how we can be both skeptical of chivalry and yet deeply invested in its promise; about how the ghosts of the medieval past still haunt our present, particularly when it comes to gender relations.

English Literature (Taylor's Version) has been one of the wildest and most rewarding journeys of my life and career so far. It has taken me to new places (the German-American institute in Freiburg, for example, and Melbourne, Australia, for the world's first international academic conference on Taylor Swift), but, most importantly, has introduced me to countless special people along the way.

In the introduction to their book *Litpop*, an exploration of the intersections between literature and pop music, Rachel Carroll and Adam Hansen note that, although listening to modern pop music might be a "strangely isolating phenomenon," when we start

to discuss what such music means to us, we open up powerful channels for connection and solidarity. If academia is an ivory tower, I hope to be Rapunzel, attempting to bridge what some wrongly perceive as a cavernous gap between serious scholarship and popular culture (I should stress that I am just one of many, many academics doing the same thing, some of whom have become wonderful friends).

I've spoken to teenagers from diverse backgrounds working on Swift-adjacent school projects all over the world: two exceptionally bright young men from the Netherlands, who traveled all the way to Ghent to hear my thoughts on *folklore*, and who wanted to share with me their own songwriting adventures; the Ukrainian refugee now pursuing a journalism course in Belgium; the two razor-sharp Americans whose college hoodies took me right back to the high school movies I enjoyed as an adolescent in the early aughts. I've spoken to students hitherto discouraged, perhaps by economically minded family members, from pursuing an apparently worthless humanities degree, whose minds have been made up to pursue their passions, and to students who have used my course to convince their skeptical professors that there *is* value in examining popular culture such as Swift. I've been invited into schools, privileged to witness the passion of today's educators who conduct extracurricular analysis of popular music with their students as a means of enhancing their syllabus material. I've spoken to large audiences of young people, whose perceptive questions about feminism, queer studies, and fandom leave me moved, inspired, and continually questioning. Their passion and intelligence are an iridescent glow in a world that often seems increasingly bleak. If these young people are the future, I find myself thinking, then we might just be OK.

My own students surprise and delight me each week. They draw unexpected comparisons between medieval chivalric poetry and

modern incel culture; between the essays of French theorist Roland Barthes and J. K. Rowling's comments about how wizards go to the toilet; between Chaucer's *Canterbury Tales* and the *Barbie* movie. You'll find some of those discussions in this book. They are artists, musicians, and aspiring filmmakers alongside their studies, and produce a stunning array of songs, paintings, and podcasts for their final assignment, one which I leave deliberately open and flexible so as to allow their ingenuity free rein. They have dark senses of humor and fierce senses of justice, moving me almost to tears with their modern versions of Mary Wollstonecraft's "A Vindication of the Rights of Woman," and making me cackle involuntarily at their evaluations of David Lowery's film *The Green Knight* ("he was neither as green as I expected, nor as big as I expected"). Perhaps the most special aspect of English Literature (Taylor's Version) is that it has—partly owing to the media attention—brought together a large number of students from very different backgrounds: students of physics and astronomy rub shoulders with those from economics and art history, among the wider crowd from literature and linguistics. They are living proof of the value of the humanities and their potential as complement to a wide variety of other academic disciplines. To quote one of them: "This course shows that you can find your entry to literature anywhere and, for me, Taylor Swift is absolutely my preferred one."

Swifterature is the place where all of this comes together: fandom, feminism, literature, history, pedagogy, and passion for both the humanities and for popular culture. It is by no means an exhaustive analysis of Swift's lyrics and work or, obviously, of English literature. Having completed my bachelor's and master's degrees at Oxford University, I'm aware that I'm writing from a very traditional English literary background, one which has historically been predominantly White, colonialist, and patriarchal—particularly since

this book focuses on literature pre-1900. I have been trying to inter-
rogate and broaden this as much as I can, while still discussing works
and authors that are widely agreed to be canonical—and in whose
place in the canon I genuinely believe (more on that in Chapter
Two). I've written mostly about the literature with which I am most
familiar, and the context with which I am most familiar—the Global
North. I'm aware that this exposes huge gaps in my knowledge and
expertise. There is still much work to do, and I am indebted to the
many scholars and educators out there already doing it.

I'm not going to offer you line-by-line analyses of Swift's
lyrics—you can find those in my other book, *Stars Around My Scars:
The Annotated Poetry of Taylor Swift*. Here, I want to show how an
idea, word, or phrase used in a particular Swift song might take
us on a journey of discovery: a voyage across my frenzied mind
map, to lively nexus points where culture, society, ideology, and
history intersect. I hope this book inspires you to make your own
comparisons and plot your own journeys across the map; to run
with your wildest ideas, think critically about popular culture, and
build communities.

Carroll and Hansen argue that we can understand ourselves
both through music and through writing, but that this intensifies
when we combine the two. Taylor Swift, through her engagement
with classic works of literature and the record-breaking popularity
of her music, invites us to reflect on both the cultures of our past
but also of our present. She prompts us to ask what her place on the
world's stage can tell us about everything from feminism to politics,
nature to childhood. Her music often urges us to be confident in
our knowledge of ourselves and the world, while also cultivating
a perpetual childlike curiosity, remaining open to change and
growth. In this way, it mirrors English literature as a discipline,
which so often asks its students to be unequivocally assertive and

yet question everything; to argue boldly but always be ready, at a moment's notice, to interrogate the very foundations upon which those arguments are built.

In her 2019 song "Paper Rings," Swift expresses intimacy and romantic contentment by declaring that she's read all the books beside her beloved's bed. It's a powerful symbol of what scholars Betsy Winakur Tontiplaphol and Anastasia Klimchynskaya, in their book *The Literary Taylor Swift*, term "the community-establishing power of a common library." *Swifterature* is a wander through that library, and a curious look at who shows up there, and why—and why it matters. Because, as I hope to show in the following pages, perceiving English literature through Swift's glittery, heart-shaped lens might just make us into better readers: of the world, of ourselves, and of each other.

Chapter One

The Stories of Us: Writing About Writing

The cause why I stonde here: som newe tydings for
to lere.

—Geoffrey Chaucer,
"The House of Fame"

I used to think one day we'd tell the story of us," sings Taylor Swift on the aptly titled "The Story of Us," released as a single in 2011. As that title suggests, it's a song that is all about stories. Not just telling them, but also hearing them, *not* hearing them, interpreting them, *mis*interpreting them, and watching them play out in real time. It's also a song about the perils and pitfalls of seeing your own life unfold through the lens of other people's stories.

The speaker thinks the story of her and her lover will be one of sparks flying instantly. People around them will tell this story, saying "they're the lucky ones." In other words: it's a love story, a little like the happy-ever-after rewriting of *Romeo and Juliet* on Swift's previous album, *Fearless*. And yet, by the end of the first verse, the speaker tells her lover that lately she doesn't even know what page they're on. The neat, sweet love story has started to break down, through complications and miscommunications. By

1

the end of the chorus, we're told that it "looks a lot like a tragedy now. Next chapter!"

Not only is the speaker trying to figure out the genre of the story she's telling; she's also acknowledging that it's still a work in progress. She's writing it in real time, improvising as she goes, veering from romance to tragedy as it unfolds. The song reminds us of the gap that exists between real events, and how those events are represented in story form: all the decisions that must be made about structure ("next chapter"; "the end"), and how we try to make sense of our own stories by relating them to the many other stories we have heard or read before.

It's rather fitting that "The Story of Us" appears on *Speak Now*, Swift's third album and the first one she wrote entirely on her own, in an attempt to silence media commentary that she couldn't possibly write her own songs. She would recall later that there was a lot riding on this attempt, since the album would really have to be *good*. The title refers to this decisive move, and the need she felt to express her own stories in her own words.

Are our stories ever entirely our own, though? Or are the "stories of us" inextricably bound up with all the other stories we're told every day—through popular culture, literature, the media, and history? How do we use those stories to make sense of our own, and what does it mean to reflect on that process in the stories we tell, while we're telling them?

In "You Are in Love," from her fifth album, *1989*, Swift seems to speak to us directly—not as one of the many personas she adopts in her music, but as the real-life songwriter herself. The majority of the song is written in the second person, apparently telling the *listener's* story. Toward the end, though, Swift switches to the first person and tells us that she's spent her whole life "trying to put it into words": "it" being, it would seem, the experience of falling

in love. The present participle suggests it's an ongoing work in progress—she's *still trying* to put it into words.

This *trying* is a process that involves drawing on many other stories. Running through Swift's entire discography is a tendency to make sense of events or feelings by seeing them, to quote "You're on Your Own, Kid," as pages turned: narrativizing them through other, preexisting stories. Sometimes these stories encompass whole genres. We see this in "The Story of Us": something the speaker thought was romance now seems to merit the label of tragedy. We also see it in "You're Losing Me," when the speaker asks, "how long could we be a sad song?" Or in "Timeless," where she compares her story to an "age-old classic"; and in "Anti-Hero," to a "tale as old as time." In "Long Live," the object of the song resembles a hero on the page of a history book. The titular character of "When Emma Falls In Love" is like a book one can't put down; perhaps the story of Cleopatra, to whom she is also compared.

In "exile," the speaker tells us that she thinks she's seen this film before. Swift's speakers certainly do seem rather knowledgeable cinephiles, in this sense. They are constantly analyzing an unfolding story, even as they are bang in the middle of it, to try and figure out where, on the colossal spectrum of stories with which they are familiar, it might end up. In "Blank Space," the speaker announces confidently, "I can read you like a magazine." Indeed, quite a lot of the love stories in Swift's songs involve a speaker who seems so literate in the text of an evolving relationship that she knows exactly where it's going to go. In ". . . Ready for It?," she says just that, plotting out the trajectory of a love story that will follow other famous templates: the fraught, on-again-off-again love of Elizabeth Taylor and Richard Burton, for example, or the gangsters Bonnie and Clyde. In "New Year's Day," she urges her lover not to read the last page, which implies that their story is already written out.

We get the opposite in "Cornelia Street," when the speaker likens a new relationship to a fresh page on the desk, the couple filling in the blanks as they go. Yet, at the same time, the speaker is also anticipating a specific last page; a tragic outcome, heartbreak that time would never mend. Similarly, in "Enchanted," she hopes that a magical meeting might be the very first page, not the end of the story—but there's an anxiety running through the song that it *might* be the last page, because he might be in love with someone else. In "Wildest Dreams," the speaker tells us she can see the tragic end before it even begins and so asks her lover to remember her for posterity. The speaker of "Electric Touch" tells us she has a history of "stories ending sadly," which seems to be the case for many of Swift's speakers: they are always ready to fill in the blank spaces on those fresh pages in line with the narratives with which they are familiar; usually sad ones. It's not just love stories, either: in one of Swift's most apparently autobiographical songs, "Clara Bow," she predicts the outcome of the story of her entire career, using as a template the stories of famous starlets from the past, Stevie Nicks and Clara Bow.

Swift is open about how she uses other stories to tell her own. In her acceptance speech at the 2023 Nashville Songwriting Awards, she revealed the three genre categories into which she mentally divides her own lyrics, nicknamed after the writing tool she most associates with them: quill, fountain pen, and glitter gel pen. The former involves antiquated words: a "quill" song might be inspired by reading Charlotte Brontë, and sound like "a letter written by Emily Dickinson's great grandmother while sewing a lace curtain," Swift said. Her quill songs create narrative by drawing on templates from classic English literature. For example, "happiness," which quotes from F. Scott Fitzgerald's *The Great Gatsby* for its poignant portrayal of separation after a long love, and "invisible string," which uses an image from Brontë's *Jane Eyre* to express

the idea of lovers' fates entwined by destiny. In "Love Story," she sees a forbidden romance play out (in some ways) like *Romeo and Juliet.* "Today Was a Fairytale" dresses up an adolescent date in the sparkling gown of a Disney movie or Hans Christian Andersen story, while "Is It Over Now?" seems to use that early-aughts young adult classic, *Twilight,* to narrate its speaker's desire to do something drastic to get her beloved's attention.

Swift noted that most of her lyrics fall into "fountain pen style," which means "modern storylines with a poetic twist." They sound like "confessions scribbled and sealed in an envelope, but too brutally honest to ever send." There's a suggestion here of another type of story: the confessional poem, popularized in America during the 1950s and 1960s by, among others, Sylvia Plath.

All of this to say: Swift is a writer acutely conscious of how she is narrating her life according to the multiple types of stories that surround us in modern culture.

This isn't really a surprise. From the beginning, Swift's career has forced her to think about her own stories, and how they fit with other stories, since these questions are also questions of genre. Having begun in the realm of country music, moving to Tennessee to pursue her dream, Swift realized very quickly that "this business operates with a very new, new, new, next, next, next mentality": one minute you're being told "your song is great," the next, "what else can you do?" In other words: change up the story; flip the script—or find a new one. Swift has spoken openly about deciding to reinvent herself with every album before the industry could replace her. One of the clearest and most concrete ways to do this was with a shift in genre: from country to pop, in *Red* and *1989,* to what Swift termed "goth-punk" in *Reputation,* to indie rock in *folklore* and *evermore.* In other words, to change the type of story used to tell her stories.

At the same time, Swift has also been critiqued for not adhering closely enough to these types—for her sound being too dissonant in *Red*, for example—and warned against departing from her original country stories. She's also been told that a man could tell her stories better than she could. *American Songwriter* wrote that singer Ryan Adams had "bestow[ed] indie-rock credibility" on Swift's *1989* with his cover version, which Anna Leszkiewicz described in the *New Statesman* as "mansplaining" Swift's album to her.

For her entire career, Swift has been judged not only by the stories she chooses to tell, but also how she chooses to tell them.

Swift pointed out in her Nashville speech that we tend to think about musical genres in relation to melody and production but often leave out the important issue of lyricism. Swift's lyrics show that she's keenly aware of how language and genre work together. How might we tell stories in a certain way to emphasize certain aspects? How might we categorize the events in our lives into genres, based on the established stories in our culture that they most resemble? And, just like in "The Story of Us," what happens when you expect a story to be in one genre, and then it suddenly switches course? What happens when you *can't* read life like a magazine?

For example, the moment in "White Horse" when the speaker comes to terms with the fact that her story is *not* the fairy tale she thought it was. Or when the speaker of "If This Was a Movie" realizes that her story bears no relation to the romances she's been fed by Hollywood. Or the speaker of "Getaway Car" seeing that the affair is actually a circus, *not* a love story. We might think, too, of the speaker of "tolerate it," who thought she was playing the main character in the story of her lover's life but realizes she's only a footnote. Or the speakers of "A Perfectly Good Heart," "The Other Side of the Door," and "exile," who regret not being better readers and interpreters of their own stories. "The Smallest Man

Who Ever Lived" implies that the romance the speaker thought was a joint, unfolding project—like the fresh page on the desk in "Cornelia Street"—was in fact a one-sided book of scurrilous gossip being written by her duplicitous lover.

Stories don't always unfold as we expect them to, whether we're reading them or telling them. Our expectations play a powerful role, perhaps without us even realizing. German scholar Hans Robert Jauss coined the phrase "horizon of expectations" to describe how we, as readers or listeners, approach a story. We come to it with cultural baggage, armed with knowledge and experience gained from the other stories we have read, which in turn prompt certain expectations. We might have these before we even start reading: book cover designs, for example, might hint at particular genres; the intro to a song might do the same.

Sometimes, these expectations make us easy targets for mischievous writers.

Swift's 2017 album *Reputation* was, in her own words, a "bait and switch." With its monochrome cover, black letter font, and first single, "Look What You Made Me Do"—whose video featured Swift as a zombie, surrounded by snakes, and wearing a lot of fishnet—it seemed to promise a story of gothic revenge and villainy. But it ultimately unfolded a romance, ending with the understated, tender ballad "New Year's Day." As one fan wrote on Reddit, "We all expected her to go dark and edgy after snakegate [see Chapter Six]—the love songs were the bigger shock." Many fans referred to the abrupt shift as "whiplash." For centuries, playful writers of literature have been doing the same: setting up our expectations and luring us in with one type of story, before gleefully surprising us with a sudden shift in genre, tone, or mood.

Aphra Behn, one of the earliest English novelists, published the short novel *Oroonoko* in 1688. It seemed to promise the gripping

adventures of an African prince and the "unconceivable wonders" of far-flung countries. But then the titular Oroonoko is betrayed and enslaved, and the book becomes something rather different: a biting political critique of slavery and colonialism, and a meditation upon the importance of human dignity. Jonathan Swift (who, in my lectures, has now been demoted to "the *other* Swift") did something similar with *Gulliver's Travels,* tempting readers with an exotic, supposedly true-to-life travelogue, only to switch to political satire. (The many children's versions of *Gulliver* tend to end at the point where the genre shifts). Oscar Wilde's *The Picture of Dorian Gray* seems to be a philosophical and social commentary on life at the turbulent end of the nineteenth century but then shifts into gothic horror. Jane Austen's *Northanger Abbey* does almost the opposite: we *think* we're in a work of gothic horror, until it reveals itself to be a decidedly un-supernatural novel of manners, and a takedown of snobbish aristocrats. Holden Caulfield, narrator of J. D. Salinger's *The Catcher in the Rye,* actually taunts us with our readerly expectations of a coming-of-age story, before telling us he's not going to fulfill them: we're not going to get any of that "David Copperfield kind of crap."

Genre bending has become increasingly common in modern literature. We love a sudden twist in the tale. Gillian Flynn's *Gone Girl* starts off suggesting murder mystery, before morphing into a psychological thriller where the presumed victim becomes the villain. Kazuo Ishiguro's *Never Let Me Go* seems to be a coming-of-age school story, but by the end resembles something more like science fiction. This shift has been adopted to productive effect in film and television, too: I'm reminded of the devastating finale to the British historical comedy *Blackadder,* which ended with the main characters all disappearing "over the top" into the trenches of the First World War. Takashi Miike's film *Audition* starts off as a rom-com and ends in wince-inducing scenes of torture; a little

like Bong Joon-Ho's *Parasite*, which starts as a kind of situation comedy-cum-satire, before abruptly transitioning into a slasher film. Robert Rodriguez's *From Dusk Till Dawn* begins as the kind of gritty crime thriller we'd expect from Quentin Tarantino, who wrote it, until it's suddenly interrupted by a load of vampires.

Perhaps writers play around with genre because they realize, as Swift's speakers often seem to do, that following existing scripts or stories is not always sufficient: they're not always capacious enough to contain the complexities of our lives. In "Our Song" from her debut album, Swift's speaker tells us she's heard every album and listened to the radio but still hasn't found "our song." So what does she do? She grabs a pen and an old napkin.

Sometimes we need to throw caution to the winds, set all other stories aside, and write our own instead.

It's an important moment of recognition—especially since it came at the beginning of Swift's career—but it isn't always representative of her style. As I'll show throughout this book, Swift's writing is often very intertextual. It situates itself in relation to a multitude of stories that are prominent in Western culture, from medieval romance to the gothic, from Romantic poetry to the Victorian novel. These stories are enduring for a reason, as I'll explore in more depth in Chapters Two and Thirteen. Even when Swift is questioning and rewriting these stories, she's still using them to try and make sense of her own.

"The Story of Us" ends with the seemingly decisive statement, "The End." Yet this finality is not really typical of Swift's music, which lives very much in the present tense. Singer Phoebe Bridgers once commented of Swift that "every 'I' is dotted, every story is finished," but this is not really the case with the stories she tells. As the speaker of "Death by a Thousand Cuts" asks: "if the story's over, why am I still writing pages?"

Reviewing Swift's album *evermore* for *Rolling Stone* in 2020, Claire Shaffer observed that Swift "seems hesitant to give her characters happy endings, or endings in general," and speculated that this might be because Swift is still "figuring out her own chapter right on the page." What makes Swift's music so fascinating, for many of us, is that we seem to watch this process play out almost in real time. Swift tells us a story, of her trying to tell *her* story, in relation to all of these *other* stories.

Put simply: Swift writes about writing. Like in "Hey Stephen," when the speaker acknowledges that all of Stephen's other admirers are beautiful, "but would they write a song for you?" and then giggles cheekily, perhaps at the sheer meta-ness of it all. Or "Dear John," which ends with "the girl in the dress wrote you a song"—the song we've been listening to all along. The same thing happens in "Ours," "Our Song," and "I Bet You Think About Me." Like the technique of breaking the fourth wall in theater or film (think *House of Cards, American Psycho, Fleabag, Fight Club*), these moments jolt us out of our suspension of disbelief and remind us that the story is a crafted fiction whose author can change it at any time.

For example, when the speaker in "Florida!!!" (voiced by Florence Welch) talks about imagining past lovers sinking into a swamp, then asks mischievously, "is that a bad thing to say in a song?" Well, if it is, then the damage is done—that song is already produced and packaged, since it's reaching our ears via vinyl, CD, or streaming. But that's not the point, of course—the point is to break the fourth wall and make the reader feel like they are there during the composition process. The speaker seems to question, in real time, what kind of story this is, and where it should go next—is a gothic motif (see Chapter Eleven) of burying past lovers in a swamp appropriate for *this* story? Or might there be another, *better* story to use as a framework for telling this one?

Speaking to journalism students at Belgium's Thomas More University in 2024, I was asked by one of them what Swift's popularity can tell us about our current times. I forget how I actually answered the question, but it was only later that day, on my way home, that I realized what I *should* have said (rather like that moment when you think of a fantastic comeback to an insult, hours too late). I think it tells us that we crave authenticity: in our stories, in our celebrities; in our celebrities' stories. Swift has, from the beginning of her career, seemed to offer fans unmediated access to her inner life: lyrics lifted from the pages of her high school diaries; intimate details of both crushes and crushing despair; glimpses into her day-to-day via social media. Whether this is *actually* authentic is, of course, debatable, but the point is that it *seems* to be, and we lap it up. Moments of self-referentiality in Swift's music, where she dispels the illusion of the microcosmic world she has built over three to four minutes, and starts talking about the prosaic details of songwriting, give us an impression of authenticity. We're seeing every step of the process: we're getting closer to Swift herself, not just the tale she has spun.

This should remind us of the instability of storytelling. Stories are fluid and ongoing and can change at any time. This fluidity is only exacerbated when the stories in question are songs, since every performance is a slightly different version, a tweaked retelling of an existing story. Consider the 2022 song "Karma," which originally featured the lyric "karma is the guy on the screen," referring to Swift's then-partner, actor Joe Alwyn. At the Eras Tour performance in Buenos Aires in 2023, she changed the lyric to "Karma is the guy on the Chiefs," referring to her new boyfriend, football player Travis Kelce (fans went wild at this updated version). Or "Mary's Song," inspired by Swift's neighbors, a couple who met at ages seven and nine and were still deeply in love at eighty-seven and

11

eighty-nine, which fans see as having spookily "predicted" Swift's (born in '89) romance with Kelce (whose football jersey features the number 87). As one fan pointed out, "it was Taylor's song, but not her story. What a full-circle moment . . . The story is now hers."

Even recorded stories are not set in stone, as Swift proved with her rerecordings of her masters, some of which have updated lyrics ("Better than Revenge"), and differ subtly in production from their originals.

And yet we cling to these stories greedily. Among her fans, Swift's stories—shaped by other, older stories—have gained a hallowed, authoritative status in their own right; canonical tales that fans now use to tell their own stories, thereby continuing this complex web of intertextuality. As writer Anna Bogutskaya points out, "pop culture is the stories that we tell ourselves about ourselves. It's our folklore." And, perhaps, our *folklore*. Swift's stories give us mouthpieces through which to *speak* our own stories *now*. In fact, the deluxe CD version of her 2019 album *Lover* included excerpts from her own diary entries alongside blank pages: an invitation for fans to meld their stories seamlessly with hers.

There is no "The End"—not really. We're always still writing pages.

In an article for *Pitchfork* in 2024, Olivia Horn referred to Swift as "her own pantheon: a tragic hero and a vindicated villain; an inadvertent antitrust crusader and a one-woman stimulus package; an alleged climate criminal and fixer; The Person of the Year of the Girl." We might also argue for her as a walking compendium of stories. Writing in *The Atlantic* that same year, Sophie Gilbert noted that "Swift has long constructed her identity out of archetype, cliche, and torn-up fragments of Americana." But Gilbert also saw Swift's latest (at the time of writing) album, *The Tortured Poets Department*, as a sign that "the legends and stories that both her music and her persona are built on simply don't contain enough

substance for her anymore." We might remember the speaker of "Miss Americana & the Heartbreak Prince," who back in 2019 saw American stories burning before her. What happens when *all* those stories are burned—no longer appropriate for Swift to use to tell her own story?

The only option, Gilbert declared, is for Swift to "write her own way out."

What might it mean to write one's way out? To extend a quill-clutching hand to the sky and grope one's way heavenward from below the pressing weight of a billion pages?

Writers pondered something similar in the early twentieth century. Shocked by the loss of millions of young men to the First World War, they felt a sense that the traditional stories humanity used to try and make sense of the world were no longer adequate. To quote modernist writer Ezra Pound, writers and artists began to "Make it new": to consciously depart from the past and interrogate every aspect of existence. Things were broken down into constituent parts and examined afresh, for example through the abstract art of Pablo Picasso and Henri Matisse, or Marcel Duchamp's "anti-art." Writers experimented with new ways of depicting human thought and feeling (more on this in Chapter Three).

The second half of the twentieth century saw even greater distrust in those grand, overarching stories that claimed to make sense of the world, such as religion, or Freudian psychology, or Marxism. German philosopher Theodor Adorno famously declared that it would be barbaric to write poetry after Auschwitz: the horrors of the Holocaust had, for many, drawn a line in the sand in our understandings of how, and why, we might make and receive stories. This led to artistic experiments that fall under the umbrella of postmodernism. In the words of scholar Hans Bertens,

postmodernism focuses on a "crisis in representation," a sense that "the representations that we used to rely on can no longer be taken for granted." The existing stories aren't enough anymore. Postmodern literature is often characterized by genre bending, by self-referentiality, and by what we now call the "meta." It encourages us to question everything we take for granted, especially the unspoken rules or contracts between a writer and a reader that pop up when a story is told; rules we maybe didn't even realize were there, until we saw them broken.

In 1969, British author B. S. Johnson published *The Unfortunates*, a novel sold in a box in loose sections. The first and last chapters are specified, but the twenty-five sections in between can be read in any order (don't even think about trying them all, though—there are 15.5 septillion possible combinations; even if you spent one second on each combination, that's 492 trillion millennia). His experimental novel breaks an unspoken agreement between author and reader: that the author will impose logical order on a story to make it accessible, and that there is one, "correct," authorial version of events. Novels like *The Unfortunates* force us, as readers, to remain awake and alert to the reading process and all it involves, rather than simply passively absorbing the story.

We might see Swift's acoustic section "mash-ups" on the Eras Tour in a similar light. They remind us that all stories can be read as puzzle pieces within wider stories. They are arrangeable in infinite combinations, and there is no such thing as correct narrative order. We might *want* it from an author, but they might not always deliver.

Postmodernist works often break the fourth wall, speaking directly to the reader to get us thinking in more depth about our role in stories. Italian author Italo Calvino's novel, *If on a winter's*

night a traveler, is partially written in the second person, and tells the story of the reader trying to read the book itself. It begins, "You are about to begin reading Italo Calvino's new novel, *If on a winter's night a traveler.* Relax. Concentrate. Dispel every other thought. Let the world around you fade." It's what we call metafiction: literature that refuses to allow the reader to suspend disbelief and fully enter the fictional world, frequently reminding them instead that they're reading a work of fiction.

It's perhaps not too much of a jump from this to Swift's afore-mentioned "You Are in Love." "Dear Reader," also written par-tially in the second person, urges the listener not to take advice from someone who's falling apart; this is, of course, a piece of advice, and reminds us of our complicated relationship, as readers or listeners, with artists. With the line "you wouldn't take my word for it if you knew who was talking," Swift refuses to let us fully inhabit the world of the song, instead reminding us that narrators can be tricky and unreliable, and stories certainly don't offer us reality.

Then there's "I Can Do It with a Broken Heart," where the speaker breaks the fourth wall in a way that tells us that the upbeat song we're listening to, apparently sung by a woman having the time of her life, is in fact an expression of deepest misery. There's an element of genre bending here, too, since the upbeat pace of the song contrasts sharply with the suicidal ideation in the lyrics. Something head-spinningly meta occurs when Swift performs this at the Eras Tour. The real-life crowd have to adopt split listening personalities: they chant MORE, fitting in with the narrative script Swift has given them in the song, while at the same time feeling sympathy for the heartbroken woman revealed within. In addition, the music video was filmed at the Eras Tour; footage of Swift seem-ingly having the time of her life is recontextualized within this new

story about abject misery, then played to an audience who, the song tells us, have no idea how depressed the speaker really is; except that she's telling them during the song. One Redditor described it as feeling like "a Black Mirror episode."

Creative, meta-leaning storytelling strategies in music have been around long before Swift. Madonna has been referred to on multiple occasions as "postmodernism personified," because of the way her music, aesthetics, and shifting personas reflect postmodernism's interest in fragmentation, the blurring of genres, pastiche, and a distrust in overarching grand narratives. While Swift does seem to enjoy a good meta reference and takes a hammer to that fourth wall every now and again, we might actually see her as Madonna's *opposite* when it comes to her use of stories. While Swift plays around with genres and archetypes, her music is certainly not as distrusting of traditional stories as it might be. In fact, Swift is forever trying on those stories in an attempt to make one of them fit her own. As I'll explore in Chapter Seven, she shows skepticism of fairy-tale romance, but also a deep desire for that dream eventually to come true. While *Reputation* seems to show Swift abandoning control of her own narrative, it's also tightly orchestrated according to scripts drawn from gothic literature, as I'll show in Chapter Eleven. In exposing the institutionalized gaslighting underlying centuries of oppression of "mad women" and suggesting that we might break free from these limiting stories, Swift in fact follows in the footsteps of nineteenth- and twentieth-century stories, as we'll see in Chapter Nine. This book explores, toward its close, what it might mean for Swift to "write her way out" of these stories and truly flip the narrative script at the peak of her fame—and whether that's even possible.

I want to end with a poem; one that, despite being written in the fourteenth century, manages to be somewhat postmodern,

centuries before postmodernism even had a name. It's called "The House of Fame," and it's written by Geoffrey Chaucer, sometimes named "the father of English poetry" (and whose other progeny we'll look at in some of the following chapters). In this poem, the narrator—apparently Chaucer himself—is visited by a magic eagle sent by the mythical god Jupiter. Jupiter wants to reward Chaucer, who has worked diligently to tell the world all about Cupid and Venus (i.e., about love) via his poetry, without any compensation thus far for his long nights of toil. The eagle takes him to a marvelous palace belonging to Fame, who is personified as a woman with as many eyes as there are feathers on a bird, and as many ears and tongues as there are hairs on mammals. Fame's house lies between heaven, earth, and sea, and everything that is ever spoken ends up there. She's surrounded by pillars upon which stand famous warriors, musicians, and writers, arguing among themselves over whose stories are true. There's also a chaotic crush of people, buzzing like bees in a hive and demanding an audience with Fame herself. Some of them crave renown, some ask that their names disappear forever; she decides, entirely arbitrarily, what will become of their stories.

Fame asks Chaucer why he's there. He tells her he wants some new stories. He's then led to a house made of colored twigs, shaped like a cage but full of open doors. In and out of these openings fly stories: whispered, gossiped, murmured stories of war, peace, marriage, labor, voyages, and more (the list of these different types of stories goes on for sixteen lines). There are people in this cage-house, too, telling stories they swear are true. As soon as one person hears a story, they go and tell someone else but embellish it a little; this person then retells the story and does the same. Chaucer likens this game of telephone to "fire that can burn a city down from a single spark." Sometimes a true story and a false story

race each other to get out of the house first, find themselves stuck together in the door, so decide to merge together and fly as one. As you might imagine, it's chaos. Sailors and pilgrims arrive, carrying boxes of lies to be deposited in the cage. People stampede over one another, crying out for more news, more gossip, and questioning what they hear. It's pandemonium, but finally Chaucer spies a man who seems about to restore order.

"He seemed to be," Chaucer tells us, "a man of great authority."

And there the poem ends.

Who is this man of great authority? Modern editions of Chaucer publish "The House of Fame" with a note that it's an unfinished poem, ending abruptly as it does, but there are also theories that Chaucer's abrupt ending is deliberate. For perhaps this is the point: there *is* no man of great authority. There *are* no original, true, unadulterated stories: only what French theorist Roland Barthes would call, centuries later, "tissues of quotations drawn from the innumerable centers of culture." All stories are patchworks of other stories, and while many of them claim authority, we can never be certain. We can never predict which stories will endure, and which will fall into obscurity, for Fame is a capricious creature. Yet despite this, we clamor for more stories that we know, deep down, can *never* be truly new. Maybe there's no such thing as objective truth. Everything is narrative, and narrative—like her mistress, Fame—is flawed and flighty.

We might see Taylor Swift's discography as a kind of palace of fame, too. Like Chaucer's, Swift's lyrical palace includes all manner of stories. It's packed to the rafters with, in Swift's words, "all the he said, she said." These stories jostle against each other, vying for dominance; sometimes, one gets the upper hand and ousts another; sometimes, they merge into a hybrid creation as they fly out of the door into the ether. They might cry earnestly that they're

offering us the truth, only to admit later that that truth has been replaced with another, *truer* truth; the guy on the screen becomes the guy on the Chiefs; the revenge story becomes the love story. More stories arrive all the time: new songs, rerecorded old songs, and mash-ups of songs are added to the catalog. What happens to these stories after they've flown free is unpredictable and follows no rhyme or reason. Some endure to ring out through the halls of the palace of posterity; some melt into oblivion. Some are taken up by Swift's listeners and shaped into yet more stories, tied by the most delicate of invisible strings to their ancestors. There is no man, nor woman, of great authority to control these stories, which are in perpetual motion; to try to control them, in fact, is only to expose how uncontrollable they really are. That is an inescapable part of their intrigue and their appeal.

This book will take you, on the back of a metaphorical eagle, to Swift's palace of fame. We will wander through its cavernous halls, looking at and listening to some of the many stories Swift has invoked over the course of her career. Some take the form of barely there allusions, drifting through the halls like ghosts; others are overt, playful name-drops who stand on pillars to proclaim their importance. They are, in many ways, the stories of *us*: stories humanity has told and retold for centuries. Perhaps they survived out of sheer luck or coincidence, because Fame was in a benevolent mood that day; or perhaps they endure because, at their core, they resemble the stories many of us are likely to experience in our own lives, even now. We will look at all these things on our journey: the survival of stories, the whims of Fame, the fluttering elusiveness of truth, and the (wo)man of great authority who may or may not be the mastermind behind it all.

And so, onward we go—to the palace. Next chapter!

Chapter Two

Who's Taylor Swift Anyway: Controversy and the Canon

To read the promiscuous rubbish of the present time to the exclusion of the select treasures of the past, is to substitute the worse for the better.

—Thomas Love Peacock,
"The Four Ages of Poetry"

In December 2023, Taylor Swift was named "Person of the Year" by *Time* magazine. This accompanied her first magazine profile since 2019, in which she speculated that her success might herald a new era in terms of how we relate to female fandom. Women, she said, have typically been fed the message that the things we gravitate toward—"girlhood, feelings, love, breakups, analyzing those feelings, talking about them nonstop, glitter, sequins!"—are more frivolous than the things men stereotypically gravitate toward. Yet the "feminine extravaganza"—to use Swift's words—that was the summer of 2023 had signaled a heartening change. The combined cultural impact of Beyoncé's Renaissance Tour, Greta Gerwig's *Barbie*, and Swift's own Eras Tour had proven that girls' culture is a significant force to be reckoned with.

In the same week as Swift's magazine feature, a friend sent me a link to something she had stumbled across on social media: a conversation between two of my students. One expressed how much she had enjoyed my Taylor Swift class: "It really felt like a cozy book club with the girls!" She shared a photo of the pastel-colored friendship bracelets that I'd awarded to students who had made extra effort. Another student replied: "So silly sometimes, but always a good atmosphere! She really needs to make more lessons for the girls at Ghent."

I took it as the highest compliment: that I had somehow turned a master's course into a space that could also accommodate silliness, girlishness, and coziness. This should not come as a surprise since Swift's discography and public persona encompass all of these things. Yet that very girlishness and silliness are what also see her so often dismissed.

In the song "cardigan," from Swift's 2020 album *folklore*, the speaker reminisces about young love. Sultry scenes of teenage romance are punctuated by the heartfelt refrain that when you are young, people assume you know nothing. It's an assumption that the speaker goes on to prove wrong: she knew *everything* when she was young, including the fact that her erstwhile lover would come back to her. She references an English literary classic, *Peter Pan*, to describe her experience. Much like J. M. Barrie's novel, "cardigan" is an ambivalent portrayal of growing up. It celebrates the loss of innocence but also wistfully regrets it. It's a bittersweet anthem to a vividly felt girlhood that is long gone, but that can be revisited and reexperienced through memory, preserved eternally inside its own lyrical Neverland.

We might read the speaker of "cardigan" as a cipher for Swift herself: often underestimated and dismissed, for reasons that have a lot to do with her dedication to girlhood and the feminine.

"You drew stars around my scars," sings the speaker of "cardigan." It's clear, after nearly two decades of her career, that Swift has done the same to a whole generation of fans, particularly women. *Time* referred to it as "the real Taylor Swift effect." She gives women and girls "permission to believe that their interior lives matter," a balm to soothe their frequent dismissal by patriarchal society.

I experienced a fair amount of this dismissal in August 2023, when news of my master's course, English Literature (Taylor's Version), spread across the Internet. Amid the hate mail and comments along the lines of "how fucking low, academically, can you get" (to quote comedian Ricky Gervais) ran a significant red thread. "It's an auditorium, not a kindergarten," wrote one snide Belgian journalist. "How is this literature? She [Swift] only writes about boys and breakups," read multiple comments on Instagram. "What a load of juvenile crap"; "another boring, mainstream act for kids." As commenters used my course as a scapegoat to express their pent-up hatred of Taylor Swift, accusations of childishness kept intersecting with pejorative references to girlhood; specifically, to youthful heartbreak. Femininity itself, and its emotions, were being framed as something awkward and embarrassing, to be shrugged off and grown out of as soon as possible. Yet, at the same time, I was being inundated with heartfelt requests—from both men and women, all over the world—to participate in this "cozy book club for the girls."

As Swift herself identified in *Time*, the ways in which young people—especially women—select and consume culture has long been perceived as problematic. English novelist Jane Austen wrote *Northanger Abbey* during a period when the novel was increasingly identified as a woman's form (by the end of the eighteenth century, half of novels published were penned by women). As Austen's

decidedly unheroic teenage heroine, Catherine Morland, transitions into society, she is surrounded by people, mostly men, telling her what she should and should not read. The plot of *Northanger Abbey* hinges upon Catherine's brains having been so addled by gothic novels that, in an awkward moment, she insinuates that her prospective father-in-law, General Tilney, murdered his wife. Perhaps Austen was thinking of Scottish poet Robert Burns's poem, "O Leave Novels":

> O leave novels, ye Mauchline belles,
> Ye're safer at your spinning-wheel;
> Such witching books are baited hooks.

Yet *Northanger Abbey* is in fact a passionate defense of women's reading. The world is unfortunately not as safe as we might like, and, for those of us who do not have the option of simply retreating to our spinning wheels, fiction can make us safer by making us smarter. Catherine is ultimately correct about General Tilney, who turns out to be a thoroughly horrible man (although, admittedly, not guilty of uxoricide).

Austen criticizes the fact that novels, a predominantly feminine form, are not given a privileged position within society, despite—to use her words—showcasing the greatest powers of the mind, the most thorough knowledge of human nature, and the liveliest wit and humor, all in the "best chosen language."

Fast forward to the twenty-first century, and Austen might well have been describing Taylor Swift's discography.

Whenever we unpack what seems to be mere snobbery—whether about Swift or Austen, *Twilight* or One Direction—we tend to find something more specific and targeted. As Mila Volpe points out, "aesthetic judgements are always moral judgements." To

criticize the popular is often a way of pigeonholing and then dismissing "ordinary" people. This is especially the case when those people identify as female. As scholar Margaret Beetham points out, women have historically been seen as prone to the dangers of "inappropriate reading." This was just another way in which misogyny manifested itself: dismissing women as fundamentally irrational creatures, governed by feelings rather than intellect, and thus particularly susceptible to novels of high emotion. Like Austen's Catherine, it was feared that they would interpret such novels as real rather than fictional and get carried away by their imaginations.

In all of this, the specter of childishness surfaces again. In a study of readers' responses to the *Twilight* series, Anne Helen Petersen found that "adult readers are ashamed of reading in a style usually associated with young girls." It's as if the heightened emotion and passion that saturates the *Twilight* saga—and other similar magnets for female fandom—should have been locked away and neatly bracketed off within adolescence, not permitted to spill out into the more refined contours of adulthood. It brings to mind the medieval notion of women as embarrassingly leaky vessels, whose messy emotions the weary patriarchy is perpetually tasked with keeping in check.

If this is so, then Taylor Swift has unapologetically opened the floodgates.

Overwhelmingly female, the Swiftie community receives frequent—often derogatory—media attention for their pack-like mentality and tendency to persecute anyone they feel has threatened their idol. While some of this may be justified (and will be discussed in later chapters), much of it is rooted in misogyny. As one of my students pointed out, female fans "are systematically delegated to one or more categories of 'screaming fangirls,'

'obsessed consumers,' 'addicted stalkers,' and 'parasocial girlfriend wannabes.'" Feminist media scholar Melissa A. Click has noted the disparity in cultural representations of "fanboys" versus "fangirls": the former attract respect, the latter are often ridiculed (indeed, to "fangirl" over something is shorthand for behaving embarrassingly and emotionally). American music critic Jessica Hopper once tweeted, "Replace the word 'fangirl' with 'expert' and see what happens" (which, in fact, once happened to me: a screenshot of me on the BBC with a banner under my name proclaiming "Academic and Taylor Swift Expert" constitutes the pinnacle of my career).

I'm reminded of English writer Lavinia Greenlaw's memoir, *The Importance of Music to Girls*. Recalling her adolescence, Greenlaw noted that the boys were serious about music, but didn't expect her to be as well. "A boy could impress a girl with his musical knowledge and taste," she says, "but it was something he was showing her, like a fleet of cars or a gun collection. She was not meant to join in."

The implication is that women and girls just cannot be trusted with culture. We take it too far. We become obsessive and emotional. Our emotion infantilizes us, sending us back into the realm of childhood, when fantasy and reality were indistinguishable from one another. In other words: when we knew nothing.

Yet, as Swift has recognized, the tide seems to be turning. I felt it in a packed room at the American Institute in Freiburg, November 2023, when I was invited to be part of a panel event titled "Talking Taylor: The Eras Explained" alongside educationalist Sarah Wagner of the Atlantic Academy in Germany. Arriving to walls strewn with glitter banners, balloons, and fairy lights, offered a "You're on Your Own (Sour Patch) Kid" Jello shot, and a choice of badges depending on my current personal Era, it felt like coming home. The event had exceeded anticipated numbers and bucked the demographic trend of the institute in terms of both age

and gender. The ninety-person audience consisted predominantly of young women, some of whom had to sit on the floor. They nodded enthusiastically, laughed at our jokes, and afterward asked insightful questions, some telling me that they felt validated by an academic approach to Swift's work.

I saw it in my students, when I tasked them with writing a modern-day version of Mary Wollstonecraft's eighteenth-century "Vindication of the Rights of Woman," in which she argued vehemently for women's education. They populated their thought pieces with Swift references. "Long story short, it's a bad time. Long story short, we [women] haven't yet survived," one wrote. (This, incidentally, is what linguists term a "fanilect," a form of community bonding through language—in this case, quoting Swift lyrics). The sense of legitimacy they had gained from taking a university course dedicated to their icon seemed to have emboldened them to think both critically and passionately about their own gendered engagement with culture.

Although my course was by no means girls only (the eventual demographic settled at around 30 percent male to 70 percent female), I found the aforementioned nickname "book club for the girls" revealing. Here was a space where students felt free to express a side of themselves that society had urged them to dismiss or repress. One pointed out the inaccuracy and inflexibility of gender stereotypes around fandom: so what, she said, if "I read Charlotte Brontë in a bedroom with pink walls underneath pink sheets adorned with flowers? I also drag around carts full of heavy beer crates wearing steel toe boots during the weekend and probably know more classic rock songs than your middle-aged dad."

Representing what Amanda Petrusich speculates might be our last remaining monoculture, the power of the Swiftie is literally seismic. Eras tourgoers made headlines in July 2023, when they

caused a minor earthquake in Seattle through their exuberance. This marks a similarly seismic shift in how we think about parts of ourselves that we were encouraged to leave behind in our childhood: frivolity, playfulness, and unbridled emotion. As journalist Sam Lansky puts it, Swift is "modeling radical self-acceptance on the world's largest stage, giving the audience a space to revisit their own joy or pain, once dismissed or forgotten."

In "Would've, Could've, Should've," from the 2022 album *Midnights*, Swift demands her girlhood back since it was hers first. She might be speaking for the legions of fans who feel, as some of my students did, that they were encouraged to grow up too soon, to jettison the silly parts of themselves too swiftly. Indeed, Petrusich notes that Swift has a large number of songs about being left behind: as early as her debut album, she was singing about being on the outside, looking in. The outpouring of love for "You're on Your Own, Kid" (also from *Midnights*), evident in the trend it spawned for exchanging friendship bracelets, perhaps stems from the way in which Swift celebrates the adolescent experience of never quite fitting in. It's often co-opted by the queer community for that precise reason.

When you are young, people assume you know nothing. Yet Swift has now percolated down to the bedrock of knowledge itself: academia. The number of university courses and academic conferences dedicated to her reached a critical mass in 2023. Despite the best efforts of past-it comedians and Internet keyboard warriors to deny and discredit it, Swift's importance to both the cultural and academic zeitgeist is now nonnegotiable.

The fact that this sparks criticism at all is, in itself, a necessary object of study.

What seems to offend most about the plethora of Taylor Swift-related university courses is the association of Swift—girlish,

American, pink, playful, provocative—with the apparently sacred institution that is academia; and, in my case, with one of its subsets, English literature (imagine that written in sloping cursive letters on parchment with a quill).

Taylor Swift literature courses making headlines suggests that there is something fundamentally newsworthy and thus potentially controversial about Swift's place on a syllabus. Yet this shows a profound misunderstanding about what English literature professors and students actually do. The study of literature is always looking to broaden itself, to encourage thinking outside the box, and that includes the box of what exactly literature *is*. We can read almost anything as a text, open for debate, analysis, and discussion. Revealing and rewarding insights can be gained from reading unexpected texts alongside each other. Far from barricading ourselves at the top of it, many literature professors aim to banish the ivory tower and set discussion free among anyone who wishes to participate. Swift on a syllabus *shouldn't* be newsworthy. Turning a master's course into a "cozy book club for the girls" *shouldn't* be radical.

To give Swift kingdom keys to the realm of English literature is perceived by many (often those outside academia, rather than within it) as a travesty. This reaction is underpinned by an assumption that such a space is reserved only for the "literary greats" of past ages. Shakespeare crops up frequently: I've lost track of how many times I've been asked whether Swift is "the new Shakespeare," whatever that means. I wasn't aware that Shakespeare was up for renewal, and I had rather assumed that there was space on the syllabus for both. While it certainly makes for fun Internet quizzes—challenging the reader to guess whether certain lines are from "All Too Well" or *All's Well That Ends Well*—it also implies a very narrow and old-fashioned idea of literature that bears little resemblance to what we do in the classroom today.

Nevertheless, I'm grateful. All the press surrounding English Literature (Taylor's Version), particularly the negative, provided me with a great way to introduce students to a number of questions that are at the heart of the study of literature: How do we judge the value of a cultural work? What social factors influence those judgments? What can this work tell us about the society that created it? Why does literature matter?

I ask my students a question, too: "Why study Taylor Swift and literature?" Their answers range from the silly ("Because yassss?"), to the analytical ("lots of intertextuality in her lyrics"), to the more complex and political ("the overlooked aspect of femininity in the literary canon"), and back again ("to shake off the haters").

Who are the haters? Why is femininity overlooked? When we bring Swift into "English Literature," we start to see that the study of literature is, to some extent, also a study of what we now call gatekeeping.

Gatekeepers determine who is let through the ornate, imposing gates of learning. They decide which voices are heard and which themes and issues deserve attention. When I asked students in my very first class, "Who decides what *is* and *is not* 'literature'?," more than one offered the answer "old white men." While the reality is, of course, a little more complex, they were certainly correct in identifying "literature" as a highly subjective and contested term (I'm using scare quotes because I'm not referring simply to published collections of words, but to literature with a capital L, used in a way that implies cultural value).

The gatekeeping of "literature" is practiced at an institutional level by publishers, university professors, awarding institutions (such as the Booker prize), and bookstores. Their decisions regarding what is and is not published, what is and is not included in syllabi, booklists, award lists, or store displays, contributes

to a certain conception of what "literature" is and what it is *not*. Certain modern Internet phenomena, like BookTok, are helping to democratize "literature" by challenging these traditional gate-keeping structures, handing over the keys instead to anyone with a smartphone.

Gatekeeping is closely linked to the notion of what we call canonicity or "The Canon." This is a selection of texts that, through repeated publication in new editions, teaching, and citation, acquire an almost mythical, enshrined status (the word "canon" was first used, in a literary context, to refer to the texts of the Bible). There is no actual authoritative list anywhere that defines the canon, although Harold Bloom's controversial *The Western Canon* (1994) comes close, as do modern incarnations like Peter Boxall's *1001 Books You Must Read Before You Die* (2006). If there's a book that you feel you *should* have read, chances are, it's part of the canon.

Yet the canon is ultimately a myth. As John Guillory pointed out in the 1990s, the canon is less about the actual literature it might contain and instead represents "cultural capital": hierarchical ideas about class, society, and civilization. These are not only elitist but are also shaped by historical discrimination. Recent years have seen calls to "decolonize" the canon, reflecting similar calls to decolonize the curriculum and the museum. Such calls point out that the traditional Western canon is almost entirely White, shaped by elitist, racist, and sexist attitudes that exclude other valuable texts. *This is the Canon: Decolonize Your Bookshelf in 50 Books*, by Joan Anim-Addo, Deirdre Osborne, and Kadija Sesay George, aims to counter the Whiteness of conventional literary canons and encourages us to be activists by being proactive in our reading choices. Such efforts often lead to headlines screaming about "political correctness gone mad," or how "wokeness" is ruining education. Anim-Addo points out that decolonizing the canon is certainly not

a call to throw out your copies of Jane Austen or "cancel" Charles Dickens, but rather "about putting together the missing bits of literature" that have shaped our entangled lives today.

Questioning who or what is idealized by the canon is often seen—by a certain subset of the population—as a form of cultural vandalism. People are oddly touchy about something that has never really existed in the first place. Much of the literature that occupies a place in that canon today was criticized upon its initial publication. The trajectory of English novelist Samuel Richardson's *Pamela*, one of the first English novels, has curious parallels with that of Swift's work. It was written, in the form of a series of letters (an "epistolary novel"), from the perspective of a fifteen-year-old servant girl, the titular Pamela. As a result, many of Richardson's contemporaries dismissed what they saw as its low and common style, eventually prompting Richardson to revise the novel. The virginal Pamela is repeatedly sexually harassed by her master, but refuses his extra-marital advances, and eventually convinces him to marry her (the novel's subtitle is "Virtue Rewarded"). Despite its controversial plot (the sex, yes, but—even worse—it was feared that the novel would inspire serving girls everywhere to try and rise above their station), it was hugely popular. It sparked a consumerist frenzy across Europe and a range of merchandise (waxworks, paintings, engravings, a theatrical adaptation, an opera adaptation, a fan, a magazine) and numerous unofficial spin-offs, parodies, and sequels.

The writings of a teenage girl about love and marriage, dismissed as low culture in ways that would prompt an authorial revision of language and style, leading to an international capitalist frenzy that would ensure their success and survival for posterity? I think I've seen this film before.

Any notion of a literary canon starts to collapse when we grapple with the slippery notion of literary and artistic value. Yet this

fundamentally flawed fantasy of cultural capital just won't die. Skeptics often challenge me to explain "why Taylor Swift is *good enough* to be literature." They contrast Swift with musicians like Bob Dylan (also the occupant of a contested literary space, with his 2016 Nobel Prize for Literature) and Joni Mitchell, asking why I didn't choose those instead, as they are "better." This is missing the point. Value judgments about art change over time and are unstable. To place Swift on a literature course is not to call her unequivocally and objectively brilliant (indeed, there is no such thing), but rather to prompt us to consider how those very notions are always subjective.

The study of literature, with a lower-case L, helps us to realize that "Literature"—capital L—has never really been the apparently sacred institution we invoke today. Long before there even *was* a canon that could be sullied by Swift's presence, writers were having to defend the mere existence of creative writing.

In 1595, English writer and soldier Sir Philip Sidney—courtier of Queen Elizabeth I—published *A Defence of Poesie*. It was a lengthy, elaborate justification of literature ("poesie" at this time meant all fictional creative writing, not just poetry), and a response to Stephen Gosson, who had written a tract called *The School of Abuse* in 1579. Gosson had criticized all fictional writing as immoral poison wrapped up in pretty words, which kept people distracted and ignorant of reality. He was echoing certain Puritan attitudes in England at the time, particularly a skepticism of theater, which was seen as profiting from lies.

One of Gosson's criticisms that Sidney most disputed was that there are "many other more fruitful knowledges" than literature. It's an argument I hear time and time again today: that I don't have a "real job"; that my course is not a "real degree"; that my students are wasting their time and money. Sidney countered this by saying that

literature is like mother's milk: we learn language through hearing stories, which then prepare us for more advanced knowledge. It would be downright ungrateful to then go back and bite the hand that fed us in our infancy. He also argued that literature can have a morally educational purpose: it's the spoonful of sugar that can help the medicine go down (an analogy Sidney made centuries before Mary Poppins). It teaches us without us even realizing we are being taught.

This book is living proof. Just as in my classroom, I've packed a wealth of literary teaching into these pages while reeling you in with the sweet promise of Taylor Swift. She's my Trojan horse, if you will—a metaphor for which we can also thank fictional literature.

My favorite part of Sidney's *A Defence of Poesie* is at the end. If, after reading his entire defense, you still doubt the value of literature, he sends you this curse: you'll end up deeply in love but will never win over your beloved because you can't write a sonnet; and when you die, you won't get an epitaph on your grave, since you were so dismissive of poetry. Ouch. I can't help but feel that Swift, who famously loves a "diss track," would approve.

Over two centuries later, in 1821, another writer found himself obliged to defend literature. English poet Percy Shelley was, like Sidney, prompted by a publication: in this case, his close friend Thomas Love Peacock's essay "The Four Ages of Poetry." In this rather tongue-in-cheek essay, Peacock said of the modern poet that he had deliberately buried himself in the past like a mole, a "semi-barbarian in a civilized community." The animal comparisons didn't end there: in a comment even sassier than Sidney's parting words, Peacock said of the poet that "the march of his intellect is like that of a crab, backward." Poetry was all "unregulated passion" and "exaggerated feeling"—studying or writing it was a waste of time and certainly not useful to society.

Peacock's essay reads like a more thoughtful, and grammatically correct, version of the comments I receive regularly about English Literature (Taylor's Version). Some people seem deeply concerned that I am stealing students away from more "useful" disciplines. This is particularly marked in the UK and the US, where the increasing commercialization and privatization of higher education has led to a growing obsession with quantifying certain curriculum disciplines in terms of their "usefulness" to society. Needless to say, this idea of utility nearly always boils down to the financial and economic, driven by that monstrous specter which strikes terror into the heart of any undergraduate: the "job market."

Shelley points out that, actually, anything that enlarges the imagination and opens the mind is "useful." Moreover, poetry can encourage us to cultivate empathy and identification, which are vital for all areas of life. To quote Shelley's poetic predecessor, Edward Young, literature "opens a back door out of the bustle of this busy, and idle world, into a delicious garden of moral and intellectual fruits and flowers." It's an argument I find myself repeating, centuries later, when asked about the most important thing students will learn from my course. I stress the increasing need for critical thinking and compassion in a twenty-first-century world riven by the—not unrelated—threats of fake news and widespread intolerance.

Shelley also makes a distinction between a mere story and a poem. Stories are a collection of detached facts, retelling a specific and unique combination of events. Poems, on the other hand, are universal, as they deal with all the abstract possibilities of human nature. By this token, Swift is something of a paradox. Her songs are stories, in the Shelleyan sense, since they relate highly specific, one-off events (dancing around the kitchen in the light of the refrigerator, or cleaning incense off a vinyl shelf). But, as hundreds

of millions of fans praising her relatability prove, they are also universal poems that deal with the whole spectrum of emotion and experience; what we call the "human condition."

Novelist Hanif Kureishi once suggested that pop music is a "form crying out not to be written about"; it's almost anti-intellectual, commanding us not to think, but to feel. But Swift's work, just like centuries worth of English literature, proves that it's certainly capable of doing both.

While we're on the subject of the human condition, perhaps my favorite defense of literature comes from British Indian author Salman Rushdie. There is rather more at stake in defending literature for Rushdie than for many other writers. His fourth novel, *The Satanic Verses*, saw him the subject of multiple attempted murders. Ruhollah Khomeini, then the supreme leader of Iran, condemned the book as blasphemous against Islam and called for Rushdie's assassination. In the decades since then, several people associated with selling or translating the book have been attacked and even murdered.

In 1990, with the controversy over *The Satanic Verses* at fever pitch, Rushdie delivered a lecture in London—or, rather, he delivered it by proxy; British playwright Harold Pinter stood in for him, due to the threat to Rushdie's life. While Shelley referred to poetry as "something divine," Rushdie's lecture, "Is Nothing Sacred?," toys with the idea that literature is sacred precisely because it is *not* sacred. The beauty of literature, he argued, is that it is the *opposite* of religion. It does not seek to elevate or sanctify one particular language or theme; rather, it is about "the way in which different languages, values and narratives quarrel," and the shifting power relations between them. The Tower of Babel in book form, if you will. He likened it to a stage upon which society's great debates can be conducted. By asking extraordinary questions, literature opens new doors in our minds.

Rushdie then offered his audience a thought experiment. Imagine you live in a house full of friends, family, lovers, colleagues, and strangers. It's not what you would have chosen; it's in fairly bad condition, and you realize there is no way out. However, there are several little rooms around the house, full of voices that whisper to you alone: about the house, everyone in it; about what has been, what is, and what should be. All the voices are different: the best ones are bitchy, sweary, loving, and funny all at once. You seek refuge in the room more and more often and realize that many others in the house do too. It makes being in the house bearable.

Now, Rushdie asks, imagine you wake up one day, and all those rooms have disappeared. You are struck by the realization that there's no way out of this house. It becomes *un*bearable: a prison. People scream and pound the walls. Men arrive with guns, and the house starts to shake. It's not a nightmare: you are already awake.

I can't help but think of Swift's "Lover House." Each color-coded room full of stories, full of voices that are indeed often bitchy, sweary, loving, and funny all at once. All of us, Rushdie points out, need these little rooms, where "within the secrecy of our own heads, we can hear *voices talking about everything in every possible way.*" After all, he points out, our imagination is like a theater that can never be closed down, playing a film that can never be destroyed. Wherever in the world people *have* tried to close down that little room of literature, "sooner or later the walls have come tumbling down." Rushdie knows this more viscerally than many: in 2022, he was stabbed multiple times while delivering a lecture in New York, ultimately losing sight in one eye and the use of one hand. Undeterred, he continued tirelessly to keep that little room open, publishing a best-selling memoir in 2024: *Knife: Meditations After an Attempted Murder.*

Swift famously burns down the Lover House on the Eras Tour, but it is reborn as the *folklore* cottage, a gateway to yet more voices and more stories. These little rooms are scattered throughout her discography. With nearly 300 songs to her name, Swift has come closer than many artists to talking about everything in every possible way, in a multiplicity of voices. The controversy around potentially incorporating her into English literature is nothing new: "literature" has been a contested space for centuries. Swift's stories, poems, voices—whatever you want to call them—keep Rushdie's little room alive. The only walls that come tumbling down as a result are those that have always been flimsy and poorly constructed anyway: those that separate high and low culture, the popular and the privileged, and the girlish and the grown-up.

Chapter Three

Why We're Still Singing Along: Swift and Style

ordinary words convey only what we know already; it is from metaphor that we can best get hold of something fresh.

—Aristotle

I'd had a few Aperol spritzes on the evening of April 18, 2024, and there was something I needed to get off both my chest and my desk (that, Dear Reader, is an example of *zeugma*, and it's something Taylor Swift likes a lot. Read on to find out more). I'd spent a sizable proportion of the preceding days talking to journalists, all of whom wanted to know one thing: Is Taylor Swift really a *poet*?

Swift was about to release her eleventh studio album, named—in an unprecedented break from her usual one- or two-word titles—*The Tortured Poets Department (TTPD)*. On her social media, she had allocated herself the title of said department's "Chairman." The media started to churn out sassy headlines like, "Wait, is Taylor Swift actually a *good poet*?" The implication was that it was unthinkable for a twenty-first-century American pop star to even call herself a poet, let alone have the audacity to be a *good* one. In

the room of my Venice hotel, I penned a prosecco-fueled blog post titled, "Is Taylor Swift a poet? Yes. Is that the wrong question to ask? Also yes."

I wrote about the potentially sexist and elitist assumptions underlying this reaction, which you've heard about in this book so far already. I then went on to offer a reminder that poetry was originally an oral form, passed down via memory before it ever saw manuscript. Until at least the Renaissance, poetry was habitually set to music and performed publicly; even the most intimate, private, and confessional creations were often circulated around a coterie of acquaintances. It's not as great a leap as we might think from the tortured sonnets of sixteenth-century English writer Thomas Wyatt, agonizing over his unrequited love for the king's wife, Anne Boleyn, to Swift including excerpts from her own diary entries as part of the promotional material for *Lover*.

This chapter is about Taylor Swift and poetry; or, rather, Taylor Swift *as* poetry, and how seeing her in this light might help us unpack the global phenomenon she has become.

In many ways, Swift is—to use one of her own song titles—"Nothing New." She uses techniques that poets have been using for millennia. She may not put narcotics into all of her songs (as she says in "Who's Afraid of Little Old Me?"), but she gets pretty close, in poetic terms. By combining a flair for observation and storytelling with a host of literary techniques dating back at least to classical antiquity, she has forged a unique songwriting style that has kept us singing along for the best part of two decades. I'll focus here on several particular techniques, which I'm calling the "Swift Six" (that, incidentally, is *alliteration*, which features in my Swift Six).

A quick note before we begin: you will notice that, throughout this book, I distinguish between Swift—the woman herself—and

what I call "the speaker," or speaking persona, of each song. Setting up this distance between the living, breathing pop star and the "I" who narrates each song is intentional. As with any kind of literature, not all songwriting is autobiographical, and even if it is, there are nearly always elements of fiction or embellishment at work. Swift has explicitly said—of albums such as *folklore* and *evermore*, for example—that she sometimes tells other people's stories; if the speaker of "no body, no crime" actually *was* Swift herself, she'd have been arrested for murder. I'll talk about this more in Chapter Six, but you'll find me referring to the *speaker* of Swift's songs so that I can discuss them without necessarily attributing everything to Swift's lived experience.

1. Universal specificity
(or, "you'll remember it all too well")

In 2023, journalists suddenly started asking me what made Taylor Swift so appealing to so many people, and I—entirely unprepared for the avalanche of publicity that accompanied the launch of English Literature (Taylor's Version)—coined this term out of the blue as a way of attempting to articulate it. How can her songs, which are often so hyper specific in their autobiographical detail, seem relatable to so many millions of people who are *not* Taylor Swift?

NPR's Leah Donnella, writing in 2018, said that "there comes a moment in a lot of Taylor Swift songs where it becomes hard to sing along." In that moment, "you realize that this song isn't about *you*." As an example, she cites "We Are Never Getting Back Together": "*Oh. I don't have a record, indie or otherwise. This song is not about my breakup. This song refers to a story I wasn't there for; a*

person I will never be." Yet millions of fans certainly *don't* find it hard to sing along (I saw firsthand evidence of this at the Eras Tour), and the word "relatability" surfaces with predictable regularity in any conversation about Swift's appeal. In fact, the more auto-biographical and microscopically detailed the song, the more we seem to relate.

Writing for *Elle* magazine a year later, Swift herself theorized that the songs "that cut through the most are actually the most detailed." These details are her main point of interest, as a writer: "I want to remember the color of the sweater, the temperature of the air, the creak of the floorboards, the time on the clock when your heart was stolen or shattered or healed or claimed forever." We don't actually *want* our pop music to be "lyrically generic," Swift opined; rather, we want the "connection and comfort" that comes with hearing others' emotional struggles, in all their minutiae. A "glimpse into the artist's story," Swift says, can "invite us to connect it to our own." It's a comforting reminder that we are not on our own (kid).

The example I always use to illustrate this concept is the refrigerator light from "All Too Well." The song, one of Swift's most popular, explores the painful aftermath of a breakup by focusing on the way the speaker is visited, spontaneously and startlingly, by memories of the relationship. They seem to pop, unbidden, into her mind—the *anaphora* (repetition of a word or phrase at the beginning of several successive phrases) of "there we are again" suggests the speaker's days are punctuated by sudden flashbacks to happier times, which she is powerless to stop.

Analepsis—telling a story through flashbacks—is central to "All Too Well." One such flashback is of the two lovers dancing around the kitchen in the light of the refrigerator. Questionable attitudes to household energy consumption aside, this is one

of Swift's most evocative, enduring, and memorable images. It paints a picture of joyful spontaneity, a couple newly in love doing quirky things, so wrapped up in each other that they forget that opening a fridge door accounts for 7 percent of the appliance's total energy use (maybe that's why the air was cold in the opening line of the song—this man habitually leaves the fridge open. I say she dodged a bullet). It's such a hyper specific recollection that you'd think it would alienate the 99.9 percent of listeners who cannot relate.

Yet we can, and we do, relate. Most of us have found ourselves the willing or unwilling recipient of spontaneous recollections pertaining to a relationship, romantic or otherwise. Our memory tends to work in what Swift terms flashbacks and echoes, presenting us with snatched fragments, sound bites, sensations, and images, rather than any kind of coherent narrative. Your "All Too Well" moment may not involve a refrigerator light, but you've almost certainly had one. That light is an invitation to revisit your own moments; to compile your own palimpsestic version of "All Too Well," a version whose patchwork of tableaux sits harmoniously atop Swift's. The specific becomes universal.

It helps that Swift sometimes uses second person address in a way that draws the listener inexorably into the story and makes it *their* story: think of the way she uses "you" in "Red" or "You Are in Love." It reminds me of a comment by writer Jeff Dolven, on the poetry of Frank O'Hara: "*you* is a flexible instrument, ambiguously available to the reader, to guess at or inhabit." Like Swift's refrigerator door, "you" is "held open in a particular way, even held ajar. Who knows who might decide to come in?"

A key part of this universal specificity is the refrigerator light itself. Swift tends to anchor emotion to symbols, usually objects or places. This leads us to another of her techniques:

2. Making the intangible tangible
(or, "trying to put it into words")

In "You Are in Love," the speaker tells us that she's spent her whole life trying to put "it" into words. "It," we realize from the context of the song, is the feeling of falling in love. In this moment, Swift seems to break the fourth wall and address us *not* as a speaking persona, but as Swift herself. If her life's work has been to articulate the seemingly inarticulable, it would seem she has succeeded. Fans frequently comment on Swift's ability to represent feelings and states that they themselves were unable to express or may not even have known they felt (the idea of songs "awakening something within me" is quite common in fan discussions).

Swift not only conjures "refrigerator light" moments in us, but she gives us the words to express how those moments then make us feel. Key to this is her use of figurative language: a broad category that encompasses *imagery*, *metaphor*, and *simile*. These are all ways of articulating something abstract by comparing it to something else more concrete. Swift once said that she needs metaphors "to understand anything that happens to me." This is one of the reasons there is such a broad "Taylor Swift Cinematic Universe": her work is intensely visual. I've seen no end of customized "Eras" denim jackets on social media, adorned with the significant artifacts that pepper Swift's lyrics: a red scarf; a cardigan; a mirrorball. They don't just *exist*; they stand for something unspoken. The red scarf is a metaphor for lost innocence (which itself might be a metaphor for lost virginity). The cardigan is a simile to express feelings of being forgotten and unwanted before being taken up and cherished. The mirrorball signifies a personality who constantly changes to fit in but is also intensely vulnerable. These symbols are the alphabet of

an emotional sign language that we can use to express the seemingly inexpressible.

In other words, she's taught us a secret language we can't speak with anyone else—except other Swifties.

We see this in action in "You Are in Love." Its verses have some of Swift's shortest lines and are comprised of single images interspersed with spare observations. Coffee at midnight; burnt toast on Sunday; kissing on sidewalks. Repeated is the idea that there's "no proof," but it's "enough." With only a few words, Swift captures the way in which, in the early blossoming of romance, even the slightest gesture becomes meaningful. The song itself tells us "not much," and yet, at the same time, more than enough. Those three simple words, "coffee at midnight," allude to how the rush of new love can disrupt our best-laid plans and play havoc with our established routines. Burnt toast and Sunday conjure up cozy domesticity: is the toast burned because the lovers are too wrapped up in each other to notice, or care? Not only do we have another example of Swift's universal specificity, but we also see how she imbues the simplest words with a wealth of meaning.

This can work with darker themes, too: think of the line in "seven," where the child speaker says she thinks her friend's house must be haunted, because her dad is always mad. It's an example of what Theon Weber calls Swift's "iceberg songs": where she "uses a tossed-off phrase to suggest large and serious things that won't fit in the song." The poignant lines imply an abusive father, and a child who doesn't have the adequate vocabulary to voice such things, resorting instead to the language of the supernatural.

Swift likes to repeat particular metaphors and comparisons. These include love as war; emotional pain as physical pain or

wounds; life or love as a book or story; memories haunting like ghosts; love as a drug. These are certainly not new comparisons, but, like all the best poets, Swift also offers us some startlingly novel ones alongside. Hanging from lips like the Gardens of Babylon. Love and longing lingering like a wine-stained dress that can no longer be worn. A toxic relationship with a vastly uneven power dynamic as a life-sized chess game. A lover as a rainstorm, and the besotted speaker as a house of cards. Ivy covering a house of stone to represent adulterous love: the plant lady in me loves this metaphor because it works even down to the botanical detail, for ivy grows quickly, is difficult to remove, and can destroy if left unchecked.

Swift's metaphors are in fact often so extended that they become closer to what we call *poetic conceits*: a metaphor that is continually developed and reveals new surprising comparisons with each recurrence. "Clean" explores the idea of being over past love by playing on the word: first as being washed free from dirt, but also as being recently sober; these two meanings capture perfectly the ways in which one can be over it but still miss it. "Getaway Car" compares a rebound relationship to the titular car, a metaphor that seems more and more fitting with each verse: as the speaker points out, nothing *starts* in a getaway car, let alone anything good, and they tend to be associated with erratic behavior, betrayal, and deceit. That a "mirrorball" is a perfect metaphor for a famous performer becomes clearer and clearer as the song develops: yes, it's sparkly, but it also reflects our own selves back at us; changes, chameleon-like, depending on its surroundings; is intensely vulnerable and breaks messily and dramatically; and still keeps spinning even after the revelers have gone home.

Some of these metaphors might even prompt us to rethink language itself.

3. Rethinking language
(or, *don't* "take the words for what they are")

One of Swift's signature songwriting techniques is defamiliariza-tion: encouraging us to see the familiar afresh, whether that be an object, an image, or even language itself. In this way, she certainly is a poet. To quote Percy Shelley, "poetry lifts the veil from the hidden beauty of the world, and makes familiar objects be as if they were not familiar."

Swift has referenced the band Fall Out Boy as one of her biggest influences, because "they take a phrase and they twist it." She's been doing this, too, from the very first lines of her very first single. When the unnamed object of "Tim McGraw" tells the speaker that her eyes shine brighter than Georgia stars, she rejects the cliché: "that's a lie." Ever since, Swift has taken well-worn idioms, clichés, and platitudes, and made us rethink their underlying sentiment, often by turning them into extended metaphors that stretch the comparison almost to breaking point. The metaphor of a broken heart for romantic grief is so overused that it has become what is known as a *dead metaphor*, but Swift pulls it apart, interrogates it, and resuscitates it. "Death by a Thousand Cuts" points out that romantic loss rarely involves one single, clean break—it's actually a lot closer to a thousand tiny wounds occurring over a longer period of time, as one wakes up alone every morning and remembers the loss anew. Similarly, "You're Losing Me," "How Did It End?," and "So Long, London" extend the idea of heartbreak to explore what might happen if a heart slowly and painstakingly stopped beating from lack of love, to the point that even repeated CPR could not revive it, and the result was an agonizing, drawn-out death rattle.

In "this is me trying," Swift probes the depths of the idiom "ahead of the curve," imagining what might happen if one continued

ahead of the curve to the point that the curve extended back around on itself and became a circle: you'd fall off, wouldn't you? That, the song implies, is exactly what tends to happen to the unusually gifted in their youth, as they crumble under pressure and waste their potential. In "Miss Americana & the Heartbreak Prince" (which, incidentally, uses the device of *antonomasia*—replacing someone's name with a nickname or phrase), Swift tells us that the damsels are depressed rather than in distress. It's a clever twist on the usual cliché, not only because it *sounds* like the original, but because it updates a medieval trope to reflect the state of modern-day women: not clamoring to be rescued from evil dragons, but instead just thoroughly miserable about the patriarchy. Swift urges us to hold both phrases in our minds, and to consider whether women are really any better off in the twenty-first century than they were in the twelfth (for more on this, see Chapter Seven).

Swift sometimes combines two idioms in ways that prompt us to rethink both. Consider "I dress to kill my time" in "Death by a Thousand Cuts." This merger of "dressing to kill" and "killing time" captures how we might attempt to alleviate the tedium and sadness of romantic loss by dressing up to impress others, or as a form of self-care. Or "you double-cross my mind," in "All Too Well (10 minute version)," which combines the idea of an unwanted flashback of an ex-lover with the notion that that flashback is also a betrayal of sorts. In a similar vein, Swift often uses zeugma: where one word relates to two others in two distinct ways, usually one literal and one metaphorical. For example, crashing a party and a rental car; or holding one's breath and the door. In playing these tricks, Swift helps us to rethink what George Layoff and Mark Johnson term the "metaphors we live by," so that they are no longer the unnoticed figures of our everyday speech, but instead a reminder of the versatility of language.

4. Confessional spontaneity
(or, "get it off my chest")

Swift has often compared listening to her songs to reading her diary. As the listener, we are supposed to feel that we are hearing a barely edited series of thoughts from Swift's own mind. This confessional feeling comes as much from the *way* in which her songs are written, as from what they're about. They are carefully crafted to seem spontaneous and unfiltered. This is, of course, something of a paradox: it takes art to make something seem so artless.

In "happiness," the speaker tells the object of the song that she hopes his new lover will be a "beautiful fool." In the next line, she immediately says "no, I didn't mean that," and apologizes. This is one of many examples of *anacoluthon*. A Greek word that literally means "not following," it evolved into the Latin non sequitur that we tend to use today. Anacoluthon occurs when a speaker abruptly changes course, interrupting themselves or changing the grammatical flow of the sentence they had been uttering. American poet and essayist Rachel Blau DuPlessis describes it as "the grammatical switching of horses in midstream of a sentence," and it reflects the way we tend to converse spontaneously, hopping on different horses as our moods and ideas shift. The speaker describing the dress she wore at midnight followed by "leave it all behind" is another example: the "it" can't refer to the dress, since "it all" doesn't really match grammatically with a single dress (would you only leave *half* a dress behind?). There's something else going on here, in the speaker's mind; something we can only guess at.

Anacoluthon might also be called "the 'AND ANOTHER THING!' technique," to quote writer Isabel Cole. Indeed, Swift's anacoluthon *is* often preceded by the word "and" which gives the

impression of the speaker rattling off ideas and thoughts as they occur, without explaining the connection. The song "Maroon" is a good example of this. If you tried to arrange the lyrics from the moment the speaker looks up at the sky to the end of the chorus, they'd make little grammatical sense. Instead, it feels like a flood of recollection rushing into the speaker's head as swiftly as the blood rushed into her cheeks in that fateful moment. Another example is in "The Black Dog," where the speaker is talking about best-laid plans one minute, then immediately tells us that her lover said she needed a brave man. Again, grammatically, the lines don't fit together, but they match perfectly the mood of the song: an "All Too Well"-style reminiscence of the key moments in a relationship that is now over.

Anacoluthon is a technique often seen in "stream of conscious-ness," a phrase we tend to use fairly freely nowadays but which initially referred to a very specific style, popularized by Modernist writers of the early twentieth century, chiefly Virginia Woolf and James Joyce. It aimed to reflect more accurately the workings of the human mind, especially in novels with a first-person narrator. Our thoughts are not neat, sequential, chronological, or hierarchical. We don't think or experience life in the ordered, curated way that suits the narration of a novel. Think of the famous opening of Woolf's novel, *Mrs. Dalloway*:

Mrs. Dalloway said she would buy the flowers herself.

For Lucy had her work cut out for her. The doors would be taken off their hinges; Rumpelmayer's men were coming. And then, thought Clarissa Dalloway, what a morning—fresh as if issued to children on a beach.

What a lark! What a plunge! For so it had always seemed to her, when, with a little squeak of the hinges,

which she could hear now, she had burst open the French windows and plunged at Bourton into the open air.

Clarissa Dalloway thinks of her chores, contemplates the freshness of the morning, and then—reminded by the thought of hinges and the morning air—is swept away into a recollection from her youth. It's like watching a free association exercise unfold in real time, and puts down on the page the often erratic, decidedly nonlinear quality of human thought. Think of the way Swift free associates from the word "blue" in "Paper Rings," going from a memory of a cold swimming pool to painting a wall. The speakers of "coney island" do something similar as they sit on that bench, offering a series of disconnected phrases about loss and disappointment before observing that it's getting cold. We then dart from a meeting place to a birthday cake to an accident to a podium; as with *Mrs. Dalloway,* there's a feeling that it all makes perfect sense within the mind of the speaker. One image unfolds another, like expanding a series of Russian dolls.

Adding to this feeling of jumping around between topics, Swift uses frequent *asyndeton*: lists of words or phrases without conjunctions between them. The best example is the litany in "Death by a Thousand Cuts," when the speaker is trying to find a part of her that her lover didn't touch: wine, spirit, trust, heart, hips, body, love, time. It's as if these spill from her lips spontaneously as they flash across her memory. The opposite effect, *polysyndeton* (words or phrases with a conjunction between every single one), can also evoke spontaneity: think of all the things she calls the object of the song in "Mean": not just mean, but a liar, *and* pathetic, *and* alone, *and*, of course, mean (multiple times). Again, this suggests an impassioned speaker throwing out insults off the top of her head, too angry to select only the choicest words.

It's the same effect as when she uses *apostrophe*: a spontaneous exclamation directed at an absent person or an object and usually prefaced with "Oh." The sweet disposition of "All Too Well," the simple complication of "The Story of Us," or the tragedy of "So Long, London," for example. In a similar vein, we have the spontaneous-sounding exclamations of "Oh my God" in "Blank Space" and "Oh, goddamn" in "ivy." All of these contribute to a raw, unfiltered feeling, as if there's barely any distance between the speaker's heart and our ears.

This style of Swift's is sometimes complemented by *anastrophe*: the inversion of traditional sentence structure in a way that "front-loads" the sentence, emphasizing a particular aspect. Think of "invisible string," whose lines don't follow the traditional subject-verb-object sentence format, but instead begin with adjectives: it's not, "the grass was green," but "green was the grass." Similarly, "Dear John" begins with anastrophe to emphasize how long those nights felt when the speaker's days revolved around the capricious, unpredictable "John." It gives those songs a more archaic, poetic tone—what Swift calls her "quill" style—but also mirrors the way we tend to think and speak, plucking the most important sensation or idea out of our minds before we do the work to fit a narrative around it.

Related to this is Swift's tendency to begin songs *in media res*: in the middle of things. Think of "You're Losing Me," which immediately plunges us, with no context, into an intimate, fraught conversation between two people struggling to communicate. It's the opposite of "Love Story," which takes time to set the scene: the age of the lovers involved, the circumstances of their meeting, their first conversation. Plunging the listener into the middle of the story gives a feeling of intimacy and spontaneity: it's like we're a fly on the wall. Rather than artificially setting out the scene for us, Swift

simply lets us tag along for the ride; a ride that, it is implied, was already in progress before we became interlopers.

And our status as interlopers is only bolstered by techniques like *onomatopoeia*—words that sound, themselves, like the sound they describe. Think of "clink clink" in "Slut!" which makes us feel like we're eavesdropping on the charged touching of those wine glasses, or the loud, elongated "screaming" in "The Black Dog"; we, too, are present for the terrible exorcising of the speaker's demons.

It's no accident that Swift's use of these techniques increases in "quill style" albums such as *folklore, evermore,* and *TTPD.* Not only does her language become increasingly complex in these albums, but they also deal with subject matter that lends itself naturally to a more intimate, confessional mode of writing: infidelity; alcoholism; murder; self-harm. There's still an emotional authenticity in Swift's earlier work, of course, but many of those songs feel far more polished and more fixed in structure, particularly as Swift moved toward the pop genre. This fixity seemed to unravel as she stepped into the folklorian woods in 2020. By the time *TTPD* arrived, she was switching (wild) horses with dizzying regularity, rather fittingly for an album featuring a track called "The Bolter."

5. Shifting time (or, "has it been twenty seconds, or twenty years?")

None of the above would be particularly interesting if Swift weren't also an excellent storyteller. She puts the three-to-five-minute window of a traditional pop (or country) song to maximum use, sometimes condensing narratives that span multiple decades into a handful of lines. Music journalist Nate Sloan has observed a "time shift" paradigm in Swift's lyrics, where the chorus alters slightly

each time to propel the story forward (or backward). We might also call it "repetition with variation," and it's an extremely common Swiftian device. Sloan uses the example of "Love Story": the first line of the chorus shifts from the speaker begging Romeo to save her, to Romeo proposing. In Sloan's words, "the payoff is exquisite. Over a three-minute song, the listener has been exposed to every stage of a couple's relationship." This is even more pronounced in "Mary's Song," which begins with two children who met at ages seven and nine and ends with them still deeply in love at eighty-seven and eighty-nine. Swift's repetition with variation often involves changing only a single word yet delivering a momentous impact. "Red" begins in the present tense—loving him *is*—and ends, poignantly, in the past—loving him *was*. In "The Black Dog," Swift need only change two letters for a gut-wrenching effect: the *magic* fabric of their dreaming becomes the *tragic* fabric, cementing the fact that this relationship is truly over.

TTPD makes frequent use of repetition with variation, perhaps most powerfully in "loml." The song's title only becomes clear in its final line, when the repeated refrain—the speaker's lover telling her repeatedly that she is the love of his life—switches to the speaker declaring him the *loss* of her life. This twist is a technique that harks back to the Renaissance sonnet, which commonly featured a "volta." From the Italian word for "turn" (the sonnet originated in Italy), the volta brings a shift in argument or point of view toward the end of the poem. A famous example is in Shakespeare's "Sonnet 130," which begins "My mistress's eyes are nothing like the sun." The speaker lists all the ways in which his mistress is not conventionally beautiful, drawing on clichés: there are no roses in her cheeks; her lips are far less red than coral; her breast is not snow-white, but dull; her breath is far from perfumed; and her voice isn't musical at all. Just when you're beginning to think this

speaker a grotesque chauvinist, the final couplet of the poem reveals that he thinks his mistress "as rare, as any she belied with false compare." In other words, she is as beautiful as any woman ("any she") spoken about using exaggerated similes. Far from needing to resort to clichés to exaggerate his mistress's beauty, the speaker loves her just as she really, truly is.

The time shift doesn't always deal in events: it can indicate an emotional journey as well as a temporal one. The chorus of "All Too Well" shifts from "I remember" to "you remember," and that of "Dear John" progresses from "I should've known" to "you should've known." Both are subtle changes, implying the speaker's journey away from self-blame and despair to righteous anger. We get the same in "Mr. Perfectly Fine" (another example of antonomasia), whose rousing final chorus wishes the object of the song "goodbye" instead of hello: he's now Mr. Too Late. "Evermore" moves from despair to cautious hope: the pain *wouldn't* be forevermore. Similarly, "You're on Your Own, Kid" moves from the sad acknowledgment that the speaker (and perhaps the listener) has always been alone, to the empowering declaration that she (and we?) can face this. Repetition with variation to indicate resilience also occurs in "long story short," which takes us from a bad time to having survived. "I Can Fix Him (No Really I Can)," on the other hand, is boldly confident and self-assured right until its final three words, when the speaker suddenly falters: maybe she *can't*, after all.

Sloan argues that Swift abandoned the time shift in *1989* to live in "an eternal present," one that reflects the "static emotional tension of pop." Think, for example, of the thirty-eight anxiety-inducing repetitions of "out of the woods" in the song of the same name. Yet this isn't strictly true: "How You Get the Girl" ends with the revelation that he *got* the girl; "You Are in Love" reveals that

not only is *she* in love, but *he* is too. Ever the storyteller, it would seem Swift just can't resist a twist.

6. Aural effects (or, "a sound you [maybe] haven't heard before")

Finally, it would be remiss of me not to discuss, at least briefly, the way Taylor Swift's lyrics *sound*. After all, her popularity and longevity are, at least partly, down to her ability to write a catchy song.

The earliest surviving poetry from England was circulated and performed orally long before it was ever written down. This meant that performers would need to remember hundreds of lines of verse. They took their cues in the form of something called "alliterative meter," a type of poetry structured by alliteration rather than rhyme. The tenth-century *Beowulf* runs to a whopping 3,182 lines, which traveling bards would need to learn by heart. Alliteration, therefore, was antiquity's equivalent of the whispered cue to an actor on stage. Or, to use a more Swiftian metaphor, the narcotics that kept people singing along long enough for these ancient poems to finally make it onto the page.

In other words, sick beats were not just a fun pastime in the Middle Ages; they were a necessity. If you wanted to write a poem for posterity, you had to make it catchy. Alliteration was one of the earliest ways of doing this; then, later, rhyme.

Swift uses alliteration frequently. Very little of it is accidental. Think of the line about **p**olishing **p**lates until they **gl**eam and **gl**isten, in "tolerate it": it's not just catchy, but the repetition of the sounds also reflects the monotony of the task. Swift also uses rhyme in diverse ways that reflect the content of the song, often going beyond the simple use of what we call "end rhyme" and "perfect

rhyme": where the sounds at the end of a lyric line rhyme completely, like "moving" and "grooving" in "Shake It Off." We also find a lot of "slant rhyme" or "half rhyme," common in rap and hip-hop, which usually involve *assonance* (matching vowel sounds, like "mistake" and "face" in "Slut!") or *consonance* (matching consonant sounds, like "elegies" and "eulogize" in "the lakes"). Slant rhyme, because it's not "perfect," is often used to give a sense of unease in Swift's songs, representing things not falling into place or working together as they should. It's used a lot in "Getaway Car," for example, to reflect the fundamental incompatibility of the speaker and her rebound lover; also, in "Clean," to reflect the state of feeling unmoored after a relationship. Swift probably uses slant rhyme more often than she uses perfect rhyme, as if to lend emphasis to the authentic voice of her speakers: this, they seem to say, is the only word that works to describe how I'm feeling, and I don't care if it rhymes or not.

Swift often uses multiple types of rhyme within the same song. Take "Miss Americana & the Heartbreak Prince," which begins with what we call internal rhyme: the rhyme is within each line rather than between one line and the next. We have "adore you" and "for you"; then, on the next line, "sixteen" and "film scene." "Sixteen" and "film scene" are already not quite a perfect rhyme. By the next line, we have "queens" and "playing": slight assonance on the "ee" sound, but it's certainly not a rhyme. Next: "lost in the lights." The rhyme has broken down completely. What began as a tight pairing of perfect rhymes has disintegrated gradually into no rhyme at all. It's not accidental, because Swift does it in the next verse, too. What we see here is the disintegrating rhyme perfectly mirroring the speaker's growing disillusionment, ending in a feeling of being lost and disconnected—just like the rhyme itself.

Swift also experiments with different types of "poetic feet": combinations of stressed and unstressed syllables. Again, these

are often chosen for a clear purpose, and match seamlessly with the subject matter of the song. The slow, ponderous tone of "The Smallest Man Who Ever Lived," which seems to agonize over every syllable, is achieved largely through the use of *spondees*: two-syllable combinations where both syllables are stressed equally. In natural speech, you'd probably only stress the 'a' of 'any', and the word 'true', in the opening line, 'Was any of it true?' Yet Swift stresses every single syllable as she mulls over the catastrophic consequences of this affair. "You Are in Love" also uses spondees, giving weight to every single aspect of its litany of images: this reflects, as discussed above, our tendency to allocate meaning to every slight detail in the beginning of a new romance. In "Slut!," Swift uses a three-syllable foot called a *dactyl*—stressed/unstressed/unstressed—at the end of each of the verse lines (think **boul**evard; **swim**ming pool). The lengthening of those syllables adds a kind of dreamy, longing feeling that fits with the theme of the song.

Swift's music is often criticized by her detractors for being derivative and unoriginal. Yet, in some ways, that is also the reason for its success. Like a classic red lip, Swift's writing will probably never go out of style, since its style is based on a foundation of tried-and-tested literary techniques that have ancient roots. She has combined these with a remarkable productivity and a tendency to focus on the emotional minutiae of everyday experiences. Drawing us in with a timeless familiarity, Swift still offers enough surprise, through her clever wordplay, to keep us chanting *more*.

Chapter Four

Nothing New:
Inspiration, Creation, and Anxiety

all the images rose up before him as things
—Samuel Taylor Coleridge,
"Kubla Khan"

In October 2012, Taylor Swift took part in a live webcast to promote the publisher Scholastic's "Read Every Day" initiative. In a Q&A with schoolchildren from across America, she reflected on her songwriting process. "It's always unpredictable," she said. "You never know what's going to hit you first. Kind of like this little cloud floats down in front of you and it's got an idea on it." At four in the morning, or while walking through an airport, "I'll just get an idea and I'll have to write it down on a paper towel." It's almost exactly what the speaker does in "Our Song," from her debut album. Swift recalled the numerous times she has found herself in a car with her friends, hunched over her phone, hurriedly recording a voice memo. "My biggest fear is that I'm going to forget about it," she said.

If only voice memos had been around in 1797, when British poet Samuel Taylor Coleridge awoke from an opium-induced nap.

In the summer of that year, Coleridge had retreated to a lonely farmhouse in southwest England for his health. He had been

prescribed opium for his symptoms—not uncommon at that time—and, under the influence, dozed off while reading a historical travel book, *Purchas His Pilgrimage*. Slumbering deeply for nearly three hours, he experienced a strange dream inspired by the book, in which vivid images rose up before him "without any sensation or consciousness of effort." During this dream, he composed several hundred lines of exquisite poetry and woke up recalling it perfectly. Grabbing a pen (not an old napkin), he started to write.

Unfortunately, soon afterward, he was called out on business by a man from the nearby village of Porlock. Returning over an hour later, Coleridge realized with dismay that he could no longer remember the poem, only a few scattered images.

American professor John Livingston Lowes apparently once told his students that "if there is any man in the history of literature who should be hanged, drawn, and quartered, it is the man on business from Porlock." We know all about him, and about Coleridge's opium dream, because Coleridge wrote a short preface to his unfinished poem, "Kubla Khan," explaining how it came into existence. It's the kind of thorough exposition that Swifties can only dream of, and it shows a number of parallels with Swift's own creative process.

On the way home, she wrote a poem. The speaker of "Sweet Nothing" tells us that this happens all the time. Both Swift's lyrics, and the way she talks about creating those lyrics, depict inspiration and creation in a way that is very reminiscent of Coleridge and his contemporaries, a group of writers now more commonly known as the Romantic poets. These are the poets Swift references in her song "the lakes," where she also puns on one in particular: William Wordsworth.

In the late eighteenth century, Coleridge collaborated with Wordsworth to produce *The Lyrical Ballads*, a collection of poems

that aimed to shake up British poetry. Its preface was a manifesto of sorts, in which Wordsworth and Coleridge outlined their poetic vision. All good poetry, they declared, "is the spontaneous overflow of powerful feelings." Poetry should show how we associate feelings and ideas when we are in a state of high emotion, following "the fluxes and reflexes of the mind." Poetry should not describe things as they *are*, but as the poet *feels* them to be. Passion and feeling are the most important aspects—it's the emotion behind the poem that makes the action and situation important, rather than the other way around.

So far, so Swift. A scarf left behind in a drawer isn't particularly interesting in and of itself but becomes poignantly meaningful in the context of the heartbreak that infuses "All Too Well." It comes to symbolize everything from youthful hope, to a noose around a doomed relationship, to Swift's virginity (according to a popular fan theory).

In the prologue to *1989 (Taylor's Version)*, Swift described new melodies "bursting" from her imagination. She has made a career out of spontaneous overflows of powerful feelings, famously motivated to compose "We Are Never Getting Back Together" after emphatically correcting someone in the recording studio that she was certainly *not* back with her ex; twenty-five minutes later, the song was born. Although self-identifying as a Machiavellian mastermind, the way Swift talks about her craft emphasizes spontaneity and the spur-of-the-moment, rather than caution and calculation.

And we love her for it, because we love the idea of an artless artist. Few things are as inspirational as inspiration, particularly when it strikes like a bolt from the blue—a eureka moment where the bathtub overflows metaphorically with a gush of ideas. Such origin stories become almost as famous as the creations themselves,

perhaps because they're our modern secular equivalent of the miracle or divine vision. In the nineteenth century, literary critic William Hazlitt argued that "the definition of genius is that it acts unconsciously; and those who have produced immortal works, have done so without knowing how or why." It's as if the work has an autonomous life of its own, and certain writers are gifted with being its chosen vessel. The idea for *Harry Potter* supposedly came out of nowhere, fully formed, into J. K. Rowling's head as she sat on a train from Manchester to London. Popular Victorian novelist Rider Haggard wrote his novel *She* "at white heat, almost without rest," after ideas arose so quickly that his writing hand struggled to keep pace with his imagination. The complete melody of the Beatles' "Yesterday" famously came to Paul McCartney in a dream (he perhaps learned his lesson from Coleridge, because he played it through on the piano as soon as he awoke, so that he wouldn't forget).

The idea of the artist as a lone genius, struck suddenly with inspiration for a groundbreaking original work, gained cultural currency in the late eighteenth century. This was an era in art and literature known as the Romantic period, and it emphasized intellect, imagination, intuition, inspiration, and emotion. There are a lot of "I" words there, which is fitting, since Romanticism focused heavily on individual subjectivity. We use a capital "R" to distinguish it from the romantic (related to sexual love) and from romance (medieval narratives of heroism and adventure), although Romanticism often incorporated both of these things. Ever since its heyday, Romanticism has shaped, for better or worse, how we think about inspiration, art, and originality.

In 1759, British novelist Laurence Sterne published *The Life and Opinions of Tristram Shandy, Gentleman*. It was an attempt to do something no one had done before: to write a novel that told every single moment of the main character's life, from birth to death. As

you might imagine, Sterne ran into difficulties. He kept finding it necessary to add background information to explain things, so the main character isn't even born until around 150 pages in. At one point, Tristram reflects on writing and originality, asking whether new books will be made forever "by pouring from one vessel into another." He's recognizing the very common tendency for authors to copy from other authors, something Sterne did frequently—that metaphor was itself taken from Robert Burton's *The Anatomy of Melancholy*, and Sterne was described in 1880 by the French essayist Paul Stapfer as a "literary pilferer."

If we look at some of English literature's most famous historical authors, copying is rife. Chaucer and Shakespeare often based their work on stories drawn from classical literature, folklore, and history. In fact, certain of their works are unusual *because* they are original. Authors frequently put their own spin on others' texts, and they didn't always cite their sources. In fact, it was rather assumed that if your use of another's work was blatant enough that the audience would recognize it, then it didn't count as plagiarism (Note to students: the same rules don't apply when it comes to university essays). Taking another's work and then improving on it was seen as perfectly legitimate, and even the mark of literary excellence. The risk, as historian Tilar Mazzeo puts it, was not in borrowing, but in borrowing *badly*.

Writers have been pouring from one literary vessel into another for centuries. All poetry, to quote Mark Ford in the *London Review of Books*, is "the result of love and theft" (appropriately, this phrase is the title of a 1993 book by Eric Lott, which in turn apparently inspired the title of Bob Dylan's thirty-first album, *Love and Theft*). However, scholar Rebecca Moore Howard argues that "by the dawn of the Romantic era, it was no longer acceptable to stand on the shoulders of predecessors." In fact, the same year that Sterne

published *Tristram Shandy*, poet Edward Young declared in his essay, "Conjectures on Original Composition," that "originals are the fairest flowers: imitations are of quicker growth, but fainter bloom." The late eighteenth century saw writers increasingly contemplate what Harold Bloom would later call the "anxiety of influence," and Walter Jackson Bate "the burden of the past": how to deal with the influences of other writers in one's own work.

Romantic writers prized what we might call "autogenous originality": an original work that appears *ex nihilo*—out of nothing. Young likened it to a vegetable, rising spontaneously from "the vital root of genius." It *grows*, he said; it is not *made*.

This is often referred to, in literary and cultural studies, as the Romantic cult of the individual genius. And Swift certainly seems like a new Romantic.

Aaron Dessner recalls that Swift wrote the song "willow" in less than ten minutes. Swift herself revealed that she couldn't stop writing songs after *folklore*, so its sister album *evermore* was released six months later. She is known for collecting lines, ideas, and melodies on her phone when suddenly inspired. In the prologue to *The Tortured Poets Department (TTPD)*, Swift describes being "struck," and it's an apt word for how her inspiration seems to work. She apparently wrote so much tortured poetry that she had to double the album to fit it in—it's as if the art controls her, not the other way around. This idea, of the poet at the mercy of his inspiration, is common in Romantic writing. John Keats once declared that his imagination was a monastery, and he was its monk.

In the prologue to *Midnights*, Swift referred to a sudden spark lighting a "tinderbox of fixation" and causing a fire of inspiration. *Folklore* apparently began with visuals that popped, unbidden, into Swift's mind, rather like Coleridge's opium dream. Her imagination ran wild, and a collection of songs and stories "flowed."

Fire and water: both can emerge almost from nowhere and grow to epic proportions in an instant. Indeed, it was quite common for Romantic writers to discuss inspiration as a fountain or river. Shelley referred to the "overflowings" of his mind. Wordsworth declared that "the stream of fiction almost ceased to flow" after his brother's death. Coleridge's imagination was often compared to flowing water. He was known for talking in monologues or "onev- ersations": his acquaintances likened his speech to a "majestic river" carrying along everything it encountered (I can't help but think of Swift's sarcastic reference to important men thinking important thoughts in "Now That We Don't Talk." I do not think I'd have liked to be on a yacht with Coleridge).

In the prologue to *Speak Now (Taylor's Version)*, released in 2023, Swift wrote that she composed the album entirely on her own after "encountering the infuriating question that is unfortunately still lobbed at me to this day: does she really write her songs?" This infuriating question is linked to wider issues, like the misogynistic higher standards to which we hold women in the music industry, and skepticism surrounding Swift's youth and privilege. Those are discussed in other chapters. What interests me here is the way in which this criticism of Swift—that she doesn't write her own songs—ignores the fact that collaboration and cowriting are common in the music industry and indeed have produced some of the finest tunes (just think of Queen and David Bowie's "Under Pressure"). Those who throw this criticism at Swift invoke a (false) Romantic myth that work only has artistic merit if original; and that original works are, to quote Wordsworth, "most naturally and most fitly conceived in solitude."

Returning to watery metaphors: allow me to burst this bubble a little. The cult of the solitary Romantic genius, and their pristine originality, is something of a myth. Keats once wrote that it is

easier to think about what poetry *should be* than to write it, and Romantic writers did indeed spend quite a lot of time pouring forth their views on the craft. While they had strong opinions on poetry, though, there was often a disconnect between the ideal and the reality.

Receiving a flash of creative inspiration in a dream seems dramatic and spontaneous, until you hear that writers have been using artificial substances for centuries to try and "encourage" the kind of reverie that prompted "Kubla Khan": everything from eating raw meat to taking opium, as Romantic writer Thomas De Quincey noted (he said that opium opened a "theater" in his brain). Keats argued that "if poetry comes not as naturally as the leaves to a tree, it had better not come at all," but there are plenty of instances of Romantic writers struggling over, or even trying to force, their creations.

Poet and novelist Charlotte Smith depended more on inspiration than most. She needed to write to support her twelve children after her abusive husband was imprisoned for debt. Yet even Smith had to remind her publishers that "poetry will not always come when it is called." Dorothy Wordsworth recalled her brother, William, often staying up late into the night and skipping meals to try and finish poems: she said that "he wearied himself to death." Shelley admitted that the best poetry is "produced by labor and study." Celebrated novelist Stephen King would say the same thing, in a rather pithier fashion, centuries later: "Amateurs sit and wait for inspiration, the rest of us just get up and go to work."

Romantic writers frequently worked together and drew inspiration from each other, which rather dilutes the idea of the solitary genius struck by a sudden creative vision. Husband and wife Percy and Mary Shelley often collaborated. William Wordsworth and Coleridge not only collaborated with each other on the *Lyrical*

Ballads, but also drew inspiration from Dorothy Wordsworth—in fact, Dorothy has often been called one of the most important writers in English history, despite the fact that she never wrote for the public. Scholars still debate whether the "inspiration" Wordsworth took from her journal counts as plagiarism. Women writers had very few ownership rights over their work during the Romantic period and were far less likely than men to describe themselves as daydreaming solitary geniuses, for fear of being ridiculed by a culture that looked upon their writing with suspicion (as it still often does). The Romantic cult of individual genius is not just a myth; it's a very gendered myth.

Far from being peppered with the geysers of original, spontaneous work erupting everywhere, then, the literary landscape of the Romantic era was more like a flood plain, where the ideas and words of multiple authors intermingled freely. The word "influence" comes originally from the Latin "to flow," which is rather fitting: the literature of this period was awash with influences from all manner of works. In fact, Wordsworth spent his later career campaigning to reform the law around copyright, worried by how fluid the notion of authorial ownership was becoming.

All of this to say: Romantic creativity is a lot more complicated than the myth of solitary genius might have us believe.

Swift said to *Rolling Stone* in 2019 that "people don't want to think of a woman in music who isn't just a happy, talented accident." As if to deliberately refute this Romantic image, Swift has always been transparent about the hard work that goes into her authorial process. She often includes voice notes and early demos as part of her album promotional materials, encouraging us to see her songwriting as collaborative and involving a lot of editing and revision. Although she described, in her speech at the 2023 Nashville Songwriting Awards, living "for that rare, pure moment when a

magical cloud floats down right in front of you in the form of an idea for a song, and all you have to do is grab it," her use of the word *rare* is telling. Because once you grab that idea, Swift said, you then "shape it like clay. Prune it like a garden." The magical clod of inspiration is nothing without the potters' wheel of hard work.

This pressure, for Swift to fit a (male) Romantic ideal of the artist, has clearly caused her anxiety. We see it in "Nothing New," where she acknowledges the public love of raw originality (the "ingenue") and worries that her audience will no longer want her when she is nothing new. This might refer to her becoming more advanced in her career, but it might also suggest that she sees her audience as less interested in her if she fails to live up to Romantic expectations of solo authorship and striking inspiration. She has spoken at length about this relentless demand for originality in the music industry, particularly how it disproportionately affects women. In the Netflix documentary *Miss Americana*, she noted that female artists have to reinvent themselves much more than male ones, for fear of losing their jobs. In her 2023 interview with *Time* magazine, she recalled realizing early on in her career that "every record label was actively working to try to replace me" and so decided to keep replacing and reinventing herself first, because "it's harder to hit a moving target."

In saying this, Swift reveals another Romantic trait. Romantic writers were obsessed with fame.

Not, however, in the sense of wanting to be instantly popular—in fact, they dismissed this as rather crass. Instead, Romantic writers were deeply concerned with posterity: how their works would be remembered once they were gone. It's something Swift also muses on in "Long Live," pleading that we tell our children her name. Many Romantic writers subscribed to a belief that (long) lives on to this day: true artistic geniuses are not appreciated in their

own time. Such stories are famous in the art world—Van Gogh and Vermeer both died in poverty—but also in literature: Edgar Allen Poe, Herman Melville, and Franz Kafka met the same fate. Eighteenth-century writer John Hamilton Reynolds commented on the "lamentable" fact that "no Author's fame gets warm till his body gets cold." Reynolds might have been thinking of his friend Keats, whose publishers were so disappointed by the commercial failure of his work that they regretted Keats had ever asked them to publish it. Even as he was dying, Keats wrote to his lover, Fanny Brawne, declaring, "I have left no immortal work behind me" (two centuries later, Keats regularly appears in poetry anthologies, and his poem "To Autumn" has been described on multiple occasions as one of the most perfect poems in the English language).

"No poem of mine will ever be popular," wrote Wordsworth, but he was content to "leave the rest to posterity." After all, he pointed out that literary greats like Shakespeare and Milton were underappreciated in their own time, too. In fact, Wordsworth saw himself as taking on a noble, sacrificial role by paving the way for other poets. He likened himself to the Carthaginian general Hannibal, who cleared a path through the Alps to invade Rome: Wordsworth saw himself helping people adapt to his new type of poetry, so that his successors would be better received.

Swift also imagines herself doing this. In "Nothing New," she speculates that she will one day meet the "new me," radiant at seventeen years old, and this young rising star will know the precise route to fame and fortune because she got the map from Swift. Swift, however, is not as relaxed as Wordsworth about this: she tells us she will cry herself to sleep when it happens.

Other Romantic writers were also of this Swiftian persuasion. Coleridge described feeling an "indefinite indescribable terror" at the thought of producing new work that could match the success

of his early poetry. Smith often discussed in her letters the pressure she felt in producing new work once she had "some reputation" to lose. Tortured poets, indeed.

This is perhaps where Swift is actually at her most Romantic: not struck by the lightning bolt of inspiration but haunted by worries about what her words are worth. She recalled feeling an intense pressure when writing *Speak Now*. If she wrote the album alone to challenge her critics, "it really had to be good." Saying the right thing at the right time, she wrote in the liner notes to the album, is so crucial that we often hesitate. What if our words aren't the right words? What if they aren't *good enough*? Are they going to be forever, or are they going to go down in flames?

It's a legitimate anxiety for Swift, since they *haven't* always been good enough. In *Miss Americana*, we see her visibly crestfallen as she discovers that *Reputation* has not been nominated for any Grammy Awards. She says, resolutely, that she just needs to make a better album next time. Is it any wonder her next album (*Lover*) gave us "The Archer," which opens with the image of thrown-out speeches? It's a song about words that aren't good enough, painful self-awareness of one's own inadequacies, and a desperate plea to hold onto "you"—which could be referring to a single person but could also mean the interest of Swift's general audience. Has she become nothing new? Do we still want her?

In 2023, indie rock band The National released the album *First Two Pages of Frankenstein*, featuring Swift's vocals on a track called "The Alcott." Aaron Dessner—member of the band and Swift's cocreator on several of her albums—reportedly sent the music to Swift and waited anxiously for her response, fearing she might turn it down. Within twenty minutes she had "written all her parts and recorded a voice memo with the lyrics she'd added . . . and everyone fell immediately in love with it. It felt meant to be."

It's another example of the Swiftian-Romantic creation myth, but also of something else that is particularly pronounced among Romantic writers: the anxiety that accompanies creativity. It's perhaps no coincidence that "The Alcott" features on an album named after Mary Shelley's famous novel, since *Frankenstein* is one of the greatest Romantic meditations on the creative process, with all its highs and its lows.

You may be familiar with the story of how Swiss scientist Victor Frankenstein creates his infamous monster, using human and animal body parts scavenged from graves at night and reanimating them with electricity. First adapted into (silent) film in 1911 by Thomas Edison, the story of Frankenstein has been pervasive in popular culture ever since, to the point that it has an almost mythical status even among those who haven't actually read the novel (a lot of popular culture representations confuse Franken- stein, the scientist, with his creation, who has no name). Perhaps less well-known is the origin story of the novel, which is almost as spooky as its contents.

In the spring of 1816, Mary Wollstonecraft Godwin and her soon-to-be husband Percy Shelley rented a villa in the mountains near Lake Geneva, not far from their friend, Lord Byron. 1816 would later be known as "the year without a summer," due to the eruption of an Indonesian volcano causing abnormal weather patterns worldwide. Godwin recalled in her journals that they were often stuck in the house for days due to rain. Some scholars have suggested that this wild, non-summery summer was key to the creation of *Frankenstein*, whose gloomy atmosphere could only have been dreamed up in such circumstances.

And dreamed up it was. One stormy night, sitting around a fire, the group decided to hold a story-writing contest, inspired by the German ghost stories with which they had been entertaining

themselves during the trip. Godwin fretted, feeling "that blank incapability of invention which is the greatest misery of authorship, when dull Nothing replies to our anxious invocations"—or, what we would now call writer's block. In fact, she would later write that she had often been frustrated by this mismatch between the originality of her "waking dreams," and the derivative and unoriginal writing that resulted when she eventually put those dreams down into words. It's perhaps similar to the kind of pressure that Swift felt when writing *Speak Now*.

One night, however, Godwin lay in bed, half asleep, and her imagination began to present her with vivid images. With "acute mental vision," she saw a scientist awakening a "hideous phantasm" with yellow, watery eyes. She saw the scientist running away in horror, hoping that the odious thing he had so imperfectly animated would revert to a corpse again.

Godwin awoke in fear, which quickly turned to delight: she had found her ghost story. Confident that "what terrified me will terrify others!" she wrote down the beginning lines of the pivotal scene in what is now *Frankenstein*: "it was on a dreary night of November . . ." On this dreary night, the scientist finally witnesses the fruit of his labors as he brings his creature to life. Labor is an interesting word for Shelley to use, since the entire aim of Frankenstein's experiment is to create life *without* labor: without a woman. In other words, it mirrors the kind of ex nihilo creation we associate with Romantic writers. It's the biological equivalent of that inspirational bolt from the blue.

Frankenstein is horrified by the creature. Although he selected only the most beautiful body parts for it, the effect of them put together is terrifying and unnatural. He flees. The creature lives in isolation, teaching himself language by reading, and observing human behavior. Desperate for companionship but rejected by

humans because of his appearance, the creature finds Franken-
stein and begs him to make him a companion; when Frankenstein
refuses, the creature kills the scientist's fiancée, Elizabeth. The two
then pursue each other across Europe and Russia to the Arctic,
where Frankenstein dies of exhaustion and hypothermia, and the
creature, miserable and purposeless, declares his intention to burn
himself alive.

Frankenstein is a novel about many things. It has been inter-
preted as a feminist political statement, a warning about genetic
modification, the first true work of science fiction, the ultimate
expression of teenage angst, a critique of slavery, a manifestation of
Shelley's postnatal depression, a Christian allegory, and a condem-
nation of the French Revolution. I have found myself comparing it
to the Sherlock Holmes stories, *Harry Potter,* and *Tom and Jerry* in
my lectures. What unites most, if not all, of these interpretations
is the spectacle of the artist, terrified by his own creation.

What if our creation turns out to be not what we expected?
What if all our labor cannot turn an inspirational dream into
reality, and the end result is disappointing? Or, worse, a nightmare
that haunts us into oblivion; one we can never shake off?

Victor Frankenstein and Taylor Swift both poured their
blood, sweat, and tears into their work—although Frankenstein's
probably involved rather more blood than Swift's (we hope).
Swift's most Frankensteinian song is perhaps "Down Bad," on
TTPD, which asks whether she was beamed up for someone to
do experiments on. It echoes "Fortnight" and its accompanying
video, which sees her receiving some kind of painful electroshock
therapy in an asylum. The theme continues in "Who's Afraid of
Little Old Me?," which also reads like a modern *Frankenstein*:
the creator creating a beast who gets out of hand, morphing
into something they can no longer control. On the surface, the

creator is fame and the monster is Swift: lured, caged, and trained by the callous world of celebrity to become something vicious, self-involved, and, well, scary. It's an idea repeated in "Clara Bow," which depicts the beauty that fame worships as a beast on all fours, roaring for more, and in "Cassandra," which refers to the speaker twisting her smiles into snarls. In "Dear Reader," the speaker paces in a pen, like a lonely, caged animal, wishing she could escape.

But this creator-creation analogy might also work in the opposite way. "Who's Afraid of Little Old Me?" might equally be interpreted as Swift expressing regret for the "monster" (on the hill) that *she herself* has created. After all, she refers to her "risks and experiments" in the prologue to *1989 (Taylor's Version)*. She is both horrified creator *and* "hideous progeny" (to use Shelley's own words about *Frankenstein*). She has *created* her anti-hero alter ego: world-famous brand, serial dater, record-smasher, and economy-booster. Swift as persona rather than person. Swift, too big to hang out, so she has to attend Christmas parties from outside like a deranged weirdo. Swift, whose fans famously pile onto anyone they believe has done her wrong. Swift, who has so expertly trained those fans to hunt Easter eggs that she is now unable to write a song without listeners performing a "paternity test" and obsessing over her romantic (and Romantic?) life. Swift, unable to live normally due to obsessive scrutiny from the press and her fans.

Songs like "peace," "Dancing with Our Hands Tied," "Delicate," "Dear Reader," and "The Prophecy" all suggest that Swift's fame and reputation render normal life—and relationships—impossible. In "Castles Crumbling," the speaker notes that people look at her like she's a monster, screaming that they hate her. Did the innocent young girl from Pennsylvania who just wanted to write and sing songs *create* that monster? Do her words in "Anti-Hero"

acknowledge her own culpability in giving metaphorical birth to a monstrous Taylor doppelgänger who is "the problem"?

Anxieties about creating art are a tale as old as time. How, though, to deal with them, in an age of media saturation and constant production, where the "anxiety of influence" is more pronounced than ever?

By doing what Swift would do—writing a song.

In 2002, American comedy rock duo Tenacious D (Jack Black and Kyle Gass) released a song called "Tribute." In the song, they describe how they meet a demon while hitchhiking. He orders them to play the best song in the world, or he will eat their souls. The duo play the first thing that comes into their heads, which luckily happens to be the best song in the world. They then inform the listener that the song they are hearing now is *not* that song—it's just a tribute to it, because they can't remember how the original song sounded.

If that isn't the twenty-first-century remix of Coleridge's "person from Porlock" story, I don't know what is.

Gass and Black say that the song arose out of discussion about the meaninglessness of calling any song "the best": a tongue-in-cheek takedown of doomed attempts to achieve creative perfection. It's a similar sentiment to "Clara Bow," which sees the star of the moment repeatedly replaced (Clara Bow, then Stevie Nicks, then Swift herself), acknowledging the transient nature of perfection and fickleness of fame.

I see in Coleridge's "Kubla Khan," and its origin story, something similar to Tenacious D's *Tribute*, and indeed Swift's "Clara Bow": a recognition of the slipperiness and impossibility of creative perfection, and the potentially damaging limitations of ambition and perfectionism. Scholars have pointed out that Coleridge's story of how "Kubla Khan" came to be is almost certainly exaggerated or embroidered, not least because *Purchas His Pilgrimage* was a book

over one thousand pages long, and heavy—unlikely to be something Coleridge would have carried with him to a lonely farmhouse to recover from a stomach bug. In her 1972 poem "Thoughts about the Person from Porlock," British poet Stevie Smith makes a good point—she asks why Coleridge hurried to let the man in; he could have just hidden and pretended not to be home. As a fellow creative, she speculates that "he was already stuck with Kubla Khan." Frustrated, perhaps paralyzed by writer's block, Coleridge welcomed an opportunity to blame his creative shortcomings on someone else.

Virginia Woolf wondered in 1918 how a man with Coleridge's gifts could, in fact, ever produce anything at all: "life is too short; ideas are too many." It's a common burden for creative types. Keats feared he would die before his pen had "glean'd my teeming brain"; in other words, before he could translate all his mental visions onto the page. Percy Shelley pointed out that when one starts writing, inspiration is already on the decline: unless one has a phone to record a voice memo, it slips through our fingers at an alarming rate. Smith speculates that many of us, especially overachieving perfectionists like Swift, actually long for a person from Porlock: a get-out clause to excuse creative work that we fear will never live up to our—or others'—expectations.

In both Coleridge's preface and Tenacious D's *Tribute*, the sentiment is the same: we *did* produce the best song/poem in the world, but unfortunately we can't remember it, so here you'll just get a fragment of that greatness.

Or, in Shelley's words: "the most glorious poetry that ever has been communicated to the world is probably a feeble shadow of the original conception of the poet."

Or, in Swift's: "the greatest films of all time were never made."

It's a convenient strategy, preempting the reader's judgment of any flaws: of *course* this isn't perfect—I never said it was! It's a good

way, too, of assuaging in advance your anxiety about how your composition might be received, since you've downplayed it from the beginning and lowered expectations. Perhaps if Frankenstein had presented his monster to an audience with the preamble, "This isn't the *best* heretical patchwork replica of a human being made from grave-robbed body parts and animated by electricity under the cover of darkness—it's just a tribute, OK?," things might have gone a whole lot better for both the scientist and his creation.

So when Swift wrote in "The Tortured Poets Department" that she isn't Patti Smith, her lover isn't Dylan Thomas, and this ain't the Chelsea Hotel, she follows in the footsteps of those great poets of the English language, Samuel Taylor Coleridge and Tenacious D, who themselves were trying to cope with the anxiety of following in the footsteps of everyone who came before, including—in Coleridge's case—their younger selves. The solution? To acknowledge your own failure before you even start; to call yourself a modern idiot. Swift has, for much of her career, been amusingly self-deprecating: she sings about indie records that are *much* cooler than hers ("We Are Never Getting Back Together"); mocks her past selves (the "Look What You Made Me Do" video); quotes critics who say that she can't sing ("Mean"); and then, of course, there's the infamous "Who's Taylor Swift anyway? Ew" line ("22"). It's an ingenious strategy, one that anticipates and shakes off criticism before it even arrives. And it's perhaps fitting that Swift's way of dealing with anxieties about what has come before is, in itself, "Nothing New"—just a tribute, perhaps, to those great tortured poets of the past.

Chapter Five

No One Knows What to Say: Death, Grief, and Elegy

So I must hold in the thoughts of my heart, though often wretched.

—Anon, "The Wanderer"

The second time I saw Taylor Swift perform "All Too Well (10 Minute Version)" was at the Eras Tour in Stockholm, May 2024. Like seemingly everyone around me, I'd sung along word for word, naturally relishing any opportunity to scream "fuck the patriarchy" at the top of my lungs (especially since I can't do it in class—a student once complained that he found my inclusion of a "smash the patriarchy" meme, in a lecture on feminism, offensive). As the song came to an end, I noticed someone who didn't seem to be having such a good time. There was a sudden vacancy in the crowd: the girl who'd been in front of me was no longer at head height but kneeling on the floor. Those around her leaped into action, summoning the nearest security guard for a paltry splash from his water bottle, and putting tentative hands on the girl's shoulders. I assumed that she, like several in the crowd, had become a bit lightheaded from the heat in the closed stadium and the fact that we'd been banned from bringing in water bottles. I was

surprised, then, when she finally stood again, and I caught a glimpse of her face. She was sobbing; seemingly floored not by a light head, but by a broken heart.

I'll never know that particular girl's story, but she certainly wouldn't be the first to have wept, uncontrollably, to "All Too Well." I can say that with certainty because I've done it myself. In the TV series *New Girl*, the newly heartbroken Jess at one point announces that she "just wants to listen to Taylor Swift alone." That moment became a meme precisely because it encapsulated something so many of us have done on our bluest days. Multiple Spotify playlists seem to exist for this exact purpose: "sad Taylor Swift songs to cry to"; "the ultimate Taylor Swift crying playlist." Swift herself even joined in with this trend in 2024, partnering with Apple Music to release curated playlists themed around what she termed the "five stages of heartbreak."

This chapter is about Taylor Swift and grief. While she's famed for her tear-jerking breakup anthems, that's only the beginning of it.

Death is never far away in Swift's music. Haunting appears in at least fourteen of her songs (including one titled "Haunted"). She has written several songs that deal explicitly with the passing, or feared passing, of a loved one: "epiphany," "Ronan," "marjorie," and "Soon You'll Get Better." These are *elegies*: poems that mourn the dead. Yet in "the lakes," Swift refers to how all of her elegies eulogize *her*, which reminds us that she writes frequently about her *own* death and dying—and not just in the tongue-in-cheek way we see in "Look What You Made Me Do."

"You're Losing Me," from her 2022 album *Midnights*, is seemingly an elegy for Swift herself, her heart stopped by a final blow from her beloved. It's such a fan favorite because it recognizes something that many of us have probably experienced. The end of a relationship—romantic or otherwise—can feel

like a bereavement and deserves to be mourned and treated as such. There is even scientific evidence to back this up—but who requests compassionate leave from work for a breakup? You're on your own there, kid.

This is what clinical psychologist Sherry Pagoto calls "disenfranchised grief": grief that is dismissed or invalidated by society at large. People might see your emotional response to a particular kind of loss as disproportionate or overreacting. Think of Swift's lines in "right where you left me": breakups happen every day—you don't have to *lose it*. Disenfranchised grief often leads to shame and loneliness because society—I'm referring largely to a Northern European and North American context here; other cultures deal with grief differently—forces us to question and hide it. I felt it in my early teens, when friends at school mocked me for being upset at the death of my pet fish, and again in my mid-thirties, when I felt the need to lie about how long I'd been "together" with the man who broke my heart, because the depths of my despair seemed completely mismatched with the short duration of our dalliance. I couldn't help but feel vindicated by Swift's lyrics in "Fortnight": your life *can* be ruined by someone you only encountered for two weeks.

As Pagoto puts it, "society seems to mandate the duration of your grief based on its assessment of the severity of your loss. Grief has rules." But Swift breaks those rules.

One of the ways in which she does this is through her creative use of *elegy*. Elegy is a poetic form originally from Ancient Greece (*elegos* means "song of mourning"), written in a form we call elegiac couplets (a hexameter followed by a pentameter). What originally made elegy was the form, not the topic: in its early days, elegy had no particular association with death but could also cover themes such as love and war. Over the centuries,

it came to be associated specifically with death, and the form became more fluid.

In 1751, British poet Thomas Gray published "Elegy Written in a Country Churchyard," often perceived as one of the first examples of Romantic poetry. With lines like "the paths of glory lead but to the grave," Gray's "Elegy" focused not on a particular death, but mused rather on mortality and memory in general. Its speaker wanders a churchyard, contemplating the hearts "once pregnant with celestial fire" that now lie beneath the earth. He considers the way in which "full many a flow'r is born to blush unseen, and waste its sweetness on the desert air": many of us will never reach our full potential, due to the cruelties of circumstance. It's a sentiment Swift explores in "Bigger Than the Whole Sky," a raw, wistful ballad about what could've been and should've been.

Several decades later, Samuel Taylor Coleridge wrote that, since poets inevitably "feel regret for the past or desire for the future, so sorrow and love become the principal themes of the elegy. Elegy presents every thing as lost and gone." In other words, humans gravitate naturally toward melancholic musing on what has passed. They ponder philosophical questions like those asked by the speaker in Percy Shelley's "Adonais," an elegy for the dead John Keats: "Whence are we, and why are we?" Are we, Shelley asked, actors in our own lives, or merely helpless spectators of the whims of fate?

One of the oldest surviving examples of poetry in the English language (technically, its precursor—Old English) contemplates these exact questions. It has many of the characteristics of an elegy. The only surviving version of "The Wanderer" dates back to the tenth century, although it may be much older, since poetry in the Middle Ages was frequently spread orally before being written down. The speaker of the poem is an exile, who mourns

his fallen comrades. Bonds between a lord and his men were vital in society during this period, and to find oneself an outcast would have been almost a fate worse than death. The "lone-dweller," as he calls himself, "longs for relief" from this pain. He reflects on the fleetingness of worldly pleasures: wealth, friends, family, humanity itself.

The poem features what we call the *ubi sunt* motif, whose name comes from the Latin for "where are . . .?" The speaker asks, "Where did the steed go? Where the young warrior? Where the treasure-giver? Where the seats of fellowship? Where the hall's festivity?" This might remind you of King Theoden's speech in Peter Jackson's film adaptation of J. R. R. Tolkien's *Lord of the Rings*: "Where now the horse and the rider? Where is the horn that was blowing?" (Or, at least, it might do if you're a fellow millennial—I'm increasingly horrified every year when I make *Lord of the Rings* references and realize my students weren't even born when that film was released). Tolkien was a scholar of Old English and drew heavily on medieval literature in his work. Just like Theoden, the Wanderer contrasts the better days of the past with the desolation that he now feels.

It's not a huge leap from "The Wanderer" to certain Swift songs that also have an elegiac mood. Like "coney island," whose speaker sits alone and wonders where their lover went, asking some *ubi sunt*-style questions. "The Wanderer" begins with the speaker contemplating the freezing ocean, then musing on the glory of moments past and the fleeting nature of time. "Coney island" sees the speaker getting colder and colder, recalling the lovers' heyday and contemplating fast times and transient memories. "Exile," too, echoes the elegiac mood of "The Wanderer," although this speaker's exile is metaphorical rather than literal. Still, both speakers muse on the inexorability of fate (being unable to turn things around) and use the symbolism of treasure (a crown, in Swift's case) to

represent the life of connection and comfort from which they have been outcast. Swift's "epiphany" seemingly searches for some sign from a higher power that might make sense of the loss and chaos the speaker has seen; the Wanderer, too, searches for this. He finds it in Christianity and the promise of heaven. "Epiphany" ends with no answers.

Elegy is tricky to pin down. There's definitely an elegiac quality to "The Wanderer," but it's not about a specific death or passing. Similarly, we find an elegiac quality in a lot of Swift's songs, even if they're not explicitly about death. The term "elegy" is sometimes used "as a catch-all to denominate texts of a somber or pessimistic tone," according to the *Oxford Handbook of the Elegy*. It falls under the category of what scholar Max Cavitch calls "the mourning arts." This would certainly encompass Swift tracks like the funereal "my tears ricochet," or that symbolism-laden hymn to disenfranchised grief, "Death by a Thousand Cuts."

Perhaps the shortest elegy in existence is that by poet W. S. Merwin (one of the longest is Alfred Tennyson's "In Memoriam," running to nearly 3,000 lines). Titled "Elegy," it consists of one simple line: "Who would I show it to." Merwin reminds us, poignantly, of the paradox of elegy: words intended for the object of the poem will never be heard by them. Angela Leighton describes it as "a form left empty, feeling the hollow shell of its literary objectlessness." This is captured by Swift's "marjorie," written for Marjorie Finlay, her grandmother who died when Swift was in her early teens. The speaker muses on the questions she *should* have asked and the things she *should* have said, before "every scrap" of Marjorie was taken from her. Similarly, in "Soon You'll Get Better," Swift faces the potential death of her mother from cancer, asking who she is supposed to talk to, if there's "no you" (fortunately, her mother did indeed get better, and *was* ultimately able to listen).

"Soon You'll Get Better" also points toward another, moral complication raised by elegy. Is it right to transform a loss into an aesthetic gain of any kind? Essayist Roland Barthes feared this exact outcome, following the death of his mother: "I don't want to talk about it, for fear of making literature out of it," he said. Swift seems to express something similar in "Soon You'll Get Better," apologizing for making it all "about her," and also told fans that it was a difficult decision to include the song on *Lover*, one on which she consulted her family (the same difficult question about aesthetic gain hangs over "The Great War," around which Swift doesn't seem to have been so circumspect. I'll discuss this in Chapter Eight).

If the story's over, Swift asks in "Death by a Thousand Cuts"—one of several songs that explore a breakup as a (slow and painful) death—then why is she still writing pages? Perhaps because death and words are two very difficult things to reconcile. The speaker tells us at the beginning of "Bigger Than the Whole Sky" that no words appear in the aftermath. The speaker of "epiphany" repeats that there are some things that you just cannot speak about. Death and loss can be paralyzing and dumbing. Poems about death therefore inevitably end up with a somewhat "meta" aspect to them: words about the difficulty, even the impossibility, of finding the right words. As poet and professor Stephanie Burt—who teaches a course on Taylor Swift and literature at Harvard University—puts it, one of elegy's oldest themes is "the inadequacy of human language before death."

British poet Tony Harrison's poem "Book Ends II" explores this exact topic. It opens with the image of the speaker and his father staring awkwardly into the fire, attempting to come to terms with Harrison's mother's sudden death. The father asks his son, who was the first in his working-class family to go to university, for

help writing the epitaph. "You're supposed to be the bright boy at description!" the father bursts out, exasperated. "It's not as if we're wanting a whole sonnet!" The speaker grapples with the small size of the headstone, and the difficulties of condensing decades of love and affection into a tiny space: "I've got to find the right words on my own." And yet the poem ends with a twist of sorts:

> I've got the envelope that he'd been scrawling,
> mis-spelt, mawkish, stylistically appalling
> but I can't squeeze more love into their stone.

Sometimes, Harrison seems to suggest, the words of another can feel more appropriate, more *right*, than our own. For millions of us, that other is Taylor Swift.

"Grief," Pagoto argues, "is a theme stitched throughout many of Taylor's albums and it is an emotion too often suffered in silence but [one that] craves a village to heal. Taylor has created that village." In October 2022, multiple news outlets worldwide ran headlines reporting that "Taylor Swift Song Is Helping People Process Miscarriage." Following the release of "Bigger Than the Whole Sky," on the deluxe version of *Midnights*, Swift fans worldwide had taken to social media to express the effect the song had on them. One revealed that she had suffered a miscarriage several months previously and was still devastated: "I haven't been able to put it into words but this song has done it for me." Another said that, while listening to the song, "all I could see in my mind is the baby I lost and thus put words to everything I've felt since the miscarriage." Regardless of what the song was actually about (see Chapter Six), fans thanked Swift for giving them the words to express their hitherto inexpressible pain.

The fact that Swift debuted "Bigger Than the Whole Sky" live at the Eras Tour in Rio de Janeiro, following the tragic death of fan Ana Clara Benevides Machado at the previous show, serves as an example of how we might use the flexibility of art to express grief when words seem to fail us. Swift had written on social media that she wouldn't be able to speak about Ana's death onstage, "because I feel overwhelmed by grief when I even try to talk about it." Yet music offered an outlet: Swift turned to words that she had written before but gave them a new context and a new meaning, just like when fans used the very same words to process their baby loss.

And those words do have a distinctly elegiac quality. "Bigger Than the Whole Sky" uses a lot of the poetic features that tend to crop up in elegy. There is sorrow—the song begins with a description of the speaker lying on her back, crying, with salt streaming into her ears; the alliteration of "s" connects concepts like "sick" and "sadness." There's a lot of repetition and anaphora, as if to emphasize the speaker circling back through the same thoughts in her grief. Similarly, there are repeated questions, as the speaker tries to understand the cruelty of fate: was it because she didn't pray? There is admiration of the dead, whose importance is indicated by the hyperbole, "bigger than the whole sky." There's a metatextual reflection on the impossibility of finding the right words. There's also the assertion that everything to come has turned to ashes, which implies that the future can never be whole after this loss. It's a common sentiment in elegy. One of the most famous elegiac poems, British poet W. H. Auden's "Stop all the clocks, cut off the telephone"—featured in the film *Four Weddings and a Funeral*—ends with the assertion that "nothing now can ever come to any good."

With her tendency toward universal specificity (see Chapter Three), Swift might have been *made* to write elegy. After all, elegy

is an oddly paradoxical form. It is specific, but it aspires to be universal, in the sense that it wants *everyone* to mourn along with it. It's written with a specific object in mind—a person who has passed—but it attempts to convince *all* of us of the utter tragedy of their death. It urges us, too, to inhabit the grief of the speaker.

The complexities of this are clear in Swift's song "Ronan." It's a heartfelt ballad mourning the death of a child Swift did not know, and aiming to evoke the grief of a woman Swift had never met. Swift was inspired by the blog of Maya Thompson, mother of three-year-old Ronan, who died in 2011 of neuroblastoma. She set Thompson's words to music, crediting her as a cowriter of the song, and released the song (with Thompson's consent) as a single, with all proceeds donated to cancer charities. Thompson described being "blown away by how she [Swift] got it. She got it in a way that most people don't. She took the time to take the intimate parts of things I'd written and put them into the song." The song, and its reception, are testaments to the success of both Thompson and Swift as writers of elegy. Thompson was able to distill her grief into language that reflected its nature, so much so that Swift could then echo those feelings back to her, and to others. Many fans report themselves unable to listen to "Ronan" more than once, finding it too painful; Thompson's grief spills out from the song, via Swift as a kind of proxy, to the listener.

In one moment in "Ronan," the speaker notes that no one knows what to say about the death of this beautiful boy who died. It gets to the heart of one of the main difficulties of writing about loss and grief: How to express the seemingly inexpressible? How to capture, in something *present*—words—what Cavitch refers to as "the trace of loss?"

Swift tends to do this through paradox. Think of her reference to silence being loud in "The Story of Us." She often expresses an

absence as something with its own presence and agency. The
metaphor of rust growing between telephones in "Maroon" is
genius because of the way it expresses a lack of communication
as something that is very much present: something that *grows,*
blooms, to the point where it becomes unbearable and untenable.
It's the same idea behind the idiom "the elephant in the room": the
continuing avoidance of something can cause it to become so big,
so *present*, that it is impossible to ignore. The same idea surfaces
in "So Long, London": the speaker carried the weight of a rift.
This is a linguistic paradox since a rift refers to a gap or cre-
vasse. Yet that contrast manages to capture the way in which a
growing silence or miscommunication can feel so burdensome
that it might almost cause one's spine to split, as the speaker
says later in the song.

British-Caribbean poet Derek Walcott's short poem "Missing
The Sea" uses a similar technique, to articulate what Barthes
referred to as the mourner going about their daily life while teth-
ered to "the presence of absence." It begins with the line, "Some-
thing removed roars in the ears of this house," using alliteration to
emphasize the paradox of absence being able to *roar*; of loss being
loud (just like in "The Story of Us"). This continues: there's "a deaf-
ening absence, a blow" that "freights cupboards with silence." The
paradox of loss being loud and heavy ("freights") runs through
the poem. Its title suggests either an elegy for the ocean itself, or
a metaphor that compares the loss of a loved one to the ringing
silence that follows when one leaves the ocean behind. The poem
seems to confirm Barthes's remark that "something *vacant* settles
in us" after a loss.

The speaker of "Soon You'll Get Better" says that she hates to
make it all about herself, but this, in some ways, is the entire *point*
of elegy. Since the object of the elegy will never hear it, for whom

does it exist, if not the author? Cavitch argues that elegy enables "fantasies about worlds we cannot reach"; worlds, for example, in which the object of the elegy is still alive, somewhere. They are self-serving fantasies, designed to comfort and console. The elegy is sometimes described as a poem of consolation, but this is disputed. Is an elegy still an elegy if it doesn't provide consolation?

More importantly, what *is* consolation? Some argue that consolation means "coming to terms with" death, while others argue that consolation lies in *not being consoled*: in continuing to mourn. Swift's "marjorie" certainly ends with a consolation of sorts: the realization that Marjorie is, and always will be, alive in Swift's head. Scottish poet W. S. Graham, in an elegy for his deceased friend, "Dear Bryan Wynter," is less certain: at one point he asks, "Are you there at all?" wondering whether he is simply "greedy" to create Bryan again from his memory.

Swift's "Death by a Thousand Cuts" ends on a note of uncertainty—"I don't know"—and the statement that it "wasn't enough." There is little consolation here. Similarly, "epiphany" ends still searching for something that might make sense of all the loss. "You're Losing Me" ends with the losing still going on. "Loml" concludes not just with a loss, but "the loss of my *life*" (which, of course, has a double meaning—the greatest loss, but also death). Surely these songs don't offer comfort or consolation.

Perhaps, though, the consolation lies in *not* being consoled. Perhaps it lies in finally being given space and permission to let out all of our grief, disenfranchised or otherwise.

Stories abound on fan forums of Swift helping them through grief, whether that be the loss of a pet or family member, or the disintegration of a relationship or friendship. These discussions often mention the same set of elegiac songs that are discussed in this chapter. Just after *TTPD* launched, writer Molly Saint-James

published an article for *Salon* titled "Taylor Swift, Grief Therapist?" She revealed how Swift's music had helped her and her daughters through the loss of her husband to cancer. Entertainment critic Coleman Spilde recalled how Swift's "marjorie" evoked memories of his own deceased grandmother, and found consolation in its message that we might reconnect with the past through dreams, learning "from people we've lost while keeping them close to us when we can't be with them anymore." One fan spoke about how certain Swift songs, including "Bigger Than the Whole Sky" and "epiphany," helped them to mourn their mother: "when I can feel a grief bubble getting ready to burst I put those on to help pop it so I can get the emotion out." Even "Ronan" has prompted fans to share their stories: either personal experiences of child loss, or—more commonly—fear of it. One fan, a mother, was "glad to know that I'm not alone in feeling sad (bawling) when I play this song."

It's not really surprising that we're turning to music for our mourning, because there's still so little science out there on the topic. In 2008, British psychoanalyst and author Darian Leader published *The New Black: Mourning, Melancholia and Depression*. In an interview, Leader recalled how he had searched for scientific work on the topic of mourning and found frustratingly little. Anna Harpin points out that moods only become relevant in the world of psychology when they are out of sync with dominant "norms." The diagnostic manual of the American Psychiatric Association, for example, suggests that feeling sad for two weeks is ordinary; beyond that, it's likely to be diagnosed as depression. When I mentioned this in class, it led to a discussion among my students—from China, Gambia, Pakistan, Turkey, and Belgium, among others—about the traditional or mandated period for mourning in their own cultures, which revealed substantial variation.

Grief, Harpin concludes, "has an ever-shrinking prescribed shelf life" in the Global North. It's becoming more and more disenfranchised. Where is the scientific literature on grief that doesn't fit into a neat diagnostic category? On a sustained period of mourning that *isn't* depression? Surely I can be sad about my dead fish for more than two weeks without it tipping over into something that needs a diagnosis? (It's been three and a half years. I'm still sad.) As grief therapist Gina Moffa points out, "Grief is messy. It's important to know that there's no timeline." Where is the scientific literature on the absolute, sprawling *messiness* of grief?

The answer, as Leader realized, is in art. "It occurred to me," he said, "that perhaps the scientific literature on mourning that I had been searching for was simply *all literature*."

Mila Volpe points out that art, in all its forms, has a much longer history as a source for healing and mourning than either psychology or medicine. Although it is often seen as just a marketable commodity, researchers have found that therapy using art, especially music, can be highly effective, costing less than pharmaceutical and medical procedures. It can help with everything from respiratory therapy to pain management and psychiatry.

Leader points out that "very often you need to engage with how other people show that they've responded to a loss, for your own mourning to get going." He used the example of Shakespeare's character Hamlet, whose own grieving for his father's death seems to be kick-started by Laertes's vocal grief for his sister Ophelia. Mourning, Leader argues, "isn't an individual enclosed process; we need to relate to other people's experiences of loss in order to do something with our own experience, to work it through." Art gives us the tools to do this.

It tracks, then, that fans have referred to Swift's music as "cathartic," since catharsis tends to have a therapeutic effect. Like

elegy itself, the concept of catharsis can be traced back to classical Greece. According to Swift's favorite philosopher, Aristotle, it's what happens when we contemplate true tragedy in art (in Aristotle's time, this would have been on the stage). It arouses pity and sadness in us, which, in a controlled setting, allows us to feel and thus release those emotions. We undergo a kind of purging or purification. The exact nature of catharsis is heavily debated, but we tend to use it in a modern sense to describe how art makes us experience intense feelings that we can then release in a safe environment. It perfectly describes Swift's *TTPD* set at the Eras Tour, which Pagoto sees as her "exorcising her demons into the mic." As Pagoto points out, Swift's writing "exposes disenfranchised grief in ways that make those who have experienced it feel seen. Listening airs out the sadness, and perhaps more importantly, the rage. . . . The permission to do so is transformative."

Jason Holland, a clinical psychologist, has pointed out that grief is still a largely taboo topic, and praised Swift's work in bringing more attention to it. In societies where grief and grieving are often shrouded in privacy and even shame, Swift's public musings on death might prompt us to start important conversations. Pagoto argues that some societies—certainly those in North America and Northern Europe—dismiss "certain emotional experiences so much that legions of people are starving for empathy and validation." Yes, "even bedazzled 13-year-old girls know grief," she points out. "Please never tell them they don't." The grief of adolescents, particularly girls, is arguably one of society's most mainstream and universal forms of disenfranchised grief. Writer Anna Bogutskaya observes "how easy it is for us to ignore real teenage pain unless it is shown in excruciating exaggerated form." Artist Audrey Wollen points out that "sad girls have been kept invisible for literally thousands of years," but

that we should pay close attention to "anything that mass culture wants to stay invisible."

This also applies to the disenfranchised grief of a breakup, and to other forms of grief that are still somewhat taboo, such as baby loss. There are ongoing moves to change this, including by women in the public eye. Model Chrissy Teigen shared photographs on Instagram following the loss of her unborn son in 2020. Meghan Markle spoke to the *New York Times* about her own baby loss, noting that, "despite the staggering commonality of this pain, the conversation remains taboo, riddled with (unwarranted) shame, and perpetuating a cycle of solitary mourning." It's no wonder many see songs like Swift's "Bigger Than the Whole Sky" as a kind of balm. Swift's fans, Pagoto suggests, decode her every lyric as a way of actually decoding "their own emotional experiences, ones the rest of the world has dismissed."

I thought a lot about elegy in August 2024, when I found myself at the center of a collective mourning. I had traveled, along with hundreds of thousands of other Swift fans, to Vienna for the Eras Tour, only to find the concerts canceled due to a planned terror attack. Heartbroken fans gathered en masse in the streets (particularly Singerstrasse and Corneliusgasse, i.e., Singer Street and Cornelia Street). They exchanged friendship bracelets and sang Swift songs at the top of their lungs. Some cried. Vienna was referred to as "the loss of my life." Messages of love and consolation were scrawled in the guestbooks of the many museums who had opened their doors for free to disappointed fans. Someone even lit a candle for the Eras Tour in one of the churches. Yet to me it was somehow more meaningful an experience than if those concerts had never been canceled because it was finally visible, tangible proof of something that I'd always felt, deep down, while listening to Swift's elegies: the transformative power of collective mourning.

Being in those crowds reminded me of how I'd felt listening to Swift perform "All Too Well (10 Minute Version)," surrounded by tens of thousands of fellow humans waving lighted bracelets, many with tears glittering on their faces. It was the momentary relief of no longer feeling disenfranchised. The weight of the rift being carried calmly on collective shoulders, and lessening slightly—for a little while, at least.

Chapter Six

Call It What You Want: Reputation, Interpretation, and Control

expos'd her Reputation to the unavoidable Censures
of the unpitying World
　　　　　—Eliza Haywood, *Love in Excess*

In 2016, Taylor Swift lost control. After criticizing Kanye West's reference to her as "that bitch" in his song "Famous," whose music video featured West in bed with a naked waxwork of Swift, Swift was called a "snake" by West's then-wife Kim Kardashian. Kardashian released a covert recording of Swift previously approving the song on the phone to West. The public were quick to denounce Swift's apparent duplicity. They flooded her social media with snake emojis and thanked Kim for exposing what they believed to be Swift's true nature. Swift defended herself with a note that claimed she was the victim of "character assassination," having been falsely painted as a liar when she was never given the full story (West hadn't specifically told her that he would use the word "bitch"). She ended her note, "I would very much like to be excluded from this narrative, one that I have never asked to be a part of, since 2009."

2009 refers to the moment West hijacked a stunned Swift's acceptance speech at the MTV VMA Awards, opining that

Beyoncé should have won the award—Best Video by a Female Artist—instead. It led to friction between West and Swift, which had supposedly healed with Swift's forgiving song "Innocent" on *Speak Now,* her playful joking with West at the 2015 MTV Awards, and West sending her an enormous bouquet of flowers, which Swift posted on Instagram with the hashtag "#BFFs." But even Swift's masterful eye for PR and social media skill could not save her this time. Having been seemingly at the height of her career success following her album *1989,* Swift was suddenly public enemy number one. #TaylorSwiftIsOverParty trended on Twitter (Swift would later ask a journalist whether "you know how many people have to hate you for that to be the number one hashtag?") She blacked out her social media and retreated from the public eye. She would later claim that nobody saw her for a year.

Although Swift had asked very politely, she was not excluded from the narrative. In fact, she was—spectacularly, publicly—no longer in control of any narratives at all. Even her request for exclusion became a meme.

This must have been particularly devastating for Swift, because up until that point she *had* been largely in control of her narrative. As she sang in "Castles Crumbling," crowds would hang on, and trust, her every word. Since the beginning of her career, she had meticulously planned meet-and-greets and secret acoustic sessions with her fans, curating the PR around her album releases firsthand (albeit with help from her parents and growing team). She described herself as "always in the pilot seat, trying to fly the plane that is my career in exactly the direction I want to take it." Conscious of a cutthroat music industry that constantly demanded novelty, Swift determinedly reinvented herself with every new album release. Aware of her growing reputation for going on "too many dates," in 2014 she focused on her female friendships,

aiming to give the press "nothing to write about." "I had a plan," she recalled in the prologue to *1989 (Taylor's Version)*, part of which may have been the hiring of her shrewd publicist, Tree Paine.

In a 2015 interview with *GQ* magazine, Swift said she felt "like I still have a sense of power over what people say about me." Barely a year later, however, the career that *GQ* noted had "unspooled with such precision" thus far was suddenly unraveling fast. *The Ringer* published a collaborative piece by its staff titled, "When did you first realize Taylor Swift was lying to you?"

The following year, Swift started posting black-and-white videos of CGI snakes on social media, before announcing her sixth studio album, *Reputation*. Its promotional campaign and iconography were heavily serpentine, as was its eventual stadium tour, which featured a gigantic inflatable snake called Karyn. The album cover showed Swift in black-and-white, surrounded by her name as newspaper headlines. A poem, titled "Why she disappeared," accompanied the record. It referred to an unnamed "she" who is broken but ultimately liberated by her fall from grace.

"In the death of her reputation," the poem concluded, "she felt truly alive."

There's a clear red thread running through *Reputation*. It's neatly summarized by the fourteenth track on the album, "Call It What You Want." Having spectacularly lost her grip on her curated self-image, Swift seemingly decided to let it go forever. In the song, the speaker describes her happiness in a new relationship. She no longer cares that the castle of her reputation has crumbled overnight and tells her audience to talk about her however they like. In another song from the album, "Delicate," she acknowledges that her reputation has never been worse, but she doesn't seem to care very much—she's more invested in wooing her new beloved. In "End Game," she declares that she has big enemies and a big reputation,

but is focused on pursuing eternal love, insisting slyly that she doesn't love the drama—it loves her. She ridicules the "he said, she said" in "This Is Why We Can't Have Nice Things," addressing her enemies condescendingly as if they are wayward children.

Most significantly, Swift used the video for *Reputation's* first single, "Look What You Made Me Do," to mock her past self—the one who asked to be excluded from the narrative—apparently ridiculing the Taylor who ever thought that was possible. In the video, she wears a dress that closely recalls the one she wore at the 2009 VMA Awards. This seems less like the move of someone who wants *out* of the narrative, and more the act of someone who wants to leap, bejeweled and screaming, into the middle of it. The album was a wild celebration of the freedom that comes with letting go.

Yet *Reputation* was reviewed by *Affinity* magazine as Swift regaining "complete control" over her narrative. *Guardian* journalist Jane Martinson titled her review, "Taking back control: Taylor Swift shows the media how it's done." Swift gave no traditional magazine interviews for the album but reverted to her old strategy: she used social media to promote it, engaging directly with fans. She appeared in both *Vogue* and *Time* magazines but insisted on using her own photographers and sending her answers in writing. She described the album as not "unapologetically commercial," but engaged in a number of high-profile commercial partnerships, with ESPN, Target, Ticketmaster, and AT&T. She opened the *Reputation* tour with soundbites from her critical media coverage. Yet, looking back at this period in a 2019 interview with the *Guardian*, Swift would say, drily, "you can't micromanage life, it turns out."

If all this seems contradictory, that's because it is. It encapsulates the strange yet very successful paradox that is Taylor Swift's narrative control. In giving us her blessing, via songs like "Call It What You Want," to interpret her work however we want, Swift actually

cements her reputation as the ultimate mastermind—one who, to quote "Better than Revenge," always gets the last word. *Reputation* was the calculated move of someone who cared deeply about letting you know that they don't care. By pretending *not* to want or need to control her own story, Swift in fact clutched it tightly in a vice-like grip. In mocking the Taylor who played the victim, she cunningly anticipated articles such as Buzzfeed's "How Taylor Swift Played the Victim for a Decade and Made Her Entire Career," which would appear shortly afterward. It's a similar strategy to the one discussed in Chapter Four: preemptively taking the sting out of critique by anticipating it.

Who, then, *really* gets to call it what they want? Who decides the narrative? Swift, or her audience?

It's a complicated question, and one that taps into a debate that has been going on in literature classrooms for decades.

One of the defining features of Swift's work, and arguably the main reason for its incredible success, is its heavily autobiographical nature. As early as 2008, Swift said in an interview with the *New York Times* that "when I knew something was going on in someone's personal life and they didn't address it in their music, I was always very confused by that." She felt she "owed it to people" to "let them in from Day One." A *Rolling Stone* review of *Fearless* in 2008 noted that for the album "to feel any more like it was literally ripped from a suburban girl's diary, it would have to come with drawings of rainbows and unicorns in the liner notes." In 2011, Swift noted that all her songs were "made very clear": that every single one was a "roadmap to what that relationship stood for. . . . Everyone will know." In 2014, Swift told NPR that, via her songs, "people have essentially gotten to read my diary for the last ten years." She later described her album *Speak Now* as "unfiltered diaristic confessions."

We might see Swift's work as *autofiction*. In the words of scholars Alexandra Effe and Alison Gibbons, this is when "the author aims to represent their self, or a dimension of their self, while also purposefully taking creative liberties in the act of self-narration." It's neither entirely fiction nor nonfiction, but a sort of back-and-forth between them, which certainly sounds like the way Swift has often described her lyrics. Discussing "Out of the Woods," she described a line of the song as both "the actual, literal narration of what happened in a particular relationship I was in," but also "a metaphor."

Writers of autofictional texts often comment on the increased creative freedom it gives them. Olivia Laing wrote of their novel *Crudo* that adopting "a made-up perspective from which to view a real moment" was liberating, allowing them to "zigzag between topics." It's similar to how Swift saw the composition of *folklore* and *evermore*: a form of escapism. Swift described those albums as "imaginary/not imaginary." We might argue the same of the rest of her work, which combines the *auto* and the *fiction* so intricately that it's nearly impossible to tell where one ends and the other begins.

As a case in point, consider the frenzy sparked by Swift's reference to a bar called The Black Dog in the song of the same name from *The Tortured Poets Department (TTPD)*. Following the album's release, Swifties overwhelmed the London pub The Black Dog on pilgrimages. The pub quickly cashed in by creating a line of merchandise and themed menu items. Yet it's entirely possible that the bar in the song is not a bar at all, but a metaphorical reference to depression (often idiomatically conceptualized in English as a black dog). Perhaps Swift watched her ex-lover walk into some other bar, but felt The Black Dog would be a fittingly poetic name that also captured his "bluest days" (to which she refers in another song on the album), not to mention beautifully ambiguous, since there are multiple bars called The Black Dog all over the world

(in Massachusetts, the Netherlands, Ireland, and New Zealand, to name a few). Where does fact end, and fiction begin? When is a bar not a bar?

Studies have shown that readers display higher emotional involvement with texts that seem rooted in reality. This might explain fans' hearty appetite for Swift's autofiction, as well as the seductive allure of the "based on a true story" tagline in literature and film more generally. Swift capitalized on this appeal of the autobiographical by including hidden clues in the liner notes for her first five albums. These spelled out significant short messages, which hinted at the intended recipient/object of the song in cryptic ("maple lattes") or not-so-cryptic ("God bless Andrea Swift") ways. This layered web of references has been referred to as the "Taylor Swift Cinematic Universe," which Emily Yahr points out is "not even really a joke. Since her debut country album in 2006, Swift has carefully and steadily built her own mythology, embedding puzzles and hints about the true meaning of her work in album notes and sprinkling clues about her life in social media posts." It has prompted behavior that fans call "clowning," where they read into every single detail of Swift's outfits, social media, visuals, lyrics—or the lack thereof (in the Taylor Swift Cinematic Universe, the absence of something can be as meaningful as its presence).

Swift acknowledges proudly that she has "trained" her fans in this way: she told a crowd at her Nashville show in 2023 that plotting, scheming, and planning are her "love language" with them. When Swift's official management team, Taylor Nation, jokingly complained on Instagram about fans assuming everything they post is an "Easter egg," the top-rated comment, with over 66,000 likes, was from a fan who pointed out—using Swift's own words from "Who's Afraid Of Little Old Me?"—that they are who they are because she trained them.

What she has trained them to do, since those early days of coded liner notes, is to assume that there is one single black-and-white meaning to each song, which Swift embedded into the lyrics when she wrote them. The writer, and her work, are a puzzle or riddle; interpret the clues correctly and access the hidden message or revelation. This was literally the case in 2023, when Swift partnered with perhaps the only online force more powerful than she—Google—to encourage fans to play word puzzles that would collaboratively reveal the titles of the five vault tracks on *1989 (Taylor's Version)*. Thirty-three million puzzles were completed in under twenty-four hours.

The lengths to which some fans take this detective work are admirable. I show my students a lengthy post on Reddit called "Who is 'So It Goes . . .' [from *Reputation*] REALLY about (Science)" which tackles the topic with the academic rigor one might reserve for a university assignment. There is even a spreadsheet. In fact, Swifties often point out that if they assigned the same level of dedication to their studies as they do to their clowning, they would graduate at the top of their classes. I've seen detailed graphs, mathematical formulas, and PowerPoint presentations, sometimes from my own students. I've seen literary analysis of a single metaphor that goes on for screens and screens. All of this is dedicated to pursuing some ultimate hidden meaning, usually identifying which of Swift's ex-lovers the song refers to.

Swift is certainly not the first poet to prompt these kinds of readings. People have puzzled for centuries over the identity of Shakespeare's muse for his sonnets, a man known only as "W. H" (there's also a "dark lady" who is similarly mysterious). Eighteenth-century Irish novelist Lady Morgan wrote a preface to her novel *The O'Briens and the O'Flahertys*, in which she stressed that she had "held private life sacred," but acknowledged that people would nevertheless scour her

work for references to real people, and "tremble lest 'Lady Morgan should put them into her book.'" These words anticipate Swift's own, centuries later: she has always emphasized her refusal to name names, and in 2014 criticized those who said "careful, bro, she'll write a song about you." Even if it would benefit her career, Lady Morgan said cuttingly, she wouldn't put into her book "the obscure insignificance and flippant pretension that bore and worry me in society." In other words: you're so unimportant that you wouldn't be worth the effort to put you in my book. It's the eighteenth-century equivalent of Swift's "I Forgot That You Existed."

Also writing in the eighteenth century, novelist Eliza Haywood was known for her "amatory fiction": stories of seduced women and illicit affairs, with risqué titles like *Love in Excess*. Her novels were particularly concerned with the fragility of the female reputation in a patriarchal society riddled with double standards. In *Epistles for the Ladies*, Haywood wrote words that could have come straight out of Swift's *Reputation*: she criticized "the inhuman pleasure some people take in exposing real faults, and broaching fictitious ones, to the ruin of the fairest reputation." Like Swift, Haywood blurred the factual and the fictional in a way that was very profitable. This led to rampant speculation about Haywood's own private life, fueled by the fact that some of her novels appeared with prefaces that insisted upon the veracity of the contents. Politician Lord Egmont claimed that Haywood had been "a whore in her youth, a bawd in her elder years, and a writer of lewd novels." Esteemed poet Alexander Pope famously mocked Haywood in his long poem, *The Dunciad*, implying that not only was she prolific in producing worthless fiction, but she was spawning illegitimate children at a similar rate. In one of her final novels, Haywood wrote a preface that anticipated almost exactly what Swift would say later in the prologue to *Reputation*: no one will ever know the true me.

If people are so invested in decoding Swift's lyrics to try and access a supposed kernel of truth, would the same approach work for encouraging students to be more dedicated to interpreting other literature? What if I taught one of Haywood's novels alongside some juicy tidbits from her private life, such as the fact that she once lived alone, a widow, in a large house in a very posh area of London, yet had multiple beds of all sizes and varieties? (As Thomas Keymer asked in an article for the *London Review of Books*, "what was Haywood doing with all those beds, or allowing others to do?") Would this then prompt students to work harder to analyze the novel?

In other words, should I teach students to practice what we might call the "extrinsic" method of analyzing literature? This assumes that literature is tightly connected to the lives of the authors who created it, and we cannot fully understand a text without understanding the sociopolitical context of the period in which it was composed. Reading Charles Dickens, for example, requires some understanding of the conditions of the Victorian working class. Reading Langston Hughes, of American race relations and the Harlem Renaissance. Knowing this background information takes us closer to understanding the work.

Many literary scholars over the decades have dismissed this approach, arguing that even the most ostensibly autobiographical literature is never *purely* autobiographical; there is always some element of fictionalization or embellishment involved in the act of writing. In literary study, we are careful to refer to what the *narrator* of a novel or the *speaker* of a poem is saying, rather than the author themself, because we recognize that every act of narration involves assuming some kind of persona. Swift referred to the speaker of "Blank Space" in the third person, as a "pretty complex character" who is "kind of exciting and interesting." Indeed, as

Swift herself wrote in the prologue to *Reputation*, "we think we know someone, but the truth is that we only know the version of them they have chosen to show us." A narrative doesn't offer us unmediated access to the actual author's mind or personality, no matter how autobiographical it may seem.

Yet Swift complicates these principles. Brittany Reid and Taylor McKee point out that it's easy to overlook the fact that Swift is playing a character in her work, and to assume that she "really is exactly who her songs say she is." Mary Fogarty and Gina Arnold refer to "Taylor Swift, the trilogy: singer, songwriter, and persona," but all too often we see them as one homogeneous entity. Even when Swift is performing multiple personas, at the core of them all is "a consistent claim to authenticity." This is because Swift, perhaps more than any other contemporary artist, has collapsed the traditional divide between poet and speaker with her autofictional tendencies.

Swift emphasizes the autobiographical nature of her work: she makes thinly veiled references to the West-Kardashian scandal in the *Reputation* prologue. But she also ridicules the idea that it's that simple: in the same prologue, she mocks the idea of scouring gossip blogs to find the man that her music is about. In a 2019 interview with *Rolling Stone*, she said that "that old version of me that shares unfailingly and unblinkingly with a world that is probably not fit to be shared with? I think that's gone." Yet several sentences later, Swift describes her new album, *Lover*, as "very very autobiographical" and with moments of "extreme personal confession."

This complication has been exacerbated by *folklore* and *evermore*. Swift explicitly declared that she was telling stories other than her own, yet also included songs like "marjorie," about her opera singer grandmother, which in turn is based on Marjorie's visits to Swift's dreams, complicating that imaginary/nonimaginary division even further.

This confusion has, perhaps understandably, resulted in an apparent desire among listeners not to call it what *we* want, but to call it what they think *Swift* wants: to perform what Swift calls a "paternity test" and unlock what is seen as an autobiographical truth at the heart of each song. As Fogarty and Arnold point out, "to *know* Taylor Swift is the prize of the pleasurable, unpaid labor of her fans, who believe they have sleuthed to find her authentic, oh-so *un*posed truth." It's also a wider problem that disproportionately affects women writers and writers of color, whose works tend to be more often interpreted as autobiographical: as Alex Clark points out in the *Guardian*, what follows this assumption is "a treasure hunt for the 'real' in their imagined worlds," and a diminution of the importance of their writing more generally.

And so, Dear Readers, we fall into a trap. It's a trap called "the intentional fallacy," a phrase coined by scholars W. K. Wimsatt and Monroe Beardsley, and one that has been enormously influential on the study of literature ever since.

Have you ever seen the meme on social media that reads "Dear English teachers: sometimes the curtains are just f***ing blue"? It mocks people like me for insisting that there is always a hidden meaning behind literary texts: that the curtains are blue to reflect the author's deep-seated sadness about his dead wife, for example. It's the same mocking impulse behind the Beatles' song "The Walrus," apparently written as a deliberately nonsensical song to poke fun at fans who scoured the band's lyrics for hidden meanings. It no doubt speaks to all those who were exasperated in literature classes at school, when forced to pore over ostensibly straightforward sentences for buried depths that your teachers insisted were there.

Wimsatt and Beardsley could have written that meme. They argued in their 1946 essay, "The Intentional Fallacy," that reading

with the aim of finding out what the author intended is fallacious: misguided, naïve, and, ultimately, doomed to failure. First, because—as we saw in Chapter Four—an author's intentions might not necessarily match up with the work they ultimately create. Second, because intention is itself nebulous and tricksy. Even if we asked an author exactly what they meant by a particular text, all we would get is *another* text: the answer might be just as mysterious as the original. For example, when asked by fans what the scarf meant in "All Too Well," Swift simply replied that it is a metaphor.

To quote scholars Andrew Bennett and Nicholas Royle, "just because it comes 'from the horse's mouth,' does not mean that the horse is telling the truth, or that the horse *knows* the truth," or indeed that what the horse has to say is any more enlightening than what anyone else has to say. Understanding literature, as Wimsatt and Beardsley point out, is "not settled by consulting the oracle."

And yet we try. Swift has said that people ask her "all the time" who her songs are about. Following the release of *1989*, Swift was interrogated by Liza Fromer for Global News on the subject of the song "Style." Fromer ignored Swift's evasive responses and continually asked questions in an attempt to get her to reveal that the song was about singer Harry Styles, even showing several photos of him on-screen. On an episode of the Ellen DeGeneres show, Swift was asked to participate in a "game": Ellen flashed photographs of celebrity men on the screen and asked Swift to ring a bell if she had written a song about them.

A thread on the /r/taylorswift Reddit community, "If you could get confirmation from Taylor on who any one song is about, which song would you pick," attracted thousands of comments. Similarly, threads such as "If you could ask Taylor ONE question, what would it be?" often resulted in responses along the lines of "I would ask who 'Maroon' is about."

It wasn't always this way. Our intense fascination with the author and their intentions is actually relatively recent. It's often seen as emerging with modern capitalism, which itself coincided with changes in copyright law. Figures like William Wordsworth fought for greater rights to protect authors and enable them to profit deservedly from their own work. For authors who saw their work as a form of offspring (Mary Shelley referred to *Frankenstein* as her "progeny"), it's only natural that they would want greater protection for it, and, perhaps, greater recognition of their role in its production.

This, of course, rings extremely true for Swift, who has campaigned for greater rights for artists in relation to their work. The author has thus been, over the past centuries, gradually endowed with more authority—it's no coincidence that those two words, author and authority, are etymologically linked. These developments happened much more quickly for men than for women, though; the latter frequently resorted to writing under male pseudonyms to gain the kind of authority and legitimacy allotted to their male counterparts, something that still happens today (Swift herself authored a number of pop hits under the pseudonym Nils Sjöberg).

The idea of "the author," then, is in some ways a fantasy that suits and feeds our consumerist appetite for celebrity, biographies, and interviews. It enables us to turn authors themselves into products, not just their books.

Literature in contemporary culture is, according to French theorist Roland Barthes, "tyrannically centered on the author." Barthes argued that we treat the author almost like an omnipotent god: Author with a capital A. We see literature as having a single secret meaning—the message of the "Author-god"—which we must work to unpack or decode. This is perhaps even more applicable to Taylor Swift

than other authors, since she is often referred to—both seriously and ironically—as a deity (an image only bolstered by the fact that, when she took her Eras Tour to Brazil, Rio de Janeiro projected a welcome message for her onto its iconic statue of Christ the Redeemer).

In theory, then, nothing could make us happier than hearing a definitive explanation from the Author-god regarding the definitive meaning of their text.

For over a decade, I have tested this theory by performing a small experiment with my students. Together, we read aloud the first verse of Lewis Carroll's poem "Jabberwocky":

> 'Twas brillig, and the slithy toves
> Did gyre and gimble in the wabe
> All mimsy were the borogoves
> And the mome raths outgrabe.

I then ask my students to discuss what they think each of the unusual words means and write up their ideas on the board (for example, students often see "gimble" as denoting a kind of playful, frolicking movement). We then turn to *Alice's Adventures Through the Looking Glass*, also by Carroll, where Alice meets Humpty Dumpty and asks him to explain this very difficult poem. He begins without hesitation, telling her that "brillig" means four o'clock in the afternoon, when you begin broiling things for dinner. Slithy is a portmanteau of "slimy" and "lithe." A tove is a creature a bit like a badger, a lizard, and a corkscrew, which makes its nests under sundials and lives on cheese.

The explanations continue in this vein. I then ask my students whether they're convinced by Humpty Dumpty's explanations, and the general consensus is that they're not. Eyebrows are raised; foreheads are furrowed.

Would it help if we could ask Carroll himself, perhaps? We turn to the prologue of Carroll's poem, "The Hunting of the Snark," where Carroll tells us that Humpty Dumpty's theory about "Jabberwocky" "seems to me the right explanation for all."

There's a lot to unpack here. Let's delve into the Lewis Carroll Cinematic Universe: we have Carroll the author, writing the persona of Carroll the narrator, telling us that the explanation of one of his fictional characters—Humpty Dumpty—to another of his fictional characters—Alice—about a poem that Carroll the author has written—"Jabberwocky"—*seems* correct. That "seems" implies he's not 100 percent sure—despite the fact that he wrote all of it. Far from bolstering the authority of Carroll the author, all of this muddles it completely. We might conclude, along with the Cheshire Cat, that everyone here is completely mad.

Now, Carroll is a notoriously slippery author to begin with (Lewis Carroll is not even his real name) and is best known for texts with more than a small component of nonsense. But if we turn to a more contemporary and less nonsensical example of an author opening up about the secrets behind their work, we still run into problems.

J. K. Rowling has been augmenting and embroidering the "Potterverse" for years since the publication of its final novel, *Harry Potter and the Deathly Hallows*. This is a phenomenon we term *retroactive continuity*, or "retconning": later adding, changing, supplementing, or contradicting information in the established world of a fictional work. Rowling "revealed" that Dumbledore was gay in 2007 and seemed unable to stop herself from expounding more of the Potterverse's details, particularly following its expansion in the *Fantastic Beasts* franchise and *Harry Potter and the Cursed Child*. This retconning has raised eyebrows and drawn outright anger from both fans and nonfans.

Rowling had supposedly been sitting for nearly twenty years on the knowledge that Voldemort's snake, Nagini, was a cursed woman based on the Naga, creatures from Indian mythology. She finally unveiled the "secret" after *Fantastic Beasts: The Crimes of Grindelwald* cast Korean actress Claudia Kim to play the character. This drew derision on Twitter: "Listen Joanne, we get it, you didn't include enough representation when you wrote the books. But suddenly making Nagini into a Korean woman is garbage." Achala Upendran saw Rowling abusing her position as creator to "rewrite cultural histories and rebrand different mythologies according to her own convenience," just as she had done in 2016 with her essay "The History of Magic in North America," which rewrote Navajo legends and the history of slavery.

Merriam-Webster points out that "a retcon allows an author to have his or her cake and eat it too." Rowling's actions are often interpreted cynically as an attempt to eat some very expensive cake: to make more money by retroactively augmenting the books so that they resonate with younger audiences more attuned to issues of diversity and representation (something that is jarringly at odds with Rowling's vocal transphobia).

In a rather different vein, in 2019 Rowling revealed an item of Potterverse trivia that absolutely no one wanted. Apparently, before they adopted Muggle plumbing methods in the eighteenth century, witches and wizards simply soiled themselves and vanished away the evidence.

As David Mitchell pointed out in an article on Rowling's retconning in the *Guardian*, "it's like with a magic trick: you're desperate to know how it's done but, when you find out, the mundane truth usually disappoints and undermines your enjoyment of the illusion." Particularly if the truth involves soiled underwear. "It was as if Leonardo da Vinci had painted a speech bubble on the Mona

Lisa in which she explained her state of mind," he argued. A more modern equivalent of this phenomenon is the villain "origin story," many manifestations of which have been criticized for ruining the mystique of enigmatic characters like Hannibal Lecter, Boba Fett, Darth Vader, the Joker, and Michael Myers.

Mitchell concluded that, when it comes to the supposedly hidden truths behind beloved fictional universes, "consumers are like children and chocolate, students and alcohol: they don't know what's good for them." Too much might actually make us feel sick.

We see something of this in the fan reaction to Swift's *TTPD*, whose lyrical clues might prompt us to read her previous work differently. Certain references suggest that songs such as "Maroon" and "the 1" from Swift's previous albums were in fact inspired by the same person or relationship as certain songs on *TTPD*. This is widely thought to be Swift's controversial old flame Matty Healy, whom the fan base had either dismissed or never even considered as a plausible muse. Some fans have expressed themselves "devastated" by the retconning that they see in *TTPD*. Perhaps we don't want to conduct those paternity tests after all.

In 1967, Barthes provocatively called for "The Death of the Author." To focus on the author of a text, he said, "is to impose a brake on it." It limits our possibilities for interpretation. I saw this play out in a review of my book, *Stars Around My Scars: The Annotated Poetry of Taylor Swift*, in which the reviewer criticized some of my readings of certain lyrics because they apparently went against certain things Swift herself has said in interviews. The Author-god had spoken; my insights were of no value.

This is one of the reasons that Oxford and Cambridge universities often ask applicants to their English literature degree programs to analyze a poem without any information about its author or date. The tutors don't want to hear regurgitated information learned in

school, or references to a poet's other works, but instead to test candidates' raw analytical skills. In other words, to practice what we call intrinsic or "new criticism": interpreting the text based purely on its language, without reference to its provenance.

Upendran, in her article on Rowling's retconning, declared: "Dear Roland Barthes: the author is no longer dead." Like her famous villain, Lord Voldemort, Rowling seems to have cheated death and lives on, tyrannically dictating how we interpret her books. Negative responses to Rowling, Swift, and Carroll, when they offer us an "explanation" of their work, show how authors, in refusing to die, can slam the brakes on our imagination and make us resent them for it.

And yet, something curious also seems to happen when authors assert their godlike authority. Their readers begin to blaspheme. Because, in slamming on the brakes, authors actually remind us of our ability to hop out of the (getaway) car and continue on a different path. They enable us to see what possibilities open up when we let go of the author and allow them to die.

As one Redditor wrote in response to a discussion of Rowling's retconning: "once a work is published, the author retains several protections (copyright, publishing, licensing, etc.) but one thing they never have a right to is the thoughts inside their audience's heads." Those dismayed by Rowling's revelations can choose to retreat back into their own private interpretations of *Harry Potter*, unmarred by unsanitary or offensive knowledge. They might write fan fiction: the world's largest repository, Fanfiction.net, contains nearly 850,000 works inspired by *Harry Potter*. This phenomenon *really* complicates ideas of authorship and authority: a reader becomes an author in order to articulate something they see in another author's original text, turning their interpretation of another's work into a kind of "Author-god" gospel of its own.

Some of these fan fictions even become published bestsellers—
E. L. James's *Fifty Shades of Grey* was originally written as *Twilight* fan fiction—which makes the authority hierarchy even more complicated.

Swift has spoken explicitly in interviews, and more elliptically in her songs, about wanting her listeners to interpret her music as they see fit: ideally in line with their own lives, not as a way to get closer to hers. She opened the Eras Tour with a similar statement. How noble that she has killed off her (authorial) self, so that we don't have to.

Swift talks about her own death a *lot*, and it's no coincidence that she does so most famously and visibly in *Reputation*. The accompanying poem referred to a woman coming alive with the death of her reputation, and Swift toys with death in the lyrics and video for "Look What You Made Me Do." Emerging as a zombie at the beginning of the video, she later tells us (in a veiled reference to that infamous recorded phone call) that the old Taylor can't come to the phone right now, because she's dead. It's significant that the album in which Swift "dies" also coincides with her vocally and publicly handing over the narrative to us.

In the Death of the Author('s reputation), the *reader* felt truly alive.

Philip Roth, in his novel *The Facts*, might have been talking about Swift when he wrote "you've written metamorphoses of yourself so many times, you no longer have any idea what *you* are or even were. By now what you are is a walking text." Swift is a living piece of literature we can interpret constantly in new ways—for ever more. Her tendency to "mash-up" two or more of her songs during the acoustic set at the Eras Tour might be read as a form of retconning. Like *TTPD*, it tends to throw into doubt everything fans thought they knew about Swift's discography. New, unexpected combinations of songs lead to new interpretations from fans, each part of the mash-up urging us to rethink the other. It emphasizes

the instability and fluidity of her writing, refuting the idea that there can ever be one single, correct intention or interpretation.

In "Dear Reader," the speaker says we wouldn't take her word for it if we knew who was talking and urges us to find another guiding light. It's a gentle nudge not to take her words as gospel, particularly when she burns all the files and deserts all her past lives with every new era's reinvention. In "The Manuscript," the closing track on *TTPD*, the speaker describes looking back on a love affair with the benefit of hindsight and wisdom, enabling her to see what all the agony had been for. The final words tell us that the story is not hers anymore.

In fact, it was never only hers. There's an interesting paradox in the fact that Swift, for the last few years, has been publicly taking back control over her narratives in the most literal ways: legally and financially, by rerecording her masters. Yet, at the same time as she engages in this revolutionary project, she reminds her audience at every step of the way that these narratives are *not* just hers. She seems to follow in the footsteps of Wimsatt and Beardsley, who declared that "the poem belongs to the public."

Swift's release of *Speak Now (Taylor's Version)* was accompanied by a post on Instagram that began "it's yours, it's mine, it's ours." Responding to a question from a reporter regarding whom "All Too Well" is about, Swift said that her songs were "mine, years ago when they were written. Now they're ours. Now they're shared." Similarly, in response to Fromer's persistent questioning about "Style" in 2014, Swift said, "I want these songs to go out into the world and become whatever my fans want them to be. I want them to picture *their* ex-boyfriend; not mine." The prologue to *1989 (Taylor's Version)* framed the album as "a reflection of the woods we've wandered through and all this love between us," telling the reader/listener that "it's been waiting for you." Swift's use of

the second person suggests that her rerecording is an act of regaining control so that she might then set that music free again.

This is emphasized by her recurring use of the symbol of the "vault." On her rerecorded albums, tracks that she had, previously, left behind for commercial reasons are listed as bonus tracks "from the vault," but she also uses the vault as a symbol to represent the music itself being liberated. In the video for "I Can See You," the *Speak Now*-era Swift is locked in a vault and must be broken out. Music critic William Hughes called it "barely a metaphor." Swift frees her music from the vault of Big Machine records (interestingly, *Reputation* was her last under their management, lending yet another level of meaning to its fixation with death and resurrection), but not in order to put it back inside a vault of her very own. Rather, she acknowledges that although she might have full *legal* ownership of her work, her control of its meaning is only ever partial. That belongs to us, and us alone.

In the eighteenth century, British writer Laurence Sterne, in his novel *The Life and Opinions of Tristram Shandy, Gentleman*, at one point introduces a character named Widow Wadman. Rather than describing her, the reader is given an empty page and told to "paint her to your own mind—as like your mistress as you can—as unlike your wife as your conscience will let you." Sterne shatters the illusion that the author is in control, while at the same time making us self-aware, as readers, of how much of ourselves we bring to every story we read. Authors give us a Blank Space, and we write whatever names seem most fitting. To quote one fan: "once the song hits my ears, I don't care who or what inspired Taylor to write the song, it's MINE NOW."

While many Redditors responded to the question "if you could have confirmation from Taylor about who any one song is about" by simply listing track titles, there was also a substantial response

along the lines of "I would ask for confirmation that the second verse of 'this is me trying' is, indeed, about me" or "I wanna know if 'Style' was written about me and the guy I kind of dated when I was 20." Another thread asked fans, "What song (or part of a song) are you convinced is written about you?" One Redditor summed up the mood of many fans succinctly: "idc [I don't care] who it's about. I will always personally project onto the songs."

Or, in the poetic words of author Salman Rushdie, forged "in the secret act of reading" (or listening) is a brand new identity, as reader and writer merge to become a collective being that creates a unique work, "their" novel—or song.

Scholar Norman Holland has argued that "interpretation is a function of identity": who we are determines how we will read (or listen). This ties into something literary critic Stanley Fish calls "interpretive communities": we read according to how we have been taught to read, within our particular culture and historical moment. We cannot help but bring something of ourselves to every text we read or hear. It's rather like the old saying about whether, if a tree falls in a forest with no one around to hear it, it makes a noise: Can a text have any meaning on its own, or does meaning only happen when a reader starts to interact with it? This is the central tenet of what we call "reader-response criticism."

All of us, Holland contends, "use the literary work to symbolize and finally to replicate ourselves." Swift's work is testimony to this, but she is far from the first to bring out this tendency in us. In the nineteenth century, author William Hazlitt talked about the uniqueness of Shakespeare's mind, because of its "power of communication with all other minds." Rushdie, writing about Italian author Italo Calvino, commented that "you're constantly assailed by the notion that he is writing down what you have always known, except that you've never thought of it before." Fans often say they

116

feel as if Swift has read their mind or looked into their soul with her lyrics. This is one of the factors that leads to the parasocial relationships for which Swifties are often derided: we feel as if she is one of our closest friends, because she so deeply *understands* us. Yet, as Bennett and Royle point out, this one-waywardness is all part and parcel of the fantasy that is reading.

The author is never the "actual" author, but instead our personal projection or idea of them. Both the author, and their work, contain something of our own selves every time we interact with them. Ultimately, as Bennett and Royle point out, "Our identifications with and ideas about authors are, in the final analysis, themselves forms of fiction. We may speculate, fantasize and tell ourselves stories about an author; but the author is a sort of phantom." Risen up from the dead to become a kind of blank space for our wildest dreams—Swift does it all the time

This Ain't a Fairy Tale:
Chivalry and the Dream of Romance

*On second thought, let's not go to Camelot. It is a
silly place.*
—*Monty Python and the Holy Grail*

"The Dark Truth about Taylor Swift," ran a clickbaity head-
line on UnHerd.com in August 2023. Expecting something
related to private jets or sweatshops making *folklore* cardigans, I
took the bait. In the article, Mary Harrington argued that Taylor
Swift's music appealed to young women because it focused on the
emotional intensity of doomed passion, rather than happily ever
after. So far, so true, I thought: it is indeed the worst trysts that
Swift writes best. Harrington then traced our "love affair with
doomed love" to the thirteenth-century massacre of the Cathar
Christian sect, whose ideas went underground and found oblique
expression in the work of French troubadours. Today's young
women, according to Harrington, crave something that is not
sexual or romantic, but spiritual, and they seek it in—among
other things—sexual breath play, disordered eating, and Taylor

Swift's genius ability to "give catchy tunes to that sweet, painful, multifaceted longing for something *other* or *higher* than what's in front of us."

It's a lot. To discover, on a Wednesday morning, drinking tea and scrolling through an article your colleague sent you, that you have actually been harboring a deep-seated yearning for total union with the divine beyond the torturous incarnation of your corporeal prison. And you just thought you liked Swift's sick beats.

While some of Harrington's argument may raise your eyebrows, she's certainly right about one thing. If, as medieval studies professor David Matthews points out, the ghosts of the Middle Ages are "unquiet," then we certainly find them loudly haunting the music of Taylor Swift.

Both Swift's "Love Story" and "White Horse," from her 2008 album *Fearless,* were apparently inspired by the same relationship, so it's unsurprising that they seem like companion or sister tracks. "Love Story" is a fantasized dream of eternal romance taken straight from the pages of a book; "White Horse" is the teary realization that fantasy was indeed all it was. Both use the same imagery: the damsel in distress, and the knight in shining armor who will (or will not, as it turns out) save her. "Love Story" famously invokes Shakespeare's *Romeo and Juliet* and, slightly less famously, Nathaniel Hawthorne's *The Scarlet Letter.* While the music video gives us a mishmash of Renaissance and Regency culture guaranteed to send historians into meltdown, the tropes of the song are actually drawn from several centuries prior: from medieval romance.

Medieval romance is difficult to define. Although "romance" originally referred simply to literature written in the romance language of French (which, following the Norman Conquest of England in 1066, was in theory the official language), it turned into something bigger around the twelfth century in Northern Europe.

Romance is less a genre, and more a set of recurring character types and events, ones we also find in fairy tales and folklore: quest and adventure; love; the search for one's identity; a hero or heroine who embodies certain ideals. All of this tends to happen in a magical or otherwise exotic location. Romance is often both wistful and nostalgic at the same time, longing for a past golden age where things were better. It's a larger-than-life blend of human and supernatural. As medieval studies scholar Derek Brewer points out, "the good people are better, their enemies more evil, the festivals grander, knights stronger, ladies more beautiful, than in everyday life." This might also be an accurate description of a lot of the stories told in Swift's discography.

When the speaker of "White Horse" points out that this isn't Hollywood but a small town, it's a nod to how ingrained the tropes of medieval romance have become in our films and television shows—even those that might seem very far removed from the Middle Ages.

This is *medievalism*: the use of settings, characters, and plots that have a vaguely medieval feel to them but aren't necessarily specifically linked to actual medieval history or literature. It's not history but a fantasy, a magpie-like approach that cherry-picks without being held back by historical accuracy. And it tends to pick elements of romance. Consider J. R. R. Tolkien's *The Hobbit* and *Lord of the Rings*, or George R. R. Martin's *Game of Thrones*. Neither of these are set in a Middle Ages that really existed, but we recognize certain elements as medieval: Bilbo's quest, Aragorn's heroism and self-discovery, and, well, are there any damsels in Westeros who *aren't* in distress? (Although it must be said that a lot of them manage that distress just fine without a knight in shining armor to help them out; indeed, the knights in shining armor are often the ones *causing* the distress—but more on that

shortly). Then there are the continued spin-offs and retellings of the King Arthur legend, from T. H. White's *The Once and Future King* through to the BBC's *Merlin*, to Guy Ritchie's *King Arthur*. Even the *Star Wars* and *Harry Potter* series have been interpreted as medieval-style quests. Then, of course, there's Disney, probably the most obvious medievalist influence on Taylor Swift's music and aesthetics. The Disney conglomerate has been wrapping medieval folklore, fairy tales, and romance up in gorgeous gowns and selling it to (mostly) girls for over a century.

We can trace some of our ongoing fascination with the medieval(ish) back to a nineteenth-century medieval revival in Britain and America, driven by the nostalgic sense that some aspects of medieval culture were worth retrieving. We see its legacy in neogothic buildings like the Houses of Parliament and St. Pancras station in London or St. Patrick's Cathedral in New York City. Museums across the globe are full of paintings of armed knights rescuing beauteous maidens with luscious locks, for which we can thank the Pre-Raphaelite brotherhood, who drew a lot of inspiration from the pages of medieval romance. Queen Victoria and Prince Albert once held a themed ball in which they cosplayed as medieval monarchs, and the late 1830s witnessed the Tournament of Eglinton, perhaps the first ever medieval reenactment event. It was in many ways a disaster, resembling a sort of early Glastonbury festival: sudden rainstorms swamped it in mud, and no one had put any crowd control systems in place for the 100,000 spectators. However, that didn't dim the nineteenth-century appetite for the medieval, nor prevent a thriving legacy of medieval reenactment that continues, worldwide, to this day.

Even if we don't dress up in chain mail on a weekend, the medieval is all around us, in our language as well as our popular culture. The way we use it, though, can be rather contradictory. Modern

conceptions of the term "medieval" often fall into two contrasting categories: the grotesque medieval, and the romanticized medieval. The former is what we mean when we refer to "medieval" forms of torture or justice, like when *Pulp Fiction*'s Marsellus Wallace declares that he's going to "get medieval on your ass" (this is not a good thing and involves pliers and a blowtorch). Medieval, here, is a condemnation. It refers to a barbarous "other," one that we like to think we've ascended from, having seen the light: like thumbscrews and the rack, it has no place in modern, civilized society (although, as historians will point out, many of the torture methods we think of as medieval were actually a product of the sixteenth century; needless to say, blowtorches are a product of neither). This idea of the barbaric medieval is a result of what was basically a PR campaign during the Enlightenment: scholars and thinkers retroactively invented a "Dark Ages," so that they could smugly show off how far they'd come.

On the flip side, we have the romanticized medieval. It's the medieval we see in Swift's "Love Story" and "Today Was a Fairytale": a world of glittering magic in the air, enchanting encounters, and beautiful ball gowns, in which valiant, passionate knights perform daring deeds for their ladies. It's the medieval we are most likely to associate with Swift, whose fans (at least early on in her career) often defined the identity of a Swiftie in terms of believing in love, Prince Charming, and fairy tales.

The problem here is that one cannot exist without the other. To rescue damsels in distress, those damsels have to *be* in distress. Behind every knight rescuing a lady is the specter of what that lady's fate would have been, had he not shown up in time: sexual violence and/or murder, either at the hands of men or monsters (think of St. George and the dragon). Perhaps for this reason, modern medievalism nearly always features both the grotesque and the romantic

medieval, just in variable ratios. Shows like *Vikings* and *Game of Thrones*, the latter notorious for its graphic violence and unsentimental sex scenes, tip rather more toward the grotesque side. They seem to confirm a popular view that the Middle Ages were characterized by excessive bloodshed, gruesome torture, and pervasive rape. On the other hand, sanitized Disney renditions of knights on horseback, and TV series like *Merlin*, sell us the romantic medieval by presenting love, loyalty, and friendship as the answer to all troubles.

The Swiftian medieval lies somewhere in between. It's never exactly grotesque or barbaric, but it isn't always perfect either. Sure, the damsel in distress is saved in "Today Was a Fairytale" and, while the Romeo of the "Love Story" video doesn't save the tower-trapped Taylor on a trusty steed, we do see them at one point with a white horse. But when that white horse resurfaces in the song of the same name, it's in rather different circumstances. Disillusionment and disappointment in a cheating lover are expressed through the realization that he's *not* a knight in shining armor, and he's not going to save her. Today may have been a fairy tale but tomorrow won't be: she was a "dreamer" and a "stupid girl" before he let her down.

They're carefully chosen words. Rescue-minded princes on white horses only exist in the childish Disney dreams that we're supposed to grow out of (it's significant that we are told they were both *young* at the beginning of "Love Story"). "Forever & Always," from the same album, begins "once upon a time," setting itself firmly within the world of fairy tale, but ends with a lover's broken promise. What if the "once upon a time" is actually bitter rather than romantic, referring to a time when the speaker was young and naïve enough to believe in these promises?

Taken together, the triad of "White Horse," "Love Story," and "Forever & Always" suggest something rotten in the state of romance.

This rottenness might be traced back to chivalry, the ideology at the heart of medieval romance and one that is far less simple than Disney's *Sleeping Beauty* or *The Sword in the Stone* (voted two of Disney's most "accurate" medieval films by curators at the Getty Museum) might have us believe. The word is derived from the French word for knight, *chevalier*, and refers to a set of values that medieval knights were expected to observe and uphold. These usually included devotion to God, loyalty to the knight's King or lord, and service to the weak, especially to women. Chivalry, in other words, is the romantic medieval that keeps the grotesque medieval in check.

When I teach this seminar in English Literature (Taylor's Version), I put "chivalry" on the board and do a quick word association game with the students. Alongside the usual suspects, such as courage, love, loyalty, fighting, castles, knights—all of which could have been drawn either from the pages of medieval romance, or Swift's *Speak Now*—I often get phrases like "holding open the door," "politeness," and "being kind." This seems to confirm what scholar Robert W. Jones argues: that chivalry is still present in modern culture, but *residually*. It's not dead—it just seems to have mutated into something different from its medieval origins.

This "something different" is often something rather tongue-in-cheek. One of my students wrote "Mojo Dojo Casa House" in response to my prompt: not just a reference to Ryan Gosling's Ken in the 2023 *Barbie* film, but specifically to the way in which Ken is the butt of the joke. *Barbie* gives us a parody of chivalry: it laughs at the idea that being an outstanding member of the patriarchy means surrounding yourself with as much horse as possible. Another student mentioned *Shrek*, which gives us the least likely knight in shining armor we can imagine. Mocking chivalry is not just a twenty-first-century phenomenon: there's a whole generation

whose first acquaintance with the King Arthur legend was not a bedtime story, but *Monty Python and the Holy Grail*. Prior to that, sixteenth-century Spanish writer Miguel de Cervantes penned *Don Quixote*, a parody of chivalric dreaming that would later be described by American author Mark Twain as sweeping "the world's admiration for the mediaeval chivalry-silliness out of existence." Quixote's brain "dries up" from too much reading of chivalric romance, to the extent that, at one point, he perceives a series of windmills as deadly giants whom it is his heroic duty to slay.

One of the reasons these parodies are so effective is that they hit upon an uncomfortable truth. Chivalry is—and has always been—just a performative fantasy that tries to hide a bunch of contradictory ideologies. Even in its heyday, it was the subject of interrogation and critique.

Geoffrey Chaucer's career as a civil servant in the fourteenth century took him across Europe and brought him into contact with a multitude of kings, knights, and noblemen. That experience primed him to write *The Canterbury Tales*, the (unfinished) poem for which he is best known and in which he himself stars as a character. It uses a "frame narrative": real-life Chaucer the writer, writing Chaucer the character, who then tells us about a group of pilgrims, who then talk about themselves and, finally, tell tales involving other characters. With so many layers, it's very difficult to know what to take at face value and what to read ironically, and this also applies to how chivalry is represented in the poem. This might explain the somewhat ridiculous caricature of Chaucer that appeared in the 2001 film *A Knight's Tale*, played by Paul Bettany.

That film takes its name, and some inspiration, from Chaucer's "The Knight's Tale," which has the privilege of being the first tale in the Canterbury series. If there *were* a clear-cut depiction of chivalry in Chaucer's poem, this is where we'd find it. We are

introduced to Chaucer's Knight as "a worthy man," who "loved chivalry, truth and honor, freedom and courtesy." The tale he tells focuses on the jealous rivalry between two knights and cousins, Palamon and Arcite, for the beautiful Emelye. They compete in a mass tournament for Emelye's hand. Arcite is thrown off his horse and mortally wounded. We are given a graphic description of how rotting matter slowly swelled his chest with venom, and how he couldn't vomit or excrete it out. On his deathbed, he calls Emelye the queen of his heart (body and soul?), blames her for ending his life, and urges her to marry Palamon. The tale ends happily ever after with Palamon and Emelye's wedding—or as happily as it can, given that it's ultimately about trigger-happy, testosterone-fueled bros beefing over a woman they've never actually met, who is treated, on the basis of looks alone, as a passive object to be passed around by the patriarchy. "Amen!" the Knight concludes.

Richard Neuse has described "The Knight's Tale" as "an essentially loveless love-story." Scholars have pointed out its decidedly unromantic language, bizarre digressions and frequent innuendo—there's a lot of punning on the word "queynte," which could mean clever or curious, but also a woman's genitals (it's where the modern c-word comes from). It's perhaps telling that in another of Chaucer's poems, "The Parliament of Fowls," he depicts three male eagles fighting jealously for the love of a single female eagle; the goddess Nature ultimately calls an end to their bickering by declaring that the female eagle should choose her own mate. It's perhaps a sly reminder that there is nothing natural about courtly love: even a bird gets more romantic agency than poor Emelye.

Monty Python's Terry Jones reads Chaucer's "The Knight's Tale" as a parody and sees it as evidence that the Knight is style over substance. Chaucer wrote him to embody everything that was wrong with fourteenth-century chivalry: namely, that knighthood could

be bought with money, and had become completely disconnected from any kind of ethical code.

"The Knight's Tale" is immediately followed by "The Miller's Tale." The Miller is so drunk that he can barely stay on his horse, and comes forward, burping, to tell his story. He makes some lewd innuendos, and Chaucer-the-narrator gives the reader a fourteenth-century trigger warning: "the Miller is a churl, you know this well" (a churl means a kind of vulgar commoner or villain). The Miller then tells a story of another love triangle—in fact, more of a love square—between a rich old carpenter, his beautiful young wife, Alison, his lodger, Nicholas, and a clerk at the local church, Absolon.

It certainly lives up to its churlish promise. Nicholas and Alison are sexually attracted to each other (there are some descriptions of Nicholas fondling her "queynte"). They hatch a plan to be alone and spend a wild night together. The next morning, they are interrupted by the lovestruck Absolon begging Alison for a kiss. Alison orders Absolon to close his eyes and sticks her naked bottom in his face. He starts to kiss it enthusiastically, then realizes something is amiss, because "he knew well that women don't have beards." Furious at being tricked—and struggling to wipe the taste away—Absolon returns with a hot poker. This time Nicholas sticks his bottom out instead and is duly impaled by the poker. I'll quote the Miller's final words using the magnificent translation of Peter Ackroyd:

> So there we are. That is how the young scholar got to fuck the young wife, despite all the carpenter's precautions. How Absolon kissed her arse. How Nicholas had a sore bum. God save us all!

Did you think medieval literature was boring?

It's no accident that "The Miller's Tale" follows "The Knight's Tale," and even repeats certain lines directly from it. The message seems to be that Palamon and Arcite are in fact no better than Absolon and Nicholas. The romantic language of chivalry could be used to disguise and legitimize the dubious actions of men (and sometimes women) driven by the most basic bodily urges. "The Miller's Tale," with all its crude, stripped-back (literally) simplicity, reminds us of that fundamental fact (indulge me in a little medieval pun here—fundament was another word for anus).

Chaucer's skepticism of chivalry has filtered down to our modern times. "White knight syndrome" describes people who compulsively seek out relationships with needy or vulnerable partners in order to "save" them, as an unconscious way of dealing with their own damaged self-image. As made clear in the title of a book by psychologists Mary C. Lamia and Marilyn J. Krueger, *The White Knight Syndrome: Rescuing Yourself from Your Need to Rescue Others*, being a modern white knight is, ironically, something to be saved *from*.

An even more negative evolution of the white knight exists in the "manosphere," the collective term for online men's support communities aimed at disillusioned, disenfranchised men and characterized by extreme misogyny: think incels and Andrew Tate. Within the manosphere, "white knight" is a derogatory term to describe men who go out of their way to protect women. It can also be used to describe benevolent sexism or, worse, men helping women only in the hope of gaining sexual favors in return.

Throw in Ken's Mojo Dojo Casa House, and we might just have witnessed the death throes of chivalry in the twenty-first century.

Swift certainly seems to criticize the wonky, sexist power dynamic of chivalry in "Call It What You Want," when she declares

that her lover doesn't need to save her. On the same album, she seems to weaponize chivalric sexism for her own gain, describing how she manipulates men by letting them *think* they saved her ("I Did Something Bad"). In "You're on Your Own, Kid," she recalls how naïve she was in her youth to think she'd be saved by a perfect kiss. The prologue to *The Tortured Poets Department* (*TTPD*) sees Swift offering up her coat of arms, sword, and talismans as evidence. These are artifacts associated with medieval romance, but usually with (male) knighthood. Could we see it as a feminist role reversal, with Swift taking up the position of questing knight rather than distressed damsel?

The cover image for *Fearless (Taylor's Version)*, released in 2021, shows Swift wearing a shirt remarkably similar to that worn by the "Romeo" figure in the original "Love Story" video. Fans have seen this as hinting at an important message: the mature Swift is perfectly capable of saving *herself*. Even as early as *Speak Now*—which is full of the tropes of medieval romance—Swift was merrily fighting dragons and building castles on her own. Two years later, she penned "Eyes Open" for *The Hunger Games* film soundtrack, which contrasts the world of childish dreaming with the cruel reality of adulthood. Written about the trilogy's badass protagonist, Katniss Everdeen, Swift's song emphasizes that no one is coming to save her, but that she might just save herself. Later, in "willow," the speaker compares her lover to a trophy or champion ring: she's a questing knight on a mission.

It might be tempting to argue that, as Swift has grown up, her lyrics have become more mature, more feminist, and she has let go of the sexist chivalric fantasy completely. It's a nice narrative, but it isn't quite true. In fact, there's a constant tension in her work: between dismissing the chivalric fantasy as the stuff of childish daydreams and desperately wanting to cling onto it as a source of

hope. As she said in an early interview with *Country Music Today*, "we're raised as little girls to think that we're a princess and that Prince Charming is going to sweep us off our feet. . . . Maybe that's not gonna happen with this guy because this guy's a jerk, but there's still that core of us that believes that it's true and that if you find the right person, you can have that." Or, to quote Swift's early Myspace page, "I'm the girl who still believes that Prince Charming exists somewhere out there."

If everyone thought Swift gave up that fantasy after "Love Story," then how do you explain the fact that we got its sequel in 2024? In "But Daddy I Love Him," the speaker again implores her lover to save her (with a car rather than a horse this time) and again craves her father's approval. It seems to reflect what Sophie Gilbert wrote for *The Atlantic* upon *TTPD*'s release: Swift seems, "on her new album, like a woman stuck in a fairy tale, who escapes one gilded cage for another, and then another, and then another." The song messes around with the listener (pretending that she's having his baby) and so seems to warn us not to take it too seriously. But the song's title conceals a different message. With its reference to Disney's childhood classic, *The Little Mermaid*, "But Daddy I Love Him" suggests something more earnest and longing.

Swift's work has always idealized childhood as a period of purity, innocence, and fantasy untroubled by the cruelty of adult pain—this is still the case in her later work, as we see in "Robin," also on *TTPD*. She ridicules chivalric fantasies as childish dreams that should be left behind but also argues that childhood *shouldn't* be left behind: "Never Grow Up." Like chivalry and romance, childishness in Swift's work is often both positive and negative: an exalted innocence and a regrettable naïveté. We get both in "But Daddy I Love Him," which seems to mock the dream of romance and yearn for it at the same time. Swift herself summarized her

attitude fairly well in an early interview on the Ellen DeGeneres show: she is "always sometimes" optimistic about love.

This ambiguity is not unique to Swift. In fact, it has always been built into the idea of chivalry, even in its heyday. Let's turn to English author Sir Thomas Malory's *Le Morte D'Arthur* ("The Death of Arthur"). It's probably the most comprehensive version of the King Arthur story in existence (it runs to nearly 1,000 pages) and the one most frequently used in modern adaptations: Disney's *The Sword in the Stone* is based on the book of the same name by British author T. H. White, which in turn is loosely based on Malory.

Chivalry is always political. It dreams of a society morally superior to that of the present. While Arthur may have been a real-life historical figure, he is now more myth than man, a kind of keystone around which authors could build their fantasies. This was true even as early as the fifteenth century, when Malory was writing; a time of civil war and political turmoil in England.

At one point, Malory's King Arthur asks his knights to swear an oath. It's the closest we get in medieval literature to an "official" description of what chivalry involves: never murder or commit treason, never be cruel, always give mercy to those who ask for it, always help women, and never fight in a wrongful battle. The reason that Arthur does this, however, is because his knights have been behaving very *un*chivalrously up until this point, doing things that wouldn't look out of place in Monty Python (or, probably, in Malory's real-life fifteenth-century England). King Pellinore, whom we have recently learned once took a woman's virginity "half by force" (let that sink in), is so eager on his quest for glory that he ignores a lady screaming for help while cradling a wounded knight in her arms. When he passes back that way later, they have both been eaten by wild beasts. Even worse, the lady in question turns out to have been his daughter. Sir Gawain,

angry at a knight for killing his greyhounds, raises his sword to strike him, but the knight's lady throws herself in front of him, and Gawain "accidentally" chops off her head. As his brother somewhat needlessly points out, "that is shamefully done!" In the very chapter after Arthur's knights swear the oath, Merlin—Arthur's right-hand wizard—sexually harasses a woman, Nineve (luckily, there is nothing she does better than revenge: she leads him on just enough to learn all his magic from him, and then promptly uses it to imprison him forever in a tree). Malory himself, for all his writing about chivalry, was hardly a shining example of it: although his identity is not 100 percent certain—it rarely is with medieval authors—the most likely "Thomas Malory" was a convicted traitor, thief, kidnapper, and rapist, and wrote *Le Morte D'Arthur* while in prison for one or more of the above.

In other words: it's too late, in the kingdom of Camelot, for any men on their white horses to come around—and, judging by how they behave, we probably wouldn't want them to anyway.

Not even if they are Sir Gawain, whom William Barron describes as "the archetypal folk-hero seeking self-knowledge through adventure." His story is the focus of the fifteenth-century narrative poem *Sir Gawain and the Green Knight*, by the anonymous author we today refer to as the "Gawain poet." It's set at the court of King Arthur and begins with a mysterious intruder interrupting the Christmas feast. He is "a mountain of a man" and also happens to be bright green. Telling Arthur that he's heard rumors of Camelot's glory, this medieval Hulk challenges him to a friendly game. He will bare his neck and allow one of Arthur's knights to strike him with his axe, on the condition that the striking knight track him down at his lodgings—the Green Chapel—in a year and a day and receive the same blow in return. If you're frowning and wondering, "where's the catch?" then welcome to medieval

literature. It nearly always involves what we call a "rash boon": a knight making a promise without knowing or thinking through the full consequences.

Gawain steps up. The Green Knight bares his neck; Gawain severs his head. And then the knight picks it up again and rides off, swinging his scalp jauntily from his fist. Come and find me in a year and a day, he reminds Gawain, "or be called a coward for ever." When his time is up, Gawain—who by now has a Big Reputation to uphold—ventures to the Green Chapel.

I won't spoil too much of the plot for you (get yourself a copy of Simon Armitage's excellent modern English translation, and enjoy), but Gawain ends up in a few moral dilemmas, including being seduced by his host's wife, who gives him a magical green girdle that will protect him from harm. He eventually tells a white lie to save his skin, finds out that this was all a test, and is rebuked by the Green Knight, who nicks his neck slightly with the axe as punishment. The Green Knight forgives him, since his dishonesty stemmed from self-preservation, and tells him he has proven himself a good knight.

Gawain doesn't see it this way. He departs full of shame back to Camelot, wearing the green girdle as a sign of his sin and frailty. He is received with enthusiasm by Arthur and his fellow knights, who comfort him and laugh at his tale, and they all start wearing green girdles in his honor. The point being made here—as with Chaucer's knight—is one of style over substance. No amount of green girdles gives you dignity. It's a point excellently dramatized in David Lowery's 2021 film adaptation, *The Green Knight*, starring Dev Patel as Gawain. Both the film and the poem are underpinned by a niggling anxiety that chivalry, the moral glue that holds medieval society together, might ultimately be meaningless.

To quote T. H. White, "What is all this chivalry, anyway? It simply means being rich enough to have a castle and a suit of

armor, and then, when you have them, you make the people do what you want."

The disillusioned epiphany in Taylor Swift's "White Horse" is more on the nose than she perhaps ever realized while penning the song. There has never been a white horse in literature that wasn't sullied with at least a few spots. Even if we trace chivalry back to what we might imagine are its purest origins—medieval romance—we find it riven with inconsistencies and contradictions. There's a certain "meta" aspect to chivalry, in that chivalry has always been the fantasized, but doomed, attempt to *make itself work*.

It's perhaps no surprise that French-Italian medieval writer Christine de Pisan felt prompted to write "The Book of the City of Ladies" (*Le Livre de la Cité des Dames*, in the original French). In it, she imagined building a walled city for virtuous women, since the noble men required by law to protect them "by negligence and apathy have allowed them to be mistreated." According to Pisan, chivalry was already dead as early as the fourteenth century.

Yet romance still has enticing potential, which is why we've never truly been able to let it go. Like the mythical Arthur who will apparently return to us in our time of need (one might question why he hasn't shown up yet, despite two world wars, the rise of global terrorism, and catastrophic climate change), chivalry glitters in the distance as a hope-giving fantasy. Barron argues, poetically, that "in every culture, in every age, romances are fugitive dreams entertained in the sleep of reason." Sometimes those dreams are interrupted with nightmares of human weakness, but we can daydream them back by imagining a better world. Swift's music, too, is always oscillating between the bitter pain of disillusionment and the relentless determination, fired by fantasy, to "Begin Again," in the hope of maybe *this time* achieving the dream.

I want to end with a look at "Miss Americana & the Heartbreak Prince," from 2019's *Lover*. In this song, the damsels are not in distress, but depressed. Why? The speaker cites the old adage, "boys will be boys," and asks where the wise men are. Not only does the song reference female frustration and fear in the face of everyday sexism and toxic masculinity, but it uses romance figures to do so. If we first met a Heartbreak Prince in "White Horse," we meet a different one now. Interpreted alternatively as a metaphor for America, the presidency, Donald Trump, Hillary Clinton, Kanye West, and even Swift herself, the Heartbreak Prince is enigmatic, but one thing is key: he is a symbol of depression and disillusionment rather than courage and hope. He is the legacy of a chivalry that was problematic from its very beginning. This prince, like his romance predecessors, is a fighter, but he's not fighting the good fight. Whose heart has he broken? It might be that belonging to "Miss Americana," which is difficult *not* to interpret as Swift, since it was also the title of the Netflix documentary in which she discussed her disillusionment with Republican America. It might also be *our* hearts he's broken, since he reminds us that the chivalry shaping our fantasies has always been a (heart)broken institution.

It's fitting that Swift uses a symbol from romance to express a disillusionment that seems to be both political and romantic, since chivalry has always been both political and romantic. It was a performative institution that lacked substance, authenticity, and integrity, which is also a fitting description of Trump's political campaigns and presidencies. While not ostensibly about knights in shining armor at all, "Miss Americana & the Heartbreak Prince" might actually be Swift's most medievalist song, since it captures all of the tensions in the original concept of chivalry. There's the disillusioned realization that no prince will save the distressed damsel, but there is also the hope and dream of a better future:

"someday we're gonna win." In fact, Swift suggests, better futures are only achievable once we abandon our romantic fantasies of rescue, place confidence in ourselves and our own abilities, and proactively start to shape our tomorrow. As she sings in "Only the Young"—which might be the sister track to "Miss Americana & the Heartbreak Prince," since it was written for *Miss Americana* the documentary—"we gotta do it ourselves."

Chapter Eight

False Gods and Crimson Clover: Love, War, and Worship

Here let me war; in these arms let me lie;
Here let me parley, batter, bleed, and die.
—John Donne, "Love's Warre"

Taylor Swift's music has caused me to feel many things over the years, but never awkward discomfort. At least, not until October 2022. As I stacked the dishwasher while listening to her latest album, *Midnights*, I tuned into the lyrics of bonus track "The Great War." It's about a relationship that, against the odds, survives a "great war" of miscommunication, paranoia, distrust, and past trauma, only to come out stronger. At the heart of the song is one long, extended metaphor: love is a war. Heartbreak is death. Emotional wounds are literal bruises. So far, so Swift. But when she sings, in the bridge, "we can plant a memory garden," and tells her lover to say a solemn prayer and place a poppy in her hair, I felt an uneasiness creeping in. It was an uneasiness that I had felt once before.

During my twenties, I taught an English literature summer school in the heart of London. One of the poems we covered was "Daddy," written by American poet Sylvia Plath in 1962, shortly

before her death by suicide. It is often interpreted autobiographically, as addressing Plath's complicated feelings for her deceased father. To express this troubled relationship, Plath presents herself as a Jew and her father as a Nazi. She describes her father as having an "Aryan eye," and calls him "Panzer-man," a reference to the tanks used by the Germans during the Second World War.

You may be wondering the same thing my students always did: Was Otto Plath a Nazi? The short answer is no. The longer answer is a little more complicated, especially since the 2012 discovery of FBI files on Otto Plath that noted his "morbid disposition" and pro-German sympathies (he was of German descent, emigrating to America aged fifteen). The general consensus, however, is that Plath's references to him as a "Fascist" and "devil" are metaphorical.

Otto Plath died of complications caused by advanced diabetes, having refused to seek timely medical help for his symptoms. It seems reasonable to conclude that his daughter might have harbored a certain amount of resentment toward him for dying an avoidable death and leaving her fatherless at eight years old (not ten, as she claims in the poem—and this is perhaps an indicator that we are not meant to take Plath's words at face value). Plath's use of the Nazi-Jew dynamic in "Daddy" seems to be a method of articulating her own personal issues with grief, abandonment, and—if you're that way inclined—an Electra complex.

My students and I would read this poem alongside Paul Celan's "Todesfugue" ("Death Fugue"), published in 1948 and written about Celan's personal experience, as a Romanian-born Jew, of a Nazi labor camp. By comparison, Plath's metaphorical use of the Nazi–Jew relationship to express a troubled longing for the father she never really knew seems deeply distasteful. Is it really acceptable to appropriate the suffering and murder of approximately six million people in order to articulate one's daddy issues?

I found myself asking a similar question in response to "The Great War." While the mentions of blood, bruises, and banners are generic enough (Swift uses the latter two in "Would've, Could've, Should've," also on *Midnights*), the line about placing a poppy in her hair resonated uncomfortably for me. With this unmistakable iconography, the song evokes one specific, very real war: the First World War (colloquially called the Great War). With its mention of bombs, it also seems to hint at the Second World War, and the reference to drawing curtains closed and drinking poison all alone recalls the suicide of Hitler's wife, Eva Braun. To compare a tempestuous relationship to the experience of millions of soldiers who died in hideous circumstances—or, indeed, to being the wife of Hitler—seems, to me, a tad inappropriate.

Yet, as I discussed with my students after reading "Daddy," perhaps that is the point. Maybe Plath's Nazi–Jew comparison is intentionally absurd: her way of saying that these are the depths to which neglect and abuse have driven her. Perhaps "Daddy" is a cry for help, made all the more poignant in hindsight by the knowledge that, several months later, its author would take her own life. The speaker of "Daddy" twice describes her tongue feeling stuck, first in her jaw and then in barbed wire. It is a poem that is more about struggling to find the right words than it is about Nazis and Jews.

Like the elegies I discussed in Chapter Five, "Daddy" explores how difficult it is to translate emotional pain into language. Plath tackles this by translating it first into physical pain. This isn't particularly surprising, when we consider that the original meaning of "trauma" (in Greek) was a physical wound where the skin was broken. Plath's poem takes us back to those roots, using literal trauma to express psychological and emotional trauma. "Daddy" features multiple examples of bodily pain and injury: a boot in the

face; the biting of a heart in two; torture implements; a vampire drinking the speaker's blood; a stake through a black heart; body parts stuck together with glue; and villagers stamping on a corpse.

Swift's references to bloodshed and bruises in "The Great War" are a reminder that, like Plath, she also tends to metabolize her pain into poetry (to paraphrase journalist Taffy Brodesser-Akner). And, like Plath, she often uses the physical as a dramatic shorthand for the emotional. As discussed in Chapter Three, Swift has a tendency to make us reconsider the linguistic clichés we use every day. "Broken heart" has become a dead metaphor, but Swift reincarnates it in songs like "Death by a Thousand Cuts," which suggests that grief is less a single break of the heart, and more a slow, torturous process of repeated wounding, all over the body. "You're Losing Me" and "So Long, London" point out that, often, heartbreak is not a break at all, but rather a steady dwindling until there's no pulse left.

Written by authors with no firsthand experience of war, "The Great War" and "Daddy" use the *idea* of war to express intense emotion. Yet, in doing so, they actually show us English literature coming full circle. They take us back to some of the earliest writing in the language: texts by authors who *did* have firsthand experience of war; so much so that it infiltrated all aspects of their work. War gave these authors a ready vocabulary to draw from when they wanted to explore the more hidden, less tangible dramas of the human condition.

Let's return to our old friend, Sir Thomas Malory. Scholar Scott Hess once remarked that the heads of Malory's characters "have no insides." He's referring to a perceived lack of psychological realism in *Le Morte D'Arthur*, which is often said to be the case with medieval romance more widely, since it focuses on plot and action rather than motivation or emotion. Knight A fights Knight B. Knight B rescues damsel and marries her. Knight B fights Knight C. Repeat.

Yet there is a reason Malory's story has endured, and it goes beyond the mechanics of the battlefield. Why would we be interested in reading nearly a thousand pages of endless fighting, if we weren't at least a little emotionally invested in those doing it? It's perhaps like reading erotica: there has to be *some* context, otherwise it's just biology. Besides being a tale of much fighting, *Le Morte D'Arthur* is also a love story, and it's precisely that close-knit relationship between love and war that makes it interesting. Lancelot is a skilled fighter, but your average person on the street is more likely to know him for his tragic adulterous affair with Queen Guinevere.

It's not that the characters of medieval literature have nothing inside their heads; rather, medieval authors tended to put the inside on the *outside*. Emotions in *Le Morte D'Arthur* are expressed somatically: via the body, rather than by speech or through an all-knowing narrator who can give us a direct line into those heads. In medieval literature, the body was the scroll or manuscript on which emotions were written—and there were emotions aplenty. A phrase that recurs in Malory's tale is "out of measure," a hyperbole used to describe extreme feeling. We see these extreme feelings expressed in metaphors of bodily wounds: Malory describes "lamentations as if they had been stung by spears"; Sir Tristram remarks that "it slays my heart" to hear of another knight's death.

In Christian philosopher Nemesis's book *De Natura Hominis* (*On The Nature of Man*), written around the fourth century and very influential on medieval medicine, sadness is described as "pain in the abdomen's mouth." It's not much of a leap from there to the modern idiom of a "gut feeling" (which exists in multiple languages in addition to English). Or, indeed, to Swift's speaker in "Peter" saying that she feels disappointment over an unfulfilled love in her *ribs*. Or the speaker of "tolerate it" referring to an unequal

relationship as a dagger lodged inside her. Or the description of a chaotic affair hitting like a gunshot to the heart in "Getaway Car." Sadness as a physical wound, often received in combat or violence, runs through Swift's work. We find references to metaphorical bleeding in sixteen of her songs, broken bones or cuts to the bone in five, scars in ten, and wounding in many more. Some of these metaphors could have come straight out of medieval literature, with their references to axes ("invisible string"), cannons ("State of Grace"), stone-throwing ("You Need to Calm Down"), and bladed weapons ("Cruel Summer," "Say Don't Go," "Bad Blood," "willow," "Daylight," "Mean," "hoax," "High Infidelity," and "long story short"). Some update the weaponry to give us a more modern take: Swift uses guns, bullets, and, occasionally, missiles as metaphors for harsh words or abuse ("Bad Blood," "Tell Me Why," "Getaway Car," "You Need to Calm Down," "Renegade").

Just as in Swift's lyrics, the connection between emotion and physical pain is particularly pronounced in Malory's *Le Morte D'Arthur* when it comes to romantic love. For example, when the wonderfully named knight Sir Garnysh (whom I like to imagine was notorious for his tendency to leave a sprig of parsley atop the bodies of those he killed) stumbles across his lover sleeping with another knight, we are told that he is so full of "pure sorrow" that he develops a violent nosebleed. His inner pain is written outwardly on his body for all to see. When Sir Palomides chances across a battle-wounded knight, screaming in more pain than he has ever heard before, he "comforts" the knight with a staggeringly insensitive display of one-upmanship: Palomides has just been rejected by the beautiful Isolde, and he reassures the bleeding knight that his own pain is "a hundredfold" worse. I'm sure the knight whose leg was hanging off was grateful for this dose of perspective.

But Palomides's declaration isn't actually as ludicrous as it sounds to us today. At the time of Malory's writing, love *was* often conceptualized as a form of battle.

C. S. Lewis—better known for his *Narnia* books—might have been thinking of Malory's Palomides when he wrote an essay on medieval literature, "The Allegory of Love," in 1936. In it, he noticed that medieval men always seem to be weeping on their knees in front of "ladies of inflexible cruelty." This is a tradition to which we now refer as "courtly love," or *amour courtois*. It originated as a social custom at the French court of Eleanor of Aquitaine in the eleventh century and was popularized by the troubadours: singers of poetry who might, as discussed in the previous chapter, have used it as a veiled analogy for heretical beliefs. Generally speaking, courtly love involves a man—usually a knight—pledging his devoted service to a lady, whom he places on a metaphorical pedestal, idolizing her as he might a goddess or a queen. A key feature of courtly love is that the lady is unattainable, usually because she is already married. The thrill of unrequitedness is the entire point: as Swift sort of says in "The Smallest Man Who Ever Lived," it's only sexy when it's forbidden.

Like the emotions in Malory's *Le Morte D'Arthur*, courtly love is expressed dramatically with the body. The blushes, racing hearts, butterfly-riddled stomachs, and swooning you might associate with a "glitter gel pen" Swift song are commonplace in courtly love, and—in contrast to more modern gender stereotypes—it's usually the man most affected. Since he can't have the lady in question, he spends a lot of time crying and swooning, declaring that he will sicken and maybe even die for love of her. In fact, some medieval medical writers did conceptualize being in love as a form of illness. When Swift's speaker tells her estranged lover in "You're Losing Me" that her face is gray and that she's dying, we may think she's

being overdramatic, but doctors of the Middle Ages might well have nodded their heads understandingly.

It's no surprise, then, that love was often portrayed as a high-stakes game in medieval literature. Not a game in the fun sense, though—more a game in the sense of having certain rules and conventions, and in which power dynamics were constantly shifting. A chess game whose rules change every day, if you will. Swift could have been referring to courtly love in "State of Grace," where she describes falling in love until it hurts or bleeds, and a lover piercing the room like a cannonball. Love, according to the lyrics, is a "worthwhile fight"; a ruthless game unless played good and right. The implications of the song are ultimately quite tragic: most of us *fail* to play this game "good and right," and are left brokenhearted. However, our bravery and wildness are to be commended, for failing at the game of love involves its own exquisite pain, which we learn to live with and even crave (some of us *only* want love if it's torture, as Swift recognizes in "Blank Space").

"State of Grace" is full of battle imagery, including a reference to the speaker's lover as her Achilles heel. It's a modern take on courtly love, but at the same time it also recalls one of English literature's oldest courtly love tales. This is Geoffrey Chaucer's fourteenth-century *Troilus and Criseyde*, a love story set against the backdrop of the Trojan War (which, of course, also featured Achilles and his renowned heel). It's based on Italian author Boccaccio's *Il Filostrato*, although Chaucer makes it his own, as he so often did. In this poetic masterpiece, which runs to over eight thousand lines, the ruthless game of love and the tension of battle become so intertwined that they are almost inseparable. Love doesn't just take place *in* a war in Chaucer's tale; love *is* a war.

Handsome knight Troilus is the son of King Priam of Troy (and brother to the more famous Hector). He has a tendency to mock

other knights for falling in love. Cupid, God of Love, is more than a little miffed at Troilus's arrogance, and decides to get revenge by making him fall head over heels for a beautiful young widow, Criseyde. We are told that Cupid hits Troilus squarely with his arrow, and it is this image that sets the scene for the rest of the poem, where the pain of love is expressed as physical pain. Like the speaker of Swift's "Slut!," Troilus is love struck, and it goes straight to his head—and "pierced to the bottom of his heart."

Troilus's love is initially unrequited since Criseyde knows nothing about it. He suffers in silence and in secret, experiencing all sorts of strange physical symptoms. He "loses color sixty times a day." He nearly drowns in his own tears. He beats his chest. He is alternately boiling hot and freezing cold. He is close to sinking into madness. His heart gets cramps. He claims he is dying. At one point he faints so completely that Criseyde and her uncle Pandarus have to perform CPR on him (unlike in Swift's "You're Losing Me" and "So Long, London," though, CPR *does* work, and Troilus is soon back to lusting after Criseyde with renewed vigor).

It's significant that Troilus first sees Criseyde in a temple. He says to himself that he doesn't know whether she's a goddess or a woman, but perhaps to be on the safe side, he starts to worship her as if she were the former. For this, Troilus is described as the "best pillar of Cupid's whole religion." The boundaries between actual religion, and love as a kind of religion, become very blurred in *Troilus and Criseyde*. This was commonplace in courtly love more generally. In fact, the word "worship" was often used in medieval literature to discuss knights' good conduct in secular and romantic matters as well as religious ones. Troilus's devotion to Criseyde is framed as a religious act: he declares that God has created him to serve her, and he describes himself as a willing martyr. Criseyde soon begins to worship Troilus, too. We are told

that to look at him was "heaven," and at one point she describes him as "Cupid's son."

Swift's speaker says in "State of Grace" that her lover was never a saint. Yet, in spite of this, the song acknowledges the same thing that Chaucer pointed out, centuries ago: we tend to literally idolize those we love. The speaker of "All Too Well (10 Minute Version)" highlights her (unreciprocated) devotion to her lover by saying that she kept him like an oath, and their love was a sacred prayer. "Holy Ground," from the same album, gives consecrated status to certain places linked to the beginning of a relationship. In "Cornelia Street," those "sacred" beginnings become the speaker's religion. In "Dancing with Our Hands Tied," the lovers' bed is a "sacred oasis." "Tolerate it" sees the speaker make her lover into a temple. In "The Great War," as we've seen, the couple commemorates their love with a solemn prayer.

Troilus and Criseyde is ultimately a tragedy (in fact, Chaucer was one of the first writers to use the term "tragedy" in English). Criseyde is handed over to the Greeks in exchange for a Trojan prisoner, and, although she initially plans to make her way back to Troilus, she fears scandal and the eventual collapse of Troy (prophesied by her father Calchas). She ultimately transfers her affections to a Greek soldier, Diomede. Chaucer warns us that both Troilus and Criseyde were ultimately foolish to place their faith in each other rather than the one true (Christian) God. His narrator ends the poem with earnest advice to the reader, urging us to shun earthly temptations and love only Jesus.

Taylor Swift clearly didn't get this memo, though. Or perhaps she did but chose to ignore it. After all, "False God," from *Lover*, is all about knowing that romance is a false god but choosing to worship it anyway. The lovers are led by blind faith; she describes his touch as heaven and their arguments as hell. None of this would

sound out of place in *Troilus and Criseyde*. With the metaphor of religion as his lips and the altar as her hips, Swift makes explicit a theme that runs through so much of her music, and all the way back to Chaucer: romantic love is a false god we choose to worship, knowing all too well that it might lead us to a bitter end. From magic and heaven to madness and sin.

Sin, of course, is the subject of "Guilty as Sin?" on *The Tortured Poets Department (TTPD)*. It could be the sequel to "False God": a more in-depth exploration of the alluring idol that is romantic love (or, perhaps more accurately, lust). The speaker knows that indulging her adulterous desires might destroy her life, but she also speculates that the object of those desires is "actually what's holy," and chooses him "religiously." In "loml," from the same album, she refers to her lover as the Holy Ghost. He seemed to offer her heaven but then took her to hell instead—it was, in fact, a "breakable heaven," to use another Swift lyric ("Cruel Summer"). All of this culminates in the sad state of affairs we get, several songs later, in "The Black Dog." The speaker needs to hire a priest to exorcise her demons: the god she worshipped has indeed turned out to be false and needs to be purged. Perhaps she should've seen the warning signs when he looked up, grinning like a devil.

I saw a few outraged posts on social media in the wake of *TTPD*'s release. Parents decried it as blasphemous and criticized Swift as a poor role model for their offspring. Her allusions to masturbation, description of infidelity as holy, and comparison of herself to Jesus in "Guilty as Sin?" were apparently too much for these listeners to handle. The mockery of the "Sarahs and Hannahs in their Sunday best," clutching their pearls and crying "God help her" when they discover the identity of Swift's roguish lover, perhaps cut a little too close to the bone for some listeners. Yet, read in the context of Swift's wider work, there's actually very

little that's controversial here. The whole *point* is that the speaker knows, deep down, that this love is a false god; that she will never manage to fix it up with a high-grade halo. The religious language in *TTPD* is there as a form of self-critique and self-ridicule: how naïve I was, it seems to say, to ever fall for these impressionist paintings of heaven.

Having fallen, the speaker tells us in "loml" that the ink starts to bleed. From dying for his sins, to dying inside ("The Smallest Man Who Ever Lived"). If love is worship in Swift's writing, it often turns to war and wounds—from trying to be your lover's bravest soldier, to being ignored on the front lines, to being dealt a devastating final blow. Again, this parallels the courtly love of *Troilus and Criseyde*. Criseyde is compared to Troilus's foes on the battlefield: Pandarus tells her that it's up to her whether Troilus lives or dies. A common trope in courtly love was the idea that the lady could kill simply by giving the knight an unfavorable glance. At one point Troilus is "shot through and pierced" by Criseyde's gaze. This is perhaps why Pandarus describes Criseyde as a tyrant, holding Troilus's life in her hands. We find the same in Swift's "You're Losing Me," where the speaker is sick, fading, and dying; only her lover has the power to bring her back to life by *doing* something.

Despite all this, Troilus refers to Criseyde as a "sweet enemy." The phrase encapsulates the fundamental contradictions of courtly love. Like the desired object of "Guilty as Sin?," love is a paradox: painful but pleasurable, hurtful yet addictive. In fact, in much of Swift's oeuvre, love isn't *really* love, unless it's painful. To paraphrase "Afterglow," love must be worth the fight. The entire premise of Swift's early song "The Way I Loved You" is that the speaker isn't "feeling anything at all" with her perfect, pleasant, parent-pleasing new man. Love isn't love unless she's screaming,

fighting, and cursing his name at 2 A.M. As a Swiftie friend of mine pointed out, "easy love seems to be suspicious to her." Our muses, as Swift noted in the prologue to *TTPD*, are those who give us bruises. Troilus refers to it as "sweet harm."

Chaucer's narrator addresses the reader at one point and asks us not to judge Troilus for his strangeness, since habits and customs change with time, and what was normal in the past might now seem ridiculous to us. What's remarkable, though, is that it doesn't seem that ridiculous at all. Eight hundred years later, we find these ideas still going strong in Swift's work, where love is often exquisite agony. Or—to quote "ivy," which also depicts love as a war—"magnificently cursed." It's why we've been losing our minds and fighting wars for millennia, as the speaker acknowledges in "You Are in Love." Some might want it comfortable; Swift's speakers want that *pain* ("Midnight Rain"). In fact, men and women for time immemorial have wanted this pain, too—and we continue to do so, if the sheer size of Swift's devoted fan base is anything to go by.

Swift would have fit right into the courts of Renaissance England, where poets flexed their creativity in search of new ways of describing the paradoxical pleasures and pains of love. In the sixteenth century, English politician and poet Thomas Wyatt introduced the sonnet to England, inspired by his travels around Europe. The sonnet originated in Italy (*sonnetto* translates as "little song") and referred to a fourteen-line poem with a fixed rhyme scheme. Nowadays we tend to associate it with love poetry. This is partly thanks to Shakespeare and his popular collection of sonnets, but Wyatt laid the groundwork. He, in turn, was inspired by the work of fourteenth-century Italian poet Francesco Petrarca (Petrarch). Petrarch penned a series of love sonnets idealizing his beloved, a married woman called Laura who did not return his affections. The paradoxes of courtly love run through Petrarch's

poetry: at one point his speaker says that he "feeds on pain" (perhaps he also gets "drunk on jealousy"?) and laughs and cries at the same time.

Wyatt brought Petrarch's sonnets back to England and made them his own, changing their rhyme schemes to create what would later become known as the English sonnet, and offering his own twist on Petrarch's ideas. His poem "I find no peace," based on Petrarch's "Rime 134," reads like it could have been written by Troilus. It begins with the line "I find no peace, and all my war is done." The war here is a romantic one, but its "wounds" are physical. Like Troilus, Wyatt's speaker seems to have a kind of love fever: he burns and then freezes like ice; one minute he hopes, the next he fears. Whether he lives or dies hangs in the balance, subject to his lady's goodwill.

The final line emphasizes the main paradox of courtly love: "my delight is causer of this strife." Unrequited love is a curiously delicious and addictive kind of pain; the highs it offers, as Swift almost says in "Blank Space," are often worth it. Swift captures this perfectly in the core image of "ivy": the speaker's pain fitting in the palm of her lover's freezing hand. Although the love in "ivy" seems to be requited (though adulterous), it mirrors the courtly love dynamic of handing one's happiness over, completely, to another, and subjecting oneself to their whims in a way that is magnificent precisely because it is treacherous; treacherous because it is magnificent. Nothing safe, as Swift reminds us in "Treacherous," is worth the drive.

As Wyatt's speaker points out in another poem, love is a matter of "extremity." Just like Plath and Swift, Wyatt used the metaphor of war to try and articulate these extremes. In one of Wyatt's Petrarch-inspired poems, "The long love that in my thought doth harbour," the speaker depicts love as a soldier camping out inside

his own body. First the love-soldier is in his heart, then in his face, "spreading his banner": in other words, he makes the speaker blush. Wyatt personifies love as a cunning, devilish rogue, who doesn't want to be "reined by reason" or held back by decorum.

It's the same idea we find in Swift's "Guilty as Sin?": love (or rather, lust) refuses to listen to reason, and the speaker seemingly surrenders her body and her mind completely to it. In the process, she abandons all thoughts of propriety. Wyatt's speaker depicts the love-soldier as his master, and says he has no choice but to live and die with him, faithfully, on the field of battle. Swift's speaker, too, seems to accept the inevitability of dying at love's command: the song is full of references to death (drowning, being eaten by wolves or smashed by rocks, fatal fantasies, graves), but these are framed almost as a noble sacrifice. Oh, she says—*what* a way to die.

And so we return to the idea of love as religion. We surrender ourselves completely, inexorably, to a god that we know is false. What may I do, Wyatt's speaker asked, but live and die for my master, Love? He seems to anticipate the speaker of Swift's "august," centuries later, who lives simply for the hope of it all. Or "Treacherous," whose speaker apparently can't decide if getting swept away is a choice. Yet the rest of that song makes it very clear that it's not: love is a slope that gravity inevitably sends us down; it's quicksand from which we cannot extricate ourselves. We cannot escape its treachery and, more importantly, we don't want to. It's treacherous, Swift sings, "but I like it."

The God's honest truth, we hear in "Would've, Could've, Should've," is that the pain of love is heaven. In Swift's discography, romance is often difficult to distinguish from self-destruction. Mary Harrington argues that Swift's music is just the latest manifestation of an eight-hundred-year-old belief that dates back to the Cathar Christians: true ecstasy comes from seeking something

higher, even if the price we must pay for it is death. The speaker's assertion in Swift's "So High School"—that she's betting her lover is going to marry, kiss, *and* kill her—might be more than just a playful declaration. After all, in ". . . Ready for it?," the speaker begins with the confession that she knew her lover was a killer the first time that she saw him, but she pursues him anyway: he can make her his phantom. Love, in the Taylor Swift universe, is a kind of exquisite death. It's one that also, certainly in "Guilty as Sin?," at least, includes a double meaning: orgasm is sometimes referred to colloquially as *la petite mort*, or "little death."

If there's something disturbingly masochistic about all of this, Swift certainly isn't the first writer to explore it. In fact, the interconnections in her lyrics between love, sex, death, and pain, accentuated by clever wordplay, remind me of sixteenth-century English poet John Donne. Growing up in turbulent political times, Donne struggled with his religious identity for his whole life, having converted to the English (Protestant) church to avoid persecution as a born Roman Catholic. During this time, he wrote a number of witty, often satirical poems, several of which revolve around a speaker persuading a woman to have sex with him. Perhaps the most famous of these is "The Flea," in which the speaker tries to convince his reluctant lover that they may as well have premarital sex, because a flea has already bitten them both and their bloods have mingled inside the flea, so the sex has basically happened already (sixteenth-century physicians saw sex as the mingling of blood rather than other bodily fluids). It's a good example of what we call a *poetic conceit*: a central, extended metaphor that often compares two very unlikely things to each other in a way that, against all odds, ends up making a kind of strange logical sense. Swift is fond of using these, too.

Donne eventually became a clergyman, and his later poems show a man anxious about his own faith and his mortality. Yet

they also retain some of the elements of his love poetry. His "Holy Sonnets," a collection of nineteen sonnets, bring love, lust, passion, religion, and death together in ways that wouldn't be out of place in a Swift song. In number fourteen of these sonnets, the speaker calls on God (in his "three-personed" form, i.e., the Holy Trinity) to assault him. I'm going to quote it in full, both because it's one of my all-time favorite poems, and because it's worth taking a deep dive into the language:

> Batter my heart, three-personed God; for you
> As yet but knock, breathe, shine, and seek to mend;
> That I may rise and stand, overthrew me, and bend
> Your force to break, blow, burn, and make me new.
> I, like an usurped town, to another due,
> Labour to admit you, but O, to no end;
> Reason, your viceroy in me, me should defend,
> But is captive, and proves weak or untrue.
> Yet dearly I love you, and would be loved fain,
> but am betrothed unto your enemy.
> Divorce me, untie or break that knot again;
> Take me to you, imprison me, for I,
> Except you enthrall me, never shall be free,
> Nor ever chaste, except you ravish me.

The speaker asks God to beat him—note the alliterated plosive sounds in the fourth line, which mirror the harsh blows the speaker is craving. There's a masochism running through the sonnet that seems to be both religious and sexual. Only by being punished by God for his sins can the speaker be clean (to use a Swiftian metaphor) again. But this is expressed more in terms of an erotic desire. At the end of the poem the speaker says he can only be

chaste if God "ravishes," or rapes, him. It's a paradox: it frames his desired, consensual union with the divine as a nonconsensual sex act. The metaphor of humanity being married to God, but committing adultery with idols, dates back to the Bible itself. Donne, however, makes it much more complicated, more explicitly sexual, and more pain-oriented. The speaker is a courtly lover, and God is the beloved who "imprisons" him, emotionally. It's pleasurably, painfully, paradoxical: he's only free when trapped ("enthralled"). There's also an interesting reversal of the traditional courtly love dynamic: it's actually the *speaker* who is married (to sin) and thus unattainable, but he longs to be divorced so that he can embrace God instead. Donne's speaker is Guilty as Sin. Given the sexualized language of this poem, it's not that much of a stretch to imagine him asking God to write "mine" on his upper thigh.

Donne wrestled, in his poetry, with the meaning and implications of his desires. Chaucer's Criseyde did, too. Toward the end of *Troilus and Criseyde*, she weeps, fearing that her reputation has been ruined through her disloyalty to Troilus, and that no one will ever sing or write anything good about her ever again. She was only partially correct. Several decades after Chaucer's tale, Scottish poet Robert Henryson wrote a 616-line poem, *The Testament of Cresseid* (Criseyde), which picks up where Chaucer left off. Criseyde is soon abandoned by Diomede after he has fulfilled his appetite for her and moved on to another woman. Devastated, Criseyde berates "false Cupid" for forsaking her. The gods are not very happy with this and enact revenge. They curse her with leprosy, making her hideously ugly and blind. She is forced to beg in the streets and join a leper colony. One day, Troilus rides past. Looking into her blind eyes, he is reminded of his former lover, and, deeply moved, gives the leper a purse of gold. When told that it was Troilus who gave her the gold, Criseyde makes a distraught speech about the

fickleness of fate, her own infidelity, and the pains of love, after which she soon dies.

Henryson framed his tale of the leprous Criseyde as a warning to women not to be false in love. Chaucer's Criseyde worries that women, especially, will think terribly of her for abandoning Troilus; they will say she has brought dishonor on all womenkind. Fast forward to the twenty-first century, however, and it seems that Criseyde needn't have worried too much about what women might think of her lack of loyalty. We now have Taylor Swift, who sings openly about illicit affairs, bad thoughts, infidelity, and faithless loves, joined by her millions of fans. Swift, who frames love as a Great War, the goddamn fight of our lives, whose battles will frequently leave us broken and bruised—and we'll learn not only to live with the pain, but even to crave it. Perhaps Swift's discography is the ultimate exoneration of poor Criseyde. Both she and Troilus found out, to their great cost, that love is a ruthless game unless played good and right. Yet Swift points out that, actually, very few of us play love's game good and right. Most of us lose, at least once, but there's maybe something strangely noble about surviving that particular Great War.

Chapter Nine

They'll Tell You I'm Insane: The Madwoman

It is a false and foolish fancy. Can you not trust me as
a physician when I tell you so?
 —Charlotte Perkins Gilman,
 "The Yellow Wallpaper"

It's October 2023. I receive an email from a colleague with the subject line, "There's nothing like a mad woman," complimenting my new Taylor Swift course. Several days later, I come across an Instagram quiz: "Which unhinged Taylor Swift lyric are you, according to your birth month?" Perusing Etsy, the Internet marketplace, looking for a birthday gift for my Swiftiest friend, I'm overwhelmed by the number of T-shirts, baseball caps, and tote bags, in seemingly infinite pastel colorways, proudly proclaiming the wearer to be a mad woman—or, more specifically, the maddest woman their town has ever seen.

It's a strange time to be alive. Taylor Swift advertises her latest "vault tracks"—from *1989 (Taylor's Version)*—as "so insane," and we respond with millions of likes. Madness has become the ultimate compliment, from one feminist to another. Bryony Gordon's book *Mad Woman*—on "surviving a world that thinks you're the

problem"—becomes a bestseller. It's cooler to be unhinged than on Hinge. And, naturally, capitalism has stepped in to help us make all of this as visible as possible. How did we get here?

Let's think of a mad woman we might have read about in our school days. Miss Havisham, a cultural icon, thanks to her unforgettable introduction in Charles Dickens's *Great Expectations*. She sits, bitter and withered, in her yellowing bridal gown, with one shoe on, surrounded by a moldering wedding feast. In her youth, she was defrauded of her riches by her fiancé, who jilted her on the morning of the wedding. Both the clock on the wall and her wistful yearnings remain frozen at that moment in time (twenty to nine). She has pledged to revenge herself upon men by training her pretty young ward, Estella, to break their hearts—a trap into which poor Pip, Dickens's narrator, falls.

Since the nineteenth century, Miss Havisham has haunted our imagination, helped by multiple film and TV adaptations that paint her as a figure of Gothic horror: a "tortured, ghostly, eternal bride-to-be," as the BBC dubbed her in 2011. She embodies what scholar Elaine Showalter has described as "an ancient association of madness, confinement, and women," one we also find in myth and fairy tale. Yet Tuppence Middleton's compassionate portrayal of the young, cruelly used Miss Havisham in the 2015 BBC series *Dickensian* hailed an important shift, encouraging our sympathy rather than our horror.

Taylor Swift, it seems, is picking up where *Dickensian* left off.

In the prologue to *Red (Taylor's Version)*, Swift wrote that "the world is a different place for the heartbroken. It moves on a different axis, at a different speed." In a 2019 piece for *Elle* magazine, she used very Miss Havisham-coded language to describe writing songs as a way of preserving memories, like fixing "the time on the clock when your heart was stolen or shattered." Fans on Reddit

were quick to detect the "Miss Havisham vibes" of her 2020 *evermore* bonus track "right where you left me." Its speaker describes herself still sitting, years later, at the restaurant where her lover broke up with her, her hair caked in dust. Said lover is still out there somewhere, probably married and celebrating Christmas with kids, but the speaker's fate is to linger on, unknowing, frozen in time. The only thing missing is the decaying wedding cake. The vibes continue in Swift's "Who's Afraid of Little Old Me?," from her 2024 album *The Tortured Poets Department (TTPD)*, in which the speaker refers to her house being full of cobwebs while she's drunk on her own tears.

Another mad woman that might spring to mind is Bertha Mason, Mr. Rochester's crazed, violent secret wife in Charlotte Brontë's *Jane Eyre*. She haunts Thornfield Hall and keeps trying to murder its inhabitants. Dehumanized using the pronoun "it" by Brontë, she resembles a "strange wild animal." I'm reminded of Swift's "The Prophecy," where the speaker howls "like a wolf at the moon" and sounds "unstable."

Bertha's memorable characterization inspired the pioneering 1970s work of feminist literary scholarship, *The Madwoman in the Attic*, by Sandra Gilbert and Susan Gubar. Taking Bertha as a starting point, Gilbert and Gubar argued that the majority of women in nineteenth-century Britain were not only forced to live in *real* houses owned and built by men (married women had no legal identity of their own, nor could they legally own property or possessions, until 1882), but in metaphorical ones too. They were pigeonholed into restrictive stereotypes that patriarchal society carved out for them, which often fell into two binary categories: the "Angel in the house"—a domestic ideal taken from Coventry Patmore's 1854 poem of the same name—or the "fallen woman," whose sexuality made her irredeemable in society's eyes. In other

words, a Madonna or a whore; a "one night or a wife." If Rochester desires Jane to be his angel in the house, Bertha is his devil in the attic.

Despite meeting a fiery end in Brontë's novel, Bertha seems to live on in Swift's song "mad woman," from *folklore*. Swift starts to unpack the troubling hypocrisy, falsehood, and sexism underlying both historical and modern depictions of "mad" women—emphasis there on the scare quotes. She discussed her motivation for writing the song in the documentary *Folklore: The Long Pond Studio Sessions*. Far too often, Swift said, women's reactions to men's bad behavior are treated as the problem, rather than the behavior itself. As Samantha Pergadia wrote in an article for the *Los Angeles Review of Books*, recalling an incident with her male psychiatrist, society so often seems to locate the problem of madness *in* women, "not in the maddening compulsions of *being* a woman." Women are blamed for disturbing the peace, while men's behavior goes unchecked. Sara Ahmed has termed this being a "feminist killjoy": "to *expose* a problem is to *pose* a problem."

In giving us "mad woman," which might have been Bertha's own version of her story, Swift follows in the footsteps of Dominican-British author Jean Rhys. Rhys's novel *Wide Sargasso Sea* identified Bertha's "madness" as an entirely logical response to her racist, neglectful, and exploitative treatment by a host of awful men, including Rochester himself. Shortly after his marriage, in Jamaica, to the wealthy Antoinette—whom he renames Bertha because he is "particularly fond" of the name—Rochester starts to hear rumors about her family history of mental illness, and becomes bitter and paranoid, flaunting an affair with the maid in front of her while she begs him to love her again. It's a scene straight out of Swift's "tolerate it." In a powerful speech, Antoinette's nurse, Christophine, rebukes Rochester: "You think you fool me? You want her money

but you don't want her. It is in your mind to pretend she is mad. I know it. The doctors say what you tell them to say."

She's not wrong. The pages of nineteenth-century fiction are littered with women like Antoinette, who were packed off to asylums by husbands, fathers, and brothers who had simply had enough of them. All that was needed was the signature of two doctors and a magistrate. It could be a way for doctors untroubled by conscience to make a little extra cash, and for some it became a lucrative business. In Wilkie Collins's 1860 novel *The Woman in White*, the institutionalization of an innocent woman is key to a (man's) plot to defraud a lady of her inheritance. This is also, loosely, the plot of Sarah Waters's 2002 historical fiction bestseller *Fingersmith*.

Such happenings are, unfortunately, not confined to fiction. After I gave a talk on Swift's mad women at Belgium's Nerdland festival in 2024, an audience member approached me to tell me that her great-grandmother had been sent to an asylum by her husband when he grew tired of her. He would then visit her with his mistresses and flaunt them in her face. Charles Dickens tried to have his wife and mother of his ten children sent to an asylum for being "excitable," so that he might pursue an affair with a young actress, Ellen Ternan. Real-life socialite Georgina Weldon was nearly sent to an asylum in 1878 because her estranged husband saw her as a drain on his finances. She sought refuge with Louisa Lowe, who had spent eighteen months in three different asylums at the behest of her abusive husband and written a book about her experience. As Lowe pointed out, resisting the medical men who came for her would only have been used as further proof of her apparent insanity, for "who but a lunatic would oppose a husband's will?"

When Swift asks whether "they" have come to take her away, at the end of *Midnights* track "Hits Different," she might be channeling Weldon, who barricaded herself in her library with sheet

music as four men demanded entry to her house, brandishing their signed order to escort a "lunatic at large." The song also echoes the tragic Blanche DuBois, protagonist of American playwright Tennessee Williams's *A Streetcar Named Desire*. Blanche has sought refuge with her sister Stella after losing her teaching job due to an affair with a student. Having also lost the family estate to creditors, Blanche has been staying at a hotel known for prostitution. She keeps this information from her sister, but there are immediate frictions between Blanche and her sister's abusive husband Stanley, who—eager to find out what happened to the family fortune he hopes to inherit—investigates Blanche's past. The play ends with Stanley raping Blanche, who then suffers a mental breakdown and fantasizes that a rich old flame is coming to whisk her away; in reality, she is removed to an asylum. It is, apparently, the only logical end for a woman who refuses to conform to the sexist double standards of 1940s American society. As Stanley says knowingly to Stella, "there wasn't no other place for her to go."

We might draw disturbing parallels with Swift in 2023, when some fans—whom she would later condemn in the song "But Daddy I Love Him"—called for her to be taken into a conservatorship after news broke of her dating Matty Healy, controversial frontman of British band The 1975. It's a clear example of madness being used as a means of controlling and containing undesirable female behavior by moving it to the margins of society; both literally, by locking the woman away, and socially, by making her an outcast. The uproar over Swift's romantic life was doubly disturbing, following as it did in the wake of revelations about the effects of Britney Spears's conservatorship on her mental health.

"Fortnight," the first track on *TTPD*, seems to begin exactly where "Hits Different" left off—a fan theory that Swift notably "liked" on social media. The video imagines what being taken

away might have looked like: it shows Swift in a sterile, topsy-turvy asylum, at one point strapped to a table while technicians in lab coats (played by Ethan Hawke and Josh Charles, in a nod to the film *Dead Poets Society*) sizzle her brain with electrodes. She's wearing something that resembles a wedding dress, amping up the Havisham vibes.

Swift could have tweaked the title of its seventh track and instead titled *TTPD* "Fresh Out The Asylum." The album unapologetically unleashes the mad woman who merely lurked at the fringes of *folklore*, *evermore*, and *Midnights*. Swift performs its songs on the Eras Tour with a hitherto unseen violent relish, giving the set the appropriate nickname "Female Rage: The Musical."

"Who's afraid of little old me?" she screams in the track of the same name and warns us that we should be. Could this be because, in letting the mad woman out of the hospital, the slammer, the asylum—whatever you want to call it—Swift reveals so-called female "madness" to be an entirely reasonable response to the often interrelated pressures of public life and bad male behavior? The asylum of the patriarchy where women are raised? Monica Lewinsky—no stranger to bad male behavior—seemed to think so: in the week following the album's release, she tweeted a picture of the White House with the asylum lyric as a caption.

This chapter is not merely about what we might blandly call "mental health themes" in Swift's work. It's about madness. Why? Because, as journalist Anna Harpin points out, the word "madness" not only encompasses a whole host of literary and historical associations on which Swift is explicitly drawing, but, like that which it describes, madness is a troubled, controversial term. With its long historical associations, its political incorrectness, its evocations of asylums, attics, and straitjackets, it awkwardly reminds us that

debates about madness, mental illness, and well-being are ongoing and always subjective.

The entire concept of the mad woman is also a very Swiftian pun. She is mad—full of female rage. Expressing this anger, though, only makes her seem *mad*—crazy. That, in turn, makes her even more enraged. Might releasing that rage visibly and publicly somehow help to address its root causes?

This is linked to what philosopher Sigrid Wallaert sees as an important shift in recent feminist discussion: toward anger as a form of activism and communication. We are thinking more about what anger can *do*, rather than what it *is*, and about the function anger plays in identity; the ways in which self-censoring our anger might also erase parts of our identity. Anger is not only a sign that something is wrong, but also a political *demand*: for respect, for change. Think of Elizabeth Warren's 2020 campaign for the Democratic presidential nomination, in which she publicly owned her anger as a way of speaking out against power imbalances and injustice. Think of the #MeToo, Black Lives Matter, and Youth for Climate movements, all initiated by women, in which anger at marginalization and injustice played a key role. Warren, and many of the women involved in these movements, were publicly ridiculed for their anger, seen as fitting a traditional script of women as "hysterical"—a script often amplified for women of color. But their rage also became a catalyst for change.

This has been going on for decades. When Black activist Cora Tucker led protests, in the 1980s, against the installation of a radioactive waste storage site in her home—the poor, mostly Black county of Halifax, Virginia—she was dismissed by White male authorities as a "hysterical housewife," prompting her to respond, "You're exactly right. When it comes to matters of life and death, especially mine, I get hysterical. If men don't get hysterical, there's

something wrong with them." In 1989, her efforts were lauded in a magazine article titled, "Hysterical Housewives (and Other Courageous Women)." Why, writer Rebecca Traister asks, is male anger seen as "stirring, downright American, our national lullaby," while female anger is seen as "the screech of nails on our national chalkboard"?

So often, writer Samantha Pergadia points out, the question of madness is actually a question of anger, and, more specifically, of its proportion. Is the anger proportionate or disproportionate to the situation? If the latter, it's often framed as madness. Yet it's impossible to judge this fairly within the strictures and stereotypes of a patriarchal system. Women are nearly always seen, to quote the title of a book by Rachel Vorona Cote, as "Too Much."

She may be "too much," but no one has come to take Taylor Swift away. She is a wealthy White woman, living in the twenty-first century. Her fascination with mad women frozen in time is particularly curious when contrasted with the dynamic, productive, gleeful whirlwind that is Swift's stage and public persona, not to mention her immense personal privilege. Yet this contrast perhaps only proves the point she makes in "I Can Do It with a Broken Heart": ostensibly happy, liberated women are still not *free* in today's society. Even if we don't literally lock women up these days for making poor choices, Swift reminds us that we still raise them to cage them within a narrative that denies the validity of their own feelings and implies their emotional perceptions to be out of touch with reality. Gaslighting, on a massive societal scale.

In other words: Are we allowed to cry? No.

Multiple memes following the release of *TTPD* mocked Swift's "asylum" lyric by posting pictures of the idyllic Pennsylvania mansion and Christmas tree farm where she grew up. The implication was clear: this privileged, stable upbringing has negated her right

to sing about her unhappiness (something she, in a very Swiftian preempting, anticipates in the song itself: we don't get to tell her about sad). "It's a metaphor, idiot," wrote one commenter. In fact, it's one that has shaped Swift's work for many years. Consider the plethora of references to cages or caged animals in her discography: "I Know Places"; "this is me trying"; "Midnight Rain"; the video of "Look What You Made Me Do"; "mad woman"; "Who's Afraid of Little Old Me." Swift's Nashville apartment features a human-sized gilt birdcage full of cushions, which begs to be read as a metaphor. In the "I Can See You" music video, Swift is locked in a vault and has to be broken out. She also uses the tag "from the vault" for tracks on album rereleases that were previously excluded for commercial reasons. This suggests that Swift's younger self was restricted in her self-expression. Fans have seen clues pointing to this in the "Fortnight" video: the bed to which Swift is strapped resembles the one in the "You Belong with Me" video, from earlier in Swift's career. The implication is that Swift has spent most of her career in a cage or asylum, one shaped by a notoriously patriarchal and misogynistic music industry and celebrity culture.

Although women like Lowe and Weldon campaigned vociferously against their treatment, with Weldon publishing a book sarcastically titled, *The Outpourings of an Alleged Lunatic* (which wouldn't be out of place as an alternative title for *TTPD*), you might be surprised to learn that many women in the nineteenth century actually *welcomed* a diagnosis of insanity. It meant they could then legitimately seek out "cures" for their rebellious natures and thereby fit more easily into a society built for men. This is emphatically *not* the case with Swift, who defiantly seeks no cure. In fact, she increasingly flaunts her apparent madness, celebrating it as a vital part of her femininity, her creativity, and her enormous

success. She reminds me of the opening lines of Adrienne Rich's poem, "The Phenomenology of Anger":

> the freedom of the wholly mad
> to smear & play with her madness
> write with her fingers dipped in it
> the length of a room.

Swift has been smearing and playing with madness for a while. Prior to *TTPD*, she had self-identified as mad, crazy, or insane in at least nine different songs. This also produced some iconic visuals. Long before the lab coats of "Fortnight," we had the video for "Blank Space," where Swift leaned into the media stereotype of the crazy ex-girlfriend. She nailed the unhinged look with a vacant grin and mascara-streaked eyes while wielding a carving knife and a crowbar and biting menacingly into a blood-red apple. Then there was the entire iconography of *Reputation*, where she dabbled in being a zombie and surrounded herself with snakes. Snakes, apples—we might recall another mad woman who really did ruin pretty much everything, if you take the Bible's word for it (and the parallel is only confirmed by Swift's explicit alignment of herself with Eve in "The Prophecy").

In "the last great american dynasty," Swift tells the story of 1940s socialite Rebekah Harkness, whose Rhode Island mansion, Holiday House, she purchased in 2013. Swift mocks the misogyny directed at Harkness's marriage to her millionaire husband. She imagines that Rebekah had a marvelous time being outrageous—filling her pool with champagne and dyeing the neighbor's dog lime green—without caring for petty gossip. Toward the end of the song, Swift and Harkness symbolically merge, as "she" becomes "I": Swift enjoys ruining everything by being the maddest woman that the town—and, by extension, her

audience—has ever seen. Online merchandise inspired by the song, clearly targeted at women, encourages us, too, to take ownership of our madness as a form of feminist resistance. Does that merchandise refer to madness (craziness) or madness (anger)? The appeal of it is, I think, that it does both.

Journalist Gary Nunn points out that quirky, outspoken, and intelligent men were, and still are, likely to be labeled "misunderstood" or a "tortured genius"—or, à la Swift, a tortured poet or "alpha type." Women possessing the same qualities are "shrill," "unhinged," "depressed," and "hysterical." Modern politics and celebrity provide plenty of examples, from Elizabeth Warren and Hillary Clinton to Serena Williams. If we think of the "mad genius," whose erratic behavior is affectionately tolerated as a necessary corollary to their artistic talent, the figures who spring to mind are nearly always male: Mozart, Munch, Michelangelo. The earless Van Gogh. Paranoid, gun-toting Hemingway. Lord Byron, apparently "mad, bad, and dangerous to know."

But, in 2024, Swift planted herself boldly and squarely in the middle of this tradition by assuming the title of Chairman—not woman—of the Tortured Poets Department. Why do mad women languish anonymously in asylums, while mad men end up feted in art galleries and libraries? This is the giant rhetorical question that haunts the album even more than Matty Healy's ghosting. One track is titled, "The Albatross," evoking the cursed bird that plagues Samuel Taylor Coleridge's ancient mariner. Fuck the patriarchy—women deserve giant spectral fowl too, you know.

What does it mean, then, that we are now following in Swift's footsteps, gleefully adorning ourselves in colorful "mad woman" merchandise?

Women using writing to explore and nuance their madness and thereby reclaim agency over both their mental health and their

anger, has a long history. In 1892, American writer Charlotte Perkins Gilman published the short story "The Yellow Wallpaper." Its protagonist is an unnamed woman suffering from what we would probably now term postpartum depression. She has been diagnosed by a male doctor with "hysteria," a beautifully catchall term that has been deployed since Ancient Egypt to encompass a wide variety of symptoms all particularly linked to the condition of having a womb (which the Egyptians believed could "wander" around the body and prompt all manner of odd behavior). Causes of hysteria listed in American physician Frederick Hollick's 1847 book, *The Diseases of Woman*, included both the physical ("suppressed menstruation") and the social ("late marriage," "vicious habits," and reading sentimental novels): a perfect illustration of hysteria being used as a method of "psycho-sexual control" over women (to quote Showalter).

The only solution, agree the narrator's husband and brother—both doctors—is what was known at the time as the "rest cure," pioneered and popularized by American physician Silas Weir Mitchell. It involved forced bed rest, a strict diet, massage and electrical therapy instead of exercise, and instructions to abstain from as much stimulation as possible: certainly no writing. There was, incidentally, a parallel "West cure" prescribed to men, which saw them sent out into the American frontier to camp, hunt, and engage in quintessentially manly pursuits. They are the hunters; we are the foxes.

You will be stunned to learn that the rest cure doesn't work. Gilman's protagonist starts to write in secret, desperate to do something. She questions her own sanity, since she *feels* strong enough to write, but John gaslights her by telling her that her mind is too feeble. It is hard to argue with him, "because he is so wise, and because he loves me so." She begins to see apparitions haunting her

in the "smoldering unclean yellow" wallpaper of the room she is locked in—it's no coincidence that it's a nursery, reflecting the way her husband infantilizes her; he calls her "a blessed little goose" and "little girl." She becomes obsessive, eventually tearing the wallpaper off with her teeth to try and free the woman she thinks is trapped behind it. The enigmatic ending sees John fainting in shock while she creeps over his unconscious body, proclaiming that she's "got out at last, in spite of you and Jane!" Students and scholars have been debating the meaning of this for over a century.

I once spent twenty-four hours in hospital for a sleep study, which involved a similar kind of forced bed rest and lack of stimulation to that mandated by the rest cure (no screens, no caffeine, no exercise). If my room had had yellow wallpaper, I'm pretty sure I'd have seen figures moving behind it too. It gave me a new appreciation for Gilman's story.

But "The Yellow Wallpaper" isn't just compelling fiction. It's semi-autobiographical, a proven example of the ways in which women might use writing to turn their unwanted—and often unwarranted—diagnoses to their own liberating advantage. It hints at what Cote suggests in her book, *Too Much*: "perhaps our real diagnosis is anger." Gilman herself was subjected to the rest cure by Mitchell, and "came so near the border line of utter mental ruin that I could see over." In a brief article titled, "Why I Wrote 'The Yellow Wallpaper'" (Swifties can only dream of Taylor offering them such exposition one day), Gilman noted that her short story was written not to drive people crazy, but to *stop* them from going crazy at Mitchell's hands. It worked—he later announced that he had stopped the rest cure after reading Gilman's words. It would take until the 1950s, though, for hysteria to be declassified as a mental disorder by the American Psychiatric Association.

"The Yellow Wallpaper" is, perhaps, the nineteenth-century equivalent of one of those Etsy T-shirts. Both remind us that reclaiming madness can be a form of empowered resistance against the social norms and roles that we—especially women—are expected to follow.

Psychologist Joan Busfield once argued that the cultural stereotype of the mad genius still hadn't been fully feminized in the twentieth century, despite the work of pioneering figures like Virginia Woolf and Sylvia Plath. With her increasing self-identification with mad women from historical literature, does Swift offer us a new model for a quintessentially feminine, twenty-first-century mad genius? Perhaps this is where her self-proclaimed nature as a "Mastermind" truly lies. When she asks us, in "Guilty as Sin?," whether she's bad, or mad, or wise, might it be that her influence is due to her combining all three? Her phenomenal success—snakes, scars, and all—is evidence of a revolutionary, wider shift in how we perceive women's *feelings*—and particularly their feelings of madness, in both senses of the word.

In her 2023 "Person of the Year" interview with *Time* magazine, Swift revealed that one of the catalysts for her feeling the most creatively fulfilled and free she's ever been was "getting canceled within an inch of [her] life and sanity." It's a telling choice of words. Referring to her 2016 feud with Kanye West and Kim Kardashian, and subsequent "cancelation" on social media (see Chapter Six), Swift recalled how it took her down psychologically to a place she'd never been before. Surviving this and coming out stronger was not only momentous for Swift but seems to have ushered in a new era for us, too. To use *Time*'s words, Swift reassures people whose emotions are treated by society as inconsequential—often women and girls—that they're "not crazy for being upset about it," or for wanting their stories to be told. The very fact that certain

critics condemned *TTPD* as "immature" exposed the stigma that women have long faced around their emotions, particularly their anger: as one fan asked sarcastically, "Didn't you know you were supposed to stop having feelings when you turned 18?"

Swift has made us feel that to channel the heartbreak and righteous fury of Miss Havisham is no longer a one-way ticket to a madhouse. To quote one fan on Twitter, "we all carry these haunted moments and Taylor creates spaces for them." Fans wear "mad woman" T-shirts with joy, talk frankly—even proudly—about their unhinged moments, and feel validated and seen not only by Swift but also by each other. It's no coincidence that Swifties often talk about Eras concerts as some of the safest spaces they've experienced—not just physically, but emotionally, too. I noticed it during Australia's "Swiftposium" in 2024—not only the first global academic conference on Taylor Swift, but also the first conference I've been to that focused so deeply on safeguarding its attendees' mental health and well-being (for example, through providing bracelet-making stations for anyone who needed a little time out).

In 2023, a survey of fourteen to twenty-five year olds in the UK found that Swift was ranked atop all artists for the positive effect of her music on mental health. The same year, private psychiatrist Suzanne Garfinkle-Crowell reported that Swift had "rocked her psychiatric practice." She observed "What would Taylor Swift do?" to be a popular refrain among her patients—one that has inevitably spawned its own range of colorful merchandise. This seems to reflect Harpin's argument that art can play a particularly significant role in mental health because it reminds us of the hopeful, positive possibility of change, which runs counter to the diagnostic, identity-based thinking so prevalent in mental health practice. It may be that we are in the midst of a revolution of sorts, in which, to

use Harpin's words again, madness—in both senses of the word—is no longer what you *are*, but what you are currently *experiencing*; just one part of our shifting, complex, mirrorball identities.

Let's return to the "Fortnight" video. Psychiatrist Jack Pressman called the lobotomy "our most visible icon for everything that is dangerous and bad about uncontrolled medical science," and it's significant that the electrocution of Swift's brain is placed alongside pen, page, and poetry in the video. It's a duality that runs throughout the entire album: science versus literature; lobotomy versus love poem; asylum versus essay; pills versus pens. Male artist versus female lunatic. When Swift talks about veins of black ink in the album's prologue, she offers the idea that writing poetry might be as valid a treatment for madness as more scientific, physiological therapies.

Running through *TTPD* is the idea that, as Harpin puts it, art is too often marginalized as a "soft distraction" from hard science but might actually offer a means of resisting certain toxic elements in the cultures of psychiatry and pharmacology. If modern mental science is problematically obsessed with madness as "something to be fixed, banished, or corrected," art can open up a space for us to explore its subjective, fluid, decidedly *un*fixed nature. After all, as Arthur W. Frank points out, describing your madness in "medicalese" denies the drama of your own personal experience. There is no "correct" way to express or describe madness: we should instead focus on how it is constructed as a concept, experienced, and treated, in order to open up space for a more nuanced dialogue about how and why people become ill. This also means *listening*, consciously and without bias or prejudice. There is, Harpin suggests, "profound value, meaning, and insight in madness that can teach us how to live better with ourselves, and each other, if only we would take the time to properly listen and to care."

Writer Jia Tolentino has pointed out that "brave girls and bitter women" are so concentrated in literature because we haven't made enough space for them in the real world. With her vocal exploration of unhappy literary heroines, Swift has increasingly made it her job to be both brave girl and bitter woman simultaneously. Refusing to censor her tumultuous inner life for anybody, she gives space and legitimacy to the rich multidimensionality of female experience. This is particularly clear in the ten-minute version of "All Too Well": critic Lindsay Zoladz points out that the shorter original is the better song, but the new version has greater power because of its "unapologetic messiness, the way it allows a woman's subjective emotional experience to take up a defiantly excessive amount of time and space." Too much, as Cote would say.

Speaking of "too much," we can't ignore the sprawling messiness of Swift's surprise double album, the thirty-two-track *TTPD: The Anthology*. A day after its release, some fans and critics were already condemning its "unnecessary songs." At the same time, one fan wrote on Reddit:

> I don't think enough people are highlighting how brave it is to be so deeply honest about your mental struggles. . . . That's incredibly difficult to do, at her level, when so many people are tuned in. And it's not necessary—she could have phoned it in.

But she didn't. And as a result, the album has inspired Swift's fans to lay bare their own struggles while offering support and recommendations to others: "it makes one feel not that alone, I had no clue that my journey wasn't unique." This, to me and many others, has always been the appeal of Swift: the curious paradox that her lyrics are intensely specific and yet highly universal. When applied

to mental health themes, this is particularly liberating for women whose psychological struggles have, for so long, been ridiculed and dismissed. As one listener said, "I feel like that sort of gave me permission to not feel ashamed and to let people in and/or to talk about it." Another identified the album as "the primal scream of someone who's had enough." It's a reminder of the positive power of fandom, too; a reminder that, to quote Hannah Ewens's book *Fangirls*, "to be a fan is to scream alone together."

This work of Swift's might be read alongside writer and artist Audrey Wollen's "Sad Girl Theory": the idea that, in Wollen's words, "the sadness of girls should be witnessed and re-historicized as an act of resistance, of political protest." Rather than being dismissed as "narcissistic panic" or teenage angst or buried under the contrived messages of self-love characteristic of neoliberal feminism, girls' sadness should be acknowledged as an appropriate and informed reaction to the fact that "being a girl in this world is really hard." By that token, being in a state of sadness—and the bodily stress that accompanies it—might be seen as an act of revolt. We could say the same of sadness *and* madness, which become conflated in many of the lyrics to *TTPD*, and in the dramatic, "tortured" poses struck by Swift for the album's promotional materials.

Swift thanked musician Aaron Dessner for helping her to figure out how to say "why this feels so bad" in "mad woman." We, in turn, might thank Swift for helping us to do the same with our own feelings of madness. One fan's therapist told her that several of her other clients had experienced "emotional breakthroughs" while listening to *TTPD*. While no one is seriously advocating substituting Swift for therapy (although the Californian Laurel Therapy Collective did post an article on their blog in 2023, "A Journey Through Trauma Therapy with Taylor Swift"), her music might encourage us to look

more closely at how we conceptualize both our mental health and our anger—and their relationship to society.

Swift has done important work in dragging the likes of Bertha Mason out of the shadows and into the spotlight, where she hands them a microphone and a tiara. That said, there are myriad artists across multiple media platforms who deal with mental health themes, and with anger, in much more depth and nuance than Swift. Swift's privilege—both in terms of wealth and Whiteness—means we risk overlooking the very real problems that disproportionately affect marginalized cultures and groups when it comes to mental health, and to anger. To use a phrase by Isabel Cole, writer of the Substack *Wild and Unwise*, we shouldn't cling too closely to "the whole narrative of Taylor Swift, High Priestess of Feelings (having them, providing them, capturing them, validating them)."

For example, *TTPD* has been legitimately criticized for its use of the asylum as an aesthetic. Fans were quick to lambaste a social media post by Swift's official fan organization, Taylor Nation, which promoted *TTPD* merchandise as "perfect for your next asylum visit." This reflects what Cote sees as a wider problem: the Anglo-American fetishization and aestheticization of psychological suffering "as something cute, tame, and thoroughly whitewashed." It's what Anna Bogutskaya refers to as "White girl sadness": the idea that mental illness in women is only acceptable if it's beautiful, "embodying a frail chicness that slots perfectly into the social narrative that White women must be protected at all costs." It's a frail chicness embodied by artists such as Lana Del Rey, and now Swift in *TTPD*.

What Swift is actually performing, Gina Arnold argues, is not female rage—which is unmarketable—but safeness. Yet at the same time, I would venture that it is Swift's safe palatability—wrapped up as it is in White girl sadness—that is crucial to the success of

her message. The fact that her "madness" is packaged in catchy, aesthetically pleasing narratives means it has the potential to spread further, sowing quiet seeds of resistance. By winning our hearts with tales from history and literature, Swift lays the foundation for us to think more deeply, ask more questions—perhaps kill more joy.

Ahmed points out that women "snapping," like twigs snapping, doesn't happen spontaneously or in isolation. We hear the snap as the start of something, but only because we've failed to notice the pressure on the twig beforehand. Swift—who herself referred to something "snapping" within her in August 2017, when she countersued DJ David Mueller for sexual assault—could well be the starting pressure on the twig, so that her dear readers might snap when they have to.

Showalter has suggested that the madwoman who made fleeting, chilling appearances in nineteenth-century novels has now become the heroine, and that "the visit to the psychiatrist, or the nervous breakdown, has become a standard, even obligatory, episode in the fictional life of women." That Swift can release an album with the raw vulnerability of *TTPD*, in which she freely alludes to struggles with depression, alcoholism, and self-harm, and that it can be received with open arms by fans conversant with the language of trauma, therapy, and healing is a significant step for mad womenkind. Gilbert and Gubar wrote optimistically in the late 1970s that women have the power to create themselves as characters, and to reach toward those trapped inside others' narratives and help them to climb out. Swift has been extending that (guitar string-scarred) hand for the best part of two decades, now, and her fans are following suit. Far from ruining everything, mad women might just be starting to make it right.

Chapter Ten

Out of the Woods: Writing Nature

nature, n. The phenomena of the physical world collectively; esp. plants, animals, and other features and products of the earth itself, as opposed to humans and human creations.

—*Oxford English Dictionary*

On March 12, 2021, as the COVID-19 pandemic forced us to retreat into our homes and reassess our relationship with the outdoors, conservation scientist Jeff Opperman published an article in the *New York Times* titled "Taylor Swift is Singing Us Back to Nature." Opperman analyzed the thirty-two songs on Swift's 2020 albums *folklore* and *evermore* and found that she used nature-themed words seven times as frequently as the thirty-two top songs in Spotify's current hits at the time. Swift sings about nature as a "place to bond, seek solace or just hang out," Opperman pointed out, and this matters more than we might think.

In 2017, a scientific study found that nature-themed words in pop music had declined 60 percent since 1950, mirroring a decline in nature itself as we logged, mined, and fished our way through the planet's resources. For many of us in the Global

North, nature's role in daily life is dwindling. Author Richard Louv coined the term "nature deficit disorder" to describe this lamentable state of affairs. Swaths of modern parenting books, including Louv's own, report alarming statistics, like the fact that American children spend a daily average of four to seven minutes playing outdoors, versus seven hours in front of a screen, or that British children are more likely to recognize Pokémon characters than native animal species from their own communities. Reaching far beyond the words used in pop songs, this disconnect has potentially grave consequences for our future.

You probably don't need me to tell you that we stand at the brink of the next mass extinction. We are living through a period called the Anthropocene, which means that human (*anthropos* in Greek) activity is the main force shaping Earth's geology, climate, landscapes, and ecosystems. The term was rejected as an official geological marker in 2023 by the International Union of Geological Sciences, but only because no one can agree on exactly when this human influence started.

It's hard to avoid warnings about the dire effects humanity has had on our planet, even if you opt not to read the news. Imaginings of our postapocalyptic future, and critiques of our troubled relationship with nature, are so common in literature and film that they've even earned their own genre: cli-fi (climate fiction).

This chapter looks at Taylor Swift through the lens of ecocriticism. Ecocriticism means exploring how literature portrays the relationship between humanity and nature. Ecocritics believe that this relationship isn't just physical or spatial: it's linguistic too. Scholar Raymond Williams has argued that nature is perhaps the most complex word in the English language; its thirty-four definitions in the *Oxford English Dictionary* certainly corroborate this (as does the word cloud that results when I ask students to define

it during class). Ecocritics argue that, for centuries, humanity has constructed its relationship to nature via language in ways that, indirectly, have set us up for the dire situation we are now in.

For one thing, we tend to think of nature as something fundamentally different from ourselves: nature versus culture, nurture, civilization. Environmental activist Frieda Gormley noticed, in 2023, that all English dictionaries defined nature in this way: as separate from humanity. "If people feel we're separate from nature," she pointed out, "how can we really consider nature in our actions?" This is connected to *anthropocentrism*—the tendency to think about the world in human-centered terms—and *anthropomorphism*—attributing human characteristics to animals in ways that can be both helpful and harmful (hello, Disney).

How humans think about nature is always political: it reflects our worldviews, biases, and priorities. These have often led to nature being framed either as a resource to be exploited, or a foe to be conquered. Swift sings on "But Daddy I Love Him" that she's forgotten how the West (of the United States) was won. Well, the answer is: with violence, justified by the framing of wilderness as something to be beaten into submission. It's an idea that goes back millennia, to one of the earliest known works of literature, the ancient Mesopotamian poem *The Epic of Gilgamesh*: the titular hero slays the guardian of the forest and cuts down a sacred tree. It's also an ideology still clear in our modern media: a recent interactive Netflix series starring British survival expert Bear Grylls was titled *You vs. Wild*.

Literary critics Andrew Bennett and Nicholas Royle go so far as to say that nature is "always already contaminated by the human and by language." It's a particularly poignant choice of phrase when we look back on the coronavirus pandemic, and the devastating consequences of what was framed as a cross contamination

between human (a market in China) and nature (a zoonotic virus), but which in fact reminded us of the dangerous repercussions of *forgetting* our interrelatedness with nature. We often see nature as something *outside* the human: we go for a walk "in nature," which implies seeking out a dedicated reserve or green space. We talk about "nature versus nurture," as if human socialization is somehow isolated from nature. The euphemism "call of nature" implies that our bodies are somehow distinctly separate from nature until the moment they inform us that we need to pee.

The way we think and talk about nature is full of dualisms: oppositions that suggest an uneven power balance. At its most dramatic, this results in ecophobia, defined by Simon Estok in his book *The Ecophobia Hypothesis* as "fear, contempt, indifference, or lack of mindfulness (or some combination of these) toward the natural environment." Some of this makes sense from an evolutionary perspective: being wary of wild animals and potentially hostile landscapes could save our lives. However, lack of mindfulness is less forgivable and maybe even more damaging when it comes to how we see and relate to our planet. Perhaps the most dangerous ecophobia is the type we experience on a daily basis; in Estok's words, one "deeply obscured by the clutter of habit and ignorance."

For example, what botanists James Wandersee and Elisabeth Schussler term "plant blindness": our inability to notice the plants in our environment or understand their importance, and our misguided anthropocentric ranking of them as inferior to animals. We can date this back to Swift's favorite philosopher, Aristotle, whose *scala naturea*, or "natural ladder," hierarchized living things in terms of their degree of perfection. Plants were right at the bottom, just above "inanimate matter." Ouch.

When I teach this class in English Literature (Taylor's Version), I conduct a brief anonymous survey with the students, asking them

to answer statements such as "Do you fail to see, notice, or focus attention on plants in your daily life?" on a scale from 1 (strongly disagree) to 5 (strongly agree). The answers usually hover around an average of 3.2. I realized while conducting the quiz that I could probably identify over 150 exotic houseplants by botanical name but would struggle to name any of the trees on my bike ride to work (unless they were elderflower or fig, and thus useful to me for making cordials or ice cream). Habit and ignorance indeed.

Ecocritics would argue that seeing nature as something separate from the human, often just a static background to human activity, has indirectly caused the destruction of our planet. We have forgotten that we are *part of* nature, part of those delicate ecosystems we continue to destroy, and we are now paying the price. While no one is arguing that books alone are going to solve the crisis, environmental historians have suggested that any solution requires first understanding the ethical issues that have led to the problem. Historians, literature scholars, anthropologists, and philosophers can help with that understanding. Taylor Swift might be able to, as well.

As I've already discussed in Chapter Three, Swift often takes a common word or phrase and turns it on its head, making us reexamine the way we use language in everyday life. The language of nature is no exception. Consider "out of the woods." The idiom—used in English to mean that the worst has passed—is rooted (pun intended) in ecophobia, since it associates the woods with a negative state. We have centuries of popular culture to thank for this: in medieval romance or fairy tales the woods are nearly always a place of danger, and that legacy is still alive in horror films like M. Night Shyamalan's *The Village*. It actually goes back to the very origins of the English language. The words "wilderness" and "bewilder" come from the same Old English roots: wild, from

"willed," meaning with uncontrollable desires or urges, and "deor," meaning animal. Wilderness, literally "the place of wild beasts," was historically used by humans to describe a place, away from civilization, where one was likely to become senseless and confused. Less a Lavender Haze, more a Laburnum Daze.

In the video for "Out of the Woods," from *1989*, we see Swift walking from a bright, sunlit beach into an increasingly dark forest, as wolves snarl. It's a wilderness in its original sense: a place of wild beasts. At various points we see her struggling, limbs ensnared in the tendrils of dark trees. You might feel you've seen this film before. You may recall the horrifying stingers of John Wyndham's triffids, or maybe the disturbing "tree rape" scene in the 1981 *Evil Dead* film or its 2013 remake. You may have flashbacks to the shooting tendrils of the giant yellow flower in *Jumanji*, which traumatized a generation of '80s kids, or the murderous vines of *The Ruins*, suffocating characters by slithering down their throats. You could well think of the violent "whomping willow" in *Harry Potter*, or perhaps you grew up with the grasping limbs of the threatening forest in Disney's *Snow White*.

Uncanny plant tendrils attacking humans has a history that far predates cinema, though. The late nineteenth century saw a swath of these "plant horror" stories, partly inspired by the publication of Charles Darwin's *Insectivorous Plants* in 1875. If plants could eat insects, who's to say there weren't plants out there—in the then "undiscovered" blank spaces of the map—that might eat bigger prey? These stories played on anxieties that Western imperial expansion, in full swing at the time, might bring home all sorts of terrifying man-eating invasive species. Sir Arthur Conan Doyle imagined a Venus flytrap large enough to pierce a human heart in "The American's Tale," while American novelist Maud Howe Elliott dreamed up an orchid that sucked human blood like a

vampire in "Kasper Craig." In *The Devil Tree of El Dorado*, by British science fiction writer Frank Aubrey, an evil dictator straps victims to a wooden platform known as the "Devil Tree's Ladle" and wheels them out to the eponymous tree, who picks them up in its greedy branches and eats them alive.

"Plant horror" exploits our fear of the unknown. Our nightmares are full of plants that refuse, dramatically, to stay still and be a mere backdrop for human existence. They remind us that we have huge blind spots when it comes to the aliveness of plants. Recent developments in mycology have made us aware how little we truly know about fungi; series like *The Last of Us* and *Hannibal* then stepped in to turn this uncertainty into horror. The same goes for plants. Plants "bewilder" us. We tend to imagine them as static, but if you've ever seen a time-lapse video of indoor houseplants, you'll know they're not. Plants are troubling because, like so many monsters in horror stories, they are liminal beings: they bridge two categories in ways that unsettle our neat, pigeonholing brains (just like the "living dead," vampires and zombies). They're alive, but their *aliveness*—the way they move, breathe, reproduce—is so fundamentally different from animals that they remain disturbingly unknowable. Those wriggling tendrils are also an uncomfortable *memento mori*: plants will be there long after we have gone and will ultimately consume our bodies. Perhaps they are actually farming *us* for food, rather than the other way around.

The video for "Out of the Woods," then, initially seems like so many other stories in this vein: the heroine attacked by threatening branches in the dark, scary forest. And yet one of the most striking scenes shows Swift standing, clean and unscathed, in a sunlit clearing, engulfed in tendrils that raise her up on a plant pedestal. She reaches toward the sky like a sylvan Statue of Liberty as fireflies glow all around, illuminating a look of wonder on her

face. The text that bookends the video tells us that she lost "him" but found herself, and this is illustrated by a bedraggled Swift emerging from the forest onto the beach to greet her (substantially cleaner) doppelgänger. The implication seems to be that the woods, as a metaphor for emotional difficulty leading to personal growth, are not something to be feared, but, rather, embraced. It's a subtle distinction, but one that sets the tone for Swift's later engagement with nature. In keeping with her typical way of prompting us to rethink the language we use every day, Swift makes the idiom "out of the woods" literal. In doing so, she reveals that there is nothing objectively threatening about the woods; it's how we approach them that matters.

This continues in *folklore* and *evermore*. The video for "willow" frames the forest as a place of benevolent, light-giving magic that Swift can walk barefoot in, wide-eyed in wonder. It evokes child-hood innocence, cat's cradle, community, and romantic love. In both "happiness" and "seven," it's only by being above the trees that the speaker achieves an epiphany of sorts. Swift literalizes another idiom—"can't see the wood for the trees"—to present nature as an inspirational space of self-knowledge and understanding. By reframing the forest in this way, reminding us that the monsters we have been socialized to fear might be, in fact, just trees, Swift might help us to recognize our ecophobic assumptions and to rethink them.

The benevolent tendrils of the "Out of the Woods" video are revisited in the lyrical imagery of "ivy." Swift uses the metaphor of winding ivy to describe falling illicitly in love (or lust). Unlike the horrific scene from *The Evil Dead*, this is a consensual plant-human embrace: the lover is putting roots in her dreamland, covering her house of stone in creepers that symbolize the awakening of a cold heart to the glow of attraction. Clover blooms and spring arrives,

the blossoming relationship and the verdant landscape becoming one. Something similar happens in "the lakes." The image of wisteria growing over bare feet is a symbolic role reversal: the speaker, who tells us she hasn't moved in years, takes the static role we traditionally associate with plants. It seems to express a longing to be more *like* plants: to grow, like a rose, with no one around to tweet about you or hunt you with cell phones.

The whole *folkmore* universe seems to fit this narrative. It wistfully imagines a world in which the boundaries between human and plant blur; in which we relinquish the desire to control our environment and instead let ourselves be borne along with it, like the speaker tossed on the waves in "evermore." It's significant that Swift performs certain songs from the albums at a moss-covered piano, almost implying that if she stays there long enough, the moss will start to cover her, too. There's a similar sentiment in "Carolina," which she wrote for the 2022 film adaptation of Delia Owens's 2018 best-selling novel *Where the Crawdads Sing*. Its sepia-tinted lyric video heavily echoes the *folkmore* aesthetic. The speaker refers to "Carolina creeks running through my veins" and describes herself as free as birds. As is also the case in Owens's novel, it's unclear where woman ends, and nature begins. And perhaps this is how it should be.

We see something similar in "Clean" and "This Love" from *1989*. Although not as obviously nature-focused as the tracks from *folklore* and *evermore*, both songs explore the positive changes that occur when we stop attempting to control our surroundings and instead embrace the whims of nature. In "Clean," the flowers that the speaker and her lover grew together have died of thirst: attempting to bend nature to their wills has resulted in failure (growing flowers is also the subject of the speaker's scorn in "Fortnight"). As the rain pours, this symbolic baptism renews

the speaker, allowing her to move on to better things. There's a paradox here: only when drowning could she finally breathe. If the ocean is a common site of ecophobic anxiety (thank you, *Jaws*), Swift urges us to take the plunge (literally—at one point in the Eras Tour, Swift seems to dive into a pool of water that has opened up in the stage). She's obviously not advocating drowning but rather portraying the unpredictability of the elements as a healing force. The speaker in "This Love" accepts the need to let things go free, so that they may then come back around, like the currents of the vast ocean. We see the same idea in "willow," where the speaker frames herself as the ocean to her lover's rolling ship, celebrating the wrecking of her plans.

Environmental historian William Cronon suggests that a better relationship with nature revolves around a question Swift also seems to be asking in these songs. Does nature always need to bend to our human will, and, if not, how can we let it flourish without our intervention?

Having said all that, though, we must acknowledge that Swift's "singing us back to nature" is certainly not as simple or hopeful as Opperman might have us believe.

For one thing, Swift is no environmentalist. She has become notorious for her private jet use, fans bemoan the dubious provenance and poor quality of her merchandise, and her marketing practices encourage fans to buy multiple versions of the same album. Swift received *Time* magazine's "Person of the Year" title in 2023, but it's perhaps ironic that in 1989, the year she was born, the magazine gave that title to "The Endangered Earth." Its burden has probably not been lightened by Swift's colossal Eras Tour.

In May 2024, I participated in a panel talk on Swift at the German-American Institute in Freiburg, alongside music critic Jenni Zylka. When answering an audience question about Swift's

environmentalism (or lack thereof), Zylka looked at me and said, "she's always talking about cars, isn't she?" While *folklore* and *evermore* might have given us some temporary respite from the traditional backdrop to Swift's songs—the "big wide city"—her latest album, *The Tortured Poets Department (TTPD)*, plants us squarely back in it: suburban backyards, speeding town cars, flooring it through the fences, six-lane Texas highways, the lights of Manhattan, plastic toys sold at the mall, buying the car you want in Florida. It's an album embedded in petroculture: a way of life founded on oil and its byproducts.

"But what about 'I Hate It Here'?" you might ask. In this song, on *TTPD*, the speaker tells us that she retreats, in times of unhappiness, to secret gardens in her mind, inspired by a book she read as a precocious child. The book in question is probably Frances Hodgson Burnett's *The Secret Garden*. It tells the story of unhappy orphan Mary Lennox, whose new life at her uncle's Yorkshire country house is significantly improved when she discovers a secret garden on the premises, long abandoned due to her uncle's grief at his wife's passing. Yet, if we break the lyrics down, "I Hate It Here" is pretty good evidence of some of the problematic ways we humans think about nature.

The song frames the garden as an antidote to urban dreams and fears, which overlooks the fact that gardens—enclosed patches of land—are always man-made. This common human fantasy, of escaping to pristine nature or wilderness, ignores the fact that there *is* no nature outside human influence. The speaker acknowledges in the song that nostalgia is a trick of the mind, which might also apply to our human tendency to look back to an ultimately nonexistent "Golden Age," when nature was supposedly pure and unspoiled. The most common version of this fantasy in Western culture is the Garden of Eden. On her Eras Tour, Swift signals

the transition between her *Reputation* and *folkmore* sets with a giant animation of a snake slithering through emerald grass. Significantly, it's the snake's disappearance that signals the arrival of the Eden-like *folkmore* idyll, a place supposedly untainted by humanity. Classical poets like Theocritus often idealized simple, unspoiled nature in a genre of poetry we call *pastoral*, from the Latin for shepherd. The idea of virgin wilderness has captivated us ever since. It was a particularly damaging myth in nineteenth-century America, ignoring the Indigenous peoples who had been custodians of the land for centuries while denying them access to their homeland in the name of conservation.

It's interesting that the speaker in "I Hate It Here" links her dreams of escaping to the garden with another childhood dream, that of escaping to the 1830s—but without all the racists and misogynists. The garden comes to stand for a kind of isolated paradise in both space and time, where bad things like sexism and racism don't exist. It's the same fantasy underlying James's hope, in "betty," that Betty might kiss, forgive, and trust him again in the garden, away from the prying eyes of all her stupid friends. It's the same impulse we see in "seven," where the speaker identifies her childhood, when she stood in the trees above the creek, as her "peak." "Are there still beautiful things?" she asks. This implies that beauty existed only in her past, where she screamed in the weeds, a child of nature before she was forced into stifling "civility." Nature is identified with a past Golden Age of childhood innocence, and contrasted with a negative, degenerate civilization or culture.

This attitude is typical of the ways in which certain British Romantic poets saw childhood, most famously in William Wordsworth's "Ode: Intimations of Immortality from Recollections of Early Childhood." In the opening lines of the poem, Wordsworth describes how there was a time when:

meadow, grove, and stream
The earth, and every common sight
To me did seem
Appareled in celestial light.

Heaven, the speaker tells us, "lies about us in our infancy," but, as we grow up, "shades of the prison-house begin to close" upon us, and we are increasingly burdened with life's difficulties. Swift says something almost identical, over two centuries later, in "Robin" (children live in "sweetness," but "the time will arrive for the cruel and the mean"). Contact with nature, for Wordsworth, is one of the ways in which we might try to regain some of that childish joy and innocence. This idea has a thriving afterlife in the trend for modern parenting manuals that urge us to get our kids back to nature and away from the damaging influence of screens.

It's telling that Swift mentions Romanticism in "I Hate It Here," since the song is indeed highly Romantic. It depicts modernity and technology (the "finance guy") as bad, and unspoiled nature (the garden) as good. But the idea of unspoiled wilderness is a problematic fantasy because it wrongly implies that we can escape our troubles. If nature is only nature when free of humans, then it follows that the only hope to restore the planet is to remove ourselves from it. You may remember that this became the subject of frequent "nature is healing" commentaries during the COVID-19 pandemic—both serious and mocking. Yearning to escape into unadulterated nature, as Cronon points out, leaves us little hope of discovering what "an ethical, sustainable, *honorable* human place in nature might actually look like." Or, to use a Swiftian analogy, it's like looking directly at the sun but never in the mirror.

This problematic fantasy is clear in Swift's "cottagecore" aesthetic, most pronounced in *folklore* and *evermore*. Cottagecore

exploded during the pandemic, enabling much-needed escapism for people who also hated it here—"here" being, in the words of Katherine Murray, who explores Swift's cottagecore in *The Literary Taylor Swift*, "doom scrolling and anti-maskers and Mitch McConnell." It offered a charming, peaceful, and nostalgic vision primarily targeted at women, one that pitted crafts, cooking, and crochet against capitalism, corporations, and COVID. By 2022, the hashtag #cottagecore had garnered over ten billion views on TikTok, while *Vox* named Taylor Swift and cottagecore (along with *Minecraft* and *Animal Crossing*) the "official aesthetic" of 2020.

In the Eras Tour, the backdrop of the Lover House famously burns down, and is replaced in the *folkmore* set by a much more modest cottage in the woods. It seems to signal the retreat from capitalist materialism into the simplicity of the forest that Swift underwent during the COVID pandemic. Yet this flashy display, projected on a huge screen behind Swift as she stands in front of a stadium audience of thousands of smartphone-wielding fans—many of whom loved *folklore* and *evermore* so much that they invested both emotionally and financially in Swift, helping to cement her now-billionaire status—encapsulates some of the awkward paradoxes of cottagecore. It uses digital platforms to build communities, but, as Murray asks, can "aspiring homesteaders and gingham-clad curators of cute actually reach cottagecore nirvana" if they need Wi-Fi to do so? Doesn't it cease to be authentic if we're hunting it with cell phones—and is there even such a thing as authenticity when it comes to such a curated aesthetic? We might ask similar questions of cottagecore's latest spin-off, the "tradwife" movement.

Cottagecore tends to imagine nature as a giant arena that passively awaits us and our leisure time, into which the privileged can retreat in order to improve themselves. This framing of nature

oozes (predominantly White) privilege. It ignores, in the words of Rebecca Jennings, the fact that rural areas have "always been unattainable for some and inescapable for others." Not everyone is able to retreat from job security, responsibilities, and dependents into a self-indulgent life in the woods. Since the nineteenth century, retreating to the wilderness has largely been a privilege reserved for the urban elite. For those in rural professions such as agriculture, the country life is one of labor and hardship, not idyllic escape: as Cronon points out, "country people generally know far too much about working the land to regard *un*worked land as their ideal." Creaking floors and catching your death in the December chill probably do not seem poetic if they are your everyday life.

This becomes even more fraught when we consider that, for some communities, the rural wild might be more associated with memories of slavery and persecution than peaceful leisure. In 1981, President Ronald Reagan seamlessly combined ecophobia and racism when he referred to "a jungle which threatens to reclaim this clearing we call civilization." In Billie Holiday's song "Strange Fruit," the "pastoral scene of the gallant South" is tainted by the knowledge that its trees were used for lynching. Black American poet Paul Dunbar's poem "The Haunted Oak" sees the speaker shudder in the shade of an old oak tree, knowing that it has been an accessory for murder. As Floridian Leola McCoy puts it in Carolyn Finney's book *Black Faces, White Spaces*, "We've had so many atrocious things happen to us in the woods."

The environmental crisis is unlikely to be solved by the fantasy of preserving peopleless landscapes that haven't actually existed for millennia. The privilege and escapism of "I Hate It Here" are part of this problematic trend. It masks an urgent need for humans to recognize both our interconnectedness with nature but also with each other. In May 2024, Swift told an enraptured crowd in a

sold-out arena in Stockholm that *folklore* and *evermore* were based on the fantasy of retreating to a cabin "somewhere in Sweden" (she would then amend this to Ireland for her Irish tour dates). The crowd roared their approval, and I thought about how that same crowd contained tens of thousands of international Swifties, many of whom had flown thousands of miles to Sweden and thereby disgorged tons of extra carbon into the air surrounding those dreamy Swedish cottages.

That's not to say we should dismiss Swift's nature writing altogether. One important thread that runs through it is related to what we call *ecofeminism*: being attuned to how nature and women are often described in the same disempowering ways. Its end goal is to liberate both women and nature from exploitation.

There is a Western tradition, dating back at least to classical literature, of conceptualizing Earth as female; as a womb from which springs all life. As humans began to advance technologically, poets and scholars anxiously observed that certain practices were akin to an act of violence against the female body. Renaissance poet Edmund Spenser and Restoration poet John Milton both likened mining to inflicting a sacrilegious wound on the Earth's womb, and it is not uncommon to find mining equated with rape. This is particularly clear in John Donne's sixteenth-century poem, "To his Mistress going to bed," where the speaker urges a woman to undress and "license [his] roving hands" to go all over her body, comparing her to his America, his "new-found-land," and a "mine of precious stones." The rise of Western colonialism saw the Earth further plundered in search of resources, at the same time as actual women fell victim to the lust and greed of the colonizers. Belgian artist Johannes Stradanus's painting of Amerigo Vespucci's "discovery" of America represents the continent as a near-naked woman, rising docilely from a hammock as Vespucci

stands, elongated staff and flag at the ready. The phallic symbolism isn't subtle.

Western patriarchal society has historically inflicted massive acts of violence on the Earth. These, in turn, have mirrored the ways in which women were—and are—exploited and denigrated. It's a metaphor made horribly visual in Darren Aronofsky's allegorical film *Mother*, where the newborn baby representing Earth is gruesomely massacred and cannibalized before its mother's eyes.

We see this legacy in the fact that women, particularly women of color, are disproportionately affected by the climate crisis. They bear the brunt of toxic waste buildup in low-income areas, which often negatively impacts their health and that of their children. Often restricted to domestic spaces, they are directly exposed to polluting fuels used for cooking. When they do engage in environmental activism, they are often excluded from negotiations and may experience gender-based threats and violence including rape. According to a UN report, 80 percent of people displaced by climate change are women.

Ecofeminism aims to heal some of these divides. It explores, in the words of Mona Chollet, how to "(re)build a connection with a nature from which we [women] have been excluded, or from which we have excluded ourselves due to being forcibly and negatively identified with it." Ecofeminism rejects dualisms like nature/culture and man/woman, in favor of compassion, nuance, and empathy. It's not as simple as dismissing patriarchal dominance over the land but rather recognizing the interconnectedness of all people and the environment. For this reason, ecocriticism increasingly looks to Indigenous cultures, many of whose traditions emphasize the interlinked nature of all beings. Joy Harjo, the first Native American Poet Laureate, describes a "knowing of the landscape, as something alive with personality"; markedly different to the Western

view of wilderness to be feared and conquered. We see some of this in Harjo's poem, "On the Stairs," written for the 2024 poetry collection, *Invisible Strings: 113 Poets Respond to the Songs of Taylor Swift*. It features the line "I know all the names of darkness, and I'm friends with all the blackbirds."

Ecofeminism might also reclaim narratives of the Earth as female, those traditionally used to justify colonization and conquest, and instead highlight how they can encourage a more compassionate relationship with nature. Cherokee Appalachian poet Marilou Awiakta's poem "When Earth Becomes an 'It'" points out that "When the people call Earth 'Mother,' they take with love and with love give back, so that all may live," but when they call Earth "it":

> they use her
> consume her strength
> Then the people die.

Similarly, Ursula K. Le Guin's short story, "She Unnames Them," explores how much closer its narrator—Eve—feels to animal life once she has undone the "clear barrier" between herself and other organisms that Adam had constructed, via his dominating act of naming them.

Ecofeminism recognizes that nature is not a passive resource. Rather, it is agentic: it acts. We see this in Swift's "Carolina." Carolina—her creeks and pines—is personified as female in the song. She stains, she pines, and she knows. Nature's actions have consequences for both the human and nonhuman world. We see signs of this thinking in recent landmark legal cases to grant "personhood" to entities such as the Magpie River in Quebec, or Whanganui River in New Zealand. While this might seem to reinforce anthropocentric ways of thinking—we will only protect rivers if we see them as

people—it is more about acknowledging the agency of nature and its right to our care and protection, concepts that have been central to Indigenous thinking for centuries.

This has now been recognized within the music industry, too. As of April 2024, following an initiative called "Sounds Right," artists can include "Nature" as a collaborator in their work on streaming platforms such as Spotify and Apple Music. This means that high-impact conservation initiatives receive royalties for the use of, for example, birdsong or river sounds. Nature now has its own "Artist Page" on Spotify; at the time of writing, it had 3.2 million monthly listeners.

Swift's line in "I Hate It Here," that only "the gentle" survived after we found a better planet, might be read as an ecofeminist statement. It advocates for an approach to the world characterized not by domination, violence, and competition, but by empathy and tenderness linked with childhood innocence. The idea of relocating to another planet to escape the environmental destruction we have wrought on this one is a common trope in fantasy and science fiction, for both adults and children: recent examples include the film *Interstellar*, Philip Reeve's *Railhead* trilogy, and Tochi Onyebuchi's *War Girls*. However, there is also a strong tradition of feminist utopian literature, dating back to at least the nineteenth century, which imagines alternate worlds ruled by matriarchal societies: Mary E. Bradley Lane's *Mizora*, Elizabeth Corbett's *New Amazonia*, Begum Rokeya's *Sultana's Dream*, and Charlotte Perkins Gilman's *Herland*, among others. While we can neither run away into space (yet), nor get rid of all the men, there is perhaps a middle ground here worth pursuing. It's characterized by gentleness: rebuilding our planet by respecting her as if she were indeed our mother.

Referring to the Sounds Right initiative, Norwegian singer Aurora commented that music can "make contact with nature

seem desirable again." For this to be truly impactful, though, we need to reframe our entire understanding of nature. Many of our environmental problems stem from seeing the environment as something *out there*, rather than here, our home. Cronon argues that the Romantic vision of sweeping mountains and ancient forest wilderness, central to the American environmentalist movement of the nineteenth century, "encouraged us to adopt too high a standard for what counts as 'natural.'" If Henry David Thoreau once famously declared that "in Wildness is the preservation of the World," then wildness has perhaps now become the problem. We need, Cronon argues, to "embrace the full continuum of a natural landscape that is also culture, in which the city, the suburb, the pastoral, and the wild each has its proper place." We need to return to a definition of nature that the *Oxford English Dictionary* lists as having been obsolete since 1873: "the whole of the natural world, including humans and the cosmos."

This is something Swift's music, with its impressive breadth, might provide. Opperman hit upon this when he recognized nature as a place to "just hang out" in Swift's discography. It might be a place where young lovers seek solace and privacy away from prying parental eyes ("Mary's Song," "Love Story," "dorothea"); a place of happy childhood adventures ("The Best Day," "marjorie"); a place to read and daydream ("invisible string," "seven"); or a place of passionate romance (as the *Guardian* once put it, Swift sings about kissing in the rain with "alarming regularity").

Fervent arguments among Swifties in 2023 over whether *1989* was in fact a "beach album" or a "city album" signal the versatility of Swift's work, which seamlessly blends New York apartment floors with the incoming tide as smoothly as the transition from sapling to skyscraper in the Eras Tour stagecraft. Songs like "hoax" and "marjorie" can take us from a barren cliffside or autumnal lake to

a movie theater or grocery store in mere lines, linking the complicated ecosystem of human social relations to the diversity of the landscapes we inhabit. There is much to be gained from Swift's singing us back to nature, despite its many limitations. It might encourage a gentler approach to our surroundings, one where we participate rather than dominate. Swift's lyricism—like that of the Romantic poets—reminds us that nature can be a state of mind, rather than a physical place. That state of mind is characterized by the kind of wonder we see in the wide-eyed "willow" Swift as she walks in the forest, or the "Out of the Woods" Swift as her eyes glow with the beams of reflected fireflies. Cultivating that wonder can help us to develop humility and respect for our fellow beings, and for the Earth itself.

The task facing us, Cronon contends, is one of "living rightly in the world—not just in the garden, not just in the wilderness, but in the home that encompasses them both."

As a result of our seminar on Swift's nature writing, one of my students dedicated her creative assignment to "curing" her plant blindness. She documented the plants she encountered in her everyday life, pairing each one with a plant-focused piece of music and a quotation from the young adult novel *Shiver*, by Maggie Stiefvater (in which both woods and wolves feature prominently). She told me that her friends had become involved in the project, too, sending her photos of the plants they encountered in their daily lives. Although such endeavors are clearly not going to save the world overnight, they are tangible evidence of the ways in which art might help us, slowly and steadily, to change how we see our own place within the biosphere. It's a similar ethos to that promoted by Jenny Odell's book, *How to Do Nothing*: "if you begin to recognize things that live around you as agents in their own right, then the effects on them will be felt in a different way."

Hannelinde began her report with the bold claim: "I'm the problem, it's me. I suffer from plant blindness." She renounced the anthropocentric perspective that had led her to overlook plants and their importance and approached her surroundings with a new sense of Swiftian wonder. Another student of mine wrote her master's thesis on plants in the work of Percy and Mary Shelley. She produced a thought-provoking video presentation in which she zoomed in on the plants that she had hitherto overlooked in her daily life: leaves sprouting out between the frames of metal bike racks; moss almost imperceptibly encroaching upon an urban wall. The locations she had filmed were at my workplace, and I realized with a pang that I had never noticed a plant presence there. Art cannot save the world on its own, but it can certainly prompt a rethink of our place in it and our responsibilities toward it. The small changes encouraged by lyrics like Swift's and the Sounds Right initiative might well turn into something bigger.

We're not out of the woods yet, and perhaps that's the point. All of us, wherever we are, live in the woods. We need to hang out in them more.

Chapter Eleven

Bad Blood: The Villain, the Victim, Ghosts, and the Gothic

There were moments, when she could almost have believed herself the victim of frightful visions, glaring upon a disordered fancy.

—Ann Radcliffe,
The Mysteries of Udolpho

Is Taylor Swift a gothic villain? She has certainly styled herself as one at times. First there was *Reputation*, described by some as Swift's "villain era," and by Swift herself as "a goth-punk moment of female rage." Its aesthetic involved many things we tend to associate with the gothic, from a fashion point of view at least: black leather and fishnets, dark lipstick, snakes, black letter fonts. In other words, my uniform as an angsty fourteen year old in 2003 (thankfully, social media didn't exist back then). Following her 2016 "cancelation," Swift made herself monstrous as a way of hitting back at her detractors. In a nod to online comments by ex-boyfriend Calvin Harris and Kim Kardashian, she appeared in the video for "Look What You Made Me Do" as a zombie and a Medusa-adjacent snake queen. The message was clear. To quote another pop-culture icon (for me, anyway), Jafar from Disney's

Aladdin: "A snake, am I? Perhaps you'd like to see how snake-like I can be!"

In 2024, Swift took her brand of gothic to new heights in the *Tortured Poets Department (TTPD)* set on the Eras Tour. Nicknamed "Female Rage: The Musical," its monochrome aesthetic certainly gave off gothic vibes. There were images of derelict asylums, with the real-life Swift backdropped by a monstrous doppelgänger avatar with eerie glowing eyes. It seemed a natural progression. As I've already discussed in Chapter Nine, Swift has, for several years now, self-styled as a monster or villain in order to criticize the misogynist scapegoating of women by a patriarchal society.

A witch, for example. In "I Did Something Bad" and "mad woman," Swift compares her unfair persecution (by both the media, and the patriarchy more generally) to that of the "witches" of sixteenth- and seventeenth-century Britain and America. She seems to point out, as Mona Chollet notes in her book, *In Defense of Witches*, that the way our contemporary society treats women cannot be disconnected from how history treated women who were perceived to be witches (usually because they didn't fit dominant views of what the ideal woman looked like). "We do not burn, hang, or drown as many women now as we did in the past," Chollet points out, "but there is no shortage of ways women's lives continue to be destroyed."

Both the video for "willow" and its Eras set see a shrouded Swift performing magic in a dark forest. Swift seems to follow in the footsteps of certain modern feminists, who have reclaimed the witch as a symbol of defiance—think of the T-shirts for sale on Etsy bearing proud slogans like "We are the granddaughters of the witches you weren't able to burn." In 2023, right-wing political candidate Kandiss Taylor accused Swift on Twitter of "celebrating witchcraft" and "influencing innocent minds to be enticed with

the dark side of spirituality." Several weeks later, Swift seemingly embraced the accusation by posting a video from the Eras Tour in Buenos Aires: as she sang the line from "Labyrinth" about a plane going down, a real-life jet swooped to land in the distance. "Never beating the sorcery allegations," she joked in her caption. Fans also use the term "Tayvoodoo" every time something bad happens to those who have criticized Swift.

The monstrosity continues. Portraying herself as haunted by past loves in her earlier albums, by 2020 Swift had flipped the script and become the ghost herself. In "my tears ricochet," from *folklore*, the speaker haunts someone who betrayed her as punishment. The tone is rather different to the tongue-in-cheek appearance of Swift as a zombie in *Reputation*. "My tears ricochet" occupies the significant "Track 5" slot of *folklore*, reserved for Swift's most emotionally vulnerable creations. It's funereal and somber in both its tone and subject matter and is laced with regret but also with righteous anger and justification. She didn't *want* to have to haunt him, but the implication is that he left her no choice. It's the same sentiment we hear in "mad woman," seven tracks later: poke that bear, and its claws *will* come out.

Haunting also features in Swift's *TTPD* track, "The Albatross." The title seems to allude to Samuel Taylor Coleridge's narrative poem, *The Rime of the Ancient Mariner*, which is riddled with gothic elements, including ghosts. The mariner of the title, his ship caught in misty waters near Antarctica, shoots an albatross, believing it to have brought misfortune upon the ship and its crew. Instead, he brings about a terrible curse. The crew force the mariner to wear the bird's body around his neck as a symbol of his crime (This is no mean feat: albatross are some of the largest birds in existence, with a wingspan of nearly ten feet. It's why we now use the albatross idiomatically in English to signal a great mental or

emotional burden). The ship languishes and its crew begin dying of thirst: "water, water, everywhere, nor any drop to drink," goes the famous line. A skeletal Death appears, along with his eerie female companion, "Life-in-Death." She is described as having red lips, yellow hair, and skin as white as leprosy; she's a nightmare who makes men's blood run cold, which isn't far from the way the speaker describes herself in "The Albatross." She claims the mariner's soul, and so he is forced, for eternity, to suffer a "living death" of torment, guilt, and shame.

Swift's "The Albatross" takes up Coleridge's notion of a supernatural cursed burden but gives it a woman's shape. The she-albatross of Swift's song seems less of a Coleridgean albatross and closer to one of the Sirens of Greek mythology: temptresses who lured hapless mariners off course. In Swift's song, wise men warn each other about her, framing her as a devil, a "bad seed" that will kill the garden (there's a Biblical reference to Eve here, too). Yet in the song's bridge, there's a significant shift. Swift implies that—as is also the case in Coleridge's poem—the "albatross" is actually the heroine, unfairly and unjustifiably victimized by "fake news." She's more angel than devil, her wings a lifesaving "parachute." It's the same idea we find in "Cassandra," several tracks later: the speaker was actually right all along. She was in fact the *victim*, not the villain, but no one listened.

Here it gets complicated. "The Albatross" shifts yet *again* toward its end. The speaker returns to the persona of an albatross who represents "terrible danger" and is "here to destroy you." We are left wondering: Who *is* the albatross, really? Angel or devil? Villain or victim?

In fact, these are important questions that we need to ask about Swift's work more generally. Looking at how she uses the gothic is a good place to start.

The gothic in Swift's work in fact runs much deeper than donning a pair of fishnets or CGI-ing herself to (un)death. While there's a surface-level gothic of monsters and madness, there are also deeper currents related to villainy and victimhood that we need to examine.

The idea of the gothic has always been unstable and tricky to define, and Swift's work is no exception. When journalists and fans talk about Swift and gothic, they tend to reference her use of monsters: zombies, witches, ghosts. These are figures mostly associated with a particular branch of literary gothic that flourished at the end of the nineteenth century in Britain and America, a period known as the fin de siècle (end of the century). Fearing that the end of the century would also signal the end of civilized life as they knew it, owing to the rapid pace of socioeconomic change, writers funneled those fears into creative fiction. There, they could give shape to fear: they wrote tangible creatures like vampires, werewolves, or monsters, which they could then fantasize about conquering, as a kind of therapeutic catharsis.

Writers were afraid of quite a few things at the end of the nineteenth century. One of them was women. Groundbreaking legal acts were passed in Britain and America that meant women's income and property no longer automatically transferred to their husband upon marriage. Women were increasingly vocal in their demands for the right to vote, with some concessions being made at local levels. As if that wasn't enough, they started to wear trousers—part of the "rational dress movement"—and ride bicycles. One cannot overstate the significance of women no longer being restricted by impractical corsets and voluminous skirts, and gaining increased mobility and freedom, both physically and socioeconomically. Men feared women would start having wild ideas, like believing they could be equal in their rights and opportunities as *well* as their clothing.

This new, empowered woman—picture her astride a bicycle, smoking a cigarette, reading an erudite novel—was, appropriately, nicknamed the "New Woman." *Downton Abbey* fans might remember Lady Sybil's portrayal of her in the early days of the series. The term was used both with pride by feminists, and with derision by those (often men, but some conservative women too) who saw her as a threat to traditional gender roles. The New Woman was the "childless cat lady" of the late nineteenth century: used by conservatives to condemn an apparent threat to society, and in turn proudly embraced by feminists to point out the absurdity of this.

Since gothic novels give shape to whatever anxieties are most pressing in society at the time, monstrous, shapeshifting, power-hungry femmes fatales (the term was coined during this period) soon started to appear in literature. Bram Stoker's *Dracula* doesn't just have the eponymous Transylvanian count as its villain: there's also the figure of Lucy Westenra, a beautiful young lady who is bitten by Dracula and transforms into a vampire who preys on children. It's a slippery slope, the novel seems to suggest, from a woman wearing trousers to her eating babies for breakfast. Rider Haggard's novel *She* featured a ruthless, two-thousand-year-old immortal beauty named Ayesha, who reigns through terror over a lost African civilization, seduces a young British explorer, and plans to conquer England with him at her side. Arthur Machen's short story "The Great God Pan" features an alluring woman called Helen who is also a monstrous shapeshifter. She drives her lovers first insane, and then to suicide. When finally confronted, she dissolves into a series of beastly forms before becoming a pool of jelly.

And *that*, Dear Reader, is what happens when you let women ride bicycles.

Swift hasn't yet cosplayed as a pool of jelly, but she's famously a shapeshifter, changing everything about herself to fit in, and

continually outpacing the capricious music industry by preemptively replacing herself with new eras. Her adoption of monstrous feminized identities harks back to the gothic fiction of the fin de siècle. I'm the New Woman, she seems to say. I'm "the actress starring in your bad dreams"; the albatross that represents all your worst misogynist fears. I'm proud to be disruptive, to be a childless cat lady (as she signed off on her 2024 endorsement of presidential candidate Kamala Harris). If that makes me a witch, she seems to say, then *light me up*.

However, a fundamental part of Swift's playing the gothic villain is her insistence that we understand something very important: that she's been *forced* into this. Her villainy is simply the inevitable result of her victimhood.

In "Who's Afraid of Little Old Me?," the speaker tells us that we *should* be afraid of her. Of course we should—she's a levitating, snarling monster, with creepy glowing eyes. But, the song also emphasizes, she's this way because we *made* her so. She's a victim: lured, caught, caged, and hurt, a circus animal flailing in blind rage because they took out all her teeth. In "Vigilante Shit," the speaker tells us that the object of the song did some bad things, but she's the worst of them. Because of what *he* did, *she's* been dressing for revenge. The word "vigilante" is significant—vigilantes are often the victims of corrupt or inadequate legal or judicial systems, forced to take matters into their own hands.

In this way, Swift's work recalls another type of gothic: Southern Gothic. This American literary phenomenon from the later nineteenth and twentieth centuries blended the real and the supernatural, musing on the decline of the aristocracy and the flawed myth of the Antebellum South. It tended to feature villains who presented themselves as victims. We find this in "no body, no crime," in which the speaker—unashamedly a murderer—still attracts our

sympathy, since she's acting out of vengeance. Or "Carolina," which Swift wrote for the soundtrack of the film adaptation of *Where the Crawdads Sing*; like the film it accompanies, the song invites us to empathize with the lonely female protagonist who hides her secrets in the marsh, rather than vilifying her for her crimes (spoiler alert: killing a man). In fact, all of Swift's songs that allude to killing a man suggest—à la *Chicago*—that he had it coming.

Even when she is at her most villainous, her most murderous and monstrous, Swift—or her speaking persona—wants us to understand that she is, really, a victim.

To slightly misquote "Who's Afraid of Little Old Me?," I am what I am 'cause you made me. Villainy is the inevitable consequence of victimhood, as all good origin story movie prequels know. The tagline to Marvel's latest (at the time of writing), *Kraven the Hunter*, is "Villains aren't born. They're made." In other words, "look what you made me do."

Exploring the multifaceted ways in which one can be a victim is arguably one of the things that has caused Swift's lyrics to resonate so powerfully and popularly, particularly with young women. As scholar Holly Crocker points out, Swift has made vulnerability "into a creative resource," and suggests that it might "help us find each other even in our most isolated, exhausted, and overwhelmed moments." We have all felt like victims at some point in our lives. Swift not only makes us realize we're not alone but also suggests that we might turn that victimhood into power, and even vengeance. Lindsay Zoladz has argued that Swift's "All Too Well (10 Minute Version)" is a shining example of the emotional work that many people, mostly women, have been doing in the wake of the #MeToo movement: reflecting on past relationships that made them uneasy; "wondering what exactly constitutes exploitation or emotional abuse; wishing they could go back and extend

some compassion or wisdom to their vulnerable younger selves." It's the exact sentiment we find in Swift's "Would've, Could've, Should've," in which she muses, with poignant hindsight, on the tragic naïveté of her nineteen-year-old self. Swift has been making space for those feelings of victimization since the start of her career. And as her career has evolved, it has also become a master class in how to turn victimhood into empowered retaliation.

In this way, Swift is rewriting the script of the earliest gothic literature. Originating in the eighteenth century, this literature might be summed up in a single image: a beautiful, virginal damsel in distress running, terrified, down a dark corridor, or desperately seeking sanctuary in a gloomy church, pursued by a man who either wants to rape her, defraud her, or murder her—and sometimes all of the above.

One of these texts was *The Castle of Otranto*, by English politician, writer, and art historian Horace Walpole. Walpole's dedication to the gothic went beyond his writing: he actually commissioned the building of a Gothic mansion full of what he termed "gloomth." Supposedly, this eccentric home—rather incongruously named "Strawberry Hill"—inspired Walpole to pen *The Castle of Otranto*, often cited as the first work of gothic literature. It purported to be a true tale, discovered in an old Italian manuscript. This was a clever marketing strategy designed to create hype around its publication and to amp up the scare factor—a sort of eighteenth-century *Blair Witch Project*.

Mere pages into Walpole's tale, the beloved son of the lord of Otranto castle is gruesomely killed when a giant helmet falls out of the sky and crushes him at his own wedding. The boy's father, Manfred, is distraught—but not so distraught that he can't think of a resourceful way to rectify the situation, which is to pursue his son's unwilling bride-to-be, Isabella, and try and father a new heir

with her, disregarding the small technicality that he already has a wife. What ensues is a complex tangle of coincidences, long-hidden family secrets, mistaken identities, harassment, assault, and murder. Although the story begins with the preposterous falling helmet, its real threat is not supernatural but all too mundane: a power-hungry, ruthless misogynist who will stop at nothing to get what he wants.

Women do not, generally, have a good time in early gothic novels. Quite a lot of those damsels in distress end up dying in horrible ways, often after experiencing sexual violence. Early gothic writers such as Walpole, Ann Radcliffe (to whom Jane Austen pays homage in *Northanger Abbey*), and Matthew Lewis (whose novel, *The Monk*, faced calls to be banned for its "evil" content) used the persecuted woman to activate the reader's emotions: to make *us* afraid, too, especially of the bad guys who pursued those women.

As I pointed out in Chapter Seven, Swift seems to have consciously rejected the idea of herself as a damsel in distress who needs to be saved by a Romeo on a white horse. Yet, as she points out in "The Man," she's always running as fast as she can—spooky corridor or not. It's not much of a stretch to see Swift as a persecuted gothic heroine, her innocence and goodness threatened by an evil, power-hungry villain, because she so often styles herself as one. The villain she's running from shapeshifts as often as Swift herself: it might be the paparazzi ("I Know Places"), the patriarchy ("The Man"), Scott Borchetta ("my tears ricochet"), Scooter Braun ("mad woman"), Kanye West ("This Is Why We Can't Have Nice Things"), Katy Perry ("Bad Blood"), her ex-boyfriends ("All Too Well"; "Would've, Could've, Should've"; "Dear John"; "The Smallest Man Who Ever Lived"), or the voracious beast that is fame ("Clara Bow")—to name but a few.

But Swift flips the script on that early gothic literature, too, imagining what might have happened if the damsel in distress had been better equipped to fight back. If she had survived and then, entirely justifiably, returned to avenge herself upon her tormentors—like that other goth-punk with female rage, Lisbeth Salander in Stieg Larsson's *Millennium* trilogy.

It's certainly an appealing narrative to any of us who have ever felt like a victim. The important question, though, is where do we draw the line? When does justice stop being justified, and victimhood tip over into villainy?

In 2023, Jennifer Bonfrisco published an article on *Medium*: "Taylor Swift is Becoming the Bully She Sings About." The same year, journalist Safia Khan expressed the same sentiment, pointing out that Swift's lambasting of Scooter Braun over the sale of her masters resulted in his ex-wife and children being sent death threats by Swift's fans. When Swift condemned a "sexist" joke at her expense on the Netflix show *Ginny & Georgia*, the show's actress, Antonia Gentry, was harassed by Swift's fans for simply delivering the lines she had been given. Swift may declare that she doesn't need a man to save her, but that might be because her white knight tends to materialize instead in the shape of an extreme subgroup of her fans, who ardently defend her on social media against anyone they perceive to have wronged her (a perception shaped, of course, by Swift herself).

Swift has never explicitly condemned this. In fact, in a 2008 interview, a journalist described her as "giddy" when she revealed that "every single one of the guys that I've written songs about has been tracked down on Myspace by my fans." She declared that she had deliberately made her songs specifically about certain individuals because she "likes to have the last word." She spoke proudly in a 2014 interview with NPR about how she had essentially

mobilized fans to police and condemn the leaking of her music online. A decade later, that mobilization takes other forms: fans are quick to denounce any perceived critique of Swift as "misogyny" (or, if it's made by a woman, "internalized misogyny"). In 2015, Jude Ellison Sady Doyle identified this as a specifically Swiftian vision of "feminism": one "that can only be enacted by Taylor Swift being the most successful woman in the room," and where your feminist credentials will be swiftly taken away if you criticize her.

Swift made just one brief announcement accompanying the rerelease of *Speak Now* in 2023: that there would be no need to defend her against "someone you think I wrote a song about 14 million years ago." Yet Swift's release of "thanK you aIMee" a year later, using her old trick of pointed capitalization to signal a song's intended object, does not suggest a woman who wants to discourage or condemn targeted abuse for something that took place years in the past. As she says herself in "End Game," she buries hatchets but keeps maps of where she puts them—and then sends her fans detailed coordinates and a shovel.

2024 marked an interesting shift in public opinion regarding Swift's victimhood. Officially a billionaire, her private jet usage the subject of frequent headlines, Swift has drawn ire in some circles for attention-seeking behavior at public events, attempting to block other artists from the charts by releasing endless variants of one album, and failing to speak out for political causes unless she has something to sell. Her perceived lack of concern or empathy for the 200,000 fans whose Eras concerts were canceled in Vienna saw many fans declare themselves "ex-Swifties," particularly after they were turned upon and called "Vienna Vipers" and "entitled" by other aggressive fans, simply because they wanted Swift to acknowledge the cancelation of three tour dates. While Swift did eventually reference the cancelations on social media, the

condescending tone of her post only added fuel to the fire. There were even calls for a Swift "blackout" on social media (unfollowing her on all platforms and abstaining from her music for twenty-four hours). In August 2024, *Forbes* published an article titled "The Week Taylor Swift and Blake Lively Lost Mindfulness," which was mysteriously taken down within twenty-four hours.

I'm reminded of the much-quoted line from the film *The Dark Knight*: "you either die a hero or live long enough to see yourself become the villain." We might rephrase it slightly in Swift's case: you either fade into obscurity as an artist, or you remain big enough in the music industry long enough to see yourself become the villain—a fate Swift herself seems to have prophesied back in 2023 with "Castles Crumbling." Sorcery, indeed.

Perhaps that villainy is inevitable. As early as 2015, Dayna Evans argued, in an article titled "Taylor Swift is Not Your Friend," that "the underdog narrative that the Swift machine has built is one of forced falsehoods; Swift is not coming from behind. She's been ahead since she started." *Cosmopolitan* reported on that narrative as "biased, comfortable, and very tired" in 2017. When *Vice* sent a reporter to Camden, "spiritual and actual home of London's goths," to ask the "goth-iest" people they could find about their thoughts on Swift's *Reputation* era, most were unimpressed. "She just wants attention—it's her answer to everything," opined one. Chris Thomas wrote of *Reputation* that "while other artists are speaking out and creating music about women's rights, our president, Black Lives matter, and other sociopolitical issues, we can count on Swift to stay focused on the one thing that matters in her life—herself."

The turning point, for others, seems to have come a little later: when Swift became a billionaire. Swift built a career on her relatability, her "girl next door" image, but it's hard for most of us to relate to, let alone sympathize with, the super-rich. Especially

when, as Hannah Williams points out in the *New Statesman*, some of that wealth has been acquired via "framing herself as a wronged party, and her fans' purchasing power as the only way to right said wrong." Moreover, Swift's influence has prompted disappointment that she doesn't do more with it. Doyle pointed out in 2015 that Swift didn't choose her privileges, "but she doesn't have to lean into them, either." As podcasters B. A. Parker and Leah Donnella note, "when you have millions and millions of followers, like it or not, you've got a platform. You've been chosen. And what you do with that platform is important." What might it look like, they speculated, for Swift to "use some of her immense influence and resources to make the world a little less comfortable for the powers that be"?

There are clashes—frequently played out on social media—between those who don't believe we should look to our celebrities to save the world, and those who point out that Swift made a documentary, *Miss Americana*, in 2019, in which she expressed her desire to be on the "right side of history" and never remain silent again. In an interview that same year, Swift told the *Guardian*'s Laura Snapes that she was trying to educate herself about her White privilege: "How can I see where people are coming from, and understand the pain that comes with the history of our world?" Yet influencer Matt Bernstein pointed out Swift's lack of follow-up to this on Twitter in 2024: "i don't expect a billionaire to lead the revolution or anything i'm just confused as to why one would make a movie about standing up for what's right at any cost only to literally never stand for anything again." Bernstein was then hounded with death threats and homophobic and antisemitic abuse by Swift's fans, prompting him to release an episode of his podcast, A Bit Fruity, that examined "The Cult of Stan Culture."

Doyle argues that "Swift has steadily stripped any political charge from every genre she's passed through." Critics slammed

her activism in 2019 as simply performative, merely another one of her "eras"; an attempt to regain fans and money when her career showed signs of dwindling after *Reputation*. They accused her of "rainbow capitalism"—appropriating the LGBTQ+ movement for profit—citing the music video for "You Need to Calm Down," in which Swift seemingly equates her abuse by Internet trolls with the oppression faced by the queer community. She also seems to locate that oppression in a seething mass of ungroomed village idiots, cruel caricatures of the rural poor, rather than the well-to-do politicians and legislators who systematically remove rights and thereby encourage said oppression.

It has been pointed out that Swift is rarely vocal about anything unless it involves—or rather, victimizes—her directly. Williams sees Swift's rerecordings as a missed opportunity: while they could have been "a demand for collective change, in reality they seem like little more than an exercise in egotism and greed, repackaged as 'empowerment.'" Moreover, it has been argued that this project of Swift's has ultimately made it more difficult for other artists to own their music, with record labels taking legal measures to prevent Swift-style rerecordings. Williams in fact alludes to the gothic when she refers to empowerment as "that gargoyle of a word that squats, grotesque and twisted and mocking, on the ramparts of modern liberal feminism." More on this in the next chapter.

In a 2014 interview, NPR journalist Melissa Block asked Swift whether she might consider using her enormous platform to "turn her lens outward," away from her diary page, and to send "a broader message to girls who would be really receptive to hearing about big ideas and the big world that's outside." What kind of messages, Swift asked. Block suggested "other characters, other experiences, things that might turn girls away from themselves in a different way" to a love song or pop song. Swift's response was to argue that

nothing is going to turn girls away from themselves at age twelve. "I'm just trying to show girls my life," she said; that "I've never ever felt edgy, cool, or sexy—not one time."

A decade later, little seems to have changed. There certainly isn't much of an outward focus in *TTPD*, in which Swift sings about spending most of her time in secret gardens in her mind, and rather impressively manages to frame herself as the real victim of her lover's mental health struggles. Writing for *The Atlantic* in 2024, Sophie Gilbert noted that Swift seems to be coming up against "the reality that there are no cultural models for what she's become . . . she's stuck being an extraordinarily rich, influential, and powerful woman who still, somehow, feels like she has no real power at all." Donnella described Swift as "the most disorienting pop star of our time" for managing to make people believe that "she lacks agency, privilege, or power." Referring to Swift's *Time* "Person of the Year" interview in 2023, Williams pointed out that "being mistreated by society in the way that many women are—particularly those who are poor, who barely scrape by working 12-hour shifts in minimum-wage service jobs" is not the same as "being uninvited from opening a tour for Kenny Chesney." She lambasted the tendency of journalists to indulge and propagate Swift's victimhood narrative, arguing instead that a truly great magazine profile of Swift would probe deeper into the rift where the two contradictory Swifts meet—the tear-stained "Everygirl" weeping in the mall car park and the star whose private jet topped a list of celebrity-owned planes' CO_2 emissions in 2022—to prize apart these competing personas and reveal the human being that exists between the two.

In other words, to look deeper at that fascinating, Swift-shaped, bejeweled area between victim and villain.

Writing as "a retired Swiftie who knows too much about Taylor Swift," blogger ShaiAnne argued of *TTPD* that "this narrative of

Swift being a wounded victim, even if she admits that some of her wounds were 'self-inflicted,' has run stale." Writer Tony Le Calvez referred to *TTPD* as "overindulgent," demonstrating a "victim complex" and an "ego trip." Singer and scholar Addie Mahmassani points out that Swift has grown "a bubble of herself, of looking inward" throughout her career, to the point that "now it's its own reality . . . almost like its own planet." But Mahmassani sees it as "unconscionable" for Swift to remain cosseted within her self-built fort on this planet, and to wield the influence she does without examining her privilege.

A key aspect of that privilege is, of course, Whiteness. Swift, to quote Parker and Donnella, "represents a type of White girlhood that has become aspirational for many people": one characterized by friendship bracelets, unbridled joy, pink, glitter, and deeply felt emotion. During the Eras Tour, a video circulated on social media with the caption "THIS IS GIRLHOOD." It displayed a gigantic banner with the slogan "The Smallest Man Who Ever Lived," the title of a Swift song on *TTPD*, accompanied by thousands of men's names scrawled in rainbow colors. This represented the "girlhood" not only of (mostly) women who felt themselves wronged, but also those who felt themselves wronged *on Swift's behalf*: the name of her ex-boyfriend, Joe Alwyn, cropped up many times. I was reminded of a question once asked by a student who attended a talk of mine: Did I think Swift's navel-gazing narrative of victimhood and revenge was a good one for new generations of girls to be absorbing? *Is* this a girlhood we want to model going forward?

"Give me back my girlhood," Swift sings on "Would've, Could've, Should've," "it was mine first." But not all girls are lucky enough to own their girlhood in the same way as Swift. Her popularity has raised important questions about who is *allowed*,

by society, to have this idealized, innocent girlhood—and who is excluded from its privilege. On NPR's "Code Switch" podcast in 2024, Parker and Donnella cited a study by Georgetown Law Center on Poverty and Inequality, which found that adults view Black girls as less innocent and more adult-like than their White peers; as needing less nurturing, protection, support, and comfort. Black girls are seen as more independent and to know more about adult topics, including sex. Black girls, in short, are less likely to be tolerated as victims. This mirrors, of course, a wider disparity in the way societies in the Global North react to crimes against White victims versus victims of color.

It also extends to the world of celebrity. Parker and Donnella contrasted the cases of Swift and Megan Thee Stallion, both of whom were involved in assault court cases in 2017; Swift appeared on the cover of *Time* magazine that year, credited with helping to launch a global movement; much of the coverage of Megan "almost framed it as if she was the one on trial, not the man who shot her." In 2015, singer Nicki Minaj criticized what she perceived as racism at the 2015 MTV Awards, tweeting: "If your video celebrates women with very slim bodies, you will be nominated for vid of the year . . . Black women influence pop culture so much but are rarely rewarded for it." Swift's response was to center herself in the dialogue and express herself wounded that Minaj would "pit women against each other" (Swift's "Bad Blood" video was nominated for an award, while Minaj's "Anaconda" wasn't). Swift reminded Minaj that she had done "nothing but love and support" her. In doing so, Swift spectacularly missed the point that Minaj was making. It was a point about intersectionality: all women are subject to oppression under a patriarchal society, but marginalized groups, such as women of color, experience this differently, owing to the additional burdens of prejudice to which they are subjected.

Swift's response seemed particularly tone-deaf, since she has often appropriated elements from traditionally Black genres such as rap and hip-hop to create what Donnella terms the narrative of "the underdog, the underappreciated, the hated, the disenfranchised." She seems to exemplify Gina Arnold's contention that "a White feminist is able, because of her privilege and class status, to focus on aspects of equality that are solely about money, power, and access, rather than having to consider the wider systemic issues at play." This often manifests via a "defensive response," rather than an attempt to address the actual issues at stake.

As one Twitter user urged Swift, "stop using 'support all girls' as an excuse to not be critical of racist media that benefits and glorifies you." It's the same issue raised by Swift's implication, in "You Need to Calm Down," that online hate is experienced in the same way by women, celebrities, and the queer community (in fairness, Swift has pointed out that this was not her intention in writing the song).

Swift should be lauded for validating the interior lives and struggles of a group historically dismissed by patriarchal society: young women. However, it is important to remember that she does this within the narrow, privileged space of (wealthy) White feminism. Even her use of the gothic is played out within this very narrow framework. As Chollet points out, "nowadays, witches have become a neo-liberal girlboss-style icon." Capitalism has gotten hold of the witch, and "like so many things capitalism touches, she is in danger of dissociating from her radical roots." It's part of a wider trend of White feminists "reinventing the wheel"; co-opting ideas and structures that have existed for decades among non-White communities but putting a new aesthetic—and thus capitalism-friendly—spin on them.

I am reminded of a poem written by one of my students as part of their creative assignment for English Literature (Taylor's Version):

Her music is white
her feminism is white

I can't fit in
it's too narrow, it's too tight
[. . .]
I'm a ghost to her.

Swift has built a phenomenally successful brand on singing about her interior struggles. As a result, she is a validating presence for millions of fans across the globe, particularly those who have faced similar struggles. But therein lies the crux of the matter. What about those who *haven't* faced similar struggles—those who have, in fact, faced far worse? Swift is unlikely to start penning songs about Palestine or climate change any time soon, nor should she. But there might be space, in between those two extremes of inward and outward, for Swift to broaden the narrative of victimhood just a little. To think about the *other* ghosts out there, and to give them shape and substance. What might it look like for Swift to, in Mahmassani's words, "model a kind of womanhood, or honestly just humanity, that is aware of other people's struggles"?

Or, even, to reflect more critically on her own position? As one Redditor wrote of "Who's Afraid of Little Old Me," from *TTPD*, "we don't have enough, if any, songs where the artists admit feeling genuinely *scared* by the power and success they've accumulated. . . . This could make for a fascinating insight coming from the most successful and powerful artist right now, and would vastly improve a composition which I otherwise find trite, shallow, and juvenile."

I would tentatively suggest that we need to look beyond what seem to be the obvious layers of gothic in Swift's work. Beyond the leather-clad cosplaying of the femme fatale, the animatronic snakes,

the kitschy stage backdrops. We need to look at the deeper roots of Swift's music in *other* gothics: gothics of female victimhood, and gothics of victims who become villains. We need to question the idea that we mustn't blame her; she is what she is because *someone else* made her. We need to look more critically at victimhood and villainy in Swift's work, persona, and PR, and to think about which other victims—both historical and contemporary—might be ignored, erased, or excluded by these narratives.

Chapter Twelve

I'm the Problem, It's Me: The Anti-Hero

What would you be doing or thinking if there was no gaze or hand to stop you?

—Toni Morrison

In October 2022, Taylor Swift provided the Internet with yet another highly quotable, memeable catchphrase: "It's me, hi, I'm the problem, it's me." The lead single from her album *Midnights*, "Anti-Hero" featured a speaker enumerating her many insecurities: growing older but never wiser; guilt over those she's ghosted; inability to self-examine; feeling monstrous; fear of abandonment; and narcissism, to name but a few. The accompanying music video suggested several more: at one point, Swift stands on a bathroom scale, which promptly delivers the judgment "FAT"; at another, she becomes literally "too big to hang out." She has to crawl, Alice in Wonderland-style, through a doorway to join a dinner party where no one wants her—in fact, they shoot her with a bow and arrow, recalling that other Swift song drenched in self-loathing, "The Archer."

Swift described "Anti-Hero" as one of the most honest songs she had ever written, one that delved deeper into her insecurities

than ever before. *Rolling Stone* saw it as "shocking," "deeply revelatory," and "deliciously diabolical and weird in ways Swift rarely lets out." *Elle* proclaimed it "cheeky" and "relatable," offering us insight into Swift's "mental health journey." *The Ringer* called Swift "the anti-hero we deserve."

What *is* an anti-hero, though? And what does it mean for Taylor Swift to so publicly and catchily self-identify as one in the twenty-first century?

In 2013, writer Laura Bennett published an article in *The New Republic*, in which she argued for retiring "television's most overused buzzword." At this point, she declared, "'anti-hero' barely means anything at all." She pointed out that Amazon had listed over three hundred titles containing the word over the past few years (my own search at the time of writing turned up 423), and that it had come to represent "an impossibly broad characterological range." Case in point: the Wikipedia list of fictional anti-heroes includes Donald Duck.

This ambiguity is perhaps unsurprising for a word that has been around since 1714. It was first used by writer and playwright Richard Steele, in a book with a rather Swiftian title: *The Lover; To Which Is Added, The Reader.* It was in the fires of the literary realm that the anti-hero was forged, and their unique characteristics mulled over. By 1889, magazines for young readers were distinguishing between an anti-hero and a villain; indeed, part of the difficulty of defining the anti-hero is precisely because they are *not quite* a villain—otherwise we'd use that word instead.

In 1749, British writer Henry Fielding published a long, satirical novel, *Tom Jones*, aiming to showcase the "prodigious variety" of human nature. It shares quite a few elements with a genre called the "picaresque novel," which originated in sixteenth-century Spain. This follows a roguish but appealing hero, usually of the lower

class, on adventures through society as he (for it is usually a he) relies on his wits to get by. Fielding's titular protagonist, a bastard abandoned as a baby who seeks to make his way in the world, was condemned by the Bishop of London as a "male prostitute," and the French apparently briefly banned the book for its depictions of lewdness. Writer and clergyman Thomas Birch, however, commended Fielding's "strong and lively painting of characters." Halfway through the novel, the narrator tells us that real life is quite a lot like the theater, "since it is often the same person who represents the villain and the hero; and he who engages your admiration today will probably attract your contempt tomorrow." It may well be one of literature's first descriptions of what we now call the anti-hero.

Much ink has been devoted to defining the anti-hero in recent years. Amanda Lotz identifies him as a "flawed protagonist" (although surely we could argue that of all protagonists) struggling to respond to "circumstances not entirely of his making" (I'll come back to that "his" later). Many writers agree that we can only understand the anti-hero in relation to the hero. Literary critic M. H. Abrams sees the hero as showing dignity and power, while the anti-hero, by contrast, is "petty, ignominious, passive, ineffectual, or dishonest." Writer Oliver Esuana says that if the hero "wears his moral compass like a badge of honor, the anti-hero's compass is more like a variable dial, adjusting based on the situation at hand." In the words of Marvel's Deadpool, the anti-hero may be super, but they're no hero. The anti-hero goes against the social order: aligned not with evil, but with resistance to the status quo. To use a Swiftian reference: if society is a straight line down, then the anti-hero is crooked.

I'm sure you can think of many examples in literature, film, and popular culture, depending on your genre preferences. Shakespeare's

Hamlet. John Milton's Satan, from *Paradise Lost*, sometimes cited as the *first* literary anti-hero—in fact, my university tutors were so sick of students parroting this tired line that they explicitly banned us from ever handing in an essay on the topic. Hannibal Lecter. Dexter Morgan (*Dexter*). Walter White (*Breaking Bad*). Tony Soprano (*The Sopranos*). Loki, Venom, and Deadpool (Marvel). Lisbeth Salander (Stieg Larsson's *Millennium* trilogy). Jack Bauer (*24*). Blair Waldorf (*Gossip Girl*). Sherlock Holmes. Most of the characters in George R. R. Martin's *Game of Thrones*. Frank Underwood (*House of Cards*). Villanelle (*Killing Eve*). Seong Gi-hun (*Squid Game*). Jimmy McNulty (*The Wire*).

No wonder we might feel we've reached saturation point. Indeed, that aforementioned Wikipedia list of anti-heroes has been flagged with a community note since 2016 for "containing excessive examples."

Fielding's contemporary, writer Samuel Johnson, criticized what he saw as a tendency for eighteenth-century authors to mingle good and bad in their characters to make them more lifelike, because the reader would then "accompany them through their adventures with delight," "interest ourselves in their favor," and "lose the abhorrence of their faults, because they do not hinder our pleasure." He would probably be horrified if he could attend a comic con today and see just how *much* we're rooting for the anti-hero.

Why are anti-heroes so appealing? Psychologists might argue that it's because they act on their base impulses without giving a damn about social propriety. Constrained as we are by etiquette and normativity, we enjoy living vicariously through them for a little while. We all have "shadow sides," according to Carl Jung; Sigmund Freud argued that we are driven by our "id," which seeks to fulfill our basic drives (toward pleasure, for example), but we have to rein it in to fit in in polite society. Anti-heroes don't bother to

hide their shadow sides or quash their ids. Watching or reading them, we fantasize about how it might feel to live with that sort of freedom.

It's exactly what we see in Swift's video for "Anti-Hero." Her shadowy, id-motivated doppelgänger is having a lot more fun, to the point where her straitlaced self (seemingly representing the Freudian superego) is compelled to say, "fuck it," and join in. Shot glasses at the ready.

Another explanation is that anti-heroes, with all their flaws, are simply more *interesting*. I'm reminded of Sir Galahad, Lancelot's son, in the King Arthur legend. Galahad is *too* perfect: he's so pure that he is one of the only knights to achieve the Holy Grail. He never puts a foot out of line, and for this reason, nobody likes him. Novelist T. H. White describes him as "inhuman" and makes fun of his abstemiousness in his Arthurian novel series, *The Once and Future King*. White's Gawain describes Galahad, disdainfully, as "a vegetarian and a teetotaller." When all the young boys are playing at battle, White's Galahad prefers to cuddle a rag doll he calls "The Holy Holy." There's a reason most people are more likely to have heard of the adulterous, conflicted Lancelot than of his boring, perfect son.

Perfect characters are not very watchable characters. It's why Captain America is the least interesting Avenger. It's perhaps the same reason for Swift's *Reputation* being such a fan favorite. This is the album where Swift publicly and ostentatiously seemed to give up on being a people-pleaser and America's "good girl." Not only did *she* claim to feel more alive after the death of (worrying about) her reputation; fans were also enlivened by this more multifaceted persona. Laura Snapes wrote in the *Guardian*: "I thought she had never been more relatable, trashing the contract of pious relatability that traps young women in the public eye."

Swift has always been good at identifying and capitalizing on trends, and so perhaps it's no coincidence that *Reputation* emerged as the female anti-hero was having a bit of a cultural moment. The wonderfully calculating and ruthless Cersei from HBO's *Game of Thrones*, for example: Swift said the show was influential on her writing of the album (she claimed to have taken her life and put it through a "Game of Thrones filter"). We also had Carrie Mathison from *Homeland*; Phoebe Waller-Bridge's *Fleabag*; Elizabeth Jennings from *The Americans*; *Killing Eve*'s Villanelle and Eve Polastri; *Gone Girl*'s Amy Dunne; and *House of Cards*'s Claire Underwood, to name but a few.

The female anti-hero has—deservedly—had rather a lot written about her in recent years. Much of it seems to agree on the essentials: that a female anti-hero (or anti-heroine) is fundamentally different from a male anti-hero, and this difference is in fact one of the *root causes of* her anti-heroism.

Melanie Haas, N. A. Pierce, and Gretchen Busl, in their book *Anti-heroines of Contemporary Media*, argue that the female anti-hero, like her male equivalent, is a flawed protagonist who makes moral compromises. The key difference is that the female anti-hero's moral compromises are judged *by*, and within the context *of*, the patriarchal system that necessitates them. The ways female anti-heroes refuse to submit to the "normal"—perhaps by not having or wanting children; perhaps by refusing to compromise career for family or romance—only remind us that "normal" is an arbitrary notion used by the patriarchy to define, limit, and subdue women.

Sarah Hagelin and Gillian Silverman point out that all the things the (male) anti-hero has historically rebelled against— "domesticity, convention, narrowly defined morality"—tend to be coded as female. The role of the woman in anti-hero fictions was, historically, to try to shepherd the male anti-hero back into

the world of polite society, much to his scorn and the scorn of the audience. We see this, still, in what has been termed "The Skyler Effect," after an outpouring of public hostility toward the fictional wife of Walter White in *Breaking Bad*. As Marion Johnson wrote in the *Huffington Post*: "a female character judges the male protagonist's bad behavior in a completely rational way, and the audience hates her for it." Skyler was described as "a cold and emotionless nag," "a henpecking woman," and a "killjoy."

Yet when a woman follows a man down the mazy path of the anti-hero—as Skyler eventually did, becoming complicit in the murky world of Walter's drug business—we still hold her to different standards, as Anna Gunn (the actress who played Skyler) pointed out.

Female anti-heroes seem to trouble us more than male anti-heroes because women are so often seen as holding the fort of society together. I'm reminded of the 1975 Women's Strike in Iceland, when almost 90 percent of the female population withdrew their paid and unpaid labor for a day, and the entire country ground to a halt. What if all women became anti-heroes of sorts, by going against the currents of social expectation? By asking themselves (to quote Hagelin and Silverman again):

> what if I don't want to have it all—career, marriage, children, friends? What if I reject the responsibility of shepherding broken men and a beleaguered economy into the twenty-first century? What if I only want raw naked power? Or, even worse, absolutely nothing?

Female anti-heroes reject many of the burdensome expectations that society tends to place disproportionately on women. *Homeland*'s Carrie and *The Americans*' Elizabeth do not want to "have

it all": they refuse to prioritize motherhood, family, or friendships over what they see as their vocations. *Girls'* Hannah Horvath freeloads off her parents and rejects responsibility and accountability. *Game of Thrones*'s Cersei pursues raw naked power and her own (raw naked) gratification, stating boldly that she "does things because they feel good," including killing her husband, having sex with her brother, and masterminding numerous murders. While many female anti-heroes utilize violence as a last resort, as a form of vigilante justice for—usually—sexual assault (think of Larsson's Salander, and Carey Mulligan's Cassie in *Promising Young Woman*), reveling in gratuitous violence, à la Cersei Lannister, is perhaps the ultimate expression of anti-heroism in a world that still associates women primarily with nurture and peacemaking. It's a source of shock value that Swift leaned into on *Reputation*, with all its allusions to gunfire and hatchets.

Emily Nussbaum, writing in 2013, identified Carrie Bradshaw from *Sex and the City* as the "first female anti-hero on television." But if we turn to English literature, we find nearly three centuries' worth of anti-heroes who could give Carrie a run for her money. Several of them in fact share her love of sex, shoes, and fine fashion.

In the 1720s, Daniel Defoe—author of *Robinson Crusoe*—penned two novels, *Moll Flanders* and *Roxana*, whose eponymous protagonists could certainly be described as anti-heroes; it's fitting that the word had entered the English language only a few years prior. Both women have malfunctioning moral compasses. They lie, cheat, and sleep around to make their way in the world. But they're also uniquely *female* anti-heroes, in that they use the tools available to them within an oppressive patriarchy—mostly their sexuality, but also their perceived vulnerability and naïveté—to protect themselves, safeguard their interests, and critique the system in which they find themselves. Indeed, Roxana tells us that she is offering

us her story to reveal the "black scheme" of "how unhappy women are ruined by great men."

What if a woman were to turn the tables, and try to secure happiness by *ruining* great men? To go from a pawn in a lover's game, to a player? In 1847, British author William Makepeace Thackeray published *Vanity Fair*, subtitled "A Novel Without A Hero." He warned readers who admired "the great and heroic in life and novels" to "take warning and go elsewhere." Later in the novel, though, he changes his mind: "if this is a novel without a hero, at least let us lay claim to a heroine." That (anti)heroine is Becky Sharp, orphaned daughter of an impoverished French "opera girl" (perhaps prostitute), whose name reflects the keenness of her wits and intelligence. Seeking to rise in society at all costs, Becky constantly schemes and lies, seducing and manipulating various suitors—including her best friend Amelia's husband—in pursuit of her ultimate goals. She's someone Swift might have been writing about in ". . . Ready for it?": stealing hearts, running off, and never saying sorry.

Canadian novelist Margaret Atwood praised Becky's characterization in a 1993 interview, describing how she uses men "as ambulatory bank accounts," and "makes no pretensions to goodness." She is a terrible mother, a terrible friend, and a terrible wife. She is "wicked, she enjoys being wicked, and she does it out of vanity and her own profit, tricking and deluding English society in the process."

We might see the forerunner of Moll, Roxana, and Becky in Lady Macbeth, whom Atwood used as a kind of shorthand for the female anti-hero in that interview. Discussing the protagonist of her new book, *The Robber Bride*, Atwood asked, "Where have all the Lady Macbeths gone?" Shakespeare's infamous Lady is willing to sacrifice anything for the power of being queen—she tells us she

wouldn't falter in dashing out the brains of her breastfeeding baby if she'd pledged to do so; Macbeth should do the same and "be so much more the man" ("man up," but in Shakespearean) and kill the king. Her anti-heroism inspired Russian author Nikolai Leskov, who wrote a novella in 1865 titled *Lady Macbeth of the Mtsensk District*, in turn adapted to opera and, more recently, to a film featuring Florence Pugh. Leskov's "Lady Macbeth," in a loveless marriage, embarks on an affair with a farmhand and murders everyone who threatens to get in the way, including a child. While it might be tempting to label her a villain, I still root for Leskov's "Lady Macbeth"—particularly Pugh's compelling portrayal of her—in a way I simply wouldn't for a man in the same scenario. Her anti-heroism never quite tips over into overt villainy, squarely rooted as it is in the desire to hold a trembling, manicured middle finger up to the strictures of upper-class nineteenth-century patriarchy.

Atwood framed her protagonist in *The Robber Bride* as a sort of reincarnated Lady Macbeth. She's a woman called Zenia who betrays her female friends, seduces and then discards men, and continually reinvents herself. This woman has "been around since Delilah," Atwood points out, and will continually return "in another form, in another book."

The female anti-hero, then, is not a new phenomenon at all. We're just more able to label her in a twenty-first-century mediascape characterized by a love for the catchy buzzword.

Has Lady Macbeth found a twenty-first-century form in Taylor Swift, though?

Hagelin and Silverman point out—along with Swift herself—that we may root for anti-heroes. We may even like them. But we rarely admire them. If this is the case, then it's hard to argue for Swift as an anti-hero. Fan behavior toward Swift encompasses many things, and one of them is certainly admiration. Cat Strav's

article on *Medium*, "Why I Admire Taylor Swift; and You Should Too," offered "four solid reasons" to admire *Time*'s 2023 person of the year. Celebrities including singers Maren Morris, Keith Urban, Dolly Parton, and Nelly Furtado, and British Indian actress Alia Bhatt, have publicly expressed their admiration for her. Even J. D. Vance, nominee for Republican vice president in the 2024 US elections, grudgingly admitted "we admire Taylor Swift's music" after Swift endorsed the Democratic ticket.

Perhaps it's more accurate to see Swift not as self-styled anti-hero, but instead as leaning into a slightly different trope: the "unlikable woman." This is certainly the case on *Reputation*, where she sings that her reputation has never been worse and fashions herself as a femme fatale on songs like "Don't Blame Me" and "End Game." It was also true on *1989*, with "Shake It Off" enumerating multiple reasons not to like its protagonist. Then "The Archer" (who could stay?), "the last great american dynasty" (she ruined everything), and "Who's Afraid of Little Old Me?" (we should be).

Although the anti-hero(ine) and the unlikable woman are often lumped together, there are subtle differences. The unlikable woman does not necessarily have the cloudy morality or act in the dubious, potentially destructive ways of the anti-hero. Her unlikability may not, in fact, have much to do with her at all. The title of Bryony Gordon's 2023 feminist book, *Mad Woman: How to Survive a World That Thinks You're the Problem*, is telling. Unlikable women are not necessarily *inherently* unlikable (value is never an objective concept); rather, they are disliked because they don't fit in with societal expectations shaped by centuries of misogyny.

In other words: maybe I'm *not* the problem, it's *not* me.

Female unlikability can take many forms. Women might be seen as just "Too Much," to quote the title of a book by Rachel Vorona Cote, which examines how women are still judged by

Victorian standards in the twenty-first century. Literary scholar Anastasia Klimchynskaya sees this "too muchness" as the defining characteristic of Taylor Swift's work: going beyond what is culturally accepted as normal and reasonable when it comes to emotion and expression. Unlikable women might also be "unruly," as Anne Helen Petersen identified in her book *Too Fat, Too Slutty, Too Loud*. They might be "insufferable prima donnas, pedantic schoolmarms or witchy women," according to law professor Joan C. Williams. Perhaps they're too ambitious, as the frequent critique of Swift's "overlong" Eras Tour or multiple album variants seems to imply. Unlikability might appear in the shape of our old friend from Chapter Nine, hysteria, or the "mad woman." There's also the "nasty woman," as Donald Trump famously described Hillary Clinton, and the complex term "bitch," one of the oldest words in the English language and applied by Swift to herself in "I Can Do It with a Broken Heart."

That women's unlikability is noted and judged much more than men's—a fact backed up by academic research—suggests that society expects women, more so than men, to be likable—and to expend as much time and energy on this as it takes. Writer and professor Jessica Bennett was once asked to recommend a "likability coach" for a woman professional. Author Heather Critchlow was interviewed about her novel *Unsolved*, and asked: "Your main character Layla is engaging, but is she likeable? Would you like her as a daughter in law?" Similarly, novelist Claire Messud was asked, regarding the protagonist of her novel *The Woman Upstairs*, "I wouldn't want to be friends with Nora, would you?" Messud rebuked the interviewer: "What kind of question is that?" It's hard to imagine a fictional male character being judged by whether or not one would want to be friends with him or have him as a son-in-law. As Messud countered: Would

you want to be friends with Nabokov's Humbert Humbert, Hamlet, or Oedipus?

We find plenty of women in literature who, despite not being friend or daughter-in-law material, have captured the popular imagination over the years. Jane Austen's Emma—whom Austen said no one would like but herself—is indeed a pretty bad friend for the bulk of her eponymous novel. Edith Wharton's Undine Spragg, from her novel *The Custom of the Country*, turns out to be a terrible daughter-in-law several times over: she marries, cheats on, and divorces various men out of self-centered boredom and to satisfy her financial goals. Yet I found her one of the most glorious fictional characters I've ever read, and I'm not alone: Julian Fellowes, creator of the British television series *Downton Abbey*, was inspired to start writing after seeing Wharton's genius in keeping the reader rooting for the thoroughly awful Undine.

When I teach this class in English Literature (Taylor's Version), we focus on Charlotte Brontë's novel *Villette*. It's Brontë's most autobiographical novel, drawing heavily on her time spent in Belgium, and thus is infused with what Brontë identified early on as her own too-much-ness: her inability to imitate "the serene and equable spirits" she saw in other women. The novel's protagonist, Lucy Snowe, is nearly universally disliked by my students. They're not alone: literary critic Matthew Arnold described *Villette* upon its publication as a "hideous, undelightful" novel, containing "nothing but hunger rebellion and rage."

"Undelightful" thus joins society's long list of euphemisms for an unlikable woman.

Lucy is hardly killing babies or plotting political domination, though. Her main sins seem to be, in the words of Brontë's contemporary, Harriet Martineau, "chronic nervous fever," being "silent and suffering," and speaking in "enigmas." She's the definition of

the unreliable narrator, telling us in Chapter Sixteen that she actually recognized one of the characters as a childhood friend, whom the reader also knows, from back in Chapter Ten, but didn't feel the need to inform us.

Swift's "Dear Reader" could have been written about Lucy Snowe. Pick somewhere on a map and just run? She does exactly this: witnessing the northern lights in the sky above England, she hears them tell her to "leave this wilderness and go out hence." Packing her meager belongings into one case, she chooses Belgium; there doesn't seem to be any particular reason why. Burn all the files and desert all your past lives? Lucy ends up in Brussels as a woman with almost no backstory or connections. So enigmatic is she that her employer, schoolmistress Madame Beck, snoops around her belongings while she thinks Lucy is asleep. Swift's line, "you don't have to answer just cause they asked you," might be Lucy's whole life philosophy. She even refuses to tell the reader exactly what happens to her fiancé at the end of the novel—the greatest of luxuries does indeed seem to be her secrets. Lucy is loath to give her heart to anyone, for fear of being "struck stone blind"; to paraphrase Swift, she chooses to be safe rather than starry-eyed. "We can never be rightly known," she says, either by ourselves or by others. It's the same message we find in Swift's prologue to *Reputation*.

Anna Bogutskaya, in her book *Unlikeable Female Characters*, argues that "if you are deemed unlikable, you have refused to be a part of the machine of femininity." Arnold seeing *Villette* as "undelightful" and full of "rebellion" perhaps tells us more about him—and that "machine"—than about Lucy Snowe. Lucy is a young woman who refuses to capitulate to anyone. She tells us that the happiest years of her life were when her fiancé was away at sea, for she seeks total independence: she tells her friend Paulina that "I shall share no man's or woman's life in this world, as you

understand sharing." She's surrounded by characters who show-case different types of ideal femininity: the beautiful flirt Ginevra (whom Swift could have been describing in "The Bolter"), and the demure, devoted daddy's girl Paulina (who would certainly never have written "But Daddy I Love Him"). They tell Lucy they cannot understand her life choices. In refusing the typical accoutrements and trajectory of an ideal Victorian lady, Lucy mystifies both her peers and her readers. How interesting that we tend to express this mystification as dislike, and to blame Lucy for it, rather than our own prejudices and expectations.

In the twenty-first century—in what Swift has termed our "enlightened" and "emboldened" state—we are asking, with increasing urgency: *why* do we consider certain women unlikable? Moreover, should women even *aspire* to be liked?

Likability, as writer Terri White points out, is a trap. Consider Amy Dunne's much-quoted monologue from Gillian Flynn's *Gone Girl*, on the subject of the "Cool Girl," which might as well read "likable girl": she never gets angry, just smiles, and always lets men do whatever they want. "Men actually think this girl exists," Dunne says scornfully. These are the men who might say, along with Swift's "Smallest Man Who Ever Lived," that "normal girls are boring." Maybe, Dunne speculates, these men are fooled "because so many women are willing to pretend to be this girl." Unfortunately, we see this play out beyond the pages of fiction. Samantha Pergadia conducted a thoroughly depressing analysis of Netflix's reality TV series *Love is Blind* in the *Los Angeles Review of Books* in 2023, observing how multiple women desperately attempted to fashion themselves as the "Cool Girl" (also known as the "pick-me girl") in order to try and turn themselves into more perfect objects of male desire and thereby achieve the Victorian-style "marriage plot."

As writer and professor Roxane Gay argued in a 2014 essay, "likability is a very elaborate lie, a performance." Even Thackeray realized this back in the nineteenth century: the narrator in *Vanity Fair* points out that the women whom other *women* find heroic are much "more glorious and beautiful" than "the kind, fresh, smiling, artless, tender little domestic goddess, whom men are inclined to worship."

Unlikable women refuse to perform for us. Gay likens them to the reality TV contestant who announces in the first episode, "I'm not here to make friends," freeing themself from the burden of likability. They are all the better for it: "fully realized, interesting, and realistic characters" who do bad things and get away with it, make mistakes, act selfishly, and speak their minds—without apologizing.

Is Swift passionately declaring herself to be "the problem" an empowering feminist statement, then? A reclamation of women's right to *not* be likable?

Maybe. But it's a little more complicated than that.

We need to think about Swift's anti-heroism in the context of *postfeminism*: the notion that feminism's goals have mostly already been achieved, rendering further effort, activism, and development largely unnecessary. We need to consider whether some of this performative female unlikability might actually call into question the entire notion of women's empowerment.

Under postfeminism, feminism is presented as not much more than the freedom for women to go shopping, have as much or as little sex as we want, and indulge in self-care. It's closely tied up with capitalism: women can be feminists simply by wearing the right T-shirt—perhaps one with a catchy slogan such as "I'm the problem, it's me" or "mad woman"—or perhaps by purchasing a series of "Kimojis" (emojis designed by Kim Kardashian) themed

around "women's empowerment," in honor of International Women's Day, for a bargain $2.99. To quote Mona Chollet, "what could have once gotten a woman killed is now available for purchase at Urban Outfitters."

At the same time, those doing important, involved feminist work may be written off for being "too extreme": what Sara Ahmed terms "feminist killjoys." In 2021, the Danish parliament condemned "excessive activism" in academia, particularly research focusing on gender studies and critical race theory. Activist Hawon Jung noted that when she shares stories on social media about women's rights issues in South Korea, "I get comments from men in the US or UK, saying 'This is the real feminism, unlike the feminazis in our country.'" Jozefien Daelemans, founder of the Flemish feminist "bookzine" *Charlie*, which ran from 2014–2019, recalled in 2020 that the "taboo-free" publication struggled with financial support because it was labeled "too feminist" or "too extreme."

Bogutskaya points out that our current era is trying to monetize the idea of female unlikability in the same way pop culture has monetized feminism—in other words, in a way that strips it of most of its political power. In 2017, *Screen Rant* declared that Netflix was "ruling TV with unlikable female leads," a clear indication of the lucrative potential of the unlikable woman. You can even now buy T-shirts with WARNING: UNLIKABLE FEMALE PROTAGONIST emblazoned across the chest. Bogutskaya recalls, witheringly, the way in which "girlboss" in the 2010s served as "White feminism's attempt to make bare-faced capitalism seem like social activism." Now, it would seem, White feminism has identified similar potential in unlikability.

Unsurprisingly, Taylor Swift has capitalized on this potential. Bogutskaya divides the unlikable women on our television screens into several categories, including the Slut, the Angry Woman,

and the Crazy Woman. The former two are (almost) the titles of Swift songs ("Slut!" and "mad woman"), and the latter is the topic of "Blank Space," whose lyrics and video were intended by Swift to satirize the trope. Essayist and critic Angelica Jade Bastién describes the unlikable woman as "your ex-girlfriend with smeared red lipstick refusing to quiet her anger during an argument," which is a perfect description of several of the tableaux from the "Blank Space" video.

At the time of writing, Swift also seems to have anticipated further marketing potential for the angry woman in particular. Having referred to the *Tortured Poets Department* Eras Tour set as "Female Rage: The Musical," Swift soon afterward trademarked the term, hinting at future developments that will surely come with a price tag. As the *Huffington Post* pithily put it, "Taylor Swift the Feminist (©Taylor Swift) asks not what she can do for feminism, but what feminism can do for her."

I find it interesting to compare Swift's ostentatious and lucrative anti-heroism to American author Ottessa Moshfegh's 2018 novel, *My Year of Rest and Relaxation*. Author Lincoln Michel has said of Moshfegh's novels in general that they are "almost like an attempt to see just how 'unlikeable' characters can get," and the unnamed protagonist of this one is no exception. She's an attractive, wealthy, educated, twenty-six-year-old New Yorker, who—bored, disaffected, and jaded with everything—decides to "hibernate" for a year to reset her life. She does this by seeking out a quack psychiatrist and fabricating symptoms to gain increasing quantities of sleeping pills, antianxiety, and antipsychotic medication, which she uses to sink herself into a stupor.

Disappearing for increasingly long naps in the supply closet at work, our protagonist is eventually fired. It's a clear sign that her plan—a self-imposed version of the Rest Cure discussed in Chapter

Nine—is incompatible with capitalism's demands. Those demands are symbolized by her "best friend" Reva (although the protagonist spends most of the novel bad-mouthing her), "a slave to vanity and status" who is always quoting from women's magazines, self-help books, and Oprah. When the protagonist tells Reva about being fired and her hibernation plan, Reva sees it as a positive breathing space to figure out her life goals, quoting from *GQ*. The protagonist is scornful: "I'm not making a career move," she snaps. "I'm going to sleep for a year."

Moshfegh's novel has been hotly debated. Some see it as a satire of privileged White women, while others—like Michel—see the protagonist as "a feminist hero who decides it is better to sleep away than lean in." She rejects society's norms and embraces her own selfish desires, regardless of how unlikable it makes her. She could also be both of these things: a blackly comic satire of the messages women are fed about how to live up to their full potential—provided that potential doesn't disrupt the patriarchy, of course.

What would it mean to drop out of this entirely—assuming that one had the privilege to do so?

This is, of course, where Swift differs. Swift never drops out or stops leaning in like Moshfegh's unlikable protagonist does. The COVID-19 pandemic, a period when Swift would have been excused for dropping out (along with most of the rest of the world), led to her most productive year of all time in terms of output. Even her hiatus from public life, following her 2016 "cancelation," became conceptual fuel for an entire album—an album which, significantly, hinged on fashioning herself as an unlikable protagonist.

The line in "Anti-Hero" about disguising narcissism as altruism, like "some kind of congressman," is an important clue as to how to interpret Swift's ostentatious anti-heroism: with a pinch of salt.

An anti-hero does not bother to disguise their narcissism. A female pop star who wants to appeal to as many people as possible—who once admitted she had "been on the internet for hours every single night figuring out what these people want from me"—does. Indeed, when the bathroom scale moment from the "Anti-Hero" video drew accusations of fatphobia, it was quickly cut. Maya Georgi from NBC News noted that Swift had "once again let criticism control her actions," abandoning the opportunity for what could have been a scathing critique of the standards by which we judge women's bodies. Less of an anti-hero and more of—to quote "You're Losing Me" instead—"a pathological people-pleaser" (Swift was damned when she did, but probably would also have been damned if she hadn't; as a friend of mine pointed out when reading this, is simply just *being* a woman in the public eye enough to make you inevitably an anti-hero?).

Modern representations of the female anti-hero have a tendency to make her a poster girl for what Hagelin and Silverman term "aggressive individualism." One of the reasons we might find the protagonist of *My Year of Rest and Relaxation* unlikable is because she is entirely selfish and individualist. While this selfishness could, in itself, be seen as a feminist statement—women are so rarely *allowed* to be selfish—it also raises interesting questions about what impact the lone female anti-hero might really have, in feminist terms.

The modern, aggressively individualist female anti-hero does what she wants. Her wants are often anchored in consumerist individual lifestyle choices, whether that's FEMINIST T-shirts or products geared toward self-care. Or, in the case of the character Swift created for "Blank Space," reveling in one's unlikability from within the comforts of one's million-dollar mansion. In her book, *Why I Am Not A Feminist*, Jesse Crispin points out that "lifestyles

do not change the world." Yet we are fed films, TV, and books in which supposedly enlightened and emboldened protagonists embrace a version of "feminism-lite" via shopping, sex toys, and girls-only mimosa brunches. As Bree Rody-Mantha wrote, in an article titled "Your Girl-Power Consumerism Isn't Feminism": "How did we fall for this?"

We might consider the Taylor Swift phenomenon from this perspective. For Swift is nothing if not aggressively individualist. In spite of collaborations with other artists, family support, and celebrity friendships, Swift's success story is framed by the media and her fans as very much an individual effort: the wannabe country singer from Pennsylvania who found her way to the top through hard work and dedication, and whose narrative is—as explored in Chapter Eleven—one of "Swift vs. the rest of the world." This is also true of her self-fashioned anti-heroism and unlikability: songs like "Anti-Hero," "The Archer," "Dear Reader," and, most explicitly, "You're on Your Own, Kid" frame the speaker as completely alone in her plight. In a scene from the "Anti-Hero" video, one Swift shows the other a blackboard pronouncing "EVERYONE WILL BETRAY YOU." Abandoning the "Girl Squad" aesthetic of *1989*, Swift's *Reputation* focused on the disappearance of "fair-weather friends," fixating on Swift and Swift alone, as the victim of "all the he said, she said."

And, as with that victim narrative, Swift's self-attributed anti-heroism should also prompt us to ask the question: Who *gets* to be an anti-hero?

In short: mostly White people. Writer Sezin Devi Koehler, in a piece for the website *Black Girl Nerds*, points out that anti-heroes are predominantly White, and their Whiteness protects them from the legal consequences of their often-criminal actions "in ways that people of color don't benefit from, in real life or on

screen." Koehler argues for the White anti-hero as "one of the cornerstones of white supremacy in visual media," humanized for morally dubious actions and given the benefit of the doubt in ways that almost never extend to people of color in fiction or in real life. This includes fan responses, too: as graphic novelist Ngozi Ukazu pointed out, fandom is a "predominantly White space" that rarely honors characters of color (including anti-heroes) with the same amount or type of content than they do White characters. In an article for *Teen Vogue*, fandom writer Stitch cited the example of *Black Panther*'s Erik "Killmonger" Stevens and *Loki*'s Kang the Conqueror, arguing that behavior that is charming when a White anti-hero does it is used as a reason to dislike a non-White character.

While the female anti-hero may parse some kind of feminist critique, she is nearly always White. Bogutskaya points out that women of color are rarely given the same nuanced characterization, instead slotted into convenient archetypes based on racist stereotypes (the "Angry Black Woman"; the "Spicy Latina"). When great Black anti-heroes do appear on screen, they are usually played or written by Black actresses or producers: Shonda Rhimes's Olivia Pope in *Scandal*; Viola Davis's Annalise Keating in *How To Get Away With Murder*; Janine Nabers and Donald Glover's TV miniseries *Swarm*, which centers Black women in its exploration of toxic fandom.

To quote Anne Helen Petersen, "the difference between cute, acceptable unruliness and unruliness that results in ire is often as simple as the color of a woman's skin." We see this uncomfortably played out in the way some of Swift's most public "beefs" have been with women of color (Kim Kardashian; Nicki Minaj; lines uttered by multiracial character Ginny in the Netflix show *Ginny & Georgia*), who have then been hounded as unlikable (or worse)

by Swift fans. Yet Swift can mock Kardashian for experiencing a robbery at gunpoint (the "Look What You Made Me Do" video) and utter a line about her mother wishing Kardashian dead with apparent impunity ("thanK you aIMee"); any unlikability there is excused or even celebrated as a feminist power move. The *Guardian* pointed out that media coverage of the Minaj and Swift spat tended to archetype Minaj as the "angry black woman," with Swift as the "feminist hero," by using photos of Minaj "pulling faces or looking daft" and of Swift looking "soft, delicate, and 'unthreatening.'"

As Laura Bennett pointed out in 2013, the very idea of the anti-hero has become so overused as to lose all meaning. Could it be that Swift's appropriation of it, far from being radical or feminist, is just another sign that the centuries-old trope is long overdue for an overhaul?

In 2022, it was announced that HBO would adapt Black American novelist Toni Morrison's 1973 novel *Sula* as a television series. Sula, the novel's titular protagonist, is raised by a mother with a reputation for promiscuity, in a Black community called "The Bottom" in Ohio during the 1920s. As a girl, she accidentally causes the death of a young boy by drowning, and later does nothing as her mother burns to death after her dress catches fire; her best friend Eva speculates that she simply watches out of curiosity. She leaves the community for several years and returns with her own reputation for promiscuity, having multiple affairs with multiple men, including White men and Eva's husband.

Responding to a post in the Reddit /r/books community that described Sula as a psychopath or sociopath, one commenter asked: "Do you think your instinct to assume Sula is a sociopath rather than a complex female character stems from your lack of familiarity with Black culture?" Another replied, "I can tell which readers are non black or white by their interpretation of this book,

the dehumanization renders them incapable of truly viewing these characters with the nuance and complexity they require and demand." It's another example of the double standards to which characters of color are held, particularly those that exhibit behavior we would relish as watchably anti-heroic in White characters.

Black poet Siaara Freeman recalls *Sula* as the first time she "saw a Black woman written so uncompromisingly." She describes Sula as "my anti-hero, my mirror": she is "strange, defiant, imaginative, curious, lonely, remorseful but hardly ever sorry," mingling innate self-love with self-preservation. Morrison wrote the novel to explore "what choices are available to Black women outside their own society's approval." She pointed out that "in much literature a woman's escape from male rule led to regret, misery, if not complete disaster. In *Sula* I wanted to explore the consequences of what that escape might be," on both a socially static Black community and on female friendship. The result is what writer and poet Elizabeth Haddad terms "an important and refreshing novel for our times because it refuses to deduce anything or anyone. And are we not in an age of tireless deduction?"

HBO's forthcoming *Sula* series, created and written by Black screenwriter Shannon M. Houston, will no doubt be an important development in the life of the female anti-hero. In danger of being commodified, cloned, and divested of all her political potential, the female anti-hero could, and should, be shaken up. Sula is, in Morrison's words, a "New World Black woman" who's "not going to take it anymore.... She's available to her own imagination. She's available for her own imagination, and other people's stories, other people's definitions are not hers."

It's not a million miles away from what Sophie Gilbert voiced in *The Atlantic* in 2024: that Taylor Swift, who has "long constructed her identity out of archetype, cliché, and torn-up fragments of

Americana," has run out of identities to perform and cultural models to emulate and appropriate (and, if we're being honest, commodify). What might it mean for Swift, and for all of us—whether as creators or consumers—to try and pierce through the clichés, prejudices, and blind spots surrounding the female anti-hero and/or the unlikable woman? To appropriate her not as an easy shortcut to postfeminist edginess, but to see her as a starting point for interrogation and critique? Not to exhaust ourselves rooting for the anti-hero, but to question whether we have, in fact, *exhausted* the anti-hero and emptied her of meaning—and to ask how we might get some of that meaning back. Given that the anti-hero started with literature, it seems fitting that we might find use in literature to revive and reclaim some of her potential.

I want to end with a thought from media scholar Amanda Lotz. She points out that, when series and characters resonate with a large audience—in the way of *Game of Thrones*, *Girls*, *Sex and the City*—we shouldn't be too quick to dismiss them as merely products of, and therefore complicit in, a patriarchal capitalist system. Instead, we should look critically at them and explore *why* they might be so popular, and how we might work with that as a starting point. While such series may not be radical, they might be the first encounters that some young women have with feminist themes, good and bad: depictions of both female empowerment and of rampant sexism and misogyny. These encounters might engage curious viewers, prompting them to seek out like-minded others with whom to share their thoughts, and lead them to other books, films, or series to satisfy their curiosity.

This is how I've come to see Swift, too. I have taken to describing her as a "gateway drug" for feminism and politics. In 2014, Swift told an interviewer that she always brings up feminism in interviews "because I think it's important that a girl who's 12 years old

understands what that means and knows what it is to label yourself a feminist, knows what it is to be a woman in today's society, in the workplace or in the media or perception." While Swift may present a version of feminism-lite that is White, immensely privileged, and not remotely intersectional, one that is clean and palatable enough to sell well without alienating her colossal fan base, this might also be a stepping stone on the way to greater curiosity among that mostly young, female fan base.

It took me well into my twenties to embrace feminism. Having grown up in the deeply toxic environment of an all-girls private school, I'm ashamed to say that my adolescence was mostly spent exhibiting the behaviors we might now identify as consistent with a "pick-me girl," trying desperately to fashion myself into the "Cool Girl" that I thought I needed to become to survive. I used to consider it a point of pride that I didn't have any female friends; "girls are too bitchy," I'd declare, unwittingly offering up more of a telling comment about myself than other women. I am thrilled when I talk, now, to Swifties in their early teens, whose grasp of feminism (not to mention politics, economics, intersectionality, environmentalism, and fashion) is already sharper, more passionate, and more nuanced than mine was at age thirty.

Sure, we probably can't credit Taylor Swift entirely for this, but if she's prized open that gateway even a sliver, then I'm not going to complain. If she has helped to make rooting for the anti-hero inspiring and galvanizing, rather than exhausting, then I think we can absolve her of at least some—if not all—accusations of being "the problem."

Chapter Thirteen

A Book Covered in Cobwebs:
Adaptation and Afterlives

Forever—is composed of Nows
—Emily Dickinson

The final track on Taylor Swift's 2024 album *The Tortured Poets Department (TTPD)* is called "The Manuscript." It begins by narrating, in the third person, the story of a girl looking back on a torrid affair that her lover insisted was "above board," despite their age difference. It leaves her heartbroken. Later, inspired by that old cliché, "write what you know," she turns the story into art, watching it played out by actors in front of her eyes. The song then switches to the first person, implying that the girl in the song has been Swift all along. It ends with the line, "Now and then I re-read the manuscript. But the story isn't mine anymore."

I wonder if William Shakespeare thought something similar when he dotted the final "i"s and crossed the final "t"s on *Romeo and Juliet*—a story that was never entirely *his* anyway, since it came originally from Italian writer Matteo Bandello. Or Charlotte Brontë, when she sent the manuscript of *Jane Eyre* off to her publisher, where it would be published as someone *else's* story, under the pseudonym Currer Bell. Or J. M. Barrie, when

he finally finished turning *Peter and Wendy*—a story that had gone through many evolutions—from a stage play into a novel; one that would then experience countless transformations in the decades to come.

These are all stories that have been taken up by Taylor Swift over the years. They're the main reason that this book you're now reading exists. Once upon a time, an English literature professor noticed the presence of these stories in Taylor Swift's own stories and started making plans. The media heard *her* story, and so did an interested publisher. So she wrote it down, interweaving it with other stories—from her students, colleagues, detractors, and friends. Now this story isn't mine anymore, either—it's in your hands.

What happens when we retell other people's stories? What does it mean for William Shakespeare to be given an afterlife—one of many—in the shape of a catchy American pop anthem from the twenty-first century? What relationship does Taylor Swift's line "Peter losing Wendy" have to Barrie's *Peter and Wendy*, and why might it matter? Is Taylor Swift a vampire?

That last question might seem like a curveball, but bear with me.

When English Literature (Taylor's Version) featured in the media in the summer of 2023, one journalist in Belgium published a disapproving newspaper column. He expressed his fervent hope that students today wouldn't need Taylor Swift to be interested in Sylvia Plath. In fact, this was the headline that the newspaper ran with. His comment implied that to approach Plath's work *via* Taylor Swift would be a kind of contamination. It would degrade and devalue Plath's original. Plath's work, it would seem, has artistic purity and dignity in its own right, which would be sullied by tarring it with Swift's glittery pink brush.

You may have seen similar sentiments in response to modern retellings of "classic" or "canonical" works: the idea that an adaptation

has irrevocably ruined or tainted the original. When Baz Luhrmann's *Romeo + Juliet* film adaptation was released in 1996, critic Roger Ebert said that he had "never seen anything remotely approaching the mess that the new punk version makes of Shakespeare's tragedy." The *Guardian* wrote that Philip Pullman's "literary triumph," *Northern Lights*, was "turned to dust" by Chris Weitz's 2007 film adaptation, *The Golden Compass*. Writing on Netflix's 2022 adaptation of Jane Austen's *Persuasion*, Kayleigh Donaldson described it as "a poorly made film that saps one of the most beloved novels of the 19th century of everything that makes it so beloved. It strips *Persuasion* of its yearning, its intricate social dissections, and complex characters, and leaves behind a derivative mess."

"It ruined the book" has become something of a cliché in response to Hollywood's rampant conversion of beloved literature into film versions that are often mediocre at best. Gary Dauberman's film adaptation of Stephen King's novel *Salem's Lot* was described as "sucking the blood out of a Stephen King classic." Adaptations take many forms, of course, and it's not only the book-to-film trajectory that comes under fire. The 1998 film-to-film remake of Hitchcock's *Psycho* was described by film critic Adrian Martin as proving "you can mechanically copy all the surface moves of a screen classic and still drain it of any meaning, tension, artistry, and fun." Madonna's "affectionless" cover version of "American Pie" was described by the *Telegraph* as "sucking the life out of a great song."

Bad adaptations do more than just *suck*, it seems. They suck life out of their original.

Adaptations are, rather inevitably, nearly always judged in relation to the original work, and often in a way that implies a parasitic relationship. It's as if they feed off the original, reducing

it to a lifeless husk, while they themselves become undeservedly glutted and gorged.

Not, though, according to scholar Linda Hutcheon. In her book, *A Theory of Adaptation*, Hutcheon writes that an adaptation is not like a vampire: it doesn't drain the lifeblood from its source and leave it dead or dying, "nor is it paler than the adapted work. It may, on the contrary, keep that prior work alive, giving it an afterlife it would never have had otherwise."

Even once an artist is dead, we still seem to imagine them reposing with a kind of invisible string attached to their creation, transcending time and space. You might hear talk of an artist "turning in their grave" in response to a bad adaptation of their work. In 2023, a Redditor posted "Little Known Fact: The entire city of Oxford, UK is now powered by the sheer kinetic force of J. R. R. Tolkien spinning in his grave after [Amazon Prime series] *Rings of Power*." The *Guardian* wrote that T. S. Eliot was probably turning in his grave at the film adaptation of *Cats*, based on Andrew Lloyd Webber's musical (and incidentally starring Taylor Swift), which was in turn based on Eliot's book (Lloyd Webber would presumably also have been turning, if he hadn't happened to be alive). The aforementioned Netflix *Persuasion* prompted one IMDB reviewer to speculate that Austen would be turning in her grave; there have been similar responses to a BBC adaptation of Agatha Christie's *The Pale Horse*, Andrea Arnold's 2011 film adaptation of Emily Brontë's *Wuthering Heights*, and the 2025 live-action remake of *Snow White*. The latter would, apparently, have Disney himself turning in his grave, despite him not being the author of the fairy tale—one wonders how much turbulence we'd have detected in the Grimm brothers' graves when Disney's cartoon *Snow White* aired in 1937. Or, for that matter, the grave of whomever first came up with the Snow White story, since fairy

tales are some of the oldest and most adapted texts in existence, and call the whole concept of originality into question anyway.

If we follow Hutcheon's thinking, though, the idea of an author or artist turning in their grave might be a positive image: one of renewed vitality, rather than anguished embarrassment. Far from cheapening, desecrating, or draining the original, even a bad adaptation momentarily revitalizes it. Graham Holderness argues that Shakespeare is always "what is currently being made of him." Is Shakespeare thrashing in anguish in his grave when he hears American pop star Sabrina Carpenter ask "Where art thou, why not uponeth me?" in her 2024 song "Bed Chem"? Or is he perhaps smiling wryly at the fact that (a version of) his words in *Romeo and Juliet* still, centuries later, rings out from the stage—albeit a stage with rather more glitter and estrogen?

Hutcheon talks about an afterlife that a work of art "would never have had otherwise." What *would* happen to great works of literature if we didn't keep performing a kind of cultural CPR on them through new reinterpretations?

One of my students pointed out that "afterlife" might not be the right word to use for an adaptation, since that implies that the original work has died. However, literary scholars Andrew Bennett and Nicholas Royle point out that we *do* sometimes treat classic or canonical works of literature like we treat the dead, to their detriment. We honor them, but at the same time, we hide them. We bury them, or we turn them into monuments, "frozen into their own tombs of eternity." We talk about them with the hushed reverence we reserve for the esteemed departed.

To adapt a classic work of art is to break down these taboos, and to breathe forth an incandescent glow of life into a monument that might otherwise stay frozen. No matter how bad Netflix's *Persuasion* was, it prompted hundreds, if not thousands, of new readers to

engage with Austen's original work. After all, they wouldn't print editions of classic literature with updated covers taken from the film adaptations if they didn't expect anyone to buy them. Corpses aren't the only things brought back to life in the absurd *Pride and Prejudice and Zombies*, by Seth Grahame-Smith—the book was marketed by Penguin as perfect for anyone who loves a "reanimated Austen." I know of several parents whose children were inspired to read *Romeo and Juliet* after listening to "Love Story," and studies like Rachel Feder and Tiffany Tatreau's *Taylor Swift by the Book*—not to mention this book you're now reading—use Swift's references to literary classics as a way of pointing readers in the direction of the originals.

If people get to Sylvia Plath—or Shakespeare, or Austen, or Brontë—via Taylor Swift, does it really matter how they got there? Or is the important thing that they are there in the first place, warm hands placed on stony monuments, helping to keep the freezing creep of time at bay?

In Swift's song "Timeless," a vault track from *Speak Now (Taylor's Version)*, the speaker recalls finding a box of black-and-white photographs in an antique shop. The couples in the photographs make her think of her lover, and she tells him that even if they'd met in 1944, they'd still have fallen in love: they would have been timeless. She then recalls finding a book covered in cobwebs, the story of "a romance torn apart by fate." It's set in the 1500s in a foreign land and tells of a woman forced to marry another man, but who ran away to be with her true love. Hundreds of years ago, she sings, people "fell in love like we did, and I'd die for you in the same way."

The book might well be *Romeo and Juliet* (a common fan theory). Swift's inclusion of Shakespeare's play in both "Love Story" and, potentially, "Timeless," does indeed suggest there's

something timeless about the work. But might this not be because Swift—along with countless others—has helped to make it so?

To paraphrase Swift in "Karma": let's ask why so many fade, but *these* books are still here.

Literary critic Frank Kermode suggests that "timeless" works of art don't necessarily endure because they are intrinsically valuable, and so worthy of being preserved for posterity. For one thing, intrinsic value is an impossible concept—all works of art are subject to individual judgment and taste. Even if a *lot* of readers decide that a work of art is good, that alone isn't going to keep it alive. They need to keep talking about it, returning to it, recommending it, throughout the generations. The art most likely to receive this life-giving treatment is the art flexible enough to survive this process of being repeatedly remade and revisited, in forever-changing contexts.

Or, to quote Kermode, "timeless" texts only *become* timeless—survive—because they possess "an openness to accommodation which keeps them alive under endlessly varying dispositions." There's something in them that makes us not only want to keep (re)reading them, but also to keep making them our own: to *accommodate* them, take them in, and host them, in our own time and place. It's no coincidence that we sometimes talk about adaptations using the analogy of viruses. Certain texts can have particularly "infective power"—a gripping core story or sentiment, for example—but, at the same time, they wouldn't have any power at all without a host. As Johannes Fehrle points out, "what people do with texts and how they do it is at least as important as what the texts themselves do." Without us, these infective texts would end up as, to paraphrase Swift, statues that crumble from being made to wait.

Let's continue with Hutcheon's supernatural analogy. Adaptations are not vampires but are more like zombies—zombies

infected with a text's viral power. Like Swift in "Look What You Made Me Do," they rise up from the dead and do it all the time. But only because we help them.

How do we do it? And, more importantly, why?

At its simplest, adaptation moves a story—or elements of a story—from one medium to another (book to film, for example), or across different versions of the same medium (film to newer film). That original story is often given a hallowed place in our thinking: it hovers, specter-like, over any adaptation, inviting constant comparison between the two. You'd be hard-pressed to find a review of any adaptation that doesn't mention the original, and particularly the idea of faithfulness to the original. In theory, faithfulness to the original is a positive thing—it's certainly nearly always intended as a compliment to label an adaptation as such. But is there such a thing as *too* faithful?

The 1998 remake of *Psycho*, which was almost a shot-for-shot replication of Alfred Hitchcock's 1960 original, was widely panned. Critic Roger Ebert saw it as an "invaluable experiment in the theory of cinema"—and perhaps in adaptation too—because it proved that "a shot-by-shot remake is pointless; genius apparently resides between or beneath the shots, or in chemistry that cannot be timed or counted." This is often the same fate that awaits Disney live-action remakes, which are usually scene-for-scene replications, albeit sometimes with some extra songs or scenes thrown in for good measure. 2022's *Pinocchio* was described by the *Radio Times*'s Patrick Cremona as "failing to improve on the tremendous 1940 animation in any meaningful way."

In fact, this is also the fate that awaited Taylor Swift, when she started rerecording her masters. Despite Swift apparently aiming to stick as closely to the originals as possible, so as to encourage nostalgic and/or scrupulous fans to buy or download

the rerecordings instead, the new versions did not always hit the mark. Lake DiStefano wrote that *1989 (Taylor's Version)* failed "to replicate the magic of the original." One Redditor complained that *Red (Taylor's Version)* "just sounded . . . boring? Refined? Plain?" *Guardian* writer Laura Snapes described *Speak Now (Taylor's Version)* as "dilut[ing] some of the original's acid . . . their piercing, youthful twang was what made these songs kick harder in all their dressing-downs and rabid desires." She ultimately described Swift's rerecording project as "starting to feel wearying and pointless."

As these examples prove, no adaptation can be completely faithful, even when it tries its hardest to be. It is always a repetition with variation and, ultimately, depends on the interpretations of those creating it. Adapters are first interpreters, and *then* creators. As Swift has proven, this is the case even when the adapter and the original author are the same person. Her rerecordings showcase not only her more mature vocals, but also her interpreting and recreating her work afresh, with the benefit of hindsight and the wisdom that comes with age (not least in the removal of problematic "slut-shaming" lyrics from the song "Better than Revenge"). This is also true of her acoustic section mash-ups on the Eras Tour, which are adaptations of her original works, reinterpreted and brought together as new creations with very different potential meanings. "Lyrical analyst" and fan @tweetsricochet on X/Twitter said of the mash-up of "hoax" and "Sweet Nothing" that it "forever changed" the latter for her. Similarly, another fan on Reddit pointed out that the "ivy" and "Would've, Could've, Should've" mash-up seems to "completely change" the meaning of the former, rendering the central metaphor sinister rather than romantic.

Scholars often point out the problem of using faithfulness as a standard by which to judge the value of adaptations. It certainly doesn't work for Swift's rerecordings, but these are nonetheless

seen as valuable for different reasons. To bring yet another analogy to this already-rather-full table of zombies, vampires, and viruses, Hutcheon and Gary Bortolotti point out that we might gain something from thinking of artistic and literary adaptations in similar ways to how we think about biological adaptations. Consider Darwin's theory of evolution. Mutations happen randomly in every new generation. Some of these mutations make organisms more likely to survive, and then they pass this onto their offspring: survival of the fittest. While remaining "faithful"—identical to one's ancestor—could lead to extinction, mutation helps organisms adapt to changing circumstances.

Hutcheon suggests that the adaptations generally deemed to be failures are those that lack the creativity and skill to make a story their own, "and thus autonomous." We often say that an adaptation either does or doesn't "stand on its own two feet." Again, this is remarkably similar to the natural world, where insufficiently independent and shaky-legged offspring are certainly a problem for species survival.

If we think of artistic adaptations as beneficial mutations from their original source, ones that allow a story to better fit new cultures or environments, then we can liberate ourselves from the somewhat irrelevant idea of faithfulness. Every adaptation is an act of sanctioned *in*fidelity. A not-so-illicit affair, if you will. Unlike Swift's illicit affairs in the song of the same name, these don't die a million little times. They live a million little times instead: a million little afterlives among new readers and generations.

To quote Isabel Cole, writer of the Substack *Wild and Unwise*, Taylor Swift is "the girl who read *Romeo and Juliet* and thought, *Good start! But I have some notes.*" Like countless artists before her (not least the creators of *West Side Story*), Swift walked into that antique shop, saw a book covered in cobwebs, and began to dust it

off. "I just took my favorite characters and gave them the ending that they deserve," she would say later.

In continuing down this path, she has created some beautiful mutations—mutations that, it turns out, had exactly the infectious quality they needed to flourish and thrive in the twenty-first century.

"Mad woman" is a Victorian novel (*Jane Eyre* in particular, but it could be one of many) adapted in a new format for a new generation, one with the vocabulary to describe and condemn concepts like gaslighting and toxic masculinity. "Right where you left me" and "tolerate it" are adaptations of beloved novels (Charles Dickens's *Great Expectations* and Daphne du Maurier's *Rebecca*) that reflect increasing and important conversations about female pain, in its multifarious forms. In fact, when Alfred Hitchcock was making his film adaptation of *Rebecca*, the producer—David O. Selznick—warned him not to remove "the little feminine things which are so recognizable and which make every woman say 'I know just how she feels . . . I know just what she's going through.'" Swift took those little feminine things and put them, devastatingly and viscerally, center stage. "The lakes" and "I Hate It Here" adapt certain sentiments from Romantic poetry to speak to a twenty-first-century desire, particularly post-pandemic, to escape the horrors of environmental destruction into a cottagecore fantasy. "White Horse" mashes up fairy tale and romance for a generation skeptical of chivalry but still charmed by Disney happy endings.

There are almost infinite ways in which one might reanimate old stories. This is increasingly the case in a "chronically online" age of rapidly growing digital media. Swift's work is a good example of this. It's no longer as simple or clear-cut as turning a book into a film; adaptation might also take the form of remixes, reboots, remakes, mash-ups, and fanfiction. Swift's songs engage with old

stories in some of these ways. Although they don't do this as fully as, for example, Kate Bush does with "Wuthering Heights," I think we can still see them as a form of adaptation. The songs of Swift's that reference old stories often have a particular vocabulary, set of imagery, or aesthetic linked to the tale in question—think of the balcony scene and costumery in the video for "Love Story"—and play out rather like mini film versions. In doing so, they fan the glowing embers of those stories.

The simplest way in which adaptation gives old stories new lives is by making people aware of those stories in the first place. The mass of publicity surrounding new film, TV, and music releases might help older literature reach new readers. Those who, for whatever reason, might never walk into the "Classics" section of a bookshop. Those who didn't study literature at school—or those who did but found it tedious—but whose interest is piqued by a glossy new adaptation. The speed at which Instagram reels or TikTok videos can go viral also increases the likelihood of old stories finding new readers. This is particularly valuable when adaptations introduce us to works from other cultures and traditions, such as the 1992 film of Mexican author Laura Esquivel's 1989 novel *Como agua para chocolate* (*Like Water for Chocolate*), which has had a ragingly successful afterlife in multiple languages, including English, and has also spawned sequels and a ballet. Vice versa, we have "Bride and Prejudice," a Bollywood adaptation of Austen's classic novel, and Japanese filmmaker Akira Kurosawa's retellings of Shakespeare's *Macbeth*, *Hamlet*, and *King Lear*. Polish novel *The Pianist* reached a much wider audience after being adapted into Roman Polanski's 2002 film, as did Stieg Larsson's Swedish *Millennium* trilogy, adapted into an American film in 2011.

Adaptation might also open our eyes to works in our own cultures that may have been historically overlooked because of the ideas

around canonization and gatekeeping that I discussed in Chapter Two. Ridley Scott's 1982 *Blade Runner* film prompted a rethink of Philip K. Dick's 1968 novel, *Do Androids Dream of Electric Sheep?*, hitherto considered niche and part of the generally "pulpy" genre of science fiction. Dick's work is now respected for its philosophical explorations of humanity, identity, and technology. Tolkien, too, was once regarded as lowbrow fiction; adaptations such as Peter Jackson's film trilogy see him now firmly located within the circles of "high fantasy." Graphic novels, once considered childish, have become compelling, nuanced film adaptations—such as Christopher Nolan's *Dark Knight* trilogy—and are now respected art forms in their own right. Video games, still used by many as a shorthand for lowbrow culture, have spawned award-winning drama series like *The Last of Us*.

The main reason I use Swift in the classroom is because adaptations help new generations connect with texts that can seem offputtingly remote in time and space. Archaic language can sometimes distract from a compelling tale. It's perhaps the reason that British comedian Richard Franks's Instagram reels, summarizing the plots of Shakespeare's plays but in Gen Z slang, receive thousands of comments along the lines of, "I understood this more than the original" and "I wish I'd had this when studying *Romeo and Juliet* in school." And, tellingly, "I bet Shakespeare would get an enormous kick out of this." Based on how much the Bard loved coining new words and playing with language, I do too—it's certainly more likely than him turning in his grave.

Society might have changed drastically since Shakespeare and Austen were writing, but the films *10 Things I Hate About You* (based loosely on *The Taming of the Shrew*) and *Clueless* (based loosely on *Emma*), by moving these stories to an American high school context, helped a new generation of viewers connect with them. In

2020, an article in *The Ringer* declared that the latter "is still the best Jane Austen adaptation"—better, even, than Helen Fielding's *Bridget Jones* books and their subsequent film versions. If Austen "was previously seen as a buttoned-up, bonneted throwback to another era," wrote Jane Hu, then *Clueless* "made her relevant to a new generation of Americans struggling to transcend their own social bubbles."

It's Kermode's idea in action: there *is* some general wisdom about "the human condition" to be found in a lot of these stories, but it helps if a creative director or writer can really bring it to the fore. It's also the reason I teach Margaret Atwood's 2016 novel *Hag-Seed* alongside Shakespeare's *The Tempest*. By moving Shakespeare's story to the present, setting it in a correctional institution, and adding a host of pleasingly "meta" elements, Atwood helps illuminate some of the important dynamics and themes present in Shakespeare's original—themes which, incidentally, also enjoy rich coverage in Swift's discography. The relationship between language and power, for example, the ethics of revenge; emotion as a metaphorical prison. They're themes that my students find immensely engaging, but ones they may not always have picked up on in the original, particularly since English is usually their second or third language.

This is another example of the power of adaptation. As well as being enjoyable in their own right (one needs no knowledge of *Emma* to appreciate *Clueless*, nor *The Tempest* to enjoy *Hag-Seed*, although they certainly enhance the experience), adaptations might also make us look at an old story with fresh eyes. This is particularly the case for those texts we might not even have read, but which we *think* we know, regardless. We often have what John Ellis terms a "generally circulated cultural memory" of certain works of art without ever having encountered them directly. The playwright

Charles Marowitz argues that there is a "kind of cultural smear of *Hamlet* in our collective unconscious," even if we have never read it. This might also be true of Joseph Conrad's *Heart of Darkness*, given a famous afterlife in the film *Apocalypse Now*. Or *Frankenstein*, so frequently adapted via film, television, and Halloween costume that we famously tend to forget that the name refers to the creature's creator, rather than the creature himself. Or *Vanity Fair*, which began as a Puritan moral allegory in John Bunyan's seventeenth-century *Pilgrim's Progress*, but has become, via William Thackeray's nineteenth-century novel and Condé Nast's magazine, an image of the celebration of wanton consumption. Or *Romeo and Juliet*, often used as shorthand (by Swift, for example) for a romantic love story, rather than what it actually is—a tragic tale of internecine warfare and double suicide.

Adaptations might make us curious enough to sift through all of this cultural baggage and get closer to the original text behind it—and then to ask some important questions, à la Swift: *I have some notes.*

When Swift's speaker sings in "cardigan" that the object of the song "tried to change the ending, Peter losing Wendy," she alludes to a story that may have been a staple of our childhoods: the tale of Peter Pan. This line in "cardigan" is deeply ambiguous. It's unclear whether he tried to change the (happy) ending, making it so that Peter instead *lost* Wendy; whether he tried and failed to change the (unhappy) ending *of* Peter losing Wendy; whether he tried to change the (unhappy) ending, *but* Peter lost Wendy anyway. Is Peter losing Wendy the *result* of his actions, or the fate he tried to change?

Regardless—or perhaps *because of*—this ambiguity, the line might prompt us to go back to J. M. Barrie's 1911 novel *Peter and Wendy*, since we might not remember what the actual ending is.

The story has been so repeated and romanticized over the years that its ending is perhaps not commonly known—a good example of Ellis's "generally circulated cultural memory." This particular cultural memory is predominantly shaped by Disney's 1953 film, *Peter Pan*. It ends with Wendy telling her parents excitedly about her adventures in Neverland. At the end of Barrie's novel, however, Peter promises to return to Wendy every year and take her to Neverland for spring-cleaning time. She waits patiently in a brand-new dress, but he never comes (I can't help but think of Swift's "The Moment I Knew"). Years later, he finally returns and finds Wendy a married woman, with Peter "no more to her than a little dust in the box in which she had kept her toys."

Peter is shocked and furious that she has dared to grow up. Wendy feels something inside herself crying, "Woman, woman, let go of me." Peter sobs, Wendy comforts him, and then she allows her daughter, Jane, to fly to Neverland with him for spring-cleaning time. The cycle continues as Jane grows up and lets her own daughter, Margaret, fly with Peter, "every spring-cleaning time, except when he forgets." This will continue indefinitely, Barrie's narrator tells us, "so long as children are gay and innocent and heartless."

It's a little jarring to end a children's book with the declaration that children are heartless. But laced through Barrie's *Peter and Wendy* is a surprising amount of vitriol directed at both adults and children. It's certainly an interesting choice for a children's classic, and it's no surprise that Disney left out a lot of its complexity (while unfortunately retaining its racism), making the Peter–Wendy relationship into more of a straightforward youthful romance.

In Swift's hands, though, we get some of that complexity back. She's certainly moved on from idealizing "never growing up," as she did on *Speak Now*. Coupled with the line "leaving like a

father, running like water," and heard in the context of the Betty–James–Augustine love triangle (we know the object of "cardigan" has cheated on the speaker), the reference to Peter losing Wendy reframes *Peter and Wendy* as the story of a thoughtless, selfish man-child who refuses to grow up and take responsibility. It's the same story, in fact, behind the coining of "Peter Pan syndrome" in popular psychology, to refer to individuals—often exhibiting similar traits to narcissistic personality disorder—that refuse to grow up. It's also the story that lurks behind Swift's "Peter," from *TTPD*: a man who promised his lover he would grow up, but, although she waited for him, he never did.

British singer-songwriter Maisie Peters, in her 2023 song "Wendy," goes even further than Swift, explicitly associating Peter Pan syndrome with potentially abusive traits. There's always a Wendy behind every lost boy, she sings—one who will take on the emotional labor of trying to keep him on the straight and narrow, until he gets bored and wanders off to the forest. In doing so, she will lose the chance to achieve her own dreams. The speaker of the song can see this future clearly and tells us it scares her: if she's not careful, she'll wake up and they'll be married, and she'll flinch at the sound of a door. It's an updated *Peter Pan* for a feminist generation cognizant of concepts like weaponized incompetence and the mental load. The song ends, "What about my wings? What about Wendy?"

What about Wendy, indeed? After all, Barrie's novel was called *Peter and Wendy*, but these days we refer to it only as *Peter Pan*. Thanks to artists like Peters and Swift, though, the resurrected Wendy is having something of a moment. It's a moment that showcases the power and importance of adaptation.

Adaptation can be both an homage to a previous text or work of art, *and* an act of intense interrogation. Adaptations don't

just descend passively from originals like an apple falling from the tree—they exist in dialogue with them. They sometimes tip over into appropriations: new cultural products that read between the lines of older texts and draw attention to their gaps or absences, particularly to voices or subjects marginalized in the originals. *Peter and Wendy*, and Swift's and Peters's lyrical appropriations, mutually enrich each other, enabling us to know and to question both, at multiple levels. Fehrle points out that perceptions of original texts are inevitably influenced by later adaptations and appropriations, so we can never in fact return to a pure original. And perhaps, in the case of *Peter and Wendy*, that is a good thing.

Peter and Wendy is a good example of a story that *shouldn't* be relegated to Neverland and permitted to "never grow up." It contains quite a few sexist and racist tropes that we really should be examining and interrogating further, in the twenty-first century. It's also not the only children's book in this category. There was uproar over the "censorship" of Roald Dahl's novels in new editions by Puffin Books in 2023. Puffin had not only removed potentially racist and fatphobic references but had also attempted to write more feminist descriptions of the "ordinary woman." *Forbes* published an article titled "Woke Willy Wonka," asking, "shouldn't these works be left untouched, so we can understand how much things have changed?" Yet the article also made the rather confusing comment that Dahl's works are "timeless, but many elements have aged badly."

This is, surely, a contradiction in terms. Timelessness implies something that *does not* age, and certainly not badly. This whole episode reveals how problematic the word "timeless" has become. We tend to use timeless as a synonym for "has been popular over a sustained period of time," rather than its actual definition.

According to the *Oxford English Dictionary*, "timeless" means: "unaffected by the passage of time or changes in fashion; perpetually relevant, valuable, appealing." But, frustratingly, this too is a contradiction. *Nothing* is unaffected by the passage of time. A work of art or literature may indeed continue to be relevant, valuable, and appealing over time, but the way it is perceived and consumed will inevitably change. We will see different values and appeal in it depending on the times and cultures we live in. To call a text timeless is to deny this. Are we really suggesting that Dahl's racism and antisemitism have exactly the same impact now as they did when he was writing?

"Timeless" is often used as get-out-of-jail-free card—a way of not having to acknowledge and deal with exclusionary and offensive references in works of art from the past. It's a wonderful catch-all that can excuse all manner of sins, in the same way you might defend a racist grandparent. But it doesn't actually make any sense. After all, we defend the racist grandparent by pointing out that "times were different back then." This is also true of art. We need to stop using timeless as an indicator of fundamental value. A work of art can have core ideas that are likely to endure over time and appeal to renewed generations of viewers and consumers, while still being unmistakably a product of its time—a product that we can continue to engage with and reshape in ways that keep it alive. We can do all this while still pointing out its flaws.

I'm reminded of the handsome prince Tithonus, from Greek mythology, whose lover Eos asked Zeus to make him immortal. She forgot, however, to also ask for his eternal youth. He wizens and shrivels horrifyingly before her eyes, begging for the death that will now never come. In some versions of the story, Eos continues to care for Tithonus, even in his extreme old age. In others, she transforms him into a cicada.

Maybe we should let our art be like Tithonus. We should allow it to age—even to age badly—while retaining its immortality. While it ages, we can still love and care for it—or we can adapt it, just like Eos did, into new forms, and allow it to enjoy new lives in new shapes. We don't necessarily have to "try to change the ending."

And now, speaking of endings, it's time for me to end this manuscript—of the entire glorious, enlivening, exhausting affair. In it, I've tried to retell a love story: between Taylor Swift and English literature. Between that girl who picked up *Romeo and Juliet* and decided she had some notes, and the many other stories she decided to retell, with those notes—and the notes she strummed on her guitar. Perhaps it's also the story of a love *triangle*: between this professor, the work she does, and her personal, ongoing love affair with the lyricism of Taylor Swift. In it, I've tried to show that there are infinite ways in which to tell a story, whether your chosen medium be the yellowed pages of a leather-bound hardback, or the lyrics pane of your Spotify app. I believe that it doesn't really matter how we get to them; what matters is that we keep telling stories, both old and new. And that we keep asking questions about those stories: What kind of afterlives do they need, and perhaps deserve, in our present times?

We can trace our stories back through the tangled roots of our past, to cast a little more light on who we are, who we have been, and what we will become. I've tried to do that in this book: to show how modern stories can help us understand not only the survival and evolution of older stories, but also the survival and evolution of ourselves—and how we might need to change and adapt to continue enduring in an uncertain future.

This is my story, your story, her story, and history. It's a reminder of our power, as both writers and readers, to bring stories to life, not

just once but endlessly. To make sparks fly from the burning embers of age-old tales about our flaws and foibles as human beings, and from those sparks to kindle something magnificent that will shine a light on us all. And to make sure that no book ever languishes, covered in cobwebs, in an antique shop.

Discussion Questions

1 How do you decide whether a work of art is of cultural value? What criteria do you use?

2 What work(s) of popular culture would you like to see taught in schools in your country, and why?

3 As a reader, how much do you need to know about the author of a book to fully enjoy, appreciate, or understand it?

4 What does chivalry mean to you? Does it have any place in our present day?

5 What role can art play in our mental health?

6 Try and think of three unlikable protagonists from your own reading/media consumption. What makes them unlikable, and what does this tell us about the society/author that produced them?

7 How would you be the unlikable protagonist in your own life story? What traits would you emphasize?

8 Can you think of a book that has frustrated or challenged your expectations? Why and how?

9 What works of art or literature can you think of that deal particularly well with grief and bereavement?

10 What literary or artistic works would you characterize as truly original? Why?

11 Do you think we, as a society, are becoming increasingly alienated from nature?

12 Has a work of art or literature about nature inspired you? If so, which, and why?

13 Are all villains also victims? Discuss.

14 Why might music be a more effective way of getting a message across than other art forms?

15 If you could write an open letter to the world arguing about one particular gender-related issue, which would you choose, and what would you say?

16 What is "girlhood," to you?

17 If you could retell one story from a different perspective, which would it be? (And from whose perspective?)

18 What does it mean to call a work of art "timeless"?

19 Consider your favorite book adaptations (in any genre). How do they offer a fresh perspective on the original, and how might this enhance our understanding of the original?

Books to Put Beside Your Bed: Reading List

Below you will find a list of the key works discussed and analyzed in this book. Those mentioned merely in passing are not listed.

Andrew Bennett and Nicholas Royle, *An Introduction to Literature, Criticism and Theory*

Anna Bogutskaya, *Unlikeable Female Characters: The Women Pop Culture Wants You to Hate*

Anna Harpin, *Madness, Art, and Society: Beyond Illness*

Anne Helen Petersen, *Too Fat, Too Slutty, Too Loud: The Rise and Reign of the Unruly Woman*

Anon, "The Wanderer"

Anon, *Sir Gawain and the Green Knight*

Betsy Winakur Tontiplaphol and Anastasia Klimchynskaya, *The Literary Taylor Swift: Songwriting and Intertextuality*

Charles Dickens, *Great Expectations*

Charlotte Brontë, *Jane Eyre*

Charlotte Brontë, *Villette*

Charlotte Perkins Gilman, "The Yellow Wallpaper"

Daniel Defoe, *Moll Flanders*

Daniel Defoe, *Roxana*

Daphne du Maurier, *Rebecca*

Darian Leader, *The New Black: Mourning, Melancholia, and Depression*

Delia Owens, *Where the Crawdads Sing*

Derek Walcott, "Missing the Sea"

Edith Wharton, *The Custom of the Country*

Eliza Haywood, *Epistles for the Ladies*

Eliza Haywood, *Love in Excess*

Geoffrey Chaucer, "The Parliament of Fowls"

Geoffrey Chaucer, *The Canterbury Tales*

Geoffrey Chaucer, "The House of Fame"

Geoffrey Chaucer, *Troilus and Criseyde*

Gillian Flynn, *Gone Girl*

Henry Fielding, *Tom Jones*

Horace Walpole, *The Castle of Otranto*

Italo Calvino, *If on a winter's night a traveler*

J. M. Barrie, *Peter and Wendy*

Jane Austen, *Northanger Abbey*

Jean Rhys, *Wide Sargasso Sea*

John Donne, "Holy Sonnet XIV"

John Donne, "The Flea"

Lady Morgan, *The O'Briens and the O'Flahertys*

Laurence Sterne, *The Life and Opinions of Tristram Shandy, Gentleman*

Lewis Carroll, "Jabberwocky"

Lewis Carroll, "The Hunting of the Snark"

Lewis Carroll, *Alice's Adventures Through the Looking Glass*

Margaret Atwood, *Hag-Seed*

Marilou Awiakta, "When Earth Becomes an 'It'"

Mary Shelley, *Frankenstein*

Mary Wollstonecraft, "A Vindication of the Rights of Woman"

Miguel de Cervantes, *Don Quixote*

Mona Chollet, *In Defense of Witches: The Legacy of the Witch Hunts and Why Women Are Still on Trial*

Nikolai Leskov, *Lady Macbeth of Mtsensk*

Ottessa Moshfegh, *My Year of Rest and Relaxation*

Percy Bysshe Shelley, "A Defence of Poetry"

Philip Sidney, "A Defence of Poesie"

Rachel Carroll and Adam Hansen, *Litpop: Writing and Popular Music*

Rachel Vorona Cote, *Too Much: How Victorian Constraints Still Bind Women Today*

Robert Henryson, *The Testament of Cresseid*

Roland Barthes, "The Death of the Author"

Salman Rushdie, "Is Nothing Sacred?"

Samuel Richardson, *Pamela*

Samuel Taylor Coleridge, "Kubla Khan"

Samuel Taylor Coleridge, *The Rime of the Ancient Mariner*

Sandra Gilbert and Susan Gubar, *The Madwoman in the Attic: The Woman Writer and the Nineteenth-Century Literary Imagination*

Sara Ahmed, *The Feminist Killjoy Handbook: The Radical Potential of Getting in the Way*

Sir Thomas Malory, *Le Morte D'Arthur*

Stevie Smith, "Thoughts about the Person from Porlock"

Sylvia Plath, "Daddy"

T. H. White, *The Once and Future King*

Tennessee Williams, *A Streetcar Named Desire*

Thomas Gray, "Elegy Written in a Country Churchyard"

Thomas Wyatt, "I find no peace and all my war is done"

Thomas Wyatt, "The long love that in my thought doth harbour"

Toni Morrison, *Sula*

Virginia Woolf, *Mrs. Dalloway*

W. K. Wimsatt and M. Beardsley, "The Intentional Fallacy"

William Makepeace Thackeray, *Vanity Fair*

William Shakespeare, "Sonnet 130"

William Shakespeare, *Macbeth*

William Shakespeare, *The Tempest*

William Wordsworth and Samuel Taylor Coleridge, *Lyrical Ballads*

William Wordsworth, "Ode: Intimations of Immortality from Recollections of Early Childhood"

Playlist of Songs

Scan the below code with your Spotify app to access the playlist of all songs mentioned in this book, or search 'Swifterature' on Spotify.

Acknowledgments

My favorite part of being a writer is the immense privilege of being able to immortalize my love for others on the page. This book is the most meaningful thing I have written in my life so far, mainly owing to the sheer wealth of special people who float in its orbit. This is for you.

Thank you to all those who read early drafts and offered your feedback: Christine, Vana, Annelies, Eveline B., Helen, Eveline V., Gözde, Sigrid, Laura, Ruth, Francis, Tai-Chun, Mateusz. You have made this into a much better book, and I am eternally grateful. Extra special thanks to Sarah, for going above and beyond and being the most attentive volunteer editor and trader of friendship bracelets a girl could ask for. I'm so glad we met all those moons ago in Freiburg!

Thank you to Phil and Stephanie, for your detailed, fun, and helpful feedback on the initial book proposal. I'm honored you took the time, and I hope I've done it justice.

Thank you to all the ludicrously talented women in my life, who inspire me every day and make me a better person, friend, and feminist. I love you all. Special shoutouts to my fellow childless cat lady and all-round superhero, Annelies, without whom this book probably wouldn't exist at all, and to the best and most supportive frolleague, Debora. You've always rooted for this anti-hero, and

I'm forever grateful. Also, to my wittiest friend, Laura, for being the greatest cheerleader for all my endeavors. I love you more than words can say. To the endlessly inspirational Lisa, Madison, and Emma, who helped brainstorm with me when English Literature (Taylor's Version) was but a glint in my crinkling eye. Thank you to Gözde, Emily, and Carol for being excellent Eras Tour companions. Thank you to Caro, for being my audience champion (twice) at the Carl Schurz Haus. Thank you, Astrid, for reminding me that IT'S AN AUDITORIUM, NOT A KINDERGARTEN <3. You gave me the courage to navigate snark with Swiftian poise.

Thank you to Amelia and Dalton, for reaching out and being sounding boards for all things pop culture and academia.

Thank you, Ernesto, for tolerating it ("it" being all the car rides we took together with Taylor karaoke deafening you), being my emotional support tortilla maker, and reminding me to look after myself. Hi, it's me.

Thank you to my parents. The thought of you attempting to explain my weird new career path to the neighbors is nothing short of hilarious, but I love you, nonetheless. Thanks, Dad, for sending me every single article you ever encounter about Taylor Swift—I'm pretty sure some of them made it into this book.

Thank you to all my wonderful students, current and past, for going on this wild journey with me, and constantly inspiring me with all your ideas and creations. Your energy and kind feedback have kept me going through the best and worst times. Thank you Simen for first making me realize how much I talk about Taylor Swift in lectures and inadvertently helping to inspire English Literature (Taylor's Version). You fully deserved that *1989* cameo you got from Taylor Nation.

Thank you to Ghent University for tolerating this mad woman and helping English Literature (Taylor's Version) to become reality.

ACKNOWLEDGMENTS

Thank you to Zoe and Rita for all your teaching help, and Chris Bulcaen and team for all the admin assistance—I'm so sorry for the absolute chaos I caused. Particular thanks to Stef for your encouragement, support, and faith; I'm not sure I'd have had the confidence to do this without it!

Thank you to everyone who has invited me to speak about Taylor Swift across the world; it is a true joy and a privilege to connect with you all. To the organizers of Nerdland festival, the Swiftposium, FAAR Festival, the staff at Epsom College (especially Hafsa), to the Media Studies center at Bergen University, Thomas More University, DIAS at Odense, Marlborough College, Tai-Chun Ho and colleagues in Taiwan, Iedereen Leest in Flanders, the German-American Institutes in Freiburg and Tübingen (special shoutout to René), and to Ruth, John, and Anna for letting me loose (albeit virtually) in your classrooms.

Thank you to everyone who has attended one of my talks—meeting you is the best part of my job. You make me feel like Taylor Swift in this light—I'm loving it.

Thank you to Charlie for your work in getting this book (and others!) off the ground.

Thank you to the team at Pegasus Books for your initial faith in this book and your hard work on every aspect of it.

Thank you to everyone who has followed Swifterature online and offered your support and ideas. I wouldn't be here today without you.

And, lastly, thank you Taylor Swift. I'm enchanted to inhabit your cinematic universe.

Index

A

Abrams, M. H., 222
absence, 87
abstract, articulation of the, 43–45
academia, xv, 27–29, 236
Ackroyd, Peter, 127
Adams, Ryan, 6
adaptations, 247–265
adolescence, 24, 27
adolescent grief, 91–92, 174
"Adonais" (Shelley), 80
Adorno, Theodor, 13
aesthetic gain, from loss, 83
aesthetic judgments, 23–24
"Afterglow" (Swift), 148
afterlives, 247–250, 255. *See also*
 adaptations
"ahead of the curve" idiom, 46–47
Ahmed, Sara, 159, 176, 236
"The Albatross" (Swift), 167,
 201–202
"The Alcott" (The National), 69, 70
*Alice's Adventures Through the Looking
 Glass* (Carroll), 108
"The Allegory of Love" (Lewis), 143
alliteration, 39, 55–56, 87
alliterative meter, 55
"All Too Well (10 Minute Version)"
 (Swift), 77–78, 93, 146, 173, 206
"All Too Well" (Swift), 41–42, 47,
 51, 54, 60, 106, 114, 208
Alwyn, Joe, 11, 215
amatory fiction, 102

American Institute, 25
The Americans (TV series), 225,
 226–227
American Songwriter, 6
"The American's Tale" (Doyle), 182
anacoluthon, 48–50
analepsis, 41–42
anaphora, 41, 85
anastrophe, 51
The Anatomy of Melancholy (Burton),
 62
anger, 54, 163, 164, 168, 169, 171,
 175, 237
Anim-Addo, Joan, 30–31
Anthropocene, 178
anthropocentrism, 179, 194–195, 198
anthropomorphism, 179
"anti-art," 13
"Anti-Hero" (Swift), 3, 73–74, 220–
 221, 224, 238–240
Anti-heroines of Contemporary Media
 (Haas et al.), 225
anti-heroism, 220–245
antonomasia, 47, 54
anxiety: creative, 67, 69–70, 74–76;
 ecophobic, 186; of influence, 63,
 74
Apocalypse Now (film), 260
apostrophe, 51
appropriations, 263
archaic language, 258
"The Archer" (Swift), 69, 220, 230,
 240

INDEX

Aristotle, 38, 91, 180
Armitage, Simon, 133
Arnofsky, Darren, 193
Arnold, Andrea, 249
Arnold, Gina, 104, 105, 175, 217
Arnold, Matthew, 232, 233
artistic value, 31–32
art therapy, 90
assonance, 56
asyndeton, 50
The Atlantic, 12, 243–244
Atwood, Margaret, 228–229, 259
Aubrey, Frank, 183
Auden, W. H., 85
Audition (film), 8
"august" (Swift), 151
aural effects, 55–57
Aurora, 195–196
Austen, Jane, 8, 22–24, 31, 208, 232,
 248–251, 258–259
authenticity, 11, 52, 104, 190
authority, 107–109, 111–116
authors: authority of, 107–109, 111–
 116; backgrounds of, 103; control
 of, 115; female, 107; identification
 with, 117; intentions of, 100–111.
 See also specific authors
autobiographical literature, 103–104
autobiographical songs, 4, 98–100,
 104–105
autofiction, 99–100
autogenous originality, 63
"To Autumn" (Keats), 68
Awaikta, Marilou, 194

B

baby loss, 84, 85, 92
"Bad Blood" (Swift), 142, 208, 216
Bandello, Matteo, 246
Barbie (film), xvi, 20, 124
Barrie, J. M., 21, 246–247, 260–261,
 263
Barron, William, 132

Barthes, Roland, xvi, 18, 83, 87, 107,
 111
Bastién, Jade, 237
Bate, Walter Jackson, 63
battle imagery, 144
Beardsley, Monroe, 105–106, 114
Beatles, 61, 105
Beetham, Margaret, 24
Behn, Aphra, 7–8
Bennett, Andrew, 106, 117, 179, 250
Bennett, Jessica, 231
Bennett, Laura, 221, 242
Beowulf, 55
bereavement, xii–xiii, 77–93
Bernstein, Matt, 212
Bertens, Hans, 13–14
"The Best Day" (Swift), 196
Bettany, Paul, 125
"Better than Revenge" (Swift), 12,
 98, 254
"betty" (Swift), 188
Beyoncé, 20, 95
Bhatt, Alia, 230
Bible, 154, 166, 202
"Bigger Than the Whole Sky"
 (Swift), xii, 80, 83, 84–85, 89,
 92
Big Machine records, 115
billionaire status, 190, 210, 211–212
Birch, Thomas, 222
"bitch," 231
Black, Jack, 74
Blackadder (TV series), 8
Black anti-heroes, 241–243
"The Black Dog" (Swift), 49, 53,
 99–100, 147
Black Faces, White Spaces (Finney),
 191
Black girls, 216
Black Lives Matter, 163
Black Panther (film), 241
Black women, 216–217, 240–243
Blade Runner (film), 258

"Blank Space" (Swift), 3, 51, 103–104, 150, 166, 237, 239
bleeding imagery, 142
Block, Melissa, 213
Bloom, Harold, 30, 63
Boccaccio, 144
Bogutskaya, Anna, 12, 91, 175, 233, 236–237, 241
Boleyn, Anne, 39
"The Bolter" (Swift), 52
Bonfrisco, Jennifer, 209
"Book Ends II" (Harrison), 83–84
"The Book of the City of Ladies" (Pisan), 134
BookTok, 30
Borchetta, Scott, 208
Bortolotti, Gary, 255
Bow, Clara, 4, 74
Bowie, David, 64
Boxall, Peter, 30
Braun, Eva, 139
Braun, Scooter, 208, 209
Brawne, Fanny, 68
Breaking Bad (TV series), 223, 226
breakup songs, 78–79, 83, 92. See also heartbreak; specific songs
Brewer, Derek, 120
Bridgers, Phoebe, 9
Bridget Jones (Fielding), 259
Brodesser-Akner, Taffy, 140
broken heart, 46, 78, 140. See also heartbreak
Brontë, Charlotte, 4, 26, 158, 159, 232–234, 246, 251, 256
Brontë, Emily, 249
Bunyan, John, 260
Burnett, Frances Hodgson, 187
Burns, Robert, 23
Burt, Stephanie, 83
Burton, Richard, 3, 62
Busfield, Joan, 170
Bush, Kate, 257
Busl, Gretchen, 225

"But Daddy I Love Him" (Swift), 130–131, 161, 179
Byron, Lord, 70, 167

C
"Call It What You Want" (Swift), 96, 97–98, 128–129
Calvino, Italo, 14–15, 116
cancelation, 170–171, 199, 238
canceled tour dates, 92, 210–211
canonicity, xi, xii, xvii, 30–32, 247–248, 258
The Canterbury Tales (Chaucer), xvi, 125–128
capitalism, 107, 157, 213, 217, 238
Captain America, 224
"cardigan" (Swift), 21–22, 260, 261–262
"Carolina" (Swift), 185, 194, 206
Carpenter, Sabrina, 250
Carroll, Lewis, 108–109
Carroll, Rachel, xiv–xv, xvii
"Cassandra" (Swift), 73, 202
The Castle of Otranto (Walpole), 207–208
"Castles Crumbling" (Swift), 73, 95, 211
The Catcher in the Rye (Salinger), 8
Cathar Christian sect, 118, 151–152
catharsis, 90–91
Cats (film), 249
Cavitch, Max, 82, 86, 88
Celan, Paul, 138
Cervantes, Miguel de, 125
Charlie (zine), 236
Chaucer, Geoffrey, xvi, 1, 17–18, 62, 125–128, 144–149, 154–155
childhood, 27, 130, 188–189, 195
childishness, 23, 24
child loss, 84, 85, 92
chivalry, 118–136
Chollet, Mona, 193, 200, 217, 236
Christie, Agatha, 249

civilization, 188, 191
"Clara Bow" (Swift), 4, 73, 74, 208
Clark, Alex, 105
"Clean" (Swift), 45, 56, 185–186
clichés, 46, 47, 53–54, 140
Click, Melissa A., 25
climate crisis, 193
Clinton, Hillary, 135, 167, 231
"clowning," 100, 101
Clueless (film), 258–259
"Code Switch" podcast, 216
Cole, Isabel, 48, 175, 255
Coleridge, Samuel Taylor, 58–60,
 64–66, 68–69, 74–76, 80, 167,
 201–202
collaboration, 64–66, 240
collective mourning, 92–93
Collins, Wilkie, 160
colonialism, 192–193
commercial partnerships, 97
comparisons, 44–46
compassion, 34
"coney island" (Swift), 50, 81
confessional poems, 5
confessional spontaneity, 48–52
Conrad, Joseph, 260
consolation, 88–89
consonance, 56
consumerism, 239, 240
"Cool Girl," 234, 245
copying, 62–63
copyright laws, 66, 107
Corbett, Elizabeth, 195
"Cornelia Street" (Swift), 4, 7, 146
Cote, Rachel Vorona, 164, 169, 173,
 230–231
cottagecore aesthetic, 189–191
country music, 5
courtly love, 143–146, 148–150
COVID-19 pandemic, 177, 179–180,
 189, 238
cowriting, 64
creative anxiety, 67, 69–70, 74–76

creative process, 59–71, 75
Crispin, Jesse, 239–240
Critchlow, Heather, 231
critical race theory, 236
critical thinking, 34
criticism, x, xi, 22, 27
Crocker, Holly, 206
Cronon, William, 186, 189, 191,
 196, 197
Crudo (Laing), 99
"Cruel Summer" (Swift), 142, 147
crying playlists, 78
cultural capital, 30, 32
cultural memory, 259–260, 261
cultural vandalism, 31
The Custom of the Country (Wharton),
 232

D

dactyl, 57
"Daddy" (Plath), 137–140
Daelemans, Jozefien, 236
Dahl, Roald, 263
damsel in distress, 208, 209
"Dancing with Our Hands Tied"
 (Swift), 73, 146
Dark Ages, 122
Dark Knight trilogy, 211, 258
Darwin, Charles, 182, 255
Dauberman, Gary, 248
Davis, Viola, 241
"Daylight" (Swift), 142
dead metaphors, 46, 140
"Dear Bryan Wynter" (Graham), 88
"Dear John" (Swift), 10, 51, 54, 208
"Dear Reader" (Swift), 15, 73, 114,
 233, 240
death, 78–84, 86, 88, 89, 91, 113,
 151, 152
"Death by a Thousand Cuts" (Swift),
 9, 46, 47, 50, 83, 88, 140
decolonization, of the canon, 30–31
defamiliarization, 46–47

INDEX

A Defence of Poesie (Sidney), 32–33
Defoe, Daniel, 227–228
DeGeneres, Ellen, 106, 131
"Delicate" (Swift), 73, 96
Del Rey, Lana, 175
De Nature Jominis (*On the Nature of Man*) (Nemesis), 141–142
depression, 89, 90, 99
De Quincey, Thomas, 65
Dessner, Aaron, 63, 69, 174
The Devil Tree of El Dorado (Aubrey), 183
Dexter (TV series), 223
Dick, Philip K., 258
Dickens, Charles, 31, 103, 157, 160, 256
Dickensian (TV series), 157
Dickinson, Emily, 246
discrimination, 30
The Diseases of Woman (Hollick), 168
disenfranchised grief, 79, 82, 90–92
disillusionment, 56, 123, 133–136
Disney, 121, 123, 124, 131, 179, 182, 199–200, 249, 253, 261
DiStefano, Lake, 254
distress, 120–121
Do Androids Dream of Electric Sheep? (Dick), 258
Doesburg, E. L., ix
Dolven, Jeff, 42
Donaldson, Kayleigh, 248
Donne, John, 137, 152–154, 192
Donnella, Leah, 40–41, 212, 214–217
Don Quixote (Cervantes), 125
"Don't Blame Me" (Swift), 230
"dorothea" (Swift), 196
double standards, 102, 161, 243
"Down Bad" (Swift), 72
Downton Abbey (TV series), 204, 232
Doyle, Arthur Conan, 182
Doyle, Jude Ellison Sady, 210, 212–213

Dracula (Stoker), 204
Duchamp, Marcel, 13
Dunbar, Paul, 191
The Dunciad (Pope), 102
DuPlessis, Rachel Blau, 48
Dylan, Bob, 32, 62

E

Earth, 192–194. *See also* nature
Ebert, Roger, 248, 253
ecocriticism, xiii, 178–198
ecofeminism, 192–195
ecophobia, 180–181, 186, 191
Effe, Alexandra, 99
Electra complex, 138
"Electric Touch" (Swift), 4
elegies, 78–92, 139
"Elegy" (Merwin), 82
"Elegy Written in a Country Churchyard" (Gray), 80
Eliot, T. S., 249
Elizabeth I, 32
Elliott, Maud Howe, 182–183
Ellis, John, 259
Emma (Austen), 232
emotional pain, 137, 139–142, 148–149, 174
emotions, 60, 91, 170–171, 173
empowerment, 213, 236, 244
"Enchanted" (Swift), 4
"End Game" (Swift), 96–97, 210, 230
endings, 10, 12
end rhyme, 55
English literature, xvii–xviii, 28, 29. *See also* literature: classics of, xiv; study of, 28–29
English Literature (Taylor's Version) course, ix–xii, xiv, xvi, 22, 29, 34, 40, 247
English sonnets, 150
Enlightenment, 122
environment, xiii. *See also* nature

environmentalist movement, 196

Eos, 264–265

The Epic of Gilgamesh, 179

"epiphany" (Swift), 78, 82, 83, 88

Epistles for the Ladies (Haywood), 102

epistolary novels, 31

Eras Tour, 11, 15, 20, 77, 85, 91, 92, 108, 113, 162, 186–188, 190, 200, 210–211, 215, 231, 254

escapism, 99, 191

Esquivel, Laura, 257

Estok, Simon, 180

Esuana, Oliver, 222

Evans, Dayna, 211

Eve, 166, 194, 202

evermore, 5, 10, 40, 52, 63, 99, 104, 158, 177, 184, 187, 189, 190, 192

"evermore" (Swift), 54, 185

The Evil Dead (film), 182, 184

ex-boyfriends, 114, 199, 208, 209

"exile" (Swift), 3, 6, 81–82

expectations, 7–8, 75–76

extended metaphors, 45, 46, 137, 152

"Eyes Open" (Swift), 129

F

The Facts (Roth), 113

fairy tales, 16, 122–123, 181, 249–250

"fallen woman," 158–159

Fall Out Boy, 46

"False God" (Swift), 146–147

false gods, 146–148

fame, 67–69, 73–74, 208

"Famous" (West), 94

fanboys, 25

fandom, 26

fan fiction, 112–113

fangirls, 24–25

fanilect, 26

Fantastic Beasts (Rowling), 109–110

fatphobia, 239

Fearless, 1, 98, 119

Fearless (Taylor's Version), 129

Feder, Rachel, 251

Fehrle, Johannes, 252, 263

Fellowes, Julian, 232

female anti-heroes, 225–230, 239–244

female authors, 107. *See also specific authors*

female emotions, 24

female experience, 173

female fandom, 24–25

female unlikability, 230–237, 239, 242, 244

femininity, 21, 22, 29, 234

feminism, xii, 77, 163, 210, 213, 237, 239–240, 244–245; ecofeminism, 192–195; postfeminism, 235–236

feminist killjoys, 159, 236

feminists, 159, 204

femmes fatales, 204, 218, 230

Fielding, Helen, 259

Fielding, Henry, 221–222

Fifty Shades of Grey (James), 113

figurative language, 43–44

film adaptations, 248–250, 253, 256–260

fin de siècle, 203–205

Fingersmith (Waters), 160

Finlay, Marjorie, 82

Finney, Carolyn, 191

first-person narration, 49

First Two Pages of Frankenstein, 69

First World War, 13, 139

Fish, Stanley, 116

Fitzgerald, F. Scott, 4

flashbacks, 41–42

"The Flea" (Donne), 152

Fleabag (TV series), 225

"Florida!!!" (Swift), 10

Flynn, Gillian, 8, 234

Fogarty, Mary, 104, 105

folklore, 5, 12, 21, 37, 40, 52, 63, 99, 104, 159, 177, 184, 185, 187–190, 192, 201

INDEX

Folklore: The Long Pond Studio Sessions (documentary), 159

Ford, Mark, 62

"Forever & Always" (Swift), 123

"Fortnight" (Swift), 79, 161–162, 165, 166, 172

"fountain pen style" songs, 4, 5

"The Four Ages of Poetry" (Peacock), 20, 33–34

fourth wall, 10, 14–15, 16, 43

Four Weddings and a Funeral (film), 85

frame narratives, 125

Frank, Arthur W., 172

Frankenstein (Shelley), 70–73, 76, 107, 260

Franks, Richard, 258

free association, 50

Freeman, Siarra, 243

Freud, Sigmund, 223

Freudian psychology, 13

friendship bracelets, 27

From Dusk Till Dawn (film), 9

Fromer, Loza, 106

Furtado, Nelly, 230

G

Game of Thrones (Martin), 120

Game of Thrones (TV series), 123, 223, 225, 227, 244

Garden of Eden, 187–188

Garfinkle-Crowell, Suzanne, 171

gaslighting, 256

Gass, Kyle, 74

gatekeepers, 29–30

"Gawain poet," 132–133

Gay, Roxane, 235

gender stereotypes, 26

gender studies, 236

genius, 61, 63–66; mad, 167, 170

genre bending, 5, 7–9, 14–16

Gentry, Antonia, 209

George, Kadija Sesay, 30

Georgi, Maya, 239

Gervais, Ricky, 22

Gerwig, Greta, 20

"Getaway Car" (Swift), 6, 45, 56, 142

ghosts, 201, 203

Gibbons, Alison, 99

Gilbert, Sandra, 158

Gilbert, Sophie, 12–13, 130, 176, 214, 243–244

Gilman, Charlotte Perkins, 156, 168–170, 195

Ginny & Georgia (TV series), 209, 241

girlhood, 21, 22, 27, 215–216

girls: Black, 216; sad, 91–92, 174

Girls (TV series), 227, 244

girls' culture, 20–23; dismissal of, xii, 23–28

Glastonbury festival, 121

"glitter gel pen" songs, 4, 143

God, 153–154

Godwin, Mary Wollstonecraft. *See* Shelley, Mary

The Golden Compass (film), 248

Gone Girl (Flynn), 8, 225, 234

"goodbye" (Swift), 54

Gordon, Bryony, 156–157, 230

Gormley, Frieda, 179

Gosling, Ryan, 124

Gosson, Stephen, 32

gothic, 10, 16, 199–206, 213, 217–219; literature, 157, 201–209; Southern Gothic, 205–206

GQ magazine, 96

Graham, W. S., 88

Grahame-Smith, Seth, 251

Grammy Awards, 69

graphic novels, 258

Gray, Thomas, 80

Great Expectations (Dickens), 157, 256

The Great Gatsby (Fitzgerald), 4

"The Great God Pan" (Machen), 204

"The Great War" (Swift), 83, 137, 139, 140, 146
The Green Knight (film), xvi, 133
Greenlaw, Lavinia, 25
grief, xii–xiii, 77–93, 140; adolescent, 91–92; disenfranchised, 79, 82, 90–92
growing up, 21. *See also* childhood
Grylls, Bear, 179
Guardian, 97
Gubar, Susan, 158, 176
Guillory, John, 30
"Guilty as Sin?" (Swift), 147, 148, 151, 152, 170
Gulliver's Travels (Swift), 8

H
Haas, Melanie, 225
Haddad, Elizabeth, 243
Hagelin, Sarah, 225–226, 229–230, 239
Haggard, Rider, 61, 204
Hag-Seed (Atwood), 259
half rhyme, 56
Hamlet (Shakespeare), 223, 260
Hannibal Lecter, 223
Hansen, Adam, xiv–xv, xvii
"happiness" (Swift), 4, 48
happy endings, 10
Harjo, Joy, 193–194
Harkness, Rebekah, 166–167
Harpin, Anna, 89, 90, 162, 172
Harrington, Mary, 118, 151–152
Harris, Calvin, 199
Harris, Kamala, 205
Harrison, Tony, 83–84
Harry Potter and the Cursed Child (Rowling), 109
Harry Potter and the Deathly Hallows (Rowling), 109, 112
Harry Potter series, 61, 121, 182
hate mail, x, xi, 22
"Haunted" (Swift), 78

"The Haunted Oak" (Dunbar), 191
hauntings, 201–202
Hawthorne, Nathaniel, 119
Haywood, Eliza, 94, 102, 103
Hazlitt, William, 61, 116
Healy, Matty, 111, 161, 167
heartbreak, 78, 79, 83, 92, 137, 140, 157, 171
Heart of Darkness (Conrad), 260
Henryson, Robert, 154–155
Herland (Gilman), 195
heroism, 222. *See also* anti-heroism
Hess, Scott, 140
"Hey Stephen" (Swift), 10
hidden meanings, 100–102, 105–106, 110–111
higher education, commercialization of, 34
"High Infidelity" (Swift), 142
hip-hop, 56, 217
"To his Mistress going to bed" (Donne), 192
"The History of Magic in North America" (Rowling), 110
Hitchcock, Alfred, 253, 256
"Hits Different" (Swift), 160–161
"hoax" (Swift), 142, 196–197
The Hobbit (Tolkien), 120
Holderness, Graham, 250
Holiday, Billie, 191
Holland, Jason, 91
Holland, Norman, 116
Hollick, Frederick, 168
Holocaust, 13
"Holy Ground" (Swift), 146
"Holy Sonnets" (Donne), 153–154
Homeland (TV series), xiii, 225, 226–227
hooks, bell, xi
Hopper, Jessica, 25
horizon of expectations, 7
Horn, Olivia, 12
House of Cards (TV series), 223, 225

"The House of Fame" (Chaucer), 1, 17–18
Houston, Shannon M., 243
Howard, Rebecca Moore, 62
"How Did It End?" (Swift), 46
How to Do Nothing (Odell), 197
How To Get Away With Murder (TV series), 241
"How You Get the Girl" (Swift), 54
Hu, Jane, 259
Hughes, Langston, 103
Hughes, William, 115
humanities, xvi
The Hunger Games (film), 129
"The Hunting of the Snark" (Carroll), 109
Hutcheon, Linda, 249, 255
hysteria, 168, 169, 231

I

"I Bet You Think About Me" (Swift), 10
"I Can Do It with a Broken Heart" (Swift), 15–16, 164, 231
"I Can Fix Him (No Really I Can)" (Swift), 54
"I Can See You" (Swift), 115, 165
"iceberg songs," 44
id, 223
ideas, 58
identity, 163, 205, 243–244
"I Did Something Bad" (Swift), 200
idioms, 46–47
"I find no peace" (Wyatt), 150
If on a winter's night a traveler (Calvino), 14–15
"I Forgot That You Existed" (Swift), 102
"If This Was a Movie" (Swift), 6
"I Hate It Here" (Swift), 187, 188, 189, 191, 195, 256
"I Know Places" (Swift), 165, 208
imagery, 43–44, 119

imagination, 63, 64
The Importance of Music to Girls (Greenlaw), 25
In Defense of Witches (Chollet), 200
individualism, 240
infidelity, 155
influence: anxiety of, 63, 74; of other writers, 63, 66; use of, 211–212, 213–214
innocence, 188, 189, 195; loss of, 21
"Innocent" (Swift), 95
insanity. See madness/mad woman
Insectivorous Plants (Darwin), 182
inspiration, 58–61, 63–69, 75
intangibles, making tangible, 43–45
intentional fallacy, 105–106
internalized misogyny, 210
internal rhyme, 56
interpretive communities, 116
intersectionality, 216
Interstellar (film), 195
intertextuality, 9, 12
"invisible string" (Swift), 4–5, 142, 196
Ishiguro, Kazuo, 8
"Is It Over Now?" (Swift), 5
"ivy" (Swift), xiii, 51, 150, 184–185

J

"Jabberwocky" (Carroll), 108, 109
Jackson, Peter, 81
James, E. L., 113
Jane Eyre (Brontë), 4–5, 158, 159, 246, 256
Jauss, Hans Robert, 7
Jennings, Rebecca, 191
Johnson, B. S., 14
Johnson, Marion, 226
Johnson, Mark, 47
Johnson, Samuel, 223
Jones, Robert W., 124
Jones, Terry, 126
Joon-Ho, Bong, 9

INDEX

Joyce, James, 49
Jumanji (film), 182
Jung, Carl, 223
Jung, Hawon, 236

K
Kafka, Franz, 68
Kardashian, Kim, 94, 104, 170, 199, 235–236, 241, 242
"Karma" (Swift), 11
"Kasper Craig" (Elliott), 182–183
Keats, John, 63–65, 68, 75, 80
Kelce, Travis, 11, 12
Kermode, Frank, 252
Keymer, Thomas, 103
Khan, Safia, 209
Killing Eve (TV series), 223
Kimojis, 235–236
King, Stephen, 65, 248
King Arthur (Ritchie), 121
King Arthur legend, 121, 125, 131–134, 224
Klimchynskaya, Anastasia, xviii, 231
Knife: Meditations After an Attempted Murder (Rushdie), 36
knights/knighthood, 119, 120, 121, 124, 129, 143–144. *See also* chivalry
"The Knight's Tale" (Chaucer), 125–128
A Knight's Tale (film), 125
Koehler, Sezin Devi, 240–241
Krueger, Marilyn J., 128
"Kubla Khan" (Coleridge), 58, 59, 65, 74–75
Kureishi, Hanif, 35

L
"Labyrinth," 201
Lady Macbeth, 228–229
Lady Macbeth of the Mtsensk District (Leskov), 229

Laing, Olivia, 99
"the lakes" (Swift), 59, 185, 256
Lamia, Mary C., 128
Lane, Mary E. Bradley, 195
language: archaic, 258; rethinking, 46–47; versatility of, 47
Lansky, Sam, 27
Larsson, Stieg, 209, 223, 257
"the last great american dynasty" (Swift), 166–167
The Last of Us (TV series), 258
Layoff, George, 47
Leader, Darian, 89, 90
Le Calvez, Tony, 215
Le Guin, Ursula K., 194
Leighton, Angela, 82
Le Morte D'Arthur (Malory), 131–132, 140–143
Leskov, Nikolai, 229
Leszkiewicz, Anna, 6
Lewinsky, Monica, 162
Lewis, C. S., 143
Lewis, Matthew, 208
LGBTQ+ movement, 213
The Life and Opinions of Tristram Shandy, Gentleman (Sterne), 61–63, 115
likeability, 234–235. *See also* "unlikeable woman" trope
Like Water for Chocolate (Esquivel), 257
liner notes, 100, 101
listening, 172
literary allusions, xiv
literary canon, xi, xii, xvii, 30–32, 247–248, 258
literary devices, 39–57
The Literary Taylor Swift (Tontiplaphol and Klimchynskaya), xviii
literary value, 31–32
literature: analysis of, 103–112; autobiographical, 103–104; courses, 28, 29; defense of, 32–36; English, xvii–xiv, 28–29;

gatekeeping of, 29–30; gothic, 157, 201–209; grief and mourning in, 90; hidden meanings in, 100–102, 105–106, 110–111; interpretation of, 103–112, 116; medieval, 140–146; nineteenth-century, 159–160; Romantic, 59–68, 74–75, 188–189, 197; study of, 32–33; utopian, 195

Litpop (Carroll and Hansen), xiv–xv

Lloyd Webber, Andrew, 249

lobotomy, 172

Loki (film), 241

"Loml" (Swift), 88, 147, 148

lone genius, 61, 63–66

"Long Live" (Swift), 3, 67

"long story short" (Swift), 54, 142

"Look What You Made Me Do" (Swift), 7, 76, 78, 97, 113, 165, 199–200, 242, 253

Lord of the Rings (Tolkien), 81, 120

Lott, Eric, 62

Lotz, Amanda, 222, 244

Louv, Richard, 178

love: courtly, 143–146, 148–150; as death, 152; pain of, 148–150; paradox of, 148–149; as religion, 151–152; romantic, 146–147; unrequited, 150; as war, 137, 155

Love and Theft (Dylan), 62

Love Is Blind (TV series), 234

Lover, 12, 69, 83, 104, 135, 146

"Lover House" (Swift), 36, 37

The Lover; To Which Is Added, The Reader (Steele), 221

love stories, 3, 4, 6, 141

"Love Story" (Swift), xiv, 5, 51, 53, 119, 122, 123, 130, 196, 251, 257

"Love's Warre" (Donne), 137

Lowe, Louisa, 160

Lowery, David, xvi, 133

Lowes, John Livingston, 59

Luhrmann, Baz, 248

lust, 147, 151

The Lyrical Ballads (Coleridge and Wordsworth), 59–60, 65–66

lyrics. *See* song lyrics

M

Macbeth (Shakespeare), 228–229

Machado, Ana Clara Benevides, 85

Machen, Arthur, 204

mad genius, 167, 170

madness/mad woman, 156–176, 203, 231

Madonna, 16, 248

Mad Woman (Gordon), 156–157, 230

"mad woman" (Swift), 159, 165, 174, 200, 201, 208, 237, 256

The Madwoman in the Attic (Gilbert and Gubar), 158

Mahmassani, Addie, 215, 218

Malory, Thomas, 131–132, 140–143

"The Man" (Swift), 208

manosphere, 128

"The Manuscript" (Swift), 114, 246

"marjorie" (Swift), 78, 82, 88, 89, 104, 196–197

Markle, Meghan, 92

"Maroon" (Swift), 49, 87, 111

Marowitz, Charles, 260

Martin, Adrian, 248

Martin, George R. R., 120, 223

Martineau, Harriet, 232

Martinson, Jane, 97

Marxism, 13

"Mary's Song" (Swift), 11–12, 53, 196

mash-ups, 14, 113–114, 254

Matisse, Henri, 13

Matthews, David, 119

Maurier, Daphne du, 256

Mazzeo, Tilar, 62

McCartney, Paul, 61

McCoy, Leola, 191

McKee, Taylor, 104

"Mean" (Swift), 50, 142

media res, 51–52

medievalism, 120–123

medieval literature, 140–146

medieval romance, xiv, 118–136, 140–141

Melville, Herman, 68

"In Memoriam" (Tennyson), 82

mental health, 171–175. *See also* madness/mad woman

Merlin (TV series), 121, 123

Merwin, W. S., 82

Messud, Claire, 231–232

meta, 14, 16, 83, 134, 259

metafiction, 15

metaphors, 43–47, 87, 115; dead, 46, 140; extended, 45, 46, 137, 152

#MeToo movement, 163, 206

Michel, Lincoln, 237

"Midnight Rain" (Swift), 149, 165

Midnights, xi, 27, 63, 78–79, 137, 139, 160–161, 220

Miike, Takashi, 8

Millennium trilogy (Larsen), 209, 223, 257

"The Miller's Tale" (Chaucer), 127–128

Milton, John, 192, 223

Minaj, Nicki, 216, 241, 242

miscarriage, 84

misogyny, 24–25, 64, 128, 165, 200, 210, 244

Miss Americana (documentary), 67, 69, 212

"Miss Americana & the Heartbreak Prince" (Swift), 13, 47, 56, 135–136

Miss Havisham (character), 157–158, 171

"Missing The Sea" (Walcott), 87

Mitchell, David, 110–111

Mitchell, Joni, 32

Mitchell, Silas Wir, 168, 169

Mizora (Lane), 195

modernism, 13, 49–50

modernity, 189

Moffa, Gina, 90

Moll Flanders (Defoe), 227–228

"The Moment I Knew" (Swift), 261

The Monk (Lewis), 208

monsters, 70, 73–74, 76, 183, 184, 200, 201, 203

Monty Python and the Holy Grail (film), 118, 125

Morgan, Lady, 101–102

Morris, Maren, 230

Morrison, Toni, 220, 242–243

Moshfegh, Ottessa, 237–238, 239

Mother (film), 193

mourning, 82, 86–93

"Mr. Perfectly Fine" (Swift), 54

Mrs. Dalloway (Woolf), 49–50

MTV VMA Awards, 94–95, 97

Mueller, David, 176

Murray, Katherine, 190

musical genres, 5, 6

music industry, 64, 95, 165, 195, 205

mutations, 255, 256

The Mysteries of Udolpho (Radcliffe), 199

"my tears ricochet" (Swift), 208

mythology, 100

My Year of Rest and Relaxation (Moshfegh), 237–238, 239

N

narcissism, 238–239

narrative: control over, 94–98, 114–115; frame, 125; underdog, 211; victim, 214–218, 240

narrators, 15, 40; vs. author, 103–104; first-person, 49; second-person, 2, 15, 42; unreliable, 233

Nashville Songwriting Awards (2023), 4, 6, 66–67

"nasty woman," 231

The National, 69

INDEX

nature, xiii, 177–198
Nazi–Jew comparisons, 138, 139
Nemesis, 141
Nerdland festival, 160
Netflix, 236, 248, 249
Neuse, Richard, 126
"Never Grow Up" (Swift), 130
Never Let Me Go (Ishiguro), 8
New Amazonia (Corbett), 195
new criticism, 112
New Woman, 204, 205
"New Year's Day" (Swift), 3, 7
Nicks, Stevie, 4, 74
1989, 5, 6, 54–55, 95, 106, 196
1989 (Taylor's Version), 60, 73, 96, 101, 114, 156, 254
Nobel Prize for Literature, 32
"no body, no crime" (Swift), 40
Nolan, Christopher, 258
Northanger Abbey (Austen), 8, 22–23, 24, 208
Northern Lights (Pullman), 248
"Nothing New" (Swift), 39, 67, 68, 76
novels, 22–24; epistolary, 31; gothic, 204–205, 208; graphic, 258; picaresque, 221–222
"Now That We Don't Talk" (Swift), 64
Nunn, Gary, 167
Nussbaum, Emily, 227

O
"Ode: Intimations of Immortality from Recollections of Early Childhood" (Wordsworth), 188–189
Odell, Jenny, 197
O'Hara, Frank, 42
Old English, 80, 81
"O Leave Novels" (Burns), 23
The Once and Future King (White), 121, 224

"the 1" (Swift), 111
"Only the Young" (Swift), 136
onomatopoeia, 52
"On the Stairs" (Harjo), 194
Onyebuchi, Tochi, 195
opium, 65
Opperman, Jeff, 177, 196
orgasm, 152
originality, 62–65, 67, 71, 250
origin stories, 111
Oroonoko (Behn), 7–8
Osborne, Deirdre, 30
"The Other Side of the Door" (Swift), 6
"Ours" (Swift), 10
"Our Song" (Swift), 9, 10, 58
"Out of the Woods" (Swift), xiii, 54, 99, 182, 183–184
"out of the woods" idiom, 181–182, 184
The Outpourings of an Alleged Lunatic (Weldon), 165
Owens, Delia, 185

P
Pagoto, Sherry, 79, 84, 91, 92
pain: emotional, 137, 139–142, 148–149, 174; of love, 148–150; physical, 139–142
Paine, Tree, 96
The Pale Horse (Christie), 249
Pamela (Richardson), 31
"Paper Rings" (Swift), xviii, 50
Paradise Lost (Milton), 223
Parasite (film), 9
parasocial relationships, 117
Parker, B. A., 212, 215, 216
"The Parliament of Fowls" (Chaucer), 126
Parton, Dolly, 230
pastoral poetry, 188
"paternity test," 105
Patmore, Coventry, 158

patriarchy, 77, 158, 164, 165, 167, 193, 200, 208, 217
"peace" (Swift), 73
Peacock, Thomas Love, 20, 33–34
perfectionism, 74–76
"A Perfectly Good Heart" (Swift), 6
perfect rhyme, 55–56
Pergadia, Samantha, 159, 164, 234
Perry, Katy, 208
personal life, 98
personas, 103–104
"Person of the Year" (2023), 20
Persuasion (Austen), 248
Persuasion (film), 248, 249, 250–251
"Peter" (Swift), 141
Peter and Wendy (Barrie), 21, 246–247, 260–263
Peter Pan (film), 261
Peter Pan syndrome, 262
Peters, Maisie, 262
Petersen, Anne Helen, 24, 231, 241
Petrarch, 149–150
Petrusich, Amanda, 26, 27
"The Phenomenology of Anger" (Rich), 166
physical pain, 139–141
The Pianist (film), 257
picaresque novels, 221–222
Picasso, Pablo, 13
"pick-me girl," 234, 245
The Picture of Dorian Gray (Wilde), 8
Pierce, N. A., 225
Pilgrim's Progress (Bunyan), 260
Pinocchio (film), 253
Pinter, Harold, 35
Pisan, Christine de, 134
Pitchfork, 12
plagiarism, 62, 66
plant blindness, 180–181, 197, 198
"plant horror" stories, 182–183
Plath, Otto, 138
Plath, Sylvia, 5, 137–138, 139–140, 170, 247, 251
platitudes, 46
Poe, Edgar Allen, 68
poetic conceits, 45, 152
poetic feet, 56–57
poetry, 33–35, 38–57; confessional, 5; elegies, 78–92; pastoral, 188; Romantic, 59–66
Polanski, Roman, 257
politics, 179, 212–213, 244–245
polysyndeton, 50
Pope, Alexander, 102
popular culture, xi, xii, xv, 12, 37
popular music, xiv–xv, 35
postfeminism, 235–236
postmodernism, 13–17
Pound, Ezra, 13
Pressman, Jack, 172
pressure, to produce, 68–69
Pride and Prejudice and Zombies (Grahame-Smith), 251
private jet usage, 186, 210, 214
privilege, 211–218, 240–241, 245
"The Prophecy" (Swift), 73, 158, 166
pseudonyms, 107
Psycho (film), 248, 253
psychological realism, 140–141
Pugh, Florence, 229
Pullman, Philip, 248
Pulp Fiction (film), 122
Puritanism, 32

Q
Queen, 64
"quill" songs, 4–5, 51, 52

R
racism, 188, 191, 216–217, 241–243
Radcliffe, Ann, 199, 208
Railhead trilogy (Reeve), 195
rainbow capitalism, 213
rap, 56, 217

INDEX

Ratajkowski, Emily, x
rational dress movement, 203
reader-response criticism, 116–117
"Read Every Day" initiative, 58
". . . Ready for It?" (Swift), 3, 152
Reagan, Ronald, 191
Rebecca (du Maurier), 256
Rebecca (film), 256
Red, 5, 6
"Red" (Swift), 42, 53
Red (Taylor's Version), 157, 254
Reeve, Philip, 195
Reid, Brittany, 104
reinvention, 5, 67
relatability, 41, 42
religion, 13, 35, 147–148, 151–154
Renaissance sonnets, 53–54
Renaissance Tour, 20
"Renegade" (Swift), 142
repetition, 85
repetition with variation, 53–54, 254
reputation, 94–98, 102
Reputation, 5, 7, 16, 69, 96–98, 104,
 113, 115, 166, 199, 201, 211, 213,
 224, 225, 227, 230, 240
rerecordings, 12, 114–115, 253–255
rest cure, 168–169, 237–238
retellings, 247–248. *See also*
 adaptations
rethinking language, 46–47
retroactive continuity (reconning),
 109–113
Reynolds, John Hamilton, 68
Rhimes, Shonda, 241
rhyme, 55–56
Rhys, Jean, 159–160
Rich, Adrienne, 166
Richardson, Samuel, 31
"right where you left me" (Swift), 79,
 256
"Rime 134" (Petrarch), 150
The Rime of the Ancient Mariner
 (Coleridge), 201–202

The Ringer, 96
Ritchie, Guy, 121
The Robber Bride (Atwood), 228–229
"Robin" (Swift), 130, 189
Rodriguez, Robert, 9
Rody-Mantha, Bree, 240
Rokeya, Begum, 195
Rolling Stone, 104
romance, xiv, 16; medieval, xiv,
 118–136, 140–141
Romantic ideal, 66–67
Romanticism, 61–66, 189
romantic love, 146–147
Romantic writers, 59–60, 65–66,
 74–75, 188–189, 197; creative
 anxiety and, 70; elegy and, 80;
 fame and, 67–69
Romeo + Juliet (film), 248
Romeo and Juliet (Shakespeare), xiv,
 1, 5, 119, 246, 250–252, 260
"Ronan" (Swift), 78, 86, 89
Roth, Philip, 113
Rowling, J. K., xvi, 61, 109–112
Roxana (Defoe), 227–228
Royle, Nicholas, 106, 117, 179, 250
Rushdie, Salman, 35–37, 116

S
sad girls, 91–92, 174
"Sad Girl Theory," 174
sadness, 174–175
Saint-James, Molly, 88–89
Salem's Lot (King), 248
Salinger, J. D., 8
Satan, 223
The Satanic Verses (Rushdie), 35
"Say Don't Go" (Swift), 142
Scandal (TV series), 241
The Scarlet Letter (Hawthorne), 119
The School of Abuse (Gosson), 32
Schussler, Elisabeth, 180
Scott, Ridley, 258
Screen Rant, 236

second person narration, 2, 15, 42

Second World War, 139

The Secret Garden (Burnett), 187

self-acceptance, 27

self-deprecation, 76

self-destruction, 151

selfishness, 239

self-narration, 99

self-referentiality, xii, 11, 14

Selznick, David O., 256

"seven" (Swift), 44, 188, 196

sex, 152

Sex and the City (TV series), 227, 244

sexism, xii, 129, 188, 244

Shaffer, Claire, 10

"Shake It Off" (Swift), 56

Shakespeare, William, xiv, 1, 5, 28, 53–54, 62, 90, 101, 116, 119, 222–223, 228–229, 246–248, 250–252, 258–260

shapeshifting, 204–205

She (Haggard), 61, 204

Shelley, Mary, 65, 70–73, 76, 107, 198

Shelley, Percy, 33–35, 46, 64, 65, 70, 75, 80, 198

"She Unnames Them" (Le Guin), 194

shifting time, 52–55

Shiver (Stiefvater), 197

Showalter, Elaine, 157, 176

Shrek (film), 124

Shyamalan, M. Night, 181

Sidney, Philip, 32–33

Silverman, Gillian, 225–226, 229–230, 239

similes, 43–44

sin, 147, 153–154

Sir Galahad, 224

Sir Gawain and the Green Knight (anon), 132–133

Sjöberg, Nils, 107

Skyler Effect, 226

slant rhyme, 56

slavery, 191

Sleeping Beauty (film), 124

Sloan, Nate, 52–54

"Slut!" (Swift), 52, 57, 237

"The Smallest Man Who Ever Lived" (Swift), 6–7, 57, 143, 148, 208, 215, 234

Smith, Charlotte, 65

Smith, Patti, 76

Smith, Stevie, 75

snake imagery, 7, 96, 166, 188, 199–200, 218

Snapes, Laura, 212, 224, 254

snobbery, xii, 23

Snow White (film), 182, 249–250

social media, 95, 97, 170, 209, 211, 212

"So High School" (Swift), 152

"So Long, London" (Swift), 46, 51, 87, 140, 145

song lyrics, interpretation of, 100–104, 107, 111–116

songs, mash-ups of, 113–114, 254

songwriting process, 2, 66–67

songwriting style, 39–57

"Sonnet 130" (Shakespeare), 53–54

sonnets, 53–54, 149–150, 153

"Soon You'll Get Better" (Swift), 78, 82–83, 87–88

The Sopranos (TV series), 223

"Sounds Right" initiative, 195–196

Southern Gothic, 205–206

speaker, 40; vs. author, 103–104

Speak Now, 2, 95, 98, 129, 210

Speak Now (Taylor's Version), 64, 69, 71, 114, 251, 254

Spears, Britney, 161

Spenser, Edmund, 192

Spilde, Coleman, 89

spondees, 57

spontaneity, 60–61

Squid Game (TV series), 223

Stallion, Megan Thee, 216

Stapfer, Paul, 62

Star Wars (film), 121

"State of Grace" (Swift), 142, 144, 146

Steele, Richard, 221

stereotypes, 241

Sterne, Laurence, 61–63, 115

Stiefvater, Maggie, 197

Stoker, Bram, 204

"Stop all the clocks, cut off the telephone" (Auden), 85

stories: fluidity of, 11–12; love, 3, 4, 6; our own, 1–3, 5, 9, 13, 19; poems vs., 34–35; unexpected, 7–8

"The Story of Us" (Swift), 1–3, 6, 9, 51, 86–87

Stradanus, Johannus, 192–193

"Strange Fruit" (Holiday), 191

Strav, Cat, 229–230

stream of consciousness writing, 49–50

A Streetcar Named Desire (Williams), 161

stressed syllables, 56–57

"Style" (Swift), 106, 114

Styles, Harry, 106

subjectivity, 32, 61

Sula (Morrison), 242–243

Sultana's Dream (Rokeya), 195

Swarm (TV series), 241

"Sweet Nothing" (Swift), 59

Swift, Jonathan, 8

Swifties, 24–27, 117, 209

"Swiftposium" (2024), 171

Swift Six, 39; aural effects, 55–57; confessional spontaneity, 48–52; making intangible tangible, 43–45; rethinking language, 46–47; shifting time, 52–55; universal specificity, 40–42

The Sword in the Stone (film), 124, 131

symbols, 43–44

T

"Talking Taylor: The Eras Explained" panel, 25–26

Tarantino, Quentin, 9

Tate, Andrew, 128

Tatreau, Tiffany, 251

Taylor, Elizabeth, 3

Taylor, Kandiss, 200–201

Taylor Nation, 100

Taylor Swift by the Book (Feder and Tatreau), 251

"Taylor Swift Cinematic Universe," 100

"Taylor Swift Is Not Your Friend" (Evans), 211

technology, 189

teenage grief, 91–92, 174

Teigen, Chrissy, 92

"Tell Me Why" (Swift), 142

10 Things I Hate About You (film), 258

The Tempest (Shakespeare), 259

Tenancious D, 74, 75, 76

Tennyson, Alfred, 82

Ternan, Ellen, 160

"*The Testament of Creseid*" (Henryson), 154–155

Thackeray, William Makepeace, 228, 235, 260

"thanK you aIMee" (Swift), 210, 242

Theocritus, 188

A Theory of Adaptation (Hutcheon), 249

theory of evolution, 255

"this is me trying" (Swift), 46–47, 165

This Is the Canon: Decolonize Your Bookshelf in 50 Books (Anim-Addo, et al.), 30–31

"This Is Why We Can't Have Nice Things" (Swift), 97, 208

"This Love" (Swift), 185, 186

INDEX

Thomas, Chris, 211

Thomas, Dylan, 76

Thompson, Maya, 86

Thoreau, Henry David, 196

"Thoughts about the Person from Porlock" (Smith), 75

1001 Books You Must Read Before You Die (Boxall), 30

"Timeless" (Swift), 3, 251–252

timeless works, 251–252, 263–265

Time magazine, 22, 67, 97; "Person of the Year" (2023), 20, 170, 186, 214

time shifting, 52–55

"Tim McGraw" (Swift), 46

Tithonus, 264–265

"Today Was a Fairytale" (Swift), 5, 122, 123

"Todesfuge" ("Death Fugue") (Celan), 138

Tolentino, Jia, 173

"tolerate it" (Swift), 6, 55, 141–142, 146, 159, 256

Tolkien, J. R. R., 81, 120–121, 249, 258

Tom Jones (Fielding), 221–222

Tontiplaphol, Betsy Winakur, xviii

Too Fat, Too Slutty, Too Loud (Petersen), 231

Too Much (Cote), 169

"too muchness," 231, 232

The Tortured Poets Department (TTPD), 12–13, 38–39, 52, 53, 63, 72, 76, 91, 99, 111, 114, 129, 130, 147–148, 158, 161–162, 172–176, 187, 200, 214–215, 246

Tournament of Eglinton, 121

toxic masculinity, 256

tragedy, 91, 146

Traister, Rebecca, 164

trauma, 139

"Treacherous" (Swift), 150, 151

"Tribute" (Tenancious D), 74, 75

Troilus and Criseyde (Chaucer), 144–149, 154–155

trolls, x

Trump, Donald, 135, 231

truth, 19

Tucker, Cora, 163–164

Twain, Mark, 125

"22" (Swift), 76

Twilight (Meyer), 5, 23, 24, 113

U

ubi sunt motif, 81

Ukazu, Ngozi, 241

underdog narrative, 211

The Unfortunates (Johnson), 14

universal specificity, 40–42, 85–86

university courses, 27–28

"unlikeable woman" trope, 230–239, 242, 244

unreliable narrators, 233

unrequited love, 150

Unsolved (Critchlow), 231

unstressed syllables, 56–57

Upendran, Achala, 110, 112

Urban, Keith, 230

utility, in higher education, 34

utopian literature, 195

V

value judgments, 32

Vance, J. D., 230

Vanity Fair (Thackeray), 228, 235, 260

vault, 115, 156, 165

Vespucci, Amerigo, 192–193

victimhood, 98, 202, 203, 205–211, 213–215, 218, 240

video games, 258

vigilantes, 205

"Vigilante Shit" (Swift), 205

Vikings (TV series), 123

villains/villainy, 199–206, 208–212, 218

Villette (Brontë), 232–234

"A Vindication of the Rights of Woman" (Wollstonecraft), xvi, 26

violence, against nature, 179

VMA Awards, 94–95, 97

Vogue, 97

Volpe, Mila, 23, 90

volta, 53–54

W

Wagner, Sarah, 25

Walcott, Derek, 87

Wallaert, Sigrid, 163

Walpole, Horace, 207–208

"The Walrus" (Beatles), 105

"The Wanderer" (anon), xii, 77, 80–82

Wandersee, James, 180

war, 139–141, 144–145, 149, 151, 155

War Girls (Onyebuchi), 195

Warren, Elizabeth, 163, 167

Waters, Sarah, 160

"The Way I Loved You" (Swift), 148

wealth, 211–212, 217

weapons imagery, 142

"We Are Never Getting Back Together" (Swift), 40–41, 60, 76

Weber, Theon, 44

Weitz, Chris, 248

Welch, Florence, 10

Weldon, Georgina, 160, 165

"Wendy" (Peters), 262

West, Kanye, 94–95, 104, 135, 170, 208

Western canon, xi–xii, xvii, 30–32, 247–248, 258

The Western Canon (Bloom), 30

Wharton, Edith, 232

"When Earth Becomes an 'It'" (Awaikta), 194

"When Emma Falls in Love" (Swift), 3

Where the Crawdads Sing (Owens), 185, 206

White, Terri, 234

White, T. H., 121, 133–134, 224

White girl sadness, 175

"White Horse" (Swift), 6, 119, 120, 134, 135, 256

white knight syndrome, 128

White privilege, 191, 212, 215–218, 240–241, 245

"Who's Afraid of Little Old Me?" (Swift), 39, 72–73, 158, 162, 165, 205, 206, 218, 230

Why I Am Not a Feminist (Crispin), 239–240

"Why she disappeared" (Swift), 96

Wide Sargasso Sea (Rhys), 159–160

Wilde, Oscar, 8

wilderness, 181–182, 187, 188, 191, 194, 196. *See also* nature

"Wildest Dreams" (Swift), 4

Williams, Hannah, 212, 213, 214

Williams, Joan C., 231

Williams, Raymond, 178

Williams, Serena, 167

Williams, Tennessee, 161

"willow" (Swift), xiii, 63, 142, 184, 186, 197, 200

Wimsatt, W. K., 105–106, 114

The Wire (TV series), 223

witches, 200–201, 203, 205

"wokeness," 30–31

Wollen, Audrey, 91–92, 174

Wollstonecraft, Mary, xvi, 26

The Woman in White (Collins), 160

The Woman Upstairs (Messud), 231–232

women: climate crisis and, 193; of color, 216–217, 240–243; mad, 156–176, 203, 231; rights for, 203–204

Women's Strike (Iceland), 226
women writers, in Romantic period, 65–66
Woolf, Virginia, 49–50, 75, 170
Wordsworth, Dorothy, 65, 66
Wordsworth, William, 59–60, 64–66, 68, 107, 188–189
"Would've, Could've, Should've" (Swift), 27, 139, 151, 207, 208, 215–216
writer's block, 71, 75
writing, about writing, 1–19
Wuthering Heights (Brontë), 249
"Wuthering Heights" (Bush), 257
Wyatt, Thomas, 39, 149–151
Wyndham, John, 182

X
xenophobia, xii

Y
Yahr, Emily, 100

"The Yellow Wallpaper" (Gilman), 156, 168–170
"Yesterday" (Beatles), 61
"You Are in Love" (Swift), 2–3, 15, 42, 43, 44, 54–55, 57, 140, 149
"You Belong with Me" (Swift), 165
"You Need to Calm Down" (Swift), 142, 213, 217
Young, Edward, 34, 63
"You're Losing Me" (Swift), 3, 46, 51–52, 78–79, 88, 140, 143–144, 145, 148, 239
"You're on Your Own, Kid" (Swift), 27, 54, 129, 240
Youth for Climate movement, 163

Z
zeugma, 38, 47
Zoladz, Lindsay, 206
zombies, 7, 113, 166, 199, 201, 203, 252–253
Zylka, Jenni, 186–187